The Official Picture

McGILL-QUEEN'S/BEAVERBROOK CANADIAN
FOUNDATION STUDIES IN ART HISTORY

Martha Langford and Sandra Paikowsky, series editors

Recognizing the need for a better understanding of Canada's artistic
culture both at home and abroad, the Beaverbrook Canadian
Foundation, through its generous support, makes possible the
publication of innovative books that advance our understanding of
Canadian art and Canada's visual and material culture. This series
supports and stimulates such scholarship through the publication
of original and rigorous peer-reviewed books that make significant
contributions to the subject. We welcome submissions from
Canadian and international scholars for book-length projects on
historical and contemporary Canadian art and visual and material
culture, including Native and Inuit art, architecture, photography,
craft, design, and museum studies. Studies by Canadian scholars on
non-Canadian themes will also be considered.

McGill-Queen's University Press

Montreal & Kingston | London | Ithaca

# THE OFFICIAL PICTURE

The National Film Board of Canada's Still Photography Division
and the Image of Canada, 1941–1971

CAROL PAYNE

© McGill-Queen's University Press 2013

ISBN 978-0-7735-4145-0 (cloth)
ISBN 978-0-7735-8894-3 (ePDF)

Legal deposit third quarter 2013
Bibliothèque nationale du Québec

Printed in Canada on acid-free paper

This book has been published with the help of a grant from the Canadian Federation for the Humanities and Social Sciences, through the Awards to Scholarly Publications Program, using funds provided by the Social Sciences and Humanities Research Council of Canada.

McGill-Queen's University Press acknowledges the support of the Canada Council for the Arts for our publishing program. We also acknowledge the financial support of the Government of Canada through the Canada Book Fund for our publishing activities.

Set in 10/13 Filosofia with Univers
Book design & typesetting by Garet Markvoort, zijn digital

Library and Archives Canada Cataloguing in Publication

Payne, Carol
The official picture : the National Film Board of Canada's Still Photography Division and the image of Canada, 1941–1971 / Carol Payne.

(McGill-Queen's/Beaverbrook Canadian Foundation studies in art history)
Includes bibliographical references and index.
ISBN 978-0-7735-4145-0. – ISBN 978-0-7735-8894-3 (PDF). –

1. National Film Board of Canada. Still Photography Division – History – 20th century.   2. Documentary photography – Government policy – Canada – History – 20th century.
3. Documentary photography – Social aspects – Canada – History – 20th century.   4. Nationalism – Canada – History – 20th century.
5. Canada – Social conditions – 1945–1971.   I. Title.   II. Title: National Film Board of Canada's Still Photography Division and the image of Canada, 1941–1971.   III. Series: McGill-Queen's/Beaverbrook Canadian Foundation studies in art history

TR26.P39 2013      770.97109'045      C2013-901675-9

For Meg and Alice

# CONTENTS

# ILLUSTRATIONS

Unless otherwise noted, all images are gelatin silver prints.

uncredited. LAC/AMICUS 7238471. Scan, Robert
Evans.   86

3.6   "A workman with a hammer repairs a ship's propeller
at a Halifax shipyard," Halifax, April 1942. Photograph,
Harry Rowed. Accession no. 1971-271, e000760663 or
WRM 1485, NFB, SPD fonds, LAC.   88

3.7   "Wartime factories," *Canada at War* 34 (March 1944):
62–3; photographs and text uncredited. LAC/AMICUS
7238471. Scan, Robert Evans.   90

3.8   "Women workers smile and pose with a machine at
the John Inglis Co. Bren gun plant," Toronto, 8 April
1941. Photograph uncredited. Accession no. 1971-271,
e000760331, NFB, SPD fonds, LAC.   91

3.9   "Cecilia Butler, former night club singer and dancer
now employed as a reamer in the Small Arms Ltd.
Section of the John Inglis Company munitions plant."
Toronto, December 1943. Photograph uncredited.
Accession no. 1971-271, e000761869, NFB, SPD fonds,
LAC.   91

3.10   "Veronica Foster, employee of John Inglis Co. and
known as 'The Bren Gun Girl,' walks on the exterior of
the John Inglis Co. Bren gun plant," Toronto, 10 May
1941. Photograph uncredited. Accession no. 1971-271,
WRM 832 or e000760465, NFB, SPD fonds, LAC.   92

3.11   "Veronica Foster, an employee of the John Inglis Co.
Ltd. Bren gun plant, known as 'The Bren Gun Girl,'
poses with a finished Bren gun at the John Inglis Co.
plant," Toronto, May 1941. Photograph uncredited.
Accession no. 1971-271, WRM 768 or e000760403,
NFB, SPD fonds, LAC.   92

3.12   "Céline and Roberte Perry, two employees of the
Dominion Arsenals plant, pray at their bedside
before going to bed," Quebec City, 24 August 1942.
Photograph, Harry Rowed. Accession no. 1971-271,
WRM2192 or PA-175994, NFB, SPD fonds, LAC.   93

3.13   "Women at War: Canada's Industry Harnesses Men,
Women and Machines," *Women at War* (1943): 1.

Photographs and text uncredited. LAC/AMICUS
2704346. Scan, Robert Evans.   94

3.14   "Where women know their bombs and shells,"
advertisement, *Women at War* (1943). Photograph at
left, Nicholas Morant; text uncredited. LAC/AMICUS
2704346. Scan, Robert Evans.   95

3.15   "Unidentified woman poses with a 'Bomb for Britain' at
the Cherrier plant," Montreal, May 1941. Photograph,
Nicholas Morant. Accession no. 1971-271, WRM882 or
e000760514, NFB, SPD fonds, LAC.   96

3.16   "Small Arms: Bren Gun Is Marvel of Mechanical
Ingenuity," *Women at War* (1943): 34–5. Photographs
and text uncredited. LAC/AMICUS 2704346. Scan,
Robert Evans.   97

3.17   "Woman worker at the John Inglis Co. Bren gun plant
welds Bren gun magazines," Toronto, 8 April 1941.
Photograph uncredited. Accession no. 1971-271, WRM
687 or e000760327, NFB, SPD fonds, LAC.   98

3.18   "These are tomorrow's yesterdays," advertisement,
*Women at War* (1943): 72–3. Photographs and text
uncredited. Scan, Robert Evans.   99

3.19   "Mrs. Jack Wright tucking her two sons Ralph and David
into bed at the end of the day," Toronto, September
1943. Photograph uncredited. Accession no. 1971-271,
WRM 3855 or e000761767, NFB, SPD fonds, LAC.   100

3.20   "Mrs. Jack Wright is assisted in her shopping by
sons Ralph and David," Toronto, September 1943.
Photograph uncredited. Accession no. 1971-271, WRM
3851 or e000761763, NFB, SPD fonds, LAC. Image
here as reproduced in *Canada at War* 43 (1945): 66;
text uncredited. LAC/AMICUS 7238471. Scan, Robert
Evans.   101

3.21   "Mrs. Jack Wright, a munitions plant employee,
punches in to work at a time clock in the munitions
factory," Toronto, September 1943. Photograph
uncredited. Accession no. 1971-271, e000761759 or
WRM3848, NFB, SPD fonds, LAC.   101

# PREFACE AND ACKNOWLEDGMENTS

In researching and writing *The Official Picture*, I have benefited from the help of many institutions and individuals. It is a pleasure to acknowledge these debts. My key resource has been the National Film Board's Still Photography Division archive, which is housed in Ottawa and divided between two federal institutions: Library and Archives Canada (hereafter LAC) and the Canadian Museum of Contemporary Photography (hereafter CMCP). The LAC holds individual Still Division photographs along with their identification materials made between 1941 and 1961, as well as a limited amount of textual material related to their publication. As the repository of most of the National Film Board of Canada's papers, the LAC is also an invaluable resource for the division's institutional history. In drawing extensively on the LAC's holdings, I also have benefited from the historical knowledge, insight, and camaraderie of its staff. Archivists Andrew Rodger, Jill Delaney, Beth Greenhorn, and Sarah Stacy have been tremendously generous and helpful. Andrew read and commented on chapter 3, and both at the LAC and since his retirement has engaged with me in long and fruitful discussions about the division. Beth, with whom I continue to work on the Nunavut visual repatriation project, read chapter 6 and offered valuable suggestions.

In 1984, the Still Division became the CMCP, now an affiliate of the National Gallery of Canada. CMCP holds materials from the later years of the division's history, beginning in 1962, including all photographic negatives made after 1962, a full run of the 565 photo-story mat releases produced between 1955 and 1971, and detailed records of their distribution, copy prints ("grey cards") of all negatives, a card-catalogue index system developed in the early 1960s, and correspondence dating from the 1960s. The photo stories housed at CMCP have yielded a particularly fascinating picture of how the division narrated Canadian nationhood in photo-textual terms. In making sense of that vast array of material, I am deeply indebted to Robert Evans, who, as a graduate research assistant, developed a database of these photo stories under funding from the Social Sciences and Humanities Research Council of Canada. (Robert also helped prepare some of the reproductions appearing in this book.) The database Robert developed has been essential to my research and will provide a useful resource for researchers interested in Canadian visual culture and cultural history during the postwar years. In turn, Claudette Lauzon provided assistance to Robert during this project. My research at CMCP was aided immeasurably by various museum staff

members, who were my much-valued colleagues when I was a curator at the museum in the late 1990s. Then-director Martha Hanna, as well as Sue Lagasi, Tim Campbell, Carmen Robichaud, Pierre Desurreault, Jonathan Newman, and Andrea Kunard, welcomed me back to the CMCP, making all material accessible and responding with patience and interest to all of my questions. At the NGC, Emily Antler and Raven Amiro facilitated image reproductions with great efficiency. Many thanks especially go to Sue Lagasi, who offered invaluable expertise and assistance with image reproductions at all stages of the project, and to Andrea Kunard, who read a draft of the manuscript.

I have been fortunate to draw upon the recollections and experiences of former division staff members. I am particularly grateful to John and Hélène Ough, Norman Hallendy, John Reeves, and Ted Grant, who gave their time and vast knowledge of the division in interviews with me and with the help of Robert Evans and Charity Marple. Interviews conducted with the division's two long-term staff photographers Chris Lund and Gar Lunney have been important to this study. Pierre Dessureault, then a producer with the division and later a curator with CMCP, interviewed Lund in 1982; Charity Marple, as a graduate student, interviewed Gar Lunney in 1996. In addition, I have also drawn on taped interviews with the photographers Walter Curtin (interviewed by Martha Hanna), Pierre Gaudard (interviewed by Pierre Dessureault), and Michael Semak (interviewed by George Baczynski). Like the Lund and Lunney interviews, these were produced as part of the *View* Canadian photographer series of audio interviews paired with images. Finally, an extensive oral history interview conducted by Lilly Koltun, formerly of the LAC, with Lorraine Monk, executive producer of the division during the 1960s and 1970s, has provided detailed information about Monk's perspectives.

I have presented aspects of this research at conferences and in special lectures including the Universities Art Association of Canada (1999, 2001, 2005, 2008), College Art Association (2007), Canadian Studies Association (2004), Mosaic (University of Manitoba) conference The Photograph (2004), and the Canadian Historical Association (2005), as well as in special lectures at Carleton University, York University, and Queen's University. I am grateful to all of the organizers, respondents, and audiences for the opportunities to test out this material and for their feedback.

Portions of this book have already appeared in print, though all have been extensively revised. Parts of the introductory chapter as well as much of chapter 6 appeared as "Lessons with Leah: Re-Reading the Photographic Archive of Nation in the National Film Board of Canada's Still Photography Division," *Visual Studies* 21, no. 1 (April 2006). I initially introduced some of the history of the division seen in chapter 1 in CMCP's catalogue *A Canadian Document* (1999), though I have added extensive new research, and wording from only a couple of paragraphs of that original text remains. An earlier version of chapter 2 was published as "A Land of Youth: Nationhood and the Image of the Child in the National Film Board of Canada's Still Photography Division" in *Depicting Canada's Children* edited by Loren Lerner (Wilfrid Laurier University Press, 2009). Finally, the discussion of natural resources photo stories that comprises about one-third of chapter 4 originally appeared in a different format in *Beyond Wilderness: The Group of Seven, Canadian Identity, and Contemporary Art*, edited by John O'Brian and Peter White (McGill-Queen's University Press, 2007). I thank all of the presses and editors for their guidance and for permitting me to republish this material.

Generous institutional support has facilitated the research, writing, and production of this book. I am grateful to the Social Sciences and Humanities Research Council of Canada (SSHRCC), which has provided a Standard Research Grant covering research on the Still Photography Division in general and then two subsequent strategic grants. The first of

these grants facilitated research for this book and the development of the database of photo stories (as described above). The strategic grants have funded ongoing research into Inuit visual repatriation – the use of photographs to reclaim histories and forge intergenerational connections between Inuit youths and elders. This latter funding was crucial to the thinking behind chapter 6 and my subsequent research program, but it also informs my discussion of the archive in other portions of the book. Two institutional SSHRCC grants administered through Carleton University helped fund student research assistants. In addition, a Research Achievement Award from the Faculty of Arts and Social Sciences of Carleton University providing course releases gave me the time to complete the manuscript, and further funding helped secure the numerous high-quality reproductions used in this book; for these, I particularly thank FASS dean John Osborne and the Research Achievement adjudicating committee. In addition, this book has been published with the help of a grant from the Canadian Federation for the Humanities and Social Sciences, through the Awards to Scholarly Publications Program, using funds provided by SSHRCC.

Over the course of writing this book, many colleagues, editors, and indulgent friends have read, listened to, and commented on portions or all of the chapters. I am grateful for the incisive ways that they have challenged my assumptions and pushed me. Thank you to Angela Carr, Katie Cholette, Robert Evans, Martha Fleming, Mitchell Frank, Beth Greenhorn, Peter Hodgins, Catherine Khordoc, Annette Kuhn, Andrea Kunard, Martha Langford, André Loiselle, Kirsten Emiko McAllister, John O'Brian, Andrew Rodger, Joan Schwartz, Carol Williams, and the anonymous readers for *Visual Studies*. Thanks, too, to Anna Khimasia and Erin Macnab for their help in the production of the book. I want to send out a special thanks to Jim Opp, who reread most of the manuscript at a near-final stage with his usual keen intelligence. I also heartily thank the three anonymous readers, who all responded to the manuscript for McGill-Queen's University Press; their comments were invaluable in helping me refine this manuscript. I am particularly grateful to series editor Martha Langford, a former executive producer of the Still Division, who brought a wealth of knowledge and experience to her reading of the manuscript. At the press, I benefited from the skilful contributions of Maureen Garvie, Ryan Van Huijstee, and Elena Goranescu, among other staff. Finally, I have had the great good fortune to work with editor Jonathan Crago, whose readings of this manuscript have enriched my thinking and whose support has been invaluable.

Throughout, I have been sustained by my family's love. John, Meg, Alice, Allan, Margaret, Susan, Mary Ellen, and Elizabeth, thank you. I dedicate this book to my daughters, Meg Collins and Alice Payne, who have lived with these images and ideas for years and who kept me looking to the future while I was immersed in pictures from Canada's past.

The Official Picture

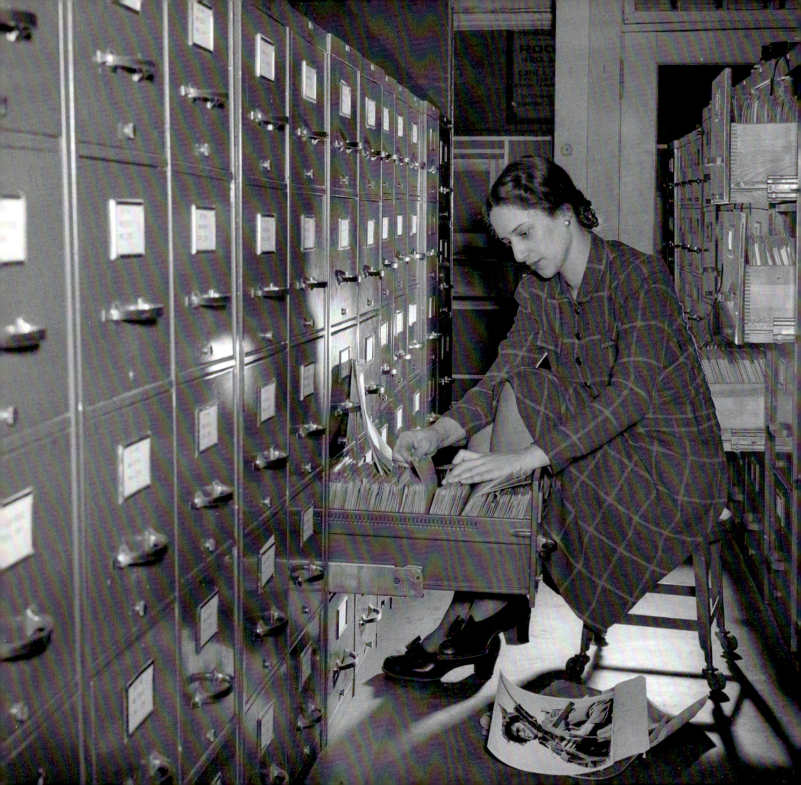

# INTRODUCTION

Several years ago while working in Ottawa at the Canadian Museum of Contemporary Photography, I began to ponder the photographs, histories, and ideas that would form this book. The museum holds an extensive collection and has organized dozens of exhibitions dedicated to Canada's vibrant contemporary photographic activity;[1] as a curator there, I spent my days immersed in contemporary photographs and photo-based art. But while I was and continue to be highly engaged by contemporary photography and art practice, I kept catching out of the corner of my eye the shadows of photographic images from the past. What I at first dismissed as a distraction soon took a solid and weighty form: a series of old file cabinets crowding the museum's former offices. As I squeezed by them, I would open a drawer here or there and surreptitiously peek inside. The cabinets were bursting with thousands of copy photographs depicting Canada and Canadian life, mainly during the 1960s, with some dating back as far as the 1940s. Organized through an elaborate cataloguing system based on subject matter, they surveyed the country: fishing scenes on the East Coast and in the Arctic, prairie vistas, depictions of forestry in the West, urban views of Toronto and Montreal, and portraits of prominent artists and politicians, as well as the faces of countless unidentified Canadians.

The file drawers I happened upon housed a portion of the photographic archive of the National Film Board of Canada's Still Photography Division,[2] the predecessor of the Canadian Museum of Contemporary Photography (CMCP), with the remaining holdings located a short walk away at Library and Archives Canada (LAC). Although it was eclipsed in the national imagination by the NFB's celebrated motion picture units, the Still Division was also a prolific chronicler of Canadian life and promoter of governmental programs. Over a history spanning 1941 to 1984 and in approximately 250,000 unique photographic images as well as numerous publications and exhibitions, the division pictured a vast array of people, places, work, leisure, and cultural activities across the country.[3] These photographs were often jingoistic, but they also included some of the most innovative photo-journalistic images made in this country at the time. They were consumed regularly by millions of Canadians as well as international audiences in newspapers, magazines, NFB-produced books, filmstrips, and exhibitions. In effect, the division served as the country's image bank, producing a governmentally endorsed portrait of Canadian society.

I wondered what these photographs had to say about the ways that Canadian identity had been imagined at the federal level during those years, what role the photographic medium

0.1  "Filmstrips Division," February 1945. Photograph, F.C. Tyrell.

played in that imagining, and how that visual archive was used – and continues to be used. Increasingly, I came to see the images less as encroachments on the present than as visual iterations in dialogue with contemporary life. This book is the result of those musings. In bringing this long-neglected agency to public light, *The Official Picture* tells the story of the Still Photography Division's role in Canadian nation building during the Second World War and the two decades that followed. At the same time, this study explores the distinctive and changing ways that the division's documentary still photographs played that role.

The NFB Still Photography Division has been the subject of surprisingly little scholarly writing. As a result, this study has been built largely from primary research, the raw materials of the historian's craft: thousands of photographic prints and negatives, publication proofs, distribution ledgers, office correspondence, scrawled notes on negatives and memos, the minutes of meetings, annual reports, and other archival records, as well as interviews with and texts written by division staff or figures affiliated with it. But there are a few noteworthy written commentaries on the division. In the late 1970s, Paul Couvrette, a photographer who had worked temporarily at the division, produced two studies, one written in 1978 for internal use and the second, completed in 1979, as his master's thesis for Ryerson Polytechnic Institute (now Ryerson University).[4] Both essentially articulate the division's self-image under Lorraine Monk's leadership and, accordingly, are useful as gauges of those attitudes during the 1960s and after, rather than as critical historic surveys. In 1984, Martha Langford, the division's former executive producer and founding director of CMCP, wrote an introduction to an in-house history of the division examining it from a more intellectual and historical perspective.[5] Langford's essay provides a brief overview of NFB activities and insightful analyses of specific images. Renate Wickens-Feldman contributed to the discussion in a 1996 *History of Photography* article, examining John Grierson's legacy in the division.[6] In articles and exhibitions for LAC, Andrew Rodger has provided invaluable material about the NFB's photographic activities.[7] CMCP curator Andrea Kunard's 2004 doctoral dissertation[8] provided a comparative institutional critique of the division and the National Gallery of Canada's Photographs Collection.[9]

During the NFB's existence, its cinematic units consistently overshadowed the Still Photography Division, and in subsequent years scholarly studies have reaffirmed that hierarchy by privileging film production, distribution, and policy over still images. Indeed, the literature on NFB cinema is vast.[10] While this body of scholarship provides little specific information on the workings of the Still Division, it has nonetheless been invaluable for historical context on the NFB and the policies that guided it. The earliest writing on the topic, again, came from the NFB itself. John Grierson, the country's first film commissioner and the film board's celebrated founder, was a prolific commentator whose essays and speeches articulated the film board's early approach to documentary and its relations with the government. Grierson's writings are indexed and annotated in an invaluable resource guide edited by Jack Ellis;[11] many of his best-known pronouncements on documentary are also included in a volume edited by Forsyth Hardy.[12] In 1964, Marjorie McKay, an NFB staff member, wrote a history of the film board that has also been useful for specific dates and information; however, like Couvrette's texts, as an in-house publication it is an index of the institution's attitudes more than an analytic text.[13] Subsequently, several historical studies appeared, including those by Peter Morris, C. Rodney James, D.B. Jones, Gary Evans, and Joyce Nelson.[14] While much literature on NFB film has focused on Grierson, recent studies by Janine Marchessault, Brian J. Low, Malek Khouri, and Zoë Druick as well as Thomas Waugh, Michael Brendan Baker, and Ezra Winton, among others, have addressed the NFB as

an institutional entity by exploring how cultural and social policy and cultural resistance impacted its work.[15]

Clearly, the Still Photography Division is overdue for an appraisal of its place in Canadian cultural history and, more specifically, in the history of Canadian visual culture. But *The Official Picture* is not merely the fruit of a recovery project, an exercise aimed to reinsert a body of work into the historic record. The Still Division also provides an exemplary case study for an examination of the role that the photograph played at the time in the formation of national identity. In these pages I explore how the rhetoric of the documentary photograph and the photographic archive reify conceptualizations of Canadian nationhood and support federal nationalism. Detailed readings of key historic periods and iconographical topoi within the division archive demonstrate how the abstract concepts of nationhood and citizenship as well as attitudes toward gender, class, linguistic identity, and conceptions of race were visualized by the division, and the social implications of that governmental vision.

The Still Division reproduced Canadian national identity not through the "grand gestures" of public monuments or stirring political oratory that we typically associate with nation building but instead with representations of the everyday and the familiar, rendered in photography, itself a commonplace and middlebrow medium.[16] Indeed, I suggest throughout this book that the power of the division's work in part rests – paradoxically – in the sheer banality of its presentation. However, in using the word "banal," I am not suggesting that the photographs are technically or aesthetically lacking; many of the images produced under the division's auspices are beautiful and technically sophisticated. Reflecting tastes in photojournalism and commercial photography of the day, they are among the most dynamic media images produced in Canada in the war and postwar periods. In adopting the term "banal" to indicate their depiction of the commonplace and their use of repetition in themes and in

widespread dissemination, I draw on Michael Billig's concept of "banal nationalism," arguing that in their routine, unobtrusive, and yet ubiquitous "flaggings" of Canada, the hundreds of thousands of photographs seen in newspapers, magazines, exhibitions, and governmental publications naturalized governmental attitudes about nationhood.[17] Billig's concept also helps me to understand that while division images produced a visual model of normative Canadian identity, it was one usually seen by Canadian viewers in a happenstance, often peripheral way. These were images that circulated amongst others, negotiated by viewers in an often disjointed manner, coming in and out of focus. But come into focus they did. Appearing in publications and exhibitions amongst dozens of other images, individual photos – particularly those that long-time staff photographer Gar Lunney termed "stoppers"[18] – drew viewers in to contemplate their image of the country. In short, division photographs were not instrumentalist impositions of federal authority so much as commonplace models that Canadians took in, fully adopting some, rejecting some, experiencing many as the backdrop of daily life, and being called to attention by others.

The banal nationalism of the Still Division's work differs significantly from the production and cultural impact of the NFB's celebrated cinematic units. Audiences purposefully attended film screenings and engaged with cinematic experience in an embodied manner that was quite different from their happenstance and routine – though periodically absorbing – encounters with mass-circulated division photographs. As such, a study of the division's banal nationalism also provides an opportunity to consider instructive distinctions and links between documentary photography and film. As a photographic unit housed within a largely cinematic agency, the division was uniquely positioned to reveal these significant though often ignored relationships. Typically, film and photography scholarship occupy discrete disciplinary positions and view their objects of study from

differing perspectives, using distinct criteria. In drawing on some aspects of both, this study attempts to illuminate how social documentary photography operated in relation to contemporary non-fiction cinema and how it "represented reality" (to borrow Bill Nichols's phrase) differently.

As a cultural history of the Still Division and its construction of Canadian identity, this book explores visual rhetoric and nationalism through necessarily selective examinations. Working with a vast archive of hundreds of thousands of photographs and other materials amassed by dozens of staff members over almost three decades, I have chosen specific case studies to illuminate larger perspectives that were present at key points in the division's history. This approach has allowed me to provide meaningfully deep readings of select images and image texts rather than a surface-level introduction to a broader scope of the archive. At the same time, I have tried to establish throughout that the division's photographs – like media photography in general – were experienced as a multiplicity. In contrast to the directed focus on a single art work in a museum, for example, media photographs are made in large numbers and consumed by viewers in groups and amongst other material. But in selecting key images, groups of images, and moments from the archive, I have, of course, also had to make omissions. Detailed analyses of photographs used in filmstrips and in the promotion of NFB films are beyond the scope of my considerations, as are cross-institutional comparisons.[19] Instead, I have focused on how images – largely seen through publications – conveyed official messages about Canadian life at key moments.

I have conducted or drawn on numerous interviews with division staff and consulted scores of archival records pertaining to their work. Staff members appear as actors throughout this study, some prominently. Long-time staff photographers Chris Lund and Gar Lunney were responsible for thousands of images in the Still Division archive,

for example; their work is featured in this history, but contributions by other photographers – including Harry Rowed, Wilfred Doucette, Ronny Jaques, Ted Grant, Michel Lambeth, and Pierre Gaudard – as well as staff members Ralph Foster, Lorraine Monk, John Ough, Hélène Proulx Ough, and Norman Hallendy, among many others, are also recounted here. Yet this is not principally an account of individual accomplishments. Instead, my focus is on developing an *institutional* picture of the division, which (as I stress in chapter 1) comprised work undertaken by a collaborative team redolent of newsroom employees.[20] I acknowledge the ways that individual staff including photographers, writers, editors, and bureaucrats shaped the division's message while also balancing individual agency with a sense of institutional authorship. And, of course, the photographs produced by the division were not straightforward or unequivocal messages absorbed passively by their audiences. These images were part of a complex network of cultural signs, which contributed to identity formation including national identity formation.

Covering a thirty-year history bracketed by the Second World War and the early 1970s, *The Official Picture* opens two years after the founding of the NFB. It was only then, in 1941, that the board established a photo service and began making and distributing still photographs. The book closes in the early 1970s when the division stopped routinely commissioning images that promoted the Canadian nation. While it continued to exist until 1984, in those remaining years it was transformed into a national collection of expressive photographic prints, subsequently becoming the CMCP. Since the 1960s, the division and then the CMCP have helped to foster the emergence of a vital and innovative community of photographers in Canada – but that is another story.[21] The narrative unfolded here follows the years when the Still Division was an unabashed visual propagandist for the federal government.[22]

## Seeing the "Official Picture": Approaches

The cabinets of Still Photography Division prints that I encountered opened up before me a composite portrait of Canada made from a nationalist and bureaucratic point of view during the Second World War and in the two decades that followed – what I have come to call "the official picture." The division itself shared and amplified that characterization: in 1950, for example, the NFB explicitly described it as "the chief official photographic agency for the federal government."[23] (The NFB's use in 1950 of the definite article, which I have adopted in this book, indicates its aspirations to present not just *an* image of the country but *the* definitive visual articulation for the Canadian government. In turn, the modifier "chief" acknowledges other photographic activities at the federal level that the NFB and the division tried to quell or render redundant.) But it was not solely at the mark of the mid-century that the division advanced itself as *the* authoritative state photographer. Indeed, throughout its history, it was guided by a mandate to foster a sense of national cohesion through the production and dissemination of photographic images that served the federal government's specific policies and programs closely. Federal legislation compelled all departments of the federal Canadian government to turn over production of photography to the NFB,[24] the Privy Council at times enforcing this regulation through an order in council.[25] As a result, the division holds a unique position in the history of Canadian visual culture as a conveyor of shared values and governmental programs developed in photographic form.

What I term "the official picture" is therefore grounded in the Still Division's own rhetoric as well as conventional uses of the adjective to designate sanctioned authority.[26] At the same time, in adopting that phrase for the title of this volume, I posit it as a study addressing the visual culture of institutional (or, more specifically, statist) authority. In this,

the book is informed broadly by Michel Foucault's influential discussions of power and knowledge.[27]

For many commentators, the photograph and the photographic archive exemplify the ways that power takes form within Foucauldian terms: not as a direct imposition of authority from above but as an impersonal network that simultaneously supports and naturalizes power relations in part through the effect of "interiorizing."[28] In this respect, the division's photographs and its photographic archive as a whole can be seen instructively within the context of "governmentality," a concept first proposed by Foucault in the late 1970s. For Foucault, governmentality or governmental rationality is, in part, "the ensemble formed by the institutions, procedures, analyses and reflections, the calculations and tactics that allow the exercise of this very specific albeit complex form of power, which has as its target population as its principal form of knowledge political economy, and as its essential technical means apparatuses of security."[29] Governmentality describes the processes and strategies through which populations, including those in liberal democracies like Canada, are managed. Although the term was not coined to refer exclusively to state power, Foucault nonetheless developed the concept, according to Colin Gordon, particularly to address "government in the political domain."[30] Foucault's analysis is, for example, central to John Tagg's important discussions of documentary realism and the state.[31] More specifically relating to the material treated here, Zoë Druick, in her study of NFB film policy, has drawn on the concept of governmentality to understand how NFB documentary films as well as the film board's extensive use of surveys and statistics (which she terms "government realism") managed the Canadian citizenry.[32]

The Still Division also developed a form of "government realism" that contributed to the regulation of Canadians. Specifically, "the official picture" it produced convincingly uses visual rhetoric and the evidentiary claims of

the documentary photograph to espouse a sense of natural plenitude and emergent economic force while privileging whiteness, middle-class status, and conventional gender roles as "normal," essentialist facets of Canadian identity. At the same time, the division consistently employed a visual vocabulary of nationalist symbolism to provide markers of Canadianness, including images of nature and the far North and portrayals of an apparently harmonious multicultural society.

Foucault's concept of governmentality offers a broad guiding model for understanding the division's institutional role. Understanding its particular photographic work, the archive it produced, and the public reception of these images called for augmentation by more specific or "local" theoretical models. These I have adapted from recent scholarly treatments of nationalism and from ideological critiques of the social documentary photograph and the photographic archive, as outlined below.

## Perspectives on the Nation

In analyzing the NFB Still Photography Division's photographic contributions to Canadian nation building, *The Official Picture* is informed by an extensive body of scholarly literature interrogating the concepts of nationhood and nationalism. Throughout the period of history discussed here, the nation-state was ensconced as "the primary societal principle of organization."[33] The nation was offered up as a "natural" division of the world community, while citizenship and nationality were presented as key markers of identity, signalling an individual's membership in a geo-political entity as fundamental to identity.[34]

Within the images and texts produced by the division, the nation was presented unquestioningly as a self-evident designation, while Canada and Canadians were assumed to possess inherent characteristics distinguishing them from other nation-states and nationalities. Such views reflect aspects of a perennialist understanding of nationhood in which the tendency for society to group into nations is considered to be innate and to recur throughout human history.[35] In mid-twentieth century Canada, this was the prevailing conception of nationhood. From the popular press to scholarship and literary writing, Canada was conventionally and widely portrayed as distinct — even while the exact makeup of the country's cultural character was the subject of perpetual debate. Arthur Irwin, the Canadian government's film commissioner and head of the NFB during the early 1950s, articulated some of these attitudes in a speech entitled "What It Means to Be a Canadian," presented in 1950 before an American audience in Buffalo, New York, and later published in *Maclean's* magazine. With a keen awareness of his audience, Irwin defined Canadian identity largely in contradistinction to that of the United States. He argued, using the patriarchal language of the time:

Two things distinguish us from other Americans. One: We are the northern North American with all that implies in terms of influence of climate and terrain on character and a way of life. Two: We are the unique American in that we alone among all the Americans of two continents have insisted on maintaining political connection with our parent stem in Europe.[36]

… I don't think you can understand the Canadian unless you appreciate that he is really two separate persons in one.

In one aspect of his being he is a Geography Man, a man molded by the geography of North America, a man who has had to build a way of life suited to a stern and difficult land, in the face of great obstacles both physical and political.

In his other aspect he is a History Man, a man who has responded and still responds to the pull of history,

a man driven by a deep intuitive response to the trad-itional values enshrined in his heritage overseas.[37]

Irwin's views would shape production at the NFB, particu-larly during his tenure as film commissioner from 1950 to 1953, but they also reflect widespread attitudes throughout the period addressed in this study.[38] Irwin suggested that Canadians possess a common and readily identifiable char-acter rooted in what he perceived to be a relatively peaceable history and in the country's harsh geographic and climactic conditions.[39] Over the past quarter-century, while such essentialist characterizations of Canada specifically, and of the nation in general, have remained surprisingly resilient, they have also been widely discredited in a large body of influential interdisciplinary scholarship. Perennialist and "primordialist"[40] approaches to the study of the nation and nationalism have for the most part been supplanted succes-sively by a modernist paradigm, then by postcolonialist and transnational critiques.[41]

Specific critiques of nationhood and nationalism from that larger recent body of scholarship have provided models for understanding the broader implications of the Still Division's enterprise and ground the present study. Ernest Gellner's discussion of the formation of national cohesion has been instructive in understanding how the division approached its explicit mandate to foster national unity[42] as has Eric Hobsbawm's writing on the ways that national cul-ture is formed through the "invention of tradition."[43] Ben-edict Anderson's influential understanding of the nation as an "imagined community" is a model for much of my analysis here. Anderson's discussion of the pivotal role of print media in the formation of nations and the importance of attending to the specific "style in which [nations] are imagined" is instructive in identifying the particularities of how nation-hood was visually represented by the division. Anderson's work is crucial to this study particularly in the discussion of

how the styling and perpetuation of national symbolism as well as the conceptualization of simultaneous time, largely experienced through mass media, are essential to the project of nation building.[44]

Understanding the division's specific style of imagining the nation called for a model that could make sense of how it contributed to Canadian nation building through such tech-niques as inundating the public with photographic images depicting commonplace, prosaic, credible, and at times clichéd scenes; here Billig's concept of banal nationalism has provided a rich explanatory tool. As referenced briefly above, Billig argues that within nations of the West, nation-alistic loyalties are not solely produced (and nation-states reproduced[45]) through grand political gestures but instead through routine, prosaic flaggings of national belonging, which he terms banal nationalism: "Banal nationalism pos-sesses a low key, understated tone. In routine practices and everyday discourses, especially those in the mass media, the idea of nationhood is regularly flagged. Even the daily weather forecast can do this. Through such flagging, estab-lished nations are reproduced as nations, with their citizenry being unmindfully reminded of their national identity. This banal flagging provides the home-making groundwork, turning ground into homeland."[46]

Billig and those who have taken up his approach attend to "the collection of ideological habits (including habits of practice and belief) which reproduce established nations as nations" and argue that these practices are located in the unremarkable habits of daily life.[47] In this, the concept of banal nationalism is indebted to the work of the sociologist Pierre Bourdieu.[48] In turn, these practices are underscored by assumptions of belonging, often suggested through the rhetorical device of *deixis*, which grounds such small but loaded words as "we" in an implied sense of shared com-munity. Banal nationalism, characterized by both the routine and a sense of familiarity, is effective in instilling a sense of

national belonging precisely because repetition and its commonplace character render it "so forgettable, so 'natural.'"[49]

"Banal nationalism" aptly characterizes the Still Division's work. For most of its history, its staff produced didactic images often designed to slip almost imperceptibly into the editorial content of newspapers and magazines. But as I suggest throughout this study, the prosaic or banal nature of that presentation was by no means a shortcoming; it was crucial to its effectiveness. By widely and repeatedly reproducing the visual clichés of Canadian nationhood, from Percé Rock to prairie grain elevators and the Arctic to portraits of government officials – without fanfare and, until the mid to late 1960s, usually without overt aestheticization – the images naturalized these scenes and faces as markers of Canadian identity. At the same time, individual images would grab viewers, imprinting their model. The division's nearly anonymous images "unmindfully reminded" viewers in Canada of their national identity.[50]

While these theorizations of nationalism provide this study's crucial underpinnings, they also have their limitations in any discussion of Canadian cultural identity formation. As Eva Mackey has argued, "National identity in settler colonies such as Canada has a different landscape and genealogy than identity in the older nations of Europe or even in the United States."[51] One key distinction noted by Mackey and Tony Bennett is that the processes of social cohesion identified by Gellner as central to nationhood are sought after far more "urgently" in Canada and such fellow settler colonies as Australia and New Zealand.[52] Without a long common history and cultural narratives to draw upon, settler governments as well as social and cultural institutions in these countries explicitly set out in search of a sense of cultural homogeneity or narratives of national cohesion. As this book argues, that perceived "urgent" need to create an identifiable (and visible) common national identity was the driving force behind the Still Photography Division.

When I first started my research, I expected to find visual and textual records that naturalized nationalist mythologies. What surprised me, however, was how overtly these formulations were articulated and acknowledged. Throughout the archival record and in interview after interview, Still Division staff saw themselves as mission bound. With passionate conviction, they sought to link the disparate peoples of the country through photographic representations. The 1939 Film Act, the legislation that established the NFB, for example, mandated its units to "help Canadians in all parts of Canada to understand the ways of living and the problems of Canadians in other parts."[53] That goal would be reiterated throughout the history of the NFB and the division. This compulsion to create a sense of national cohesion, in part by defining Canadian identity visually, was a key national preoccupation for decades and indeed persists today. Arthur Irwin's treatise on "What It Means to Be a Canadian," quoted above, is but one example. Such explicit acknowledgments of nation building require, as Mackey identifies, more reflexive study than approaches employed in other international cases.[54]

## Critiques of the Documentary Photograph and the Photographic Archive

In addition to recent writing on the nation and nationalism, *The Official Picture* is informed by several influential ideological critiques of social documentary photography written by, among other scholars, Martha Rosler, Abigail Solomon-Godeau, Maren Stange, Sally Stein, Alan Trachtenberg, Allan Sekula, and John Tagg.[55] Associated with what Blake Stimson and Robin Kelsey have recently called the "*October* moment," these figures established a body of scholarly literature rooted in various aspects of critical theory and published in or influenced by the journal *October*.[56] As a whole, that scholarship devotes itself to the ideological critique of the

photographic representation and does so by attending to the specific historic and material conditions of the production and reception of photographs used institutionally as evidence. In these scholars' work – as well as in recent writing by Shawn Michelle Smith and Jae Emerling, among others – photographs and photographic archives are privileged objects of study in investigating the complex relationship between power and representation.[57]

Over more than two decades, archives – including photographic archives – have been the focus of extensive cultural analysis. As repositories of memory and knowledge, they are often seen in these studies as key sites for the formation of cultural identity. As Joan M. Schwartz and Terry Cook have argued, for example, "archives – as institutions – wield power over the administrative, legal, and fiscal accountability of governments, corporations and individuals, and engage in powerful public policy debates around the right to know, freedom of information, protection of privacy, copyright and intellectual property, and protocols for electronic commerce. Archives – as records – wield power over the shape and direction of historical scholarship, collective memory, and national identity, over how we know ourselves as individuals, groups and societies."[58] And as Shawn Michelle Smith has argued within an American context, "Archives of photographs with distinct visual genealogies function as sites through which narratives of national belonging and exclusion are produced. The nation itself, as 'imagined community,' is not simply the referent of photographic images but also the product."[59]

Scholarship exploring the power dynamic of the photographic archive and drawing on Foucauldian models is extensive;[60] among the most influential of such works are essays by the theorist and photographer Allan Sekula. In two often-cited essays of the 1980s, "Reading an Archive" and "The Body and the Archive," Sekula explores the photographic archive as a regime of truth.[61] For him, the archive is,

at core, "contradictory."[62] Photographic meaning is simultaneously "liberated from use" – decontextualized from the point of production – and yet imposed with another set of meanings established by ownership.[63] Ultimately, by fixing a "general equivalence between images," photographic meaning is always subordinated to the unity of the archive as a whole, creating a coherence of individual parts.[64] In the case of the Still Photography Division, the meaning of individual images, for example, is subordinated to that larger, enveloping message of Canadian national cohesion. Moreover, according to Sekula, the photograph's position within the archive – as well as information in accompanying texts – effectively directs editorial placement and subsequent reception toward that hegemonic reading.

For Sekula, in imposing unity, the "photographic archives by their very structure maintain a hidden connection between knowledge and power."[65] Power rests on the "illusory neutrality" of the archive's two key components: first, its bureaucratic organizational system and, second, the analog photograph's character as an indexical sign. Both belie for him at base an "aggressive empiricism, bent on achieving a universal inventory of appearance."[66]

The first of those two components, the taxonomic system of the archive and the way that it wields and yet veils authority, is familiar. Its bureaucratic organization suggests neutrality, comprehensive knowledge, and closure while nonetheless situating its material within the spectrum of a specific ideological position.[67] The Still Division's archive was organized numerically, as well as by assignment, photographer, geographical region, and subject. Subject was – and remains – the "field" most often used by researchers.[68] Division staff and other photo editors could search for images with the aid of dozens of subject designations. By 1963, the use of the archive was facilitated by the publication of the *Canadian Picture Index*, a catalogue of the division's photographs illustrated by thumbprint photographs.[69] From

such classifications as "aerial views" to "winter scenes" in the card catalogue, and "people," "the North" and "science" in the picture index, these categories cover a wide span of Canadian life.

Norman Hallendy, who expanded the division's cataloguing system in the early 1960s, recalled in an interview his descriptions as a personal response to the varying content of the images rather than guided by the needs of the federal departments that most often used the images. In Hallendy's words, his indexing was "a personal evaluation that I was making. It was totally subjective."[70] At first glance, those descriptions might seem simply to replicate the content of images without imposing another filter through which they were catalogued and are now read. Yet closer inspection reveals a telling pattern in the division's organizational categories, one that privileges institutional authority – just as the taxonomic system does structurally. Within the subject categories, not only do bodies such as Parliament, various arms of the military, the RCMP, and numerous governmental departments figure prominently but also there is an emphasis throughout on professional expertise and management. Despite Hallendy's personal and pragmatic approach to the archive, the key uses of the division's images as visual support for the federal Canadian government shine through. The category "housing," for example, seems a benign designation that we might expect to include reference to a broad scope of habitations. Instead, it features governmental programs such as "wartime housing," "community apartments," and "emergency shelter." In short, I suggest that the organizational structure of the archive encoded such truth claims as the government's paternalistic care of its citizenry.

Hallendy and his fellow staff members enthusiastically took on the values and mandate of the division, reproducing its model of a cohesive, harmonious Canada both pictorially and archivally. Staff photographer Gar Lunney recalled

that they sought "to show Canada to Canadians. I mean the people in Quebec and the Maritimes know very little about the people in Saskatchewan and B.C. How are they going to know? … So we are now telling through still stories and daily newspapers where people don't go to a film show and it's gone. They can sit and study the picture; this is the big thing."[71] In effect, not only production but, importantly, the organizational system of the division archive reveal ideology taking shape – through the mobilization of "common sense" notions but also through the assumption of neutrality in its organization and interpretation by staff. Therefore, despite the suggestion of neutrality, by encoding its holdings according to assumptions that disclose a particular worldview, the division's organizational system naturalizes contemporary understandings of nationhood and national belonging through and by means of its own specific model of Canadian identity.

Photographic indexicality – the conventional understanding of photography's existence as a seemingly unmediated imprint of its referent – marks the second component on which, according to Sekula, the power of the photographic archive rests.[72] Throughout its history, the Still Division exploited perceptions about photographic indexicality, promoting its images as neutral, omniscient, and therefore authoritative conveyors of fact. These views were buttressed by the rhetoric of documentary espoused by Grierson as head of the NFB as a whole, and perpetuated long after his departure from the film board in the mid-1940s. Yet here too the appearance of neutrality masks an ideological position. As chapter 2 outlines in detail, Grierson's – and, following him, the NFB's – understanding of "documentary" was intertwined with contemporary social science and its engagement with social management.[73] In short and as referenced above, these images and their organizational system constitute examples of what Druick terms "government realism."

The NFB sought to serve the state by shaping public opinion in part through photographic and filmic projections of normative Canadian life.[74] Over the three decades addressed in this book, the photographic discourse of social management continued to underpin Still Division production. Its images are by no means neutral imprints of Canadian life. Instead, they visually illustrate contemporary governmental programs and social attitudes shared by and directed to a wide national and international audience. At the same time, their characteristic banal nationalism subtly underscores the naturalizing effects of indexicality and marks a key distinction from the cinematic documentary produced by the NFB.

Sekula's ideological critique of the photographic archive provides a model, adopted in much of this study, for understanding how, within the division's photographic archive, power is simultaneously wielded and yet masked under pretence of neutrality. Within that archive, the images imprint the authority of various governmental policies and an interpretation of governmental authority in general while simultaneously naturalizing such messages as Canada as a cohesive political entity, the federal government as a paternalistic caregiver, and citizenship as a central marker of modern identity. I suggest that through its photographic archive rather than its individual images the division came closer to achieving the NFB's overarching mandate of fostering an idealized model of a cohesive Canada.[75] This study analyzes that idealized represented society as a means to construct the division's "official picture" of the nation.

While Sekula's discussions of the archive are instructive in exposing the constitutive power of that "official picture," at the same time I also emphasize that the photograph is a malleable carrier of meaning that can be read in ways not prescribed or predicted by the makers of the images or designers of its archive.[76] Yet I contend here that although interrogating institutional (and statist) mandates is a crucial component in the complex analysis of how historic photographs function in society, it does not preclude or contradict the acknowledgment of other subject positions and other readings. As John Tagg suggests, "to place emphasis on the institutionalization of certain systems of discursive constraint is not at all to suggest that the fixities of meaning … were ever coherent, accomplished, stable, or secured. These systems are not machines that work smoothly and ergonomically, without wastage … these machineries do not come with guarantees. They do not invariably work well. And, of course, they are resisted."[77]

Many Canadians constructed and continue to construct their own narratives of Canada through photographs and as viewers of NFB images, negotiating with and challenging its normative representations. While this book chiefly looks at "the official picture" of the Still Division in order to place that important institutional history in the public record, it also recognizes how visual discourse can be read in variant ways. For example, an active and at times resistant reception of the division's "official picture" has included the reuse of NFB photographs depicting women munitions workers in the Second World War and the poet Rina Lasnier's stubborn defiance against the division's image of Canadian citizenry in the centennial volume *Ces visages qui sont un pays*. Chapter 6 offers the book's most sustained consideration of photographic resistance, a detailed discussion of how NFB images are being used today in "Project Naming," an innovative collaboration between the Library and Archives Canada and Inuit groups.

*The Official Picture* proceeds from a broad historical perspective to specific, deep readings of themes within the Still Division archive and closes by returning to look at the archive from today's perspective. Along the way, it takes the reader from institutional critique to the analysis of reception

and resistance. In their various ways, these chapters together address how the division's production and dissemination of still photographs served as a form of banal nationalism, signalling national identity through commonplace, seemingly authoritative, and ubiquitous photographs.

The first section, Surveying the History of the Still Photography Division, 1941–1971, comprising chapters 1 and 2, provides a chronological narrative account of the division as well as a detailed discussion of documentary photography. These two opening chapters establish crucial frameworks for those that follow. As the Still Division is rarely remembered today, the survey in chapter 1 supplies crucial historical material and context for what follows. It outlines the collaborative work of division photographers and other staff as well as the governmental structure of the institution, drawing extensively on archival records and interviews. At the same time, this survey emphasizes that the "banal" and bureaucratic nature of much division work was key to its effectiveness in naturalizing the governmental vision of a cohesive Canada.

Chapter 2 also surveys the division archive as a whole but here to come to terms with the central concept of documentary. Clarifying the distinctions and overlap between filmic and photographic documentary helps to identify the historically specific ways that photographic documentary produced by the division made meaning. To illuminate these distinctions, I trace one loaded iconographical theme evident throughout the division's history and represented extensively in its archive: the image of childhood. Placing these works within the context of film theorists Bill Nichols's and Julianne Burton's discussions of expository and observational modes of documentary cinema, I use those models to discuss how the experience of photographic realism – particularly the banal nationalism of division photographs – adapts elements of the cinematic and yet differs from it.

The second section, Readings in the Archive (chapters 3, 4, and 5), is the heart of the book. These chapters include a series of close readings, or, in the language of anthropology, "thick descriptions"[78] of distinct periods in the division's history and within each period, a prominent theme: the representation of work during the Second World War, depictions of the land in the 1950s and 1960s, and portrayals of Canadian citizenry during the centennial year. Chapter 3, "Made in Canada," looks closely at images of industrial labour produced under the auspices of the NFB in conjunction with the Wartime Information Board in terms of class and gender. In many respects this body of images is an anomaly within the division archive as a whole: following the war and prompted by disputes with commercial photographers, the division in effect ceased to picture industry in depth. But during the war, it produced over five thousand negatives profiling wartime industry's production and industrial labourers. I examine two aspects of this work: images of production, and profiles of female workers. I argue that photographs picturing production in general aestheticize industry and symbolically diminish the agency of the worker. Portrayals of the female munitions workers then entering the formalized workforce in phenomenal numbers instead focus intently on various women at work in factories. The Wartime Information Board and the National Selective Service drew on these images to recruit women workers. NFB photographs used in these campaigns provide telling records of conflicted attitudes toward gender at this crucial historic moment. As various historians have demonstrated, the shifts in gender hierarchies during the war years yielded long-term changes for women; however, within the "official picture" of the division archive, conventional gender roles would continue to be reified for years to come.

Chapter 4, "For the Land ... Has Always Held the Nation Together," bridges the middle years of the division's history, introducing depictions of the Canadian land made primarily

during the 1950s and 1960s. Within its archive, representations of the Canadian land figure prominently. They served not only as markers of Canadian identity but also as sites for promoting economic status and enacting cultural and racial hierarchies. I look particularly at photo stories and the division's celebrated 1967 publications (in English and French versions) *Canada: A Year of the Land* and *Canada, du temps qui passe*. My treatment of these works is informed by W.J.T. Mitchell's assertion that "landscape circulates as a medium of exchange, a site of visual appropriation, a focus for the formation of identity."[79] I argue that the division's extensive pictorial and textual treatments of the Canadian landscape are encoded in terms of racial representation and erasure.

The following chapter, "'*Ces visages qui sont un pays*': Portraiture, Citizenship, and Linguistic Identity in Centennial Canada," reinserts the citizen into the discussion. I examine how the division mobilized the form of the portrait to serve the project of nationhood and the ways that portraits were coded in terms of class and linguistic identity. Portraiture was a mainstay of the division's work throughout its history, but its most elaborate uses appeared during the centennial period, in *The People Tree*, an installation at Expo 67, and in two 1968 publications, *Call Them Canadians: A Photographic Point of View* and *Ces visages qui sont un pays*. These projects not only provide extensive, ambitious portrayals of Canadian citizens at the moment of the centennial but also reveal how French and English Canada were presented officially. At the same time, I argue that *Ces visages qui sont un pays*, through the editorial involvement of the poet Rina Lasnier, constitutes a model of resistance to the division's dominant vision of Canada, producing in effect a photographic counter-narrative of the nation.

The third and final section, Revisiting the Archive, considers how the division's archive is being used today, in a discussion of indigenous repatriation of the photographic archive. Chapter 6, "Lessons with Leah: Rereading the Photographic Archive from the North," introduces current reuses of the archive as a way of resisting "official" narratives of national belonging. In recent years, various indigenous groups around the world have begun using ethnographic and documentary photographs, like those produced by the division, as tools of memory work and means of solidifying cultural and community identity. This chapter draws on findings from one such initiative, Project Naming, and an extension of Project Naming in which I am involved. In these projects, Inuit in the territory of Nunavut use archival photographs to help identify community members and recount familial and community histories. In doing so, they employ photographs, division images among them, in efforts toward Inuit cultural consolidation. The information they convey and narratives they tell about the photographs offer a new perspective on the division, effectively decentring its dominant model of nationhood, its "official picture."

Surveying the History of the Still Photography Division, 1941–1971

# "Civil Servants with a Camera": A History of Still Photography at the National Film Board of Canada

In a 1976 interview, Lorraine Monk, then executive producer of the National Film Board of Canada's Still Photography Division, spoke about the bureaucratic environment in which she and her staff had long laboured. Division photographers – and other staff – she protested, were treated as little more than "civil servants with a camera."[2]

Yet during most of the division's history, photography production was decidedly institutional and bureaucratic. Routinely described as a "service" to the federal government, the Still Division aided various federal departments and agencies in producing the Canadian government's "official picture." For decades it rendered in visual form a range of departmental policies and broader governmental attitudes about Canada and its citizenry. Some of the specific images, displays, and publications the division produced over its existence were certainly prosaic. Yet as I suggested in the introduction, the division's contributions to Canadian nation building were partly effective due to, not in spite of, their mundane character and ubiquitous presentation. In short, these effects of governmentality constitute examples of what Michael Billig has termed "banal nationalism."

This chapter maps the routine, institutional history of still photographic production at the NFB. Rather than bemoaning the Still Photography Division's institutional links, I pay

Like the state, the camera is never neutral … it arrives on the scene vested with a particular authority, authority to arrest, picture and transform daily life … This is not the power of the camera but the power of the apparatuses of the local state which deploy it and guarantee the authority of the images it constructs to stand as evidence or register a truth.

John Tagg, *The Burden of Representation*[1]

particular attention to its existence as a branch of and servant to the federal Canadian government while exploring its production as a form of banal nationalism. Serving the state was in fact central to the division's mandate, often shaping key aspects of its production and its intended reception of its images. Indeed, a close examination of the division's institutional history – that is, its existence as a group of "civil servants with a camera" – provides a remarkable record of how the photographic image was deployed to serve the Canadian state in the mid-twentieth century.

## Foundations

The National Film Board of Canada's still photography production was bureaucratic even at its origins. The NFB as a whole was established in 1939 by an act of Parliament. John Grierson, a pivotal figure in the history of non-fiction cinema, drafted the Film Act, the NFB's founding legislation, and served as the country's first film commissioner (fig. 1.1). The act provided legislation only around motion pictures and "activity in relation to the production, distribution or exhibition of motion pictures."[3] At its origins, the NFB was an advisory body rather than a production house, yet it was granted extensive powers over other governmental film work including advising on production, financing, distribution, and liaison within and beyond the government. The act legislated that "all departments of the Government before initiating the production of any film shall refer the matter to the [Film] Commissioner who will arrange for the production."[4]

In contrast to the fanfare of the NFB's 1939 legislative founding, its engagement with the production and dissemination of still photographs arose out of that most banal of governmental initiatives, a departmental transfer. On 8 August 1941, Order-in-Council PC6047 formalized the transfer of the Still Photography Division of the Canadian Government Motion Picture Bureau from the Department

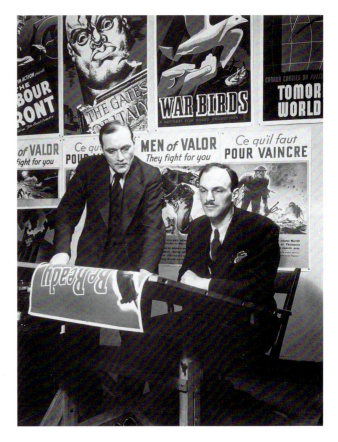

1.1 "John Grierson (*left*), chairman of the Wartime Information Board, meeting with Ralph Foster, head of Graphics, National Film Board of Canada, to examine a series of posters," February 1944. Photograph, Ronny Jaques.

of Trade and Commerce to the National Film Board, which two months earlier, through an order in council issued by the Privy Council on 11 June 1941, had absorbed the bureau's cinematic activities.[5]

The Motion Picture Bureau (MPB), which dated from 1923, had served as the government's chief means of visually

promoting Canada within the country and abroad.[6] Under the auspices of Trade and Commerce, it was mandated to advertise internationally "Canada's scenic attractions, agricultural resources and industrial development" and to disseminate material within the country as "a valuable educational medium by which one part of Canada is enabled to know the other."[7] As its title indicates, cinema was the MPB's chief vehicle for nationalist propaganda. Yet, according to Charles Backhouse, by the mid-1920s it had also designated a still photographic section formalizing the bureau's pre-existing use of still photographs. This division was highly active and would expand over the course of its history, supplying photographs to magazines and other publications nationally and internationally.[8]

With its absorption of the MPB, the role of the National Film Board changed considerably from that of an advisory body charged with coordinating governmental film production and distribution.[9] The MPB under Captain Frank Badgley was in Grierson's view a retardataire service; he ostensibly sought to take charge of and improve the quality of its filmic productions, but by controlling it he simultaneously eliminated a chief rival for governmental funds and centralized film production.[10] The second order in council now gave the NFB sweeping control over still photographic production for the government. The transfer was justified by "the need and the advisability of maintaining a certain technical stills service for the use of all departments and a first class laboratory service for the use of the … Department of National War Services and … this consultation also establishes the advisability of having the supervision of laboratory services at a common professional centre under the administration of the National Film Board."[11] The order in council legislated that all departments of the federal government were to use the NFB's newly established Photographic Service for promotional work. That legislation would guide governmental production of still photography for decades and

establish the NFB's photographic archive as the government's "official picture" of the nation.

Photographic production and distribution were regarded by the NFB as relatively autonomous and ancillary parts of its overall enterprise. In the first years after the transfer, these activities were modestly and generically known as Photo Services, originally the largest component of Graphics, a section headed by Ralph Foster that also included Displays, Art and Publication Layout, and Filmstrips.[12] These units consistently received less funding and promotion than the higher-profile Motion Picture Production and Distribution sections. The Photo Services unit consisted of a production department (photographers, photo editors, and writers responsible for captions and text accompanying images), a still photography library, business and order offices, and an extensive laboratory/darkroom that processed black-and-white and colour photographs as well as filmstrips[13] (fig. 1.2). Staff largely produced still images for promotional exhibitions, publications, and filmstrips but they also provided images for governmental records and produced still photographs of film productions.

From the earliest days of the NFB, the question of national unity had been central to its mission and, accordingly, that mandate extended to Photo Services. Because the NFB was founded in 1939 and shortly became known for wartime films, it may appear to have been formed largely in response to the dramatic events of the Second World War, but the archival record tells a different story. The National Film Act of 1939 prioritized anxieties around Canadian unity over concerns about the war.[14] The Film Act charged the government film commissioner with "the making and distribution of national films designed to help Canadians in all parts of Canada to understand the ways of living and the problems of Canadians in other parts."[15] The mandate, which echoed the MPB's emphasis on cinema (and photography) as a means for "one part of Canada … to know … other [parts of Canada],"

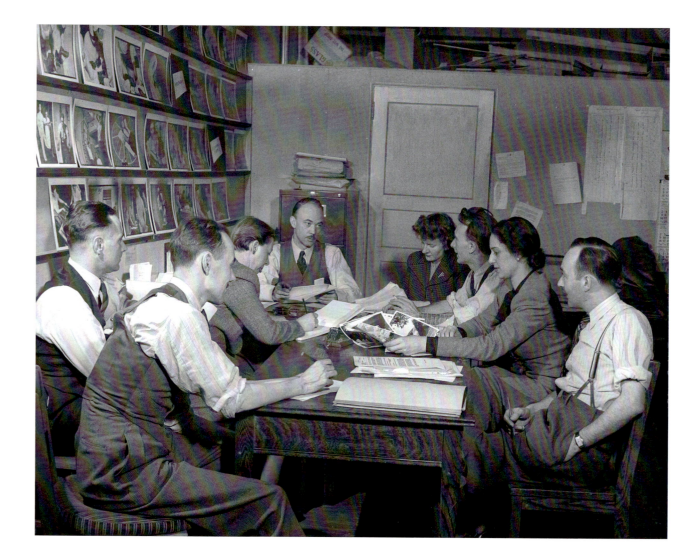

1.2   "Filmstrip Section, National Film Board of Canada,"
February 1945. Photograph, F.C. Tyrell.

would be reiterated throughout the NFB's history and accen-
tuated by its leaders, including Grierson.[16] Indeed, it became
such a prominent rallying cry that it would be echoed by staff
for years. In a 1996 interview, long-time NFB photographer

Gar Lunney, for example, reiterated that rhetoric proudly, announcing, "Our job … in the National Film Board, as I understand it, was: to show Canada to Canadians."[17]

## Picturing the Home Front: Still Photography during the Second World War

Still photographs were deployed by the NFB during the Second World War largely to promote war efforts on the home front. The film board was, as staff member Marjorie McKay later recalled, a "peacetime" agency that responded to the international conflict within a Canadian context.[18] Domestic morale and Canadian contributions to the war were highlighted in most NFB productions of the time, including its two celebrated newsreel series *Canada Carries On* and *The World in Action*. The former, initiated in April 1940, promoted war efforts on the home front in didactic and inspirational terms.[19] *The World in Action*, developed about two years later to address the conflicts overseas, was far more internationally oriented, yet it too represented a Canadian perspective on the war.[20] The NFB's still photography production followed the model established in *Canada Carries On*, focusing on efforts made on the home front. Images like Harry Rowed's depiction of a Toronto parade celebrating the launching of the thousandth Canadian-made war vessel exemplified NFB photographs of the time in endeavouring to rally citizens around the war effort (fig. 1.3).

During the war years, Photo Services thrived. Under the leadership of Ralph Foster, the unit produced and distributed images for a range of materials including publications, exhibitions, and filmstrips and in support of cinematic productions. These activities would expand in 1943, when the NFB acquired the Wartime Information Board's Still Photography Division.[21] NFB's Photo Services undertook an extensive series – established through orders in council in 1943 and 1944 – for the Department of Munitions and Supply

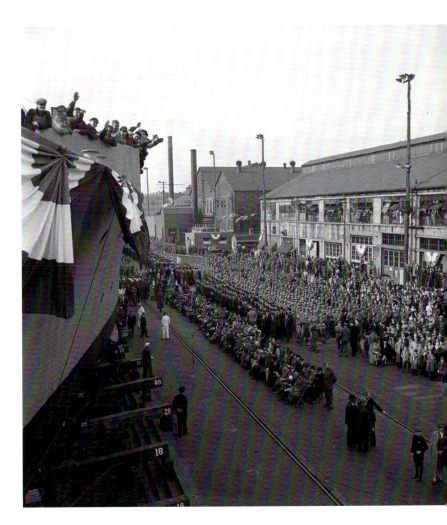

1.3   "General view of the crowd at the launching of the 1,000th Canadian-built vessel at the opening of Canada's seventh Victory Loan," 21 October 1944. Photograph, Harry Rowed.

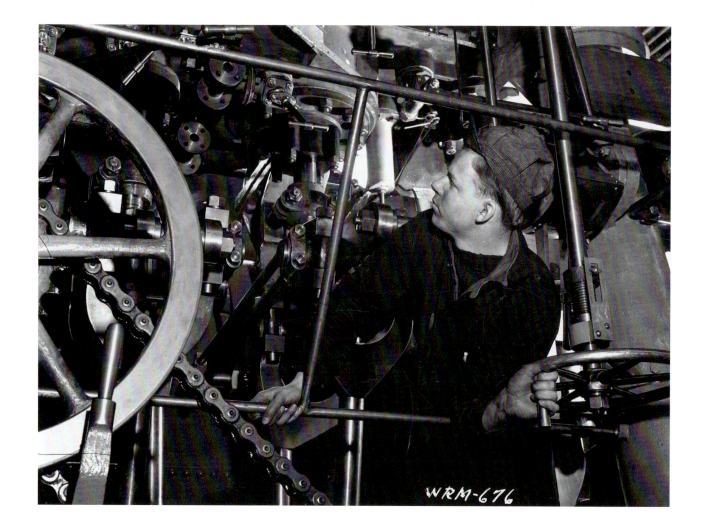

WRM-676

1.4    "Workman adjusts machinery at the John Inglis Co. Bren gun plant," 8 April 1941. Photograph uncredited.

to photographically promote wartime munitions production (fig. 1.4).[22] By 1945, just following the cessation of conflict, the unit would boast seventy employees out of the NFB's total staff of 787.[23]

The NFB employed a series of young photographers conversant in the visual rhetoric of industrial promotion,

advertising, and photojournalism. They included Nicholas Morant, a news photographer, who had also been employed by the Canadian Pacific Railway as a photographer;[24] George Hunter, a former photographer for the *Winnipeg Tribune*;[25] Ronny Jaques, who would go on to be a staff member of the national publication *Weekend Magazine*;[26] and Jack Long. A young Chris Lund was hired as a darkroom technician during the war years; he would later become one of the NFB's most active staff photographers.[27] Harry Rowed, another prolific photographer during the war, had photographed for both the Canadian National Railways and Trans-Canada Airlines before joining the predecessor of the Wartime Information Board (WIB).[28] Rowed became head of Photo Services in 1945.[29] The photographers were a colourful, industrious, and inventive bunch, as indicated by a brief description from a 1943 *Globe and Mail* profile of Morant (see figs. 3.15, 4.2), then shooting in pre-confederation Newfoundland: "With him he lugs something like 15 different cases of photographic equipment, a standard typewriter – 'Portables don't stand up,' he explains – a sleeping bag; a tent, first aid equipment and a box of water colors, and he piles it all into several corners of his hotel room. His only explanation is that 'you never know what you might want at any given moment.'"[30]

Clearly, NFB photographers, like Morant, worked independently in the field. However, they were part of a larger enterprise that included "producers" (as the executive staff were known), editors, and writers, all answering to the demands of the federal government and the shifting concerns of Ottawa bureaucracy. As Chris Lund later recalled of the war years when he was working as a lab technician for Photo Services, "In those days, the scene was a couple of photographers. They came in with their stories and we'd do the processing. But it wasn't a nice big happy family at that point. Everybody was disjointed."[31] In the field, photographers followed assignments given to them in Ottawa, often thousands of miles away from where they were shooting;

they improvised on others on location. Accordingly, while these photographers were certainly central to the images produced by Photo Services and had agency in the making of images, they should more accurately be considered the partial authors of NFB photographs. In effect, work produced by Photo Services was decidedly collaborative.

Photographers and other staff members chiefly served the Canadian government itself at this time as throughout most of the NFB's history. As discussed in chapter 3, NFB activities during the Second World War were closely intertwined with the government's key propaganda vehicle, the WIB. In addition, Photo Services produced photographs for, among other governmental agencies, the Departments of Labour, National Health and Welfare, External Affairs, Munitions and Supply, Mines and Resources, Agriculture, and Trade and Commerce, which were all required by legislation to use the NFB for still photography production.[32] One of its largest contracts was undertaken in 1943 and 1944 when Photo Services established an extensive relationship with the Department of Munitions and Supply; the unit was contracted (with individual contracts of up to $41,000) to produce promotional photographs highlighting Canada's wartime munitions industry.[33] Other governmental assignments fulfilled during the war by Photo Services included such mundane assignments as the production of identity portraits as well as supplying these departments with printing services and access to its stock library. In addition, it supported film productions by making still images on set. The unit also produced lengthy thematic photo stories, which were used in NFB-produced educational filmstrips, in WIB displays, and by individual departments (fig. 1.5). Predictably, the unit also made photographs expressly for the Canadian military during the war years. By 1942 two additional darkrooms had to be installed to meet specific demands from the army and the director of Public Information.[34]

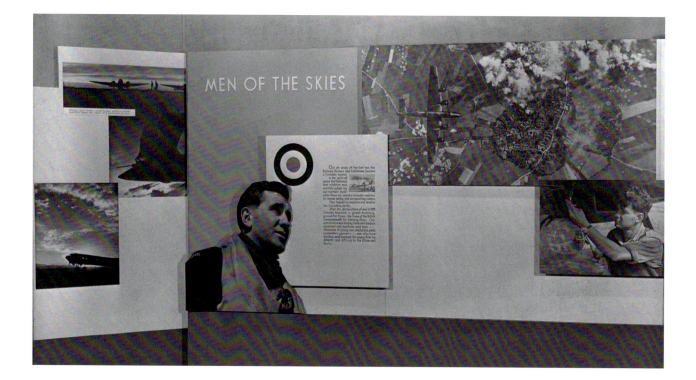

1.5 "Section of a photo mural display about pilots during
WW II at a museum in Ottawa, Ontario," March 1945. Photograph,
Chris Lund.

The NFB also increasingly supplied photographs for
non-governmental newspapers, magazines, and school
textbooks and to foreign governments. Indeed, although
photography may have been seen as a subordinate part of the
NFB's overall enterprise, Grierson would come to recognize
its potential for reaching a large public through mass circu-
lation publications, particularly newspapers. During an NFB
meeting on 8 June 1943, he introduced a confidential report
on the "values of various media in public appeals" that rated
radio and newspapers as the most effective for the country.[35]
This endorsement of print media and radio by Grierson, a
figure who is widely and almost exclusively associated with
filmic expression, may seem remarkable. Yet it demonstrates
that he — as well as his vision for the NFB — was motivated
primarily by a will to foster an engaged citizenry through
propaganda, not to develop a cinematic style.

The roughly 25,000 images made under Photo Services'
auspices (in part through its absorption of the WIB) typically
focused on Canadian civilian life during the war as well as
military activity at home. These photographs were intended
to stimulate a sense of duty toward the war effort, comfort

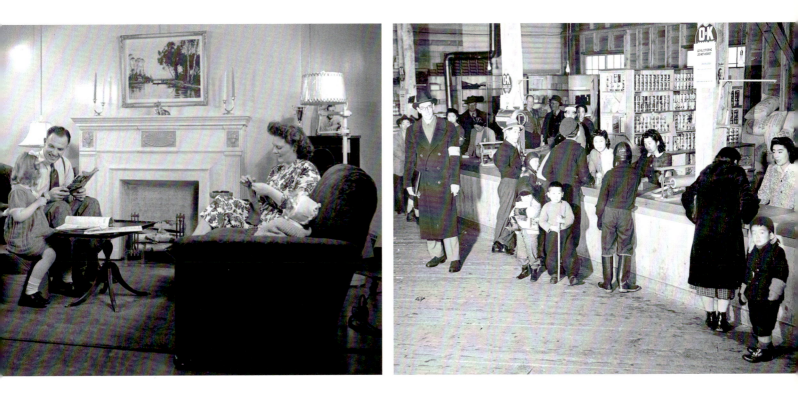

Canadian citizens, and foster patriotic support of the government's war effort. Among the shoots directly dealing with the military were several that addressed domestic defence, including extensive documentation of the opening of a joint Canada/US highway at the border of Alaska and the Yukon in 1942, as well as images addressing air raid protection in Vancouver. Other photo series looked at the government's support of military families at home; these included promotional images of new government-funded housing and support of soldiers' families through allowances (fig. 1.6).[36]

At other times, Photo Services recorded newsworthy events but always with an emphasis on heart-warming stories that bolstered national morale. A 1943 NFB photo

1.6 (*left*)  "Kalek family relaxing in their living room in their newly constructed prefabricated house," Vancouver, May 1944. Photograph, Harry Rowed.

1.7 (*right*)  "Store at Japanese-Canadian internment camp," Slocan City, B.C., ca. 1942. Photograph uncredited.

shoot, for example, depicted the Dutch Queen Juliana, who spent the war years in exile in Ottawa, where her daughter Princess Margriet Francisca was born.[37] Others showed a more ominous side of war on the domestic front: a series of photographs made in 1942 and 1943, for example, depict

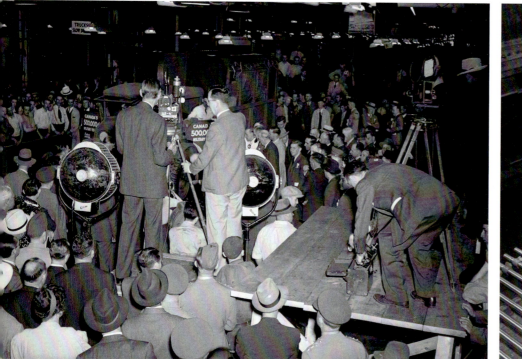

1.8 (*left*)  "Crowd gathered at the end of the assembly line to commemorate Canada's 500,000th military vehicle, a battery charger lorry" (Hon. C.D. Howe and Colonel J.L. Ralston, Minister of National Defence presiding, Oshawa, Ontario), June 1943. Photograph uncredited.

1.9 (*right*)  "Female worker Jenny Johnston of Winnipeg, Manitoba, gauging bores of barrels of Lee Enfield rifles being produced for China by Small Arms Ltd.," Long Branch, Ont., April 1944. Photograph, Ronny Jaques.

some of the British Columbia internment camps, where people of Japanese heritage were incarcerated during the war. Such images as a 1942 photograph of a store at the Slocan City camp simultaneously show the inmates' containment while, by focusing on routine aspects of life in the camp, present it as a humane environment (fig. 1.7). Still, the figure of an official in the mid-foreground, apparently overseeing the store's transactions, along with the anxious glances toward the camera, disrupts that sense of normalcy. This is an imprisoned community under surveillance where the inmates themselves were forbidden from photographing.[38] Other NFB images more explicitly endorse the government's incarcerations. A photograph by Jack Long

depicting Japanese-Canadian school children in tidy rows eagerly studying a book is captioned: "Loyalty to the British Empire is taught to these second- and third-generation Japanese-Canadian children."[39]

As chapter 3 discusses in detail, industry was one of the most prominent subjects of photography produced by the NFB in association with the WIB during the war. Photo Services depicted industrial production in support of the war effort in over five thousand individual photographs and dozens of shoots (fig. 1.8). Arms manufacturing, aluminium and steel production, shipbuilding, and the production of military vehicles as well as the manufacture of military clothing and contemporary scientific innovation were regularly depicted.[40] Many of the photographs of this period reflect the machine aesthetic of stylized and geometric compositions that was the mainstay of several of the photographers' earlier commercial and industrial work. Others humanize the factory and thereby promote the war effort that individual Canadians were making. This is particularly evident in the hundreds of images depicting women, who entered the paid workforce en masse during the war (fig. 1.9). In the NFB archive, they appear on assembly lines, working in shipyards, and writing to soldiers overseas as well as in various other roles in support of the war.

## NFB Photography and Postwar Reconstruction

In the months before the war ended and to the end of the 1940s, NFB photographs explicitly addressed reconstruction and the return of veterans to "Civvy Street" (fig. 1.10). While NFB photographers captured the exuberant celebrations of the allied victory in many images, this was in fact the beginning of a trying period for the NFB, which came simultaneously under political scrutiny and financial restraints. Yet in the midst of these trials, the NFB, including Photo Services, continued to be highly prolific.

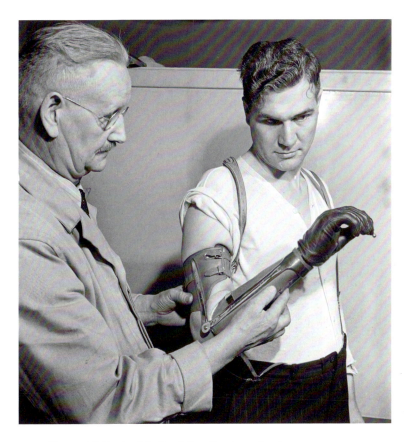

1.10   "Private Ed Gerris of the Royal Canadian Army Service Corps, seen here with Principal Eccles of Shaw Business Schools, is using a specially designed glove-covered artificial hand to learn penmanship during a retraining course on Primary Accountancy," Toronto, 1944. Photograph, Ronny Jaques.

In November 1945, Grierson resigned as government film commissioner just as the NFB became the object of right-wing attacks. Two months before his resignation, in a notorious incident in Canadian postwar history, Igor Gouzenko, an employee of the Soviet Embassy in Ottawa, handed over

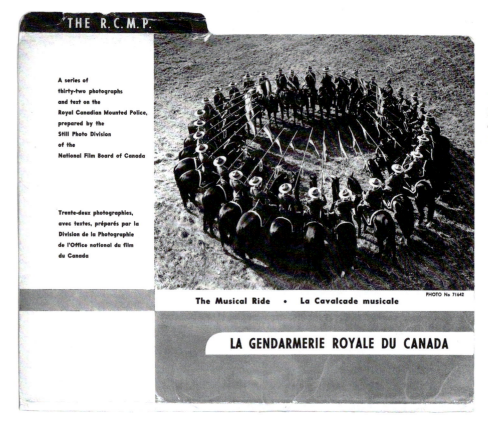

A series of
thirty-two photographs
and text on the
Royal Canadian Mounted Police,
prepared by the
Still Photo Division
of the
National Film Board of Canada

Trente-deux photographies,
avec textes, préparés par la
Division de la Photographie
de l'Office national du film
du Canada

The Musical Ride  •  La Cavalcade musicale

PHOTO No 71642

LA GENDARMERIE ROYALE DU CANADA

1.14 "The Musical Ride," cover photograph, *La Gendarmerie royale du Canada* photo set, ca. 1954–63. Photograph, Guy Blouin.

photographs and distributes them so that Canadians may know more about their own country, and so that people in other lands may become better acquainted with Canada."[89]

The division produced or contributed to numerous publications, including special publications such as a souvenir album commemorating Queen Elizabeth's 1959 visit to Canada.[90] In 1954, it established an agreement with the Queen's Printer, the government's publication house, to produce sets of photographs in specially designed folders as directed by the Canadian Education Association–NFB Advisory Committee.[91] Intended for classroom use (a rare example of NFB still photographs aimed at children), these sets of pictures addressed various aspects of Canadian geography and life in didactic, bilingual text and a series of about thirty-two photographic reproductions. The series included *The Story of Milk*, *Logging in Canada*, *Fishing on the West Coast*, *Mining in Canada*, *People of the High Arctic*, *The Rockies*, *Provincial Capitals*, *Farming in Canada*, *Maple Sugar*, and *The R.C.M.P.* (fig. 1.14).[92] As with many division activities, government sponsors were closely involved in

these publications: the Department of Northern Affairs and National Resources, for example, cooperated on the production of *People of the High Arctic* (see figs. 6.4, 6.11), while Forest Products Laboratories of Canada cooperated on *Logging in Canada*. Each set featured photographs printed on card stock with accompanying captions in English and French. Language and images alike were didactic; they played on stereotypes of a rugged land rich in natural resources while addressing – like the NFB's contemporary expository cinema – the intended young viewers directly as the inheritors of these riches. The photo sets reflect the NFB's contemporary emphasis on education during the postwar years.[93]

## The Photo Story

While the division experimented with other forms of publication for distribution, most of its images reached viewers through "photo stories," narrativized arrangements of photographs with text. While photo stories also typically included captions and brief text, the narrative was conveyed visually; however, text played an important role as, to use Roland Barthes's term, "anchorage," weighting the meaning and directing the viewer's interpretation of image.[94] The photo story had been a staple of mass circulation publications since the emergence of the picture magazine in Europe in the 1920s. By the 1930s and 1940s, such publications as *Life* in the United States and *Vu* in France had popularized them and photojournalism widely; in Canada, *Weekend Picture Magazine*, *Perspectives*, and *Star Weekly* featured photo stories extensively.

Since the 1940s, the division had been producing photo stories by the score.[95] As early as 1946–47, for example, Photo Services reported creating and distributing twelve major photo stories with a total circulation of 15,276,993.[96] Over the course of the 1940s and early 1950s, it regularly supplied pictorials to Canadian rotogravure supplements in

The Gallaghers attend Sunday morning service with their children at St. Louis Roman Catholic Church in Chiswick.

# WINTER ON THE FARM

**For this Ontario family it's a bustling, contented interlude before the land comes to life again**

**Story by Francois Morisset**

**Photos by Chris Lund**

WINTER on the average Canadian farm is a time when the farmer catches up on work he is too busy to do in the summer. From planting to harvest he works day and night wresting a living from the earth. During the cold months he has more leisure, but uses it for such activities as repairing equipment and buildings and cutting firewood.

Bernard Gallagher, who operates a 190-acre farm near Chiswick, Ont., some 22 miles from North Bay, always finds plenty to occupy his winter days. This winter and last he has put a bathroom in his house, installed air pipes for milking machines in his barn,

and built a new implement shed. Material for the latter was hauled from his 75-acre bush lot which supplies the farm with lumber and firewood.

Now 35, Gallagher started farming when he was 15. After serving in World War II he inherited his father's farm and married Betty Ulrich, who lived a few miles away. They have three children, Monica, 11, John, 9,

and Ken, 4. Gallagher's mother lives with them. Gallagher owns 40 head of cattle, two horses, 30 hens and two pigs. His farm machinery is up to date and he hopes in the near future to buy some of the implements he now borrows from his neighbors. He owns a 1960 Ford car, which he uses two or three times a week to do errands at the general store in Powassan, 11 miles away, to attend church at Chiswick, and for pleasure trips. He participates in a Farm Forum group held in conjunction with C.B.C. radio broadcasts in order to keep abreast of most recent farming techniques, and for straight recreation takes his son John on hunting expeditions.

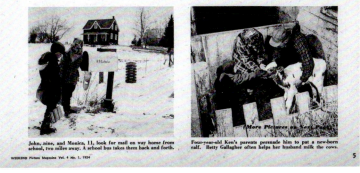

John, nine, and Monica, 11, look for mail on way home from school, two miles away. A school bus takes them back and forth.

WEEKEND Picture Magazine Vol. 4 No. 1, 1954

Four-year-old Ken's parents persuade him to pat a new-born calf. Betty Gallagher often helps her husband milk the cows.

5

1.15 "Winter on the Farm," *Weekend Picture Magazine* 4, no. 1 (9 January 1954): 5. Photograph, Chris Lund; text, François Morisset.

character of the upper-left photograph of an aircrew candidate being tested for airsickness would certainly fix viewer attention. In many other photo stories, a protagonist with whom the viewer is encouraged to identify is placed in this position in the layout, with the other images arranged to move the viewer around the story. Here, photographs framed around curvilinear RCAF test equipment effectively draw the eye to the right and up. In this way, photo story images were presented and would be "read" as coherent narratives even though they were often not made on the same shoot. Although this layout credits only Lund, the second image at upper right, from Churchill, Manitoba, for example, is the work of freelance photographer Herb Taylor.

The attention to visual drama on the part of division photographers and staff marked a distinction between photo stories and many routine news images. Division staff were intent on captivating the viewer. In 1996, Lunney recounted his working process: "I got high angles, low angles, I shoot through things, I try to make things look dramatic. Of course, you do. Anything to get away from a straight news picture. You come in BANG, you've got the same scene. It runs in the paper the next day. That doesn't work in a photo-story. You've got to say, how can I make this dull looking picture look good?"[107]

Along with the consistent demands of government, news agencies were a source for many stories. Lunney remembered, "Basically, they would [scan] the newspapers. You know, we got the dailies and especially the weekend editions and they'd say, oh, here's a little something going on in Saskatoon or Victoria, Edmonton or Charlottetown, looks like it might make a nice little photo story. And then they'd try to line up three or four in that area … and the rest was up to you [the photographer]. So you got as much information as you could while you were there and you bring it back and you write what you can write to help the people who have to put the story together. Because they have only limited knowl-

edge. You know, it's always evolving. It seems like … in some sense it's rather fun because you are losing support systems when you are out in the field which makes you more reliant upon yourself."[108]

Photo stories were collaborative productions, involving division photographers, photo editors, writers, and administrative staff. From 1955 through spring 1960, the production schedule and restraints were daunting: Lorraine Monk recalled that for each weekly story the division had a $100 budget to cover photography, writing, and the making of plates.[109] The layouts were compiled from photo assignments devised by the division or drawn from its archive of photographs. Lund and Lunney were responsible for most of the visual content from 1955 and after. They regularly travelled the country on specific assignments or on broad regional tours, as Lunney described. The division also continued to hire from a large pool of freelance photographers. Archival records and interviews with division photographers Lund, Lunney, Ted Grant, Jack Marshall, and John Reeves, as well as John Ough and Hélène Proulx-Ough, indicate that photographers had a good deal of agency in fulfilling assignments.[110] They were apparently rarely given the explicit shooting scripts with which, for example, Roy Stryker supplied photographers for the celebrated U.S. Farm Security Administration during the 1930s.[111]

Back in Ottawa, division staff would select and arrange the handful of images to be used from a lengthier shoot, while French and English staff writers composed captions and text, based in part on the photographer's notes but largely written after the fact. These positions were held for many years by François Morisset, Gaston Lapointe, and John Ough. By 1962, French and English mat releases were being produced simultaneously, based on the same layout of images.[112] The writers worked somewhat autonomously, and so French and English texts are not direct translations but variant interpretations of general themes and the scenes depicted (figs. 1.17

Big harvest moon shines over grain elevators at Estlin, Saskatchewan, where wheat bound for the four corners of the world awaits railroad transport to distant seaports.

# CANADA
## *The Rich Earth*

Stretching in a vast fertile horseshoe between the great sweep of the precambrian shield in the east, the towering Rocky Mountains in the west and the sub-arctic forests to the north, lies Canada's famous wheat-growing region. Bigger than the whole of France and still growing, this massive expanse of uninterrupted farmland has again yielded a fine harvest of more than 700 million bushels of wheat, most of it destined for shipment to 50 countries around the globe. With overseas exports expected to reach 600 million bushels during the crop year of 1965-66, surpassing by far the big sales of recent years, Canada's wheat farmers are busier than ever. Fresh land is being broken, yield per acre is increasing, and individual farms themselves are growing larger (to an average of 700 acres), becoming more valuable (with an average worth around $40,000).

Across the prairie wheat lands of Alberta, Saskatchewan and Manitoba, 200,000 operating farms are producing annual harvests with a total cash value breaking the $1,000,000,000 mark. Behind this gigantic industry of such vital concern to millions of people throughout the world is the continuing scientific story, stretching back over 60 years, of the development of special wheat varieties to obtain the richest yields from the fertile prairies and the vast organizational story of how the wheat is shipped from farmer to railway, to dockside elevator and its eventual departure on deep-laden ships around the globe. Canada's rolling prairies, which long ago lured hardy settlers with prospects of great wealth from the rich soil, are still fulfilling their promise, with 20,000,000 tons of golden grain this year's proof of Canada's claim to the title—*The Rich Earth.*

*—photos by Chris Lund*
*story by John Ough*

*Left:* Wheat farmer Jim Traynor operates tractor-drawn swather.

NATIONAL FILM BOARD PHOTOSTORY

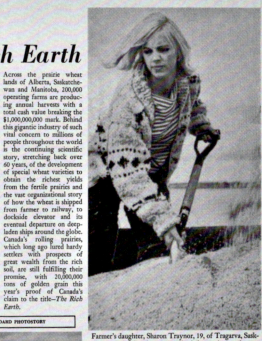

Farmer's daughter, Sharon Traynor, 19, of Tragarva, Saskatchewan, levels wheat in 150-bushel-capacity truck.

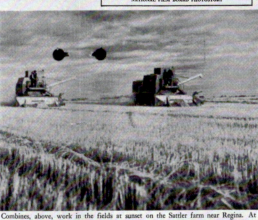

Combines, above, work in the fields at sunset on the Sattler farm near Regina. At right, Arnley Denzin pours wheat from combine into truck during bustling harvest.

65-6587

1.17    Photo Story 402A, "Canada: The Rich Earth," 2 November 1965. Photographs, Chris Lund; text, John Ough.

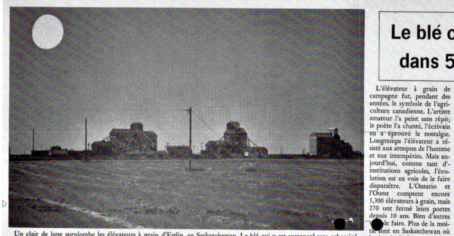

Un clair de lune surplombe les élévateurs à grain d'Estlin, en Saskatchewan. Le blé qui y est entreposé sera acheminé vers les grands ports de mer.

# Le blé canadien dans 50 pays

L'élévateur à grain de campagne fut, pendant des années, le symbole de l'agriculture canadienne. L'artiste amateur l'a peint sans répit; le poète l'a chanté, l'écrivain en a éprouvé la nostalgie. Longtemps l'élévateur a résisté aux attaques de l'homme et aux intempéries. Mais aujourd'hui, comme tant d'institutions agricoles, l'évolution est en voie de le faire disparaître. L'Ontario et l'Ouest comptent encore 5,300 élévateurs à grain, mais 270 ont fermé leurs portes depuis 10 ans. Bien d'autres le feront. Plus de la moitié sont en Saskatchewan où le chemin de fer songeait l'an dernier à abandonner 53 embranchements. Le train disparu, certains élévateurs continueront à livrer leur grain aux camions. Quelques-uns seront déménagés ailleurs. Même s'il pour le cultivateur c'est un vieil ami qui meurt, il comprend que c'est pour le progrès et que la tendance est maintenant orientée vers les élévateurs centraux, comme ceux de Fort William et Port Arthur, moins nombreux mais plus spacieux. Partout, la vie rurale diffère de ce qu'elle était il y a vingt ans. Le blé est devenu la ressource première du Canada et la Commission canadienne du blé, dont le siège social est à Winnipeg, prévoit une exportation de 600 millions de boisseaux pour la saison 65-66. Avec ces commandes colossales venues de Russie et de Chine, l'industrie canadienne du blé représente désormais un chiffre d'affaire qui frise le milliard. Malgré les difficultés de température de cet automne, les choses s'étant améliorées au point d'imposer un travail de jour et de nuit, les spécialistes entrevoient la possibilité de faire face à une année record.

*Photos: Chris Lund*
*Texte: Gaston Lapointe*

*A gauche:* Jim Traynor est au contrôle d'une moissonneuse.

PHOTO-REPORTAGE DE L'OFFICE NATIONAL DU FILM

Dans un camion d'une capacité de 150 boisseaux, Sharon Traynor, de Tragarva, en Saskatchewan, tasse le grain.

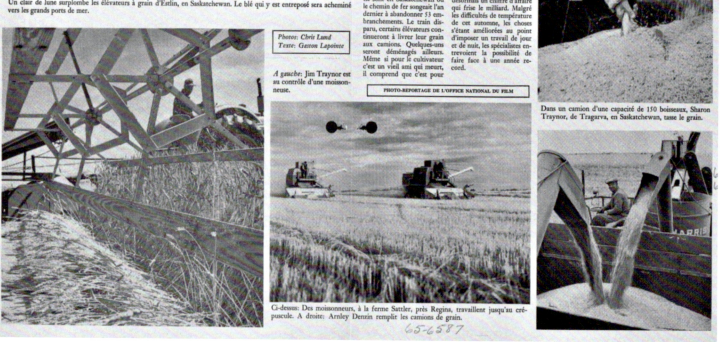

Ci-dessus: Des moissonneurs, à la ferme Sattler, près Regina, travaillent jusqu'au crépuscule. A droite: Arnley Denzin remplit les camions de grain.

65-6587

1.18   Photo Story 402A, "Le blé canadien dans 50 pays," 2 November 1965. Photographs, Chris Lund; text, Gaston Lapointe.

and 1.18). Ough, who joined the division in 1961 and took charge of photo story production after that date, recalled that he not only wrote most of the English texts during the 1960s but occasionally contributed photographs; Gaston Lapointe wrote most of the French texts during the same years.[113] Ough claimed to feel no direct political pressure and instead developed ideas for pictorials simply through staying abreast of current events by reading the *Financial Post* and other publications. Yet his deep nationalist commitment – evident in conversation as well as in prose – indicates that he, like most division staff, was committed to the division's central mandate: promoting and naturalizing Canadian national identity in visual form.

From 1955 until the early 1970s, photo stories were distributed extensively within Canada and abroad. Newspapers across the country enthusiastically printed the pictorial layouts or individual photos on a theme. In an unpublished memoir, John Ough recalls, "These ready-to-use stories were available to editors in three ways: as an impressed cardboard mat ready for reproduction through the hot-lead process; a set of scanagraver-sized glossy pictures cropped as per the layout; or as a set of 8-x-10-inch photographs. Also offered was a page or two of back-up text plus facsimiles of a dozen or more other photographs and captions to allow different newspapers to publish individually designed or more extensive treatments of the story."[114]

By 1957 the division would boast that more than one hundred Canadian publications were frequent users of photo stories.[115] They appeared in such diverse papers as the *Globe and Mail*, the *Northwest British Columbian*, *La Presse*, the *Sydney Post Record*, and the *Orillia Packet and Times*. Some of these publications reprinted the layout supplied in the mats, while others selected images for their own purposes. The *Toronto Daily Star* on Saturday, 23 June 1959, for example, carried two images by NFB freelancer Malak from a larger photo story on the Canadian textile industry to accompany

an article on the current economic conditions of textile production written by *Star* staff reporter Gordon McCaffrey. The images were credited to the NFB; Malak was not named.[116]

Photo stories played a role in nation building within Canada, but international distribution was equally important. As throughout its history, the division worked extensively for the Department of External Affairs, which distributed photo stories through Canadian missions overseas. "Canada's Scientists Get behind the Serviceman," the 1955 photo story discussed above, for example, was distributed to news agencies in the Netherlands, Switzerland, Spain, Venezuela, Denmark, Italy, and Brazil through the Canadian diplomatic missions in those countries. Photo stories were apparently used by External Affairs – and, to some degree, designed by division staff – in part to promote Canada to potential immigrants and investors. In addition to publications, photo stories were also presented in exhibition format. In November 1966, for example, the division organized an exhibition of photo stories at Ottawa's Château Laurier Hotel.[117]

Photo stories depicted Canada in glowing, jingoistic terms as a prosperous and harmonious nation (fig. 1.19). The hundreds of these pictorials are notably diverse. Division staff were clearly at pains to represent all regions of the country. Stories on the Arctic, West Coast, Prairies, Ontario, Quebec, and the Maritimes appeared in regular rotation. However, some areas were more often seen. Like a politician seeking the popular vote, the division usually emphasized areas of greater population density. Thus, more photo stories were shot in Ontario and Quebec and in urban centres than in the country's other regions or rural areas. One notable exception (discussed in chapter 6) was the Arctic and sub-Arctic, which became favoured subjects far in excess of their population. Division photo stories addressed myriad individual topics, yet some broad themes recurred: Canadian natural resources (including agriculture, fisheries, mining, and

Canada's pavilion takes preliminary shape at the *Expo 70* site, Osaka, Japan.

*Right:* Tranquilized polar bear with her cubs during wildlife survey.

Medical team led by Dr. Pierre Grondin, above, did much of initial research work connected with 1968's wave of heart transplants.

# 1968: A Good Year for Canada

NATIONAL FILM BOARD PHOTOSTORY

A new surge of energy during 1968 set Canada on course for her second century of nationhood. With the population nudging the 21 million mark, the gross national product climbing up to $66,000,000,000, total exports of $13 billion comparing well with imports of $12 billion and a per capita average income of $2,500 a year, the richness of the country has never before been so apparent.

And for all the hard work that makes these figures possible the nation remains a country second to none as a place to live. For here, where technology, science and bustling commerce lead the way to burgeoning industrial prosperity the needs of other important human interests were pursued on every hand. During the past year, while some Canadians wrested massive sources of power from the wilderness others looked to the future of its wildlife. Meanwhile, as the diversified nation forged ahead with national unity, it had yet the spirit to offer its assistance overseas and, while the technicalities of new space-age scientific developments were initiated across the land, the arts and cultures of the nation were advanced in solid fashion.

It was a year of excitement in politics, a year of vigorous exploration for valuable minerals, a year of great changes in the fields of medicine and religion. It was also a year to remember the events of a half century ago, to plan with flexibility for evolving new patterns of society that are already forming, and to consider the nation's increasing role in the complexity of international affairs.

But most of all it was a year of steady national growth and another year of life to be fully lived in a land of continuing accomplishment and promise. — *John Ough.*

The war memorial in Ottawa—a reminder that 50 years have passed since the armistice.

*Below:* A member of the Jehovah's Witnesses who gathered by thousands in Ottawa.

Pierre Elliott Trudeau was chosen party leader then Prime Minister.

*Right:* The new National Arts Centre took shape in Ottawa.

1.19    Photo Story 485, "1968: A Good Year for Canada," 27 December 1968. Photographs, Ted Grant, Chris Lund, and Terry Pearce; text, John Ough.

forestry), achievements by Canadian individuals or institutions, particularly in the arts and sciences, and the country's diverse geographic and multicultural makeup. In addition, photo stories served the NFB's longstanding mandate to promote official Canada through coverage of special occasions, including the annual opening of Parliament and royal visits. The division continued to produce photographs of government staff for official uses.[118] As well, it produced pictorials publicizing federal social programs and promoting tourism with scenic views and laudatory texts on winter sports and favourite tourist spots like Banff, Jasper, and Niagara Falls. Canadian foreign aid, including its participation in the Colombo Plan, was also featured.

## Photographic Modernism in the 1960s

By 1960, when Lorraine Monk became the Still Photography Division's executive producer, the photo story was firmly established as a mainstay of division activity. Yet Monk and other staff members were becoming critical of the cheerful didacticism characteristic of most photo stories and their governmental assignments. In a 1965 memo to Grant McLean, the NFB's then director of production, Monk disparaged the division's production as "a solid documentary record of salmon fishing and wheat fields – gold-mining and logging – Legislative Buildings and legislators. We have filed so many pictures of Peggy's Cove and Lake Louise – Percé Rock and the Winnipeg rail yards – that, after 25 years of effort, we [are] in danger of amassing little more than a well-indexed collection of photographic clichés."[119]

Over the course of the 1960s, Monk and other staff attempted to disassociate the division from its reputation as a group of "civil servants with a camera." During these years, the division would undergo two key changes: the adoption of new ways to bring photography to its public (including the publication of an ambitious series of picture books and other publications as well as the establishment of a gallery)

1.20   Grey Cup game, Toronto, November 1965. Photograph, Ted Grant.

and the promotion of a new generation of photographers who embraced a more personal, direct, and often self-reflexive approach to the documentary photograph. This turn to a more spontaneous, exuberant approach to photographing Canada was evident in the work of long-time NFB freelancer Ted Grant (fig. 1.20). Many of Monk's programs during the 1960s were prompted and funded by the country's lavish centennial celebrations and, like the spectacles organized around the country, division productions took a decidedly more ambitious tone. In effect, the division began to transform itself from Canada's official picture agency to a federal advocate of independent contemporary photographic practice – although in the course of these changes, it continued to promote Canada visually and while doing so, also

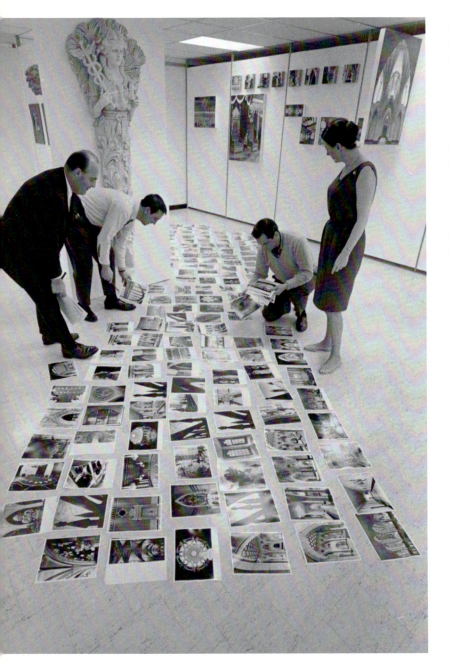

added a few "photographic clichés" to the archive. These changes were the result of work and initiatives established by the whole staff, including at various times Ron Solomon, Richard Sexton, John Ough, Gaston Lapointe, Hélène Proulx, and Norman Hallendy (fig. 1.21). As Hallendy later stated, "We were creating – and I include all of us, not just Lorraine Monk but … Hélène Proulx, Johnny Ough – all of us were creating a kind of ambience … kind of a field in which things could grow."[120]

The changes undertaken by the division during the 1960s – the field in which new photographic practice grew – reflected a widespread embrace of photographic modernism, in which the medium was seen as an expressive and aesthetic form rather than principally a reportial medium. Photography was becoming widely associated with art practice, the study of art history, and the various institutions of art. It was now taught in a number of art schools and fine arts departments of universities. Museums also increasingly began collecting photography and studying the medium through the values and techniques of art connoisseurship. Histories of photography, again modelled after art historical narratives and initially associated with museological practice, became more popular. Canada too experienced this aestheticization of the photograph: in 1967, James Borcoman established the National Gallery of Canada's internationally renowned Photographs Collection, and commercial galleries in Toronto and Montreal began to promote the medium.[121] In 1965, Ralph Greenhill published *Early Photography in Canada*, the first narrative history of photographic practice in Canada. Like Beaumont Newhall's popular *History of*

1.21   "Chris Lund, Richard Sexton, Norman Hallendy, and Lorraine Monk looking at an exhibition layout in the library," December 1966. (Exhibition is *Stones of History*.) Photograph, Ron Solomon.

*Photography*, its text is technologically deterministic, stressing technical developments and biography.[122]

Division staff also changed the ways that their images were disseminated, turning away from a reliance on journalistic means of distributing their work. And with that, the photo story's days were numbered. Indeed, over the course of the 1960s, the division gradually phased out the popular pictorials, reducing their production from a weekly to a twice-monthly schedule in April 1960. By July 1969 they were further diminished to monthly until their production ceased entirely after April 1971.

Rather than primarily using the production of photo stories to satisfy the federal government, the division refined its system of access to the photographic archive. During these years, according to John Ough, the photo library became

the vital part of the operation … Ever growing, it daily absorbed a fluctuating but ever incoming flood tide of negatives and colour-slides from the work of both staff and contract photographers. In addition there were contributions from professional and amateur freelance photographers. In this way the library contained an up-to-date, and always in wide demand, multi-faceted portrait of Canada showing every conceivable subject, activity, geographical location and mood. Clients from across Canada and other countries engaged in producing encyclopaedias, text books, movies, school books, newspapers and magazines, advertisements, displays, anything needing illustrations, would sit at long tables or wander the rows of filing cabinets combing the vast store of photographs for their specific requirements.[123]

Norman Hallendy, who worked on a variety of projects at the division during the 1960s, initiated the reorganization of the photo archive. He replaced the numerical system that had been established in 1947–48 with an extensive system of cross-referencing. Images were now classified according to assignment, photographer, the geographic location of the shoot; most importantly, they were cross-referenced by subject (with about five different subjects per image). It was the subject field that was extensively employed by the archive's most frequent users, largely information officers from governmental departments and editors from various types of publications.[124] Hallendy recalled being motivated to undertake the reorganization to make the collection more readily accessible: "I thought, I've got to put some order into these photographs. So, not knowing anything about computers, not knowing anything about indexing or filing or any of this stuff was a great advantage. I said to myself, I've got to be able to find anything I want in this 200,000 collection of stuff. So, what I did was to simply set up a cross-indexing system. That's all. For every image you looked at, you said, okay, first of all, 'crowd,' 'ship,' 'children,' whatever it was here, the date, the place, the time, the photographer. So, you wound up with approximately five subjects per image, and I'm saying on an average."[125] His organization was, in his words, "totally subjective." For example, he recalled that he added the designation "special" to indicate what he thought to be "the best, the juiciest, the sexiest images."[126]

Beginning in 1963, the division began publishing its *Canadian Picture Index* (*Répertoire des photos du Canada* in French) (see fig. 5.4), a catalogue of division photographs since 1941.[127] These volumes were also thematically organized following some of Hallendy's categories, grouping disparate images initially created to satisfy various assignments and circumstances according to such subjects as landscape, people, science, culture, and religion. The index greatly facilitated the use of the archive as a stock library for government and publishers. Hallendy's reorganization of the archive and the development of the *Picture Index* reinforced the division's overall tendency in the 1960s to aestheticize

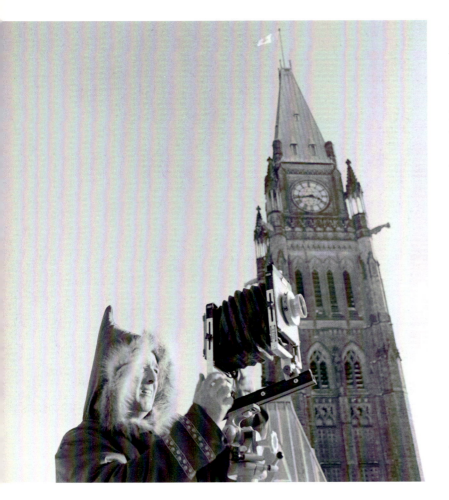

1.22 "Chris Lund, NFB photographer, taking pictures of Canada's Parliament Buildings," 1966. Photographer unknown.

its holdings.[128] As noted above, the division's collection, like photographic archives generally, aspires to an overall sense of unity; under this reorganization, the concept of a coherent

Canadian nationhood remained the holdings' overall message but now viewed through an aesthetic lens.

While the division satisfied various governmental departments largely by this more elaborate cataloguing system, it continued to produce images on assignment, though less frequently. During the centennial year, for example, it undertook an extensive collaboration with the Centennial Commission to record official events. NFB cameras captured such diverse centennial activities as the World Water Ski Championships in Sherbrooke, Quebec, small-town parades, and the royal tour.[129] On such occasions, staff photographers Lund and Lunney continued to serve as "civil servants with a camera."

Despite these service demands, the division turned its attentions largely to a series of high-quality publications and exhibitions aimed to celebrate Canada's centennial year (see fig. 1.21). These efforts included supervising the photographic content of *The People Tree*, an elaborate photographic installation at Expo 67 dedicated to the Canadian citizenry, and organizing the exhibition *Photography/Photographie: Canada 1967*.[130] The same year the division published or put into production three ambitious photographic books: *Canada: A Year of the Land* (1967), *Stones of History: Canada's Houses of Parliament* (1967), and *Call Them Canadians: A Photographic Point of View* (1968; in a different version in French, *Ces visages qui sont un pays*). *Canada: A Year of the Land* was the division's most popular and ambitious publication as well as an exhibition. In hundreds of lavishly printed colour photographs by Freeman Patterson, John De Visser, and Malak, among dozens of others, and in poetic text, the book exalts the beauty of the land, drawing a familiar correspondence between nature and Canadian identity. *Stones of History*, in contrast, was a more focused project. Also taking form as an exhibition and a publication, it included both black-and-white and colour prints by staff photographer Lund (figs. 1.21, 1.22, and 1.23), who contributed most of the

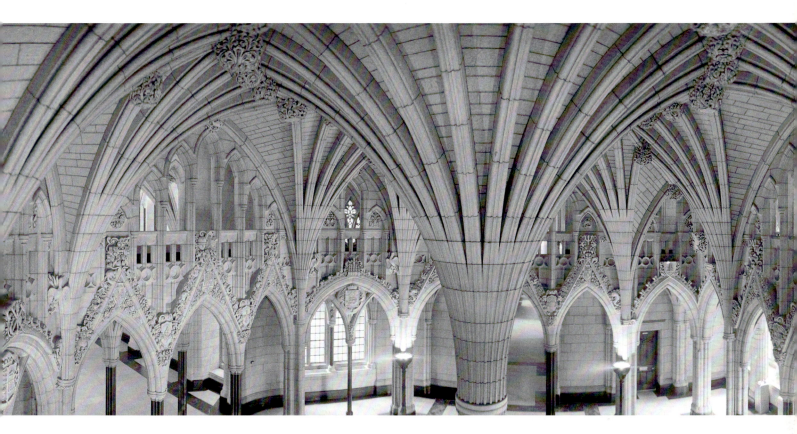

images, and Malak. The book opens with a brief foreword by Governor General Vincent Massey and an historical essay by Stanley Cameron.[131] *Call Them Canadians* and *Ces visages qui sont un pays*, like Expo's *People Tree*, included dozens of black-and-white likenesses of Canadians, selected from NFB archives or commissioned for the books and interspersed with poetic verse. These two books featured such young photographers as Pierre Gaudard, Michel Lambeth, John Max, Nina Raginsky, and Michael Semak. Their portrayals were seemingly more spontaneous and edgier than typical division work up to this point.

1.23   View of vaulting, Parliament buildings rotunda, from *Stones of History*, book and exhibition, 1967. Photograph, Chris Lund.

Indeed, in many respects, all of these photo books differ greatly from the former staple of its publications program, the photo story. Their glossy large format was aimed at a more selective, affluent audience. Rather than integrating didactic texts with a montage of images, text and captions are minimal and usually separated from images in discrete sec-

IMAGE 2

1.24 Montreal, Quebec, 1966. Cover of *Image 2: Photography / Photographie: Canada 1967*. Photograph, Jeremy Taylor.

tions. Typically each photograph appears alone on a page as though a framed work of art. If the photo stories of the postwar years were frankly instructive, these centennial publications attempted to be metaphoric and visually seductive. Nonetheless, as Melissa Rombout has shown, division photo books, too, were ideologically coded. By diminishing the

contextual information in *Call Them Canadians*, for example, differing social conditions are levelled and the country is portrayed – following the model of Edward Steichen's *Family of Man* exhibition – as one harmonious family, aided by the work of government.[132]

Cementing its interest in presenting photography as an expressive form, the division established its own exhibition space during the 1960s. Initially the Government Photo Centre Picture Gallery (or the Photo Gallery, as it was more commonly known) was situated on Kent Street in downtown Ottawa. Its first exhibition was intended to celebrate the publication of *Canada: A Year of the Land*. The division would later relocate to the governmental complex at Tunney's Pasture in Ottawa's west end and establish an exhibition space there. Among the exhibitions were ones designed and curated from the collection by Hallendy, including *The Sweet Life* and *Seeds of the Spacefields*.[133] Around the same time, the gallery hosted and published the catalogue for the *Bytown International* photography exhibitions.[134]

The division also began producing under the general title *Image* a series of exhibition-related publications, each devoted to a specific photographer or theme. Hallendy worked with some autonomy on the first five of these publications.[135] In total, ten would be published, the last, Pierre Gaudard's *Les Ouvriers*, appearing in 1971. Others included work from an annual of creative photography in Canada, particularly in Toronto and Montreal (*Image 2*) (fig. 1.24); *BC Almanac*, an extensive survey of then recent photographic production in British Columbia (*Image 8*); and issues devoted to the work of individual photographers including Lutz Dille (*Image 1*) and Michael Semak (*Image 4*).[136] The series established a new model for the presentation of expressive photography in publications. These volumes were directed at a smaller audience interested in photography and art rather than the mass audience the division addressed in its coffee-table books.

1.25 Art gallery, display window, Montreal, 1965. Photograph, Pierre Gaudard.

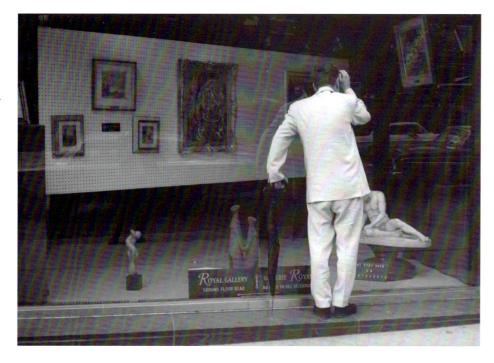

In the Photo Gallery, the *Image* series, and the two 1968 photo books, the division championed the work of photographers including Semak, Lutz Dille, Jeremy Taylor, and Pierre Gaudard, who were engaged in a new approach to documentary photography[137] (fig. 1.25). As Hallendy later recalled, there was a great deal of excitement at the division over the new work being produced:

Now, there we were these images now starting to come in that were not for the department of agriculture and not photographed for the egg marketing board that were not photographed for the Canadian government propaganda thing … there was a whole new perspective that was developing that was not determined by any

one person, it was a kind of synergistic kind of thing that was just happening and the Michael Semaks, the Freeman Pattersons, gosh, there were a whole bunch of them, began to create this kind of blossoming of these wonderful images about our country and the people, especially the people.[138]

In the early 1970s, when its staff was fully devoted to the promotion of these new photographers' work, the division became a very different institution than it had been over the course of its preceding history.[139] In April 1971, it dispatched its final photo story, a travelogue with text by John Ough about artists selling their works on Quebec City streets.[140] While the division's fondness for the photo story format had

been waning for a decade, the termination of these publications conclusively signalled an end to the Still Photography Division as the government's "official" photographer.

That change was confirmed bureaucratically later in 1971 when two-thirds of its staff was transferred to Information Canada, the newly founded federal communications agency.[141] Information Canada would oversee the visual promotion of federal concerns that had been a mainstay of the division. The photographic archive too was dispersed: the Public Archives (now Library and Archives Canada, LAC) acquired photographs and negatives dating from the Second World War to the early 1960s, while Information Canada absorbed recent photographs and those deemed marketable for its commercial image bank, Photothèque. As Martha Langford has stated, the archival dispersal "marked the loss of an important collection along with the means to rebuild it."[142] By 1975, Information Canada itself was terminated, and in a 1976 governmental transfer, Photothèque was returned to the NFB.[143] But by that point in the mid-1970s, the division no longer focused its attentions on governmental promotions, the mainstay of its earlier activities.

Instead, the cheerful Canadian jingoism of such promotional vehicles as the photo story (and the sometimes more subtle nationalist sentiments embedded in the centennial books and The People Tree) were largely supplanted at the division by the language of aesthetics. In the 1970s, it did, however, produce a few large-scale nationalist picture books. These included A Time to Dream in 1971, the 1973 picture book simply titled Canada, and the 1976 photographic tribute to the US bicentennial, Between Friends / Entre amis. With their emphasis on landscape, seductive colour, and high production value, the last two of these publications in particular attempted to recreate the success of Canada: A Year of the Land / Canada, du temps qui passe. And, indeed, Between Friends / Entre amis became a Canadian bestseller.[144] The division also produced The Female Eye / Coup d'oeil feminine,

featuring the work of female photographers in Canada, to mark International Women's Year.

But more often, the division's energies were directed toward developing an exhibition program at the Photo Gallery, amassing a collection of individual photographers' work, and mounting an extensive touring program. In short, by the 1970s, division programs attended to photographic art. In 1972, for example, the NFB was touting its exhibitions, which "circulate to appreciative viewers throughout Canada through the cooperation of art galleries, public libraries and educational institutions. They bring to all Canadians a live sense of the beauty of the country, the character of its people and the capacity of its artists."[145] The emphasis was now on a monographic presentation of photography as the work of individual artists; while the division still engaged in thematic work, presentations of individual photographers' visions dominated. Rooted in the modernist shift in thinking about photography that had been developing throughout the 1960s, these changes at the division were entrenched by the early 1970s when it expressed its mandate as bringing "public awareness to the relatively unknown talent of the many established Canadian photographers and also to the growing number of emerging younger artists."[146]

My narrative of the Still Photography Division's history closes at that decisive shift in mandate, bureaucracy, and style that occurred in the early 1970s. Rather than a discussion of the critical aesthetics of the 1970s and after, this book looks back to that earlier period from 1941 to the early 1970s when the NFB's still photographic service explicitly engaged in the project of constructing a cohesive model of national identity in visual form — through the mass of photographs it produced and, of equal importance, the idealized image of Canada apparent in its archive.

# "The Materials of Citizenship": Documentary and the Image of Childhood in NFB Still Photography

The story of the NFB's Still Photography Division and its "official picture" of Canadian nationhood is one of bureaucrats, memos, policies, and the routine, daily work undertaken by photographers, writers, editors, and other staff. But it is also a visual story told through the hundreds of thousands of photographs (as well as photo texts) that the division produced and the changing styles of those photographic representations. According to Benedict Anderson, nations are distinguished "by the style in which they are imagined."[3] At the NFB, that "style" was defined by the broad concept of documentary, a term coined by John Grierson, the first government film commissioner and head of the NFB. In order to present more fully the division's photographic story – that is, the style in which it imagined Canada at the federal level – this chapter looks closely at the concept of documentary as it was employed by the NFB as a whole and within the division more specifically. As such, the following pages serve as a pendant to the first chapter's institutional history of the division. Traversing the same chronological period, the three decades from the early 1940s to the early 1970s, they lay the groundwork for the close readings in chapters 3 through 6. But here memos and policies are set aside in order to attend closely to the style of image making and its contribution to the manner in which the division imagined Canadian nationhood.

The materials of citizenship today are different and the perspectives wider and more difficult; but we have, as ever, the duty of exploring them and of waking the heart and will in regard to them. That duty is what documentary is about. It is, moreover, documentary's primary service to the state.

John Grierson, "The Documentary Idea: 1942"[1]

Like all realist strategies, documentary seeks to construct an imaginary continuity and coherence between a subject of address and a signified real – a continuity and coherence in which not only the work of the sign but also the effects of power of a particular regimen are elided.

John Tagg, *The Disciplinary Frame*[2]

## Canada's Birthday Brings Thoughts of Tomorrow
# Nation's Future Belongs to Them

63- 6822                                                    63- 5739

Entering its 98th year as a nation, Canada is still a land of youth. A third of all Canadians today are under the age of 15 years, can expect their lives to reach well into the 21st century. Within a few decades these young Canadians will be entrusted with an expanding nation in a world far different from that of today. Theirs will be an age that will bring transportation speeds to shrink the globe ever smaller, bring interplanetary travel to a reality and scientific-technological developments to fashion an environment beyond present-day imagination. And Canada's next generation will have its own special legacy. A wide, rich land of promise, a multiracial population to nourish the roots of tolerance, a broad foundation of knowledge, wisdom, technology and freedom upon which to build the future and explore the widening avenues of philosophy and adventure. Their heritage will be the natural beauty of vast woodland vistas, the clear waters of millions of lakes, the freshness of wilderness rivers, the ruggedness of mountain ranges and arctic expanse. They will inherit good, rich soil to sustain many people, untold wealth in sub-surface rocks, valuable tools of learning and room to build. This Canada — nearly 100 years old — has a future dependent on the outlook, energy and knowledge of its youngest citizens — the adult Canadians of the world of tomorrow.

Two young Canadians from the Pacific coast face the future brim-full of confidence.

In Salvage, Newfoundland, two little girls live out their childhood within sight of the Atlantic.

Young Chinese-Canadians enjoy themselves with balloons during sports day at their school in Vancouver, British Columbia.

NATIONAL FILM BOARD
PHOTOSTORY

Smiling Japanese-Canadian boy at his lessons in a classroom at Steveston, British Columbia.

A Jewish boy from Montreal, Quebec.

Young Canadians romp in the water of an outdoor swimming pool in Ottawa, Ontario, the nation's capital.

A little Indian girl from the West Coast.

In a Toronto, Ontario, day nursery, a young Canadian Negro boy plays in the yard during recreation period.

2.1     Photo Story 367, "Canada's Birthday Brings Thoughts of Tomorrow: Nation's Future Belongs to Them," 27 June 1964. Photographs, Chris Lund, Gar Lunney, Ted Grant, and Pierre Gaudard.

Familiarly, Grierson advocated the non-fiction film as a socially engaged alternative to Hollywood cinema; but for him, documentary was also intertwined with notions of social management. In the 1942 essay cited above, for example, he asserted that documentary's "duty" was to serve the state by "waking the heart" of the citizen. Under his leadership and long after, documentary films and still photographs produced by the NFB were dedicated to managing the citizenry of the country. In this respect, documentary can be seen instructively as one of the procedures of governmentality or government rationality, techniques in the management of populations and the exercise of power.[4]

An exploration of visual rhetoric at the Still Photography Division, a unit housed within a largely cinematic agency, also provides an opportunity to consider the ways that photographic and cinematic documentary differ and intersect. Typically, photo studies eschews reference to cinema or film studies scholarship; as a field often aligned with art history, photo studies more often draws parallels with painting and the graphic arts. In contrast, I suggest that film studies scholarship on the documentary mode can offer instructive models for historicizing documentary photographs and for understanding the nationalist values these images promoted. Cinematic and still photographic representations (as well as the reception of them) differ significantly; yet tracing those differences (while acknowledging links) can also clarify how the images at the core of this study function. I argue in this chapter that drawing from and making comparisons to filmic experiences reveal that still images produced by the division contributed to a larger project of nation building through the devices of "banal nationalism." In happenstance and unremarkable encounters with seemingly ubiquitous photographic representations of Canada, these images flagged national belonging in a largely unobtrusive way.

Addressing photographic documentary across an archive of some quarter of a million photographs is an insurmount-

2.2   "Steveston, B.C.," September 1963. Photograph, Ted Grant.

able task; instead, I have narrowed my discussion to one loaded theme that recurs throughout the division's history: the image of childhood (figs. 2.1 and 2.2). This is by no means an arbitrary subject within the division archive.

Children appear time and again in division images as markers of Canadian identity, the citizenry as a whole, and embodiments of national aspiration. The specific style in which childhood was presented as a signifier of the Canadian citizenry and nation changed significantly over the division's history.[5] Yet, unlike NFB cinema, its still photography production was, throughout its history, highly malleable and unobtrusive, with images appearing ubiquitously in the press and other publications. This ubiquity was central to the key ways that the documentary photography – in contradistinction to cinema – naturalized governmental values by producing a form of banal nationalism in photographic form.

In exploring the Still Division's numerous and diverse representations of childhood, this chapter seeks to theorize and historicize the documentary image and, in so doing, provide a grounding for the chapters that follow. The aim here is not so much to codify representational styles but to elucidate the kind of institutional messages conveyed by them and the ways in which the NFB's varied public negotiated with those messages in ways that were distinct from their experiences with cinema.

## Documentary and the State

Documentary was the foundation upon which the Still Division was built. The approximately 250,000 photographs the division would produce over the course of its history, depicting Maritime fisheries, workers at logging camps, prairie wheat fields, Inuit in the Far North, and, as discussed in this chapter, childhood, made claims to factuality and neutrality while wielding heightened realism to promote governmental initiatives. Particularly in the NFB's early years, its film and photographic production units became standard-bearers for a particular model of documentary expression that was committed to the state and to the social management of the citizen.

Documentary as a concept dates from the late 1920s and would become highly resonant with the public by the 1930s.[6] As John Tagg notes, John Grierson introduced and elaborated on the term in his early writings in 1926 and 1927.[7] Those pronouncements reflect the contemporary currency of social management – applications of social control and planning by governments, social scientists, and industry – and the emergence of the welfare state.[8] Grierson was exposed to the precepts of social management as a graduate student at the University of Chicago during the mid-1920s. At the time, the University of Chicago was the hub of social science activity in the United States, and while there Grierson encountered some of the leading figures in public opinion including Harold Lasswell as well as Grierson's academic advisors Charles E. Merriam and Robert Park.[9] As Zoë Druick argues, the Chicago School of Social Science's influence on Grierson's subsequent work at the NFB was profound; specifically, his interest in the paramount importance of state management carried out through propaganda directed at (supposedly) malleable citizens was initiated in Chicago and executed later at the NFB.[10] According to Peter Morris, under Grierson and after, the NFB "reflected a statist orientation"[11] that employed the documentary image as a key strategy for "waking the heart" of citizenship.[12]

For Tagg, the statist strategy of "documentary realism" is a "rhetoric of recruitment"[13] driven by a commitment to activist education. This model of education was aimed at training audiences in "modern citizenship."[14] According to Tagg, "Framed by an elitist view of the management of communications and an idealist view of collective social institutions, documentary harnessed itself to the service of a State that needed to shape public opinion just as it needed to manage its population through its techniques of social governance. In this field of social technologies, documentary's function was the procurement of identification in order to produce citizens inculcated with a sense of responsibility appropriate to

their role in the collective whole. For Grierson, this was the central purpose: the production of civic subjects adequate to their representation in the State."[15]

Audiences – not only within Canada but internationally – were thought to be highly receptive to the documentary image. In a well-known study of the United States during the 1930s, historian William Stott argues that the American public flocked to material that promised unimpeachable factual information in the midst of the devastating economic disaster of the time and a resulting crisis of trust in authority.[16] A range of non-fiction production, including radio docudramas and first-person journalistic accounts as well as documentary film and photography, came to define the era.

In Canada, still photographic production at the NFB drew on the enduring power of documentary simultaneously to serve as a means of national social management and to satisfy a lasting public call for and faith in hard information. These images were effective largely due to a widely held perception that a photograph is – in Peircean terms – not only an iconic and symbolic sign but an indexical form of representation.[17] Surpassing the merely mimetic, the photograph appears to bear a privileged relationship to its referent, existing as a seemingly unmediated imprint of the thing and time it represents. Photographic images produced by the Still Division, for example, seem to offer the viewer a direct, unmediated representation of life and therefore effectively naturalize the point of view or specific governmentally endorsed message espoused. If the photograph generally can be understood as an indexical sign, the concept of documentary entrenches that reading; the documentary photograph often delimits interpretative possibilities by emphasizing the camera as a direct conveyor of fact, while the emotional appeal of the image further enhances its persuasiveness.[18]

Particularly since the advent of digital technology, this characterization of the photograph as a direct and unmediated "emanation of its referent" has been widely discredited.[19] Scholars of visual culture, for example, have long characterized camera images as *representations*, thereby underscoring the ways in which these representations *mediate* optical experience through (among myriad other means) framing; extraction from a temporal continuum; alterations in depth, colour, and tone made by translating the visible onto a two-dimensional surface; and recontexualization achieved through placement, accompanying text, and the idiosyncrasies of reception. A photograph in the end is neither "objective" nor ideologically neutral. Instead, it has long been recognized as an effective tool for imposing views largely because the photograph convincingly disguises subjective opinion as fact. Grierson himself acknowledged the disguised subjectivity of the filmic and photographic image when he famously defined documentary as the "creative treatment of actuality."[20] As noted above, at its origins in the 1920s and 1930s, as throughout the NFB's specific history, documentary photography was intertwined in the project of institutional social management. Yet in 1941, when the Still Photography Division was founded, the public typically conventionalized this simulacrum of human optics as neutral, objective, and authoritative data; the photograph came to embody irrefutable fact. As Tagg argues, "documentary seeks to construct an imaginary continuity and coherence between a subject of address and a signified real – a continuity and coherence in which not only the work of the sign but also the effects of power of a particular regimen are elided."[21]

It was this enduring faith in documentary realism – in cinema as well as still photographs – that made it an ideal tool for the NFB's larger project of moulding the "materials of citizenship," as Grierson termed it in 1942. In this respect, the NFB's myriad documentary productions can be seen as effective instruments of what Foucault terms "governmentality" – "the ensemble formed by the institutions, procedures, analyses and reflections, the calculations and tactics that allow the exercise of …

power, which has as its target population."[22] As Druick observes in her study of NFB filmmaking and federal policy, documentary films constitute a form of "government realism … concerned with a particular way of seeing the population as material to be managed."[23]

Still photography produced by the NFB can also be seen instructively as a form of government realism. Division photographs, too, rendered governmental attitudes in visual form and in this way defined Canadian identity while contributing to the regulation of the country's citizenry. Guided by the same mandate, policies, budget priorities, and bureaucratic structure as the film board's cinematic units and, indeed, overshadowed by filmic production, the Still Photography Division reflects cinematic documentary in many ways. Of course, still photographs are not films; the forms, reception, and cultural meaning of still photography differ from that of cinema. In order to consider more fully what documentary, this particular form of "government realism," meant at the NFB in cinematic and still photographic forms, it is instructive to explore a single theme appearing in both media. Contrasting how the prominent trope of childhood was addressed in NFB cinematic and still photographic work reveals key distinctions between the two media.

## The NFB's Children: Cinema and Photography

The image of childhood holds a notably prominent place in the production of the National Film Board as a whole. Brian J. Low has demonstrated that a concern with childhood was central to NFB cinematic production,[24] identifying more than seven hundred out of about eight thousand NFB films with significant portrayals of children.[25] The Still Division's archive too is filled with young faces. From 1955 to 1960 alone, sixty-six out of 250 photo stories produced by the division feature children prominently. And by 1967, images of children were mainstays in the division's extensive pro-motions of both the country's centennial celebrations and emergent multiculturalism policies.

In the most straightforward and practical terms, NFB films and photographs were often designed for different audiences, and this was particularly true in representations of children. From the Second World War to the end of the 1980s, children were not only the key subjects of numerous documentary (and fiction) films but, importantly, became their targeted audiences too. According to Low, once television became more widely accessible, beginning in the early 1950s, "the audience for the NFB [film] became largely juvenile" as the NFB increasingly distributed films directly to television and to schools.[26] With children as intended viewers, the films focused on children's experiences and their life concerns; as a result, Low convincingly demonstrates, these films reflect significant changes in attitudes toward child-rearing and education. In contrast, the Still Division rarely aimed its promotional materials at a juvenile audience.[27] Its images and pictorials were usually distributed to the media and embassies as well as being shown in exhibitions, venues where the intended audience was decidedly adult. In those images the division only occasionally depicted scenes related explicitly to children's health, education, and rearing. Such topics do appear in individual images and photo stories, providing didactic information about children's literacy, infant care, and mental health. However, these are exceptions within the division archive. More often than not, images of children appear in contexts that do not overtly address issues relating to what are conventionally deemed to be children's experiences. Indeed, out of the sixty-six photo stories with prominent images of children cited above, only twelve are actually devoted to such child-centric issues as children's education, health care, and leisure activities. The remaining fifty-four pictorials address an idiosyncratic range of topics including federal parklands and natural scenery, sugar beet production, and

fur merchandising. In short, most Still Division images were less concerned with addressing the social welfare of children than with the loaded symbolism of childhood or the emblematic use of the image of the child.

For most film studies scholars – along with a range of other theorists – the emphasis on time, arguably an ontological characteristic of both media, marks *the* key distinction between cinema and photography. Writing in 1960, André Bazin, for example, influentially noted that the photograph "embalms time," whereas cinema constitutes "objectivity in time."[28] Christian Metz characterized the photograph as a fixed object and potential fetish, while maintaining that cinema offers a more encompassing and voyeuristic experience.[29] Famously in *Camera Lucida*, his final book and an influential work on the subjective reception of photography, Roland Barthes equated the still photograph with death and a distillation of the past.[30] Gilles Deleuze (and Félix Guattari) in turn see the photograph as a mere "tracing" in contrast to the more directly involving and temporally rich cinematic image.[31] In all of these discussions, cinema is defined in terms of temporal duration in contradistinction to the still photograph's apparently inherent ability to fix a past moment. The arguments imply a hierarchy and teleology, with the photograph as cinema's modest ancestor.

While the temporal is a crucial distinction between the two media, the almost unabated stress on time has obscured other instructive delineations, key among them what some scholars have termed the mobility of the still image. Not to be confused with the illusion of movement in cinema, "mobility" here is used to suggest photography's ability to appear in a multiplicity of contexts through reproduction and dissemination.[32] As noted earlier, the division archive served as a stock library for its own publications as well as those of other government agencies and commercial publishers; accordingly, its images, including those of children, were regularly reused in different contexts. For example, photo stories routinely combined images from the work of various photographers and different shoots represented in the division archive. As in any stock library, generic images (photographs that were not indelibly associated with one temporal or thematic circumstance and thereby allowed for a wider range of applications) were encouraged.[33] As Allan Sekula explains, and as noted in the introductory chapter, within a photographic archive, photographic meaning is "liberated" from the context in which it was originally taken, while other meanings accrue owing to its new placement or ownership; the archive itself defines one key set of meanings accrued to the photographs.[34] In short, unlike cinema, still images can be readily recontextualized. While the films featuring children studied by Low, for example, are grounded temporally and by cinematic narrative to specific child-related themes, images of children from the Still Photography Division archive are, within a somewhat limited range, quite pliant. These emblematic images of kids are typically experienced as fragmentary encounters seemingly excised from a contextual and temporal continuum.

If the division's images could shape-shift, slipping readily into different contexts and accruing new meanings, they also circulated widely. According to David Campany, "the photographic image circulates promiscuously, dissolving into the hybrid mass of mainstream visual culture."[35] Damian Sutton terms this circulation a form of mobility specific to the photograph:

A different, qualitative mobility has existed with the photograph since its invention, from the pocket-sized daguerreotype to cartes-de-visite that could be bought off barrows at railway stations or presented as visiting cards of the gentry. The photograph that appears in our newspapers or subway advertisements is similarly mobile, an image everywhere that more directly

becomes an anywhere in the sense that anywhere we look, we see photographs that refuse to stay put. They follow us or insist, by repetition and reproduction, on a constant presence that relies on their evanescence … This is a different mobility of the photograph, but one no less a part of the photograph's role in the civilization of the image than the immobility so often associated with photography.[36]

Still Division images too were highly mobile. To meet their mandate of fostering national cohesion and promoting the country internationally, division staff distributed images extensively to publications and embassies. In the Canadian press, division images became ubiquitous. But their omnipresence was, paradoxically, underscored by a semblance of neutrality and anonymity, conferred by the apparently "factual" nature of the photograph and limited credit information. They were seen everywhere, but nowhere were they really focused upon.

Photographs rendered "government realism" into a still and yet highly mobile, fragmentary, and ubiquitous form that did not demand the concentrated attention of viewers but instead passed through the peripheral vision of quotidian experience and in and out of sustained focus. The film board's still photographs became – particularly due to their mass reproduction and ready recontextualization – much more ubiquitous and unremarkable forms than the much-touted spectacle of cinematic presentation. Their banal nationalism reminded viewers of Canada not through the spectacle of cinema but in prosaic, happenstance, and routine encounters with photographs in the mass-circulated press.[37] Grierson's assertion in 1943 at an NFB board meeting that newspapers and radio were the most effective means of reaching the country's citizenry suggests an awareness of the power of routine and familiar flaggings of national belonging.[38]

## Photographing Childhood from the 1940s to the Early 1960s

In March 1953, division staff photographer Chris Lund produced a photograph of a young girl stricken with polio (fig. 2.3).[39] Shot frontally, the image is framed by the rails and bars of a ramp designed to teach polio patients to walk with braces. The rails provide orthogonal lines for the sharp perspectival view around which the picture is organized. Centred at the vanishing point is the tiny girl, her hands clutching the rails. A woman in a medical uniform leans over and encourages the patient along. The child's gaze is directed toward both the camera and a doll that has been placed in the foreground at the opposite end of the ramp. The doll is apparently intended as a reward or lure, but, at the same time, resting on its sturdy little plastic legs, it mirrors the child's own apparent aspirations for strength, mobility, and independence.

The image addresses perhaps the most emotionally loaded health crisis of the time in Canada. In the years before the Salk vaccine was introduced in 1954 and 1955, poliomyelitis afflicted thousands of Canadian children annually. According to the historian Christopher J. Rutty, in 1953, the year this image was made, the poliovirus infected approximately 9 per cent of all children in Canada.[40] Today, the disease has still not been eradicated internationally. Polio is an acutely infectious disease that can attack the nerve cells activating muscles, resulting in irreversible paralysis and, in severe cases, death.[41] Largely affecting children under three years of age, before the development of a vaccine, the disease crossed all socio-economic lines.

Lund's image of the tiny polio patient in many respects exemplifies key aspects of social documentary photography, or what is sometimes termed socially concerned photography. It addresses a social problem (polio) not through scientific information but in a highly personalized and

sentimentalized fashion. Indeed, the photograph exploits viewer empathy. The prominent bars, the light from a side window, and the curved back of the child's attendant all lead the viewer's eye inescapably to the child's body and particularly, to her own gaze. We feel ourselves meeting that gaze, in effect directly encountering this child and her plight. At the same time, the directness of the perspectival composition entraps the child "in the field of vision."[42]

The emotional impact of this photograph was self-consciously rendered. Like most photojournalists of the day, Lund made dozens of negatives during a single shoot; this image, for example, was one of thirty-five shot in March 1953 at the Sudbury Polio Clinic in northern Ontario.[43] Notes made by the photographer tell us that the image discussed here depicts "Mrs. E. Marr, physiotherapist, with Dorothy Gifford, 2 ½, at the walking bars in the polio clinic, Sudbury General Hospital, Sudbury, Ont."[44] In fact, this is one of four extant negatives made showing Dorothy Gifford's struggle to walk. In shooting multiple negatives, Lund was clearly at pains to compose the image precisely. The negative of the image discussed here is annotated with the words "All available of doll in f.g. [foreground]" and by two small arches extending the legs of the doll. The message, written perhaps by Lund or a photo editor to the printer, shows a concern with heightening the composition's impact. In a 1982 interview Lund acknowledged with audible pride how he constructed the composition: "It is dramatized with a low angle … I mean, I set this thing up. The converging lines of the bars, the walking bars. You look at this thing, your eye widens and it goes right down to the child and the nurse … helping that child, helping her reach her goal."[45]

If photographer and photo-editors carefully crafted this image, its eventual editorial placements also mediated its meaning. This photograph appeared as the lead picture in a 7 April 1955 photo story, "Canada Will Start Trials of Polio Vaccine April 18," promoting the Salk vaccine (fig. 2.4).[46]

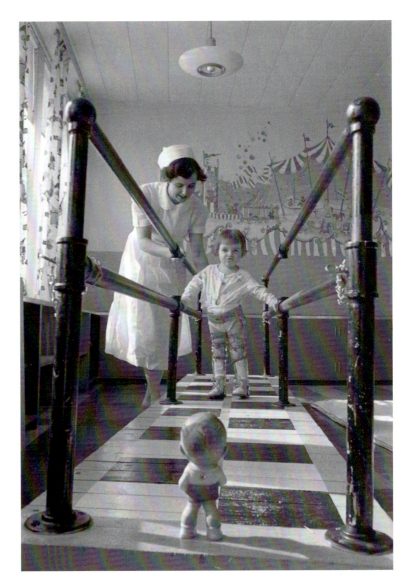

2.3   "Mrs. E. Marr, physiotherapist, with Dorothy Gifford, 2 ½, at the walking bars in the polio clinic, Sudbury General Hospital, Sudbury, Ont.," March 1953. Photograph, Chris Lund.

# Canada Will Start Trials of Polio Vaccine April 18

Behind front-line polio treatment facilities lies a two-way research program now under way at the Institute of Microbiology and Hygiene at Montreal and at Toronto's Connaught Medical Research Laboratories. Here, backed by an $83,000 federal research grant, studies of polio virus, and its cultivation in tissue culture, are being made, aimed at further developing and perfecting a vaccine for the prevention of this crippling disease. And at the Connaught Labs, technicians are producing quantities of the Salk vaccine which this year will be given extensive trials throughout Canada.

These trials, which will see an estimated 500,000 Canadian schoolchildren vaccinated, will be arranged and conducted by provincial health departments. Up to $375,000 of national health grant funds, to be matched by an equal amount from the provinces, have been earmarked to ensure an adequate supply of the Salk vaccine for the trials.

NATIONAL FILM BOARD PHOTOS

Animals, like the lab monkey shown here, are playing an important part in the intensive research program to find and perfect an effective deterrent.

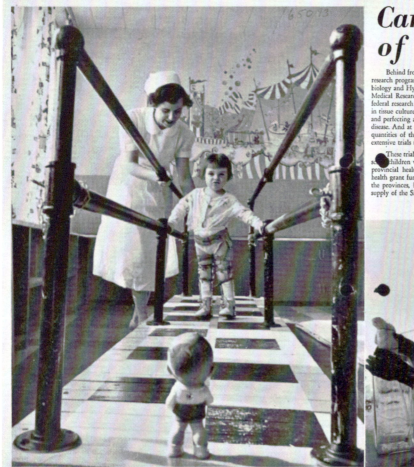

Treatment centres, like this Rotary-sponsored clinic at Sudbury, are key weapons in the successful rehabilitation of polio sufferers. But medical men look forward to the day when preventive vaccines will make therapy and leg braces unnecessary.

Connaught Laboratory technicians "harvest" virus to be used in production of Salk vaccine. Recent tests conducted by Connaught Lab in conjunction with federal Food and Drug authorities have proven vaccine's complete safety for trials.

2.4   Photo Story 003, "Canada Will Start Trials of Polio Vaccine April 18," 7 April 1955. Photographs, Chris Lund (*left and upper right*) and Gar Lunney (*lower right*); text uncredited.

Within the photo story, meaning, already modified by the photographer and the constraints of the photographic medium, would shift again. Filling almost half of the layout, the image dramatically draws the reader in. Two other images show laboratory scenes. The image at the lower right,

by Lund's colleague Gar Lunney, depicts two lab technicians at the Connaught Medical Research Laboratories of the University of Toronto, a key facility in the development of the Salk vaccine for North American trials.[47] At the upper right is a small image by Lund of a researcher with a monkey used in laboratory experiments. The two images were made in separate shoots. The facility in Lund's photograph is apparently unrelated to Salk vaccine research. Dating from January 1950, it depicts a scene at the University of Montreal laboratory, part of a shoot largely depicting cancer research in Montreal.[48] But viewers at the time would probably not have recognized these inconsistencies. Instead, the images would appear to fit seamlessly. Together in the photo story, they dramatize advances in medical efforts to eradicate poliomyelitis within specifically nationalist terms. And while the lead image would draw viewers in emotionally, the decision to combine it with two laboratory scenes underscores the emphasis on Canadian medical research. The title itself "anchors" the images to a nationalist reading,[49] while text emphasizes the financial contributions made by federal and provincial governments. We are told, for example, that an $83,000 federal research grant funded the work at the Connaught laboratory. Text continues to inform the reader: "These trials, which will see an estimated 500,000 Canadian school children vaccinated, will be arranged and conducted by provincial health departments. Up to $375,000 of national health grant funds, to be matched by an equal amount from the provinces, have been earmarked to ensure an adequate supply of the Salk vaccine for the trials."

While the text stresses a governmental commitment to research in specific terms, the caption accompanying the image of the polio patient is far more generalized: "Treatment centres, like this Rotary-sponsored clinic at Sudbury, are key weapons in the successful rehabilitation of polio sufferers. But medical men look forward to the day when preventive vaccines will make therapy and leg braces unnecessary." Dorothy Gifford is presented not as a specific individual but as a typology. She stands for all Canadian children battling polio, and, at the same time, the dramatic photograph of her struggling toward a goal is a metaphor for the research work undertaken in Canadian laboratories. The context provided by words, images, and layout effectively directs or limits readings of this photograph. It has been transformed from an emotionally wrenching photograph of a small girl with a potentially deadly ailment to a composition around which arguments about Canadian achievements in medical science are marshalled.[50]

The connection between nationalism and the fight to save children afflicted with polio was, of course, one that the division fabricated. It does not mark the sole, fixed interpretation of the image. Lund's photographs of the Sudbury polio clinic were featured in another prominent photo story that only alluded to the question of nationhood. On 10 October 1953, eleven images of the clinic were published as the photo story "Sudbury's Polio Clinic: A Whole Community of Volunteers Pitches in to Operate" in *Weekend Magazine*, a pictorial supplement to newspapers across the country.[51] Appearing many months before the introduction of the Salk vaccine, this story centres on community involvement in the treatment of polio patients. The selected images all emphasize warm relationships between patients and nurses or physiotherapists. Text announces that until "the day when the dreaded disease will be licked completely … the fight goes on, a splendid achievement of civic enterprise and community spirit."[52] In short, the key concern here is the "remarkable and heart-warming community" of Sudbury; while additional attention is given to the signs of the disease, it is not framed as a Canadian problem. In contrast, the editorial treatment of the Sudbury polio clinic in the division photo story is wholly nationalistic.

2.5   "Chinese Canadian Children Watching a National Film Board Film," Vancouver, December 1945. Photograph, Jack Long.

The polio photo story exemplifies the division's representation of children from the 1940s through the early 1960s. As noted above, children are privileged subjects in the archive, and yet what might be termed "children's concerns," including childhood literacy, health, leisure, and education, are shown largely to promote the nation, not the welfare of children specifically. During the war, for example, images of the new day nurseries are evident but largely as a means of promoting the war effort and women's contributions, as discussed in the next chapter. Children were more likely to appear in shoots promoting war bonds, veterans' return to civilian life, the postwar housing boom, and even non-theatrical NFB film screenings (fig. 2.5). In the postwar period, they appeared frequently in pictorials of the Canadian family, deployed as markers of a return to gender "normalcy."[53] As noted earlier, children appear in about one-fourth of all photo stories produced in the late 1950s. Few of these pictorials directly address children's care; most cover a divergent range of themes. In some, a predictable correspondence is established between childhood and leisure, as in the 1956 pictorial "Hobby of Millions: Pets with Personality!" (fig. 2.6); at times such photo stories were imbued with religious overtones as in the December 1957 pictorial "Canada Exports 'Merry Christmas': Yule Tree Industry Boom."[54]

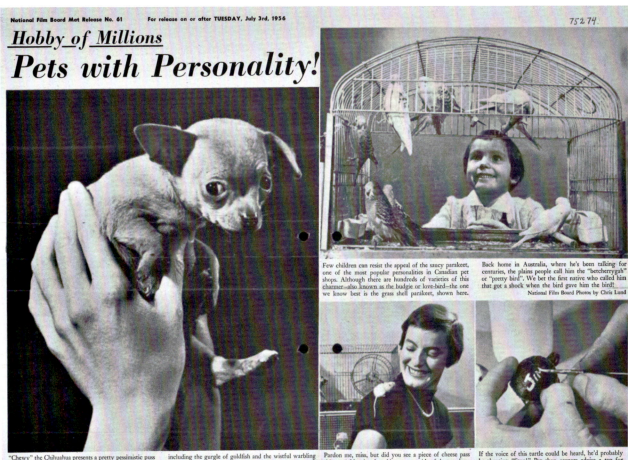

## Hobby of Millions
# Pets with Personality!

Few children can resist the appeal of the saucy parakeet, one of the most popular personalities in Canadian pet shops. Although there are hundreds of varieties of this charmer—also known as the budgie or love-bird—the one we know best is the grass shell parakeet, shown here.

Back home in Australia, where he's been talking for centuries, the plains people call him the "betcherrygah" or "pretty bird". We bet the first native who called him that got a shock when the bird gave him the bird!

National Film Board Photos by Chris Lund

"Chewy" the Chihuahua presents a pretty pessimistic puss to people visiting the pet shop where he lives. His roommates include puppies and guppies, cats and rats—but no bats. And when he lifts his South-of-the-Border baritone in song, he can be sure of some powerful company, including the gurgle of goldfish and the wistful warbling of the canary. Pets like Chewy appeal to children and adults alike, help to take people's minds off their troubles. Through this appeal, pet shops today are a million-dollar business. 76627.

Pardon me, miss, but did you see a piece of cheese pass this way? Maurice the white mouse, pride of the pet shop, seems to be asking this question of a pretty visitor to his domain. Maurice and other animals like him make pet shops big business today. 75278.

If the voice of this turtle could be heard, he'd probably be shouting "Stop!" Pet shop owners advise a tag for identification. Turtles depend on colour and texture of their shells for control of body temperature. Paint can torture or kill them. 75282.

In these images and, indeed, throughout its first two decades, the division consistently drew on common associations with the "Romantic child," which Anne Higonnet describes as the modern conceptualization of childhood as a period characterized by innocence and purity.[55] The division

2.6   Photo Story 061, "Hobby of Millions: Pets with Personality!" 3 July 1956. Photographs, Chris Lund.

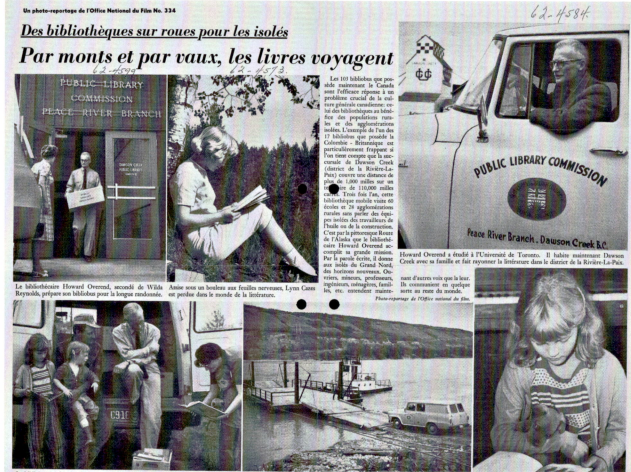

**Des bibliothèques sur roues pour les isolés**

# Par monts et par vaux, les livres voyagent

Les 103 bibliobus que possède maintenant le Canada sont l'efficace réponse à un problème crucial de la culture générale canadienne: celui des bibliothèques au bénéfice des populations rurales et des agglomérations isolées. L'exemple de l'un des 17 bibliobus que possède la Colombie - Britannique est particulièrement frappant si l'on tient compte que la succursale de Dawson Creek (district de la Rivière-La-Paix) couvre une distance de plus de 1,000 milles sur un territoire de 110,000 milles carrés. Trois fois l'an, cette bibliothèque mobile visite 60 écoles et 28 agglomérations rurales sans parler des équipes isolées des travailleurs de l'huile ou de la construction. C'est par la pittoresque Route de l'Alaska que le bibliothécaire Howard Overend accomplit sa grande mission. Par la parole écrite, il donne aux isolés du Grand Nord, des horizons nouveaux. Ouvriers, mineurs, professeurs, ingénieurs, ménagères, familles, etc. entendent maintenant d'autres voix que la leur. Ils communient en quelque sorte au reste du monde.

*Photo-reportage de l'Office national du film.*

Le bibliothécaire Howard Overend, secondé de Wilda Reynolds, prépare son bibliobus pour la longue randonnée.

Assise sous un bouleau aux feuilles nerveuses, Lynn Cazes est perdue dans le monde de la littérature.

Howard Overend a étudié à l'Université de Toronto. Il habite maintenant Dawson Creek avec sa famille et fait rayonner la littérature dans le district de la Rivière-La-Paix.

Le bibliobus s'arrête chez M. et Mme Haight, de Sunrise Valley. En moins de quatre mois, les livres parcourent quelque 2,000 milles et s'échangent au rythme de 8,000.

A Clayhurst, le bibliobus doit prendre le chaland pour franchir la Rivière-La-Paix. Il distribue par année, en trois voyages, quelque 25,000 volumes aux écoles.

Judy Haight, âgée de 12 ans, partage les belles histoires avec "Scamp", le chiot gâté de leur ferme du nord.

2.7    Photo Story 334, "Des bibliothèques sur roues pour les isolés: Par monts et par vaux, les livres voyagent," 2 April 1963. Photographs, Rosemary Gilliat.

appears to have regularly exploited perceptions of childlike cuteness, charm, and vulnerability – perhaps cynically – as eye-catching devices. But, more pointedly, the idealized and innocent Romantic child served a symbolic function in division pictorials as a marker of the Canadian citizenry and the aspirations of the nation as a whole.

## *Where Elegance and Fashion Meet*
# Canadian Mink Reigns Supreme

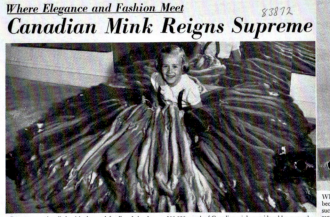

Once upon a time little girls dreamed fondly of the day when they would meet their man; now the sophisticated miss dreams of meeting her mink. The pretty lass above is in the enviable position of being surrounded by

$30,000 worth of Canadian mink, considered by many the finest in the world. Canada's mink market has grown tremendously in the past decade in response to ever increasing demand for the luxurious fur.

While experts maintain that wild mink from interior Quebec reigns supreme, the delicate hues of mutation mink such as that worn by the model above have helped boost ranch bred mink into top position on the world market.

Canadian models arrive in Paris for an exhibition of fur fashions. Canadian mink has been widely used on costumes created by many of the world's top couturiers.

National Film Board of Canada Photos by Jean Gainfort Merrill

Hundreds of operations, many of them manual, go into the making of a mink coat. Here, mass production is unheard of, for each garment is a painstakingly individual project. A full length mink coat requires from 65-85

skins. Some 10 miles of thread are used in stitching the carefully matched "let-out" skins together. The pattern is first blocked out by veteran craftsmen who use about 12,000 brass pins in the process.

Canadian export of mink has risen from $7 million in 1945 to $17 million in 1956. The U.S. and U.K. are biggest purchasers. Skins are carefully dried before shipment to fur auctions in Montreal, Winnipeg and Vancouver.

Scientifically controlled breeding of ranch mink has produced the highly prized and popular pastel shades. The handsome, if haughty, character above is a snow-white champion known as "Rex".

---

Occasionally the figure of the Romantic child is invoked in photo stories to promote the Canadian land with particular reference to presumptions about pristine nature;[56] however, in most cases from 1955 to the early 1960s, children appear in commercial or institutional contexts (fig. 2.7) and are almost ubiquitous in stories on health care, like the

2.8    Photo Story 134, "Where Elegance and Fashion Meet: Canadian Mink Reigns Supreme," 3 December 1957. Photographs, Jean Gainfort Merrill.

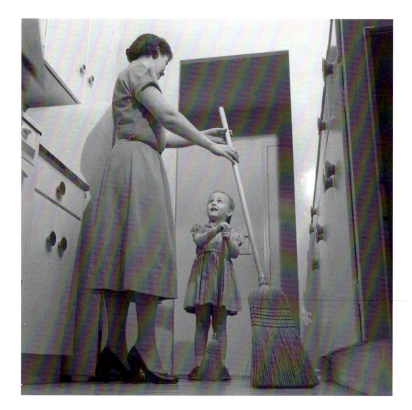

2.9   Girl and mother with brooms, ca. 1956. Photograph, Jean Gainfort Merrill.

polio pictorial.[57] At times they are invoked to promote the Canadian economy in, for example, photo stories devoted to agricultural production[58] and even the fur trade[59] (fig. 2.8).

Viewed from a distance of decades, there seems something distinctly unchildlike about most of these kids. Tidy and well behaved, they march into dentists' and doctors' offices stoically and listen attentively – even admiringly – to adults (figs. 2.9 and 2.10). In virtually all of these photographs, the children depicted possess an aura of poise and

self-confidence that few of their elders could match. The playful irreverence and noise of childhood have been muted. In short, children are usually not depicted in division images of the time to reference childhood itself; instead, this determined yet obedient group of kids serves a metonymic function, standing for an idealized Canadian citizenry reliant on the paternalistic care of government.

The message of paternalistic authority is underlined in the compositions and style of the images. In most of them, like the Lund image of Dorothy Gifford, the photographer adopts what is colloquially termed a "fly on the wall" view. Subjects often seem unaware of the photographer's – and by implication, our own – gaze and presence. (When, like little Dorothy, they do meet the gaze of the camera, their look suggests deference to authority.) That all-seeing and all-powerful gaze became a common feature in division images of the 1950s and early 1960s. It marked a still photographic equivalent of the "voice of God" narratives so familiar from documentary films produced by the NFB during the same years.[60] Images were carefully choreographed to achieve a clear visual message, though without obvious manipulation. In the 1982 interview cited above, Chris Lund described the working method for a division photographer shooting a photo story: "You staged, but you had to be very careful when you staged. You had to be very meticulous that it didn't look staged. And if it does look staged today, it was a sign of the times. Everything was stilted back then."[61]

It is instructive to view these documentary images within the context of NFB film of the time. In the years during and following the Second World War, the NFB became one of the chief propagators of what film theorists Bill Nichols and Julianne Burton have termed an "expository mode" of documentary representation. For Nichols and Burton, expository documentary is exemplified by the cinematic productions that Grierson oversaw earlier in his career at the Empire Marketing Board in England and then at the NFB. These

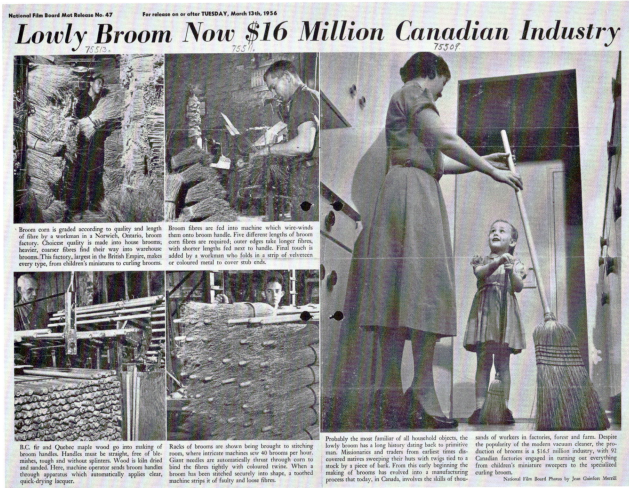

National Film Board Mat Release No. 47      For release on or after TUESDAY, March 13th, 1956

# Lowly Broom Now $16 Million Canadian Industry

75513.      75511.      75509.

Broom corn is graded according to quality and length of fibre by a workman in a Norwich, Ontario, broom factory. Choicest quality is made into house brooms; heavier, coarser fibres find their way into warehouse brooms. This factory, largest in the British Empire, makes every type, from children's miniatures to curling brooms.

Broom fibres are fed into machine which wire-winds them onto broom handle. Five different lengths of broom corn fibres are required; outer edges take longer fibres, with shorter lengths fed next to handle. Final touch is added by a workman who folds in a strip of velveteen or coloured metal to cover stub ends.

B.C. fir and Quebec maple wood go into making of broom handles. Handles must be straight, free of blemishes, tough and without splinters. Wood is kiln dried and sanded. Here, machine operator sends broom handles through apparatus which automatically applies clear, quick-drying lacquer.

Racks of brooms are shown being brought to stitching room, where intricate machines sew 40 brooms per hour. Giant needles are automatically thrust through corn to bind the fibres tightly with coloured twine. When a broom has been stitched securely into shape, a toothed machine strips it of faulty and loose fibres.

Probably the most familiar of all household objects, the lowly broom has a long history dating back to primitive man. Missionaries and traders from earliest times discovered natives sweeping their huts with twigs tied to a stock by a piece of bark. From this early beginning the making of brooms has evolved into a manufacturing process that today, in Canada, involves the skills of thousands of workers in factories, forest and farm. Despite the popularity of the modern vacuum cleaner, the production of brooms is a $16.5 million industry, with 92 Canadian factories engaged in turning out everything from children's miniature sweepers to the specialized curling broom.

National Film Board Photos by Jean Gainfort Merrill

didactic films directly address the viewer and are organized around establishing a solution for a social problem. Audio commentary unifies images and puts forth a textual argument. Typically they employ voice-over narratives and editing to retain a sense of rhetorical continuity. And crucially, they emphasize the notion of unquestioned objectivity.[62]

2.10   Photo Story 047, "Lowly Broom Now $16 Million Canadian Industry," 13 March 1956. Photographs, Jean Gainfort Merrill.

Division images and photo stories depicting children during this same period translate many of those characteristics into still photographic terms. Organized around a specific social message, as in the photo story featuring Dorothy Gifford, they offer governmental protection and intervention as solutions to stated problems. The images are carefully selected and edited to support a written text. Finally, the characteristic of objective authority remains unquestioned and is pivotal to the image. It appears in the use of an all-seeing vantage point but also in the rhetoric of the captions and text. As these characteristics are transposed into the distinctive banal nationalism of the Still Division image, that message of governmental authority is further naturalized through the ubiquity and commonplace character of the mass-circulated photograph.

The expository mode of photographs and photo stories from the 1940s through the early 1960s, with their representational reinforcement of institutional authority, reflected the constraints of life during the war and a return to "normalcy" in the wake of the war. With their emphasis on obedience to authority and inflexible gender roles, division images and pictorials functioned as "technologies of normalcy," to borrow Gleason's phrase, visualizing a model of the "normal" Canadian citizen.[63] Moreover, the ubiquity and commonplace character of the division's banal nationalism underscored the normalcy of their renderings. In these ways, they provided a visual form for the division's ideological emphasis on the government as a paternalistic caretaker for its citizenry, its needy children. As an agency effectively serving the federal government as a public relations tool, the division pictorially and textually promoted policies during the period that Canada emerged fully as a Keynesian welfare state.[64]

But while archival records indicate that the division had a close relationship with the federal government and maintained its existence by supporting official policy, division staff also had a great deal of autonomy in subject matter and modes of representation. It seems clear that while the division in some instances served as handmaid to the government, directly illustrating policy, in others, staff were so immersed in notions of the Canadian government as a paternalistic caretaker that they reproduced that construction as a "natural" state. In most of the division's depictions of the young over these years, there is an implicit message that the government is a trusted caretaker and Canadian citizens are the children of a caring state.

## The Sixties Child

By the mid-1960s, the Still Division would dramatically change the way it pictured Canada and disseminated its visual message to Canadians. Although photo stories continued to be produced, this format was slowly phased out in favour of ambitious picture books, exhibitions, and small monographic publications; many programs were developed specifically for the Canadian centennial. Division publications and exhibitions of the time were not only more ambitious than before but also took on a youthful tone, featuring the work of a young generation of photographers including Pierre Gaudard, Michel Lambeth, John Max, Nina Raginsky, and Michael Semak. The film board's 1968–69 annual report characterized them and their colleagues as "gifted photographers who travel across the country and record its life from their personal points of view."[65] Their work was in marked contrast to the didactic, staged images made earlier by Chris Lund and his contemporaries. Michel Lambeth's poetic description of his own best work characterizes production by this entire generation: "photographs which are memorable in that they are, in a way, analogues of terse poetry, images which give up their message very quickly without pretence of gimmick, subterfuge or flippancy."[66] Similarly, in a later interview, Pierre Gaudard expressed his distaste for

dramatic vantage points, instead characterizing his approach as simple and respectful of his subjects.[67]

In short, the documentary photography that the division began now to promote presented a seemingly more direct and unvarnished view of the world. These photographers may have drawn on precedents in the work of such figures as Robert Frank and Helen Levitt and those associated with New York's Photo League. Moreover, they – and the division – conceived of photography as, if not as an art form, then at least an expressive medium with a premium placed on the individualistic vision of each photographer.

Although the look of photography, the manner in which it was disseminated, and attitudes toward photographers changed in the division during the 1960s, some of its time-honoured iconography would remain. Childhood, for example, continued to be a prominent trope. Indeed, a number of the division's major projects of this period privileged the image of childhood and youth. The centennial publications *Call them Canadians: A Photographic Point of View* and *Ces visages qui sont un pays*, as well as the Expo 67 installation *The People Tree*, for example (see chapter 5), prominently featured images of children and youth. This preoccupation with youth can be seen in other projects including the exhibition *Photography: Canada 1967*.

The first annual photography exhibition organized by the division, *Photography/Photographie: Canada 1967* was intended "to stimulate creative photography across the land" (see fig. 1.24).[68] Its catalogue would become the second in the division's series of *Image* books, with high-quality reproductions and an emphasis on artistic vision. The exhibition, and the *Image 2* publication that appeared in 1967, included 149 photographs by fifty-three Canadian photographers, with the work of young photographers such as Lambeth, John Max, Michael Semak, and Pierre Vinet figuring prominently. Like many of the division's centennial projects, both exhibition and catalogue were intended to convey the diversity

of contemporary Canadian experience while promoting photography as an art form. Lorraine Monk characterized them as presentations of "the day-to-day world" with an emphasis on aesthetic vision.[69]

While *Image 2* also features landscapes and nudes, it is largely dominated by casual images of Canadians' daily life, with an emphasis on youth. It closes with fully thirty-five images of scenes from childhood; paradoxically, in this photographic portrayal of Canada at its centennial, the placement signals the prominence of youthfulness. Accordingly, the images reveal changing approaches to representation and, in turn, the symbolic rendering of the nation and citizenship. Among them is a photograph by Lambeth, which exemplifies this new manner of representing the child (fig. 2.11). The photograph depicts a girl, perhaps five years of age, seated at the foot of a staircase, a broom leaning on the steps behind her.[70] On the surface, the subject matter – a child in a domestic setting – calls to mind images of the Romantic, obedient children of years earlier. A photograph by Jean Gainfort Merrill, for example, of a mother and a small girl in a tidy kitchen each wielding a broom, was featured in a 1956 photo story as an apparent means of humanizing Canadian industry (see figs. 2.9 and 2.10).[71] But Lambeth shows no interest in promoting industry, middle-class aspiration, or youthful compliance. Unlike the photo story, everything in his photograph seems ragged: the floor and stairs are made of coarse boards littered with debris, shavings, and loose nails; the child wears oversized adult socks and a tattered dress; her hair is roughly cut. The photograph was made in 1965 in the tiny, impoverished parish of St Nil on the Gaspé Penninsula, while Lambeth was on assignment for the *Star Weekly*. Lambeth intended "A Candle for St. Nil," the photo essay he prepared for publication, as a "microcosm" of economic hardship in rural Quebec.[72] In the end, the *Star Weekly* never ran the pictorial. Instead, the Still Division purchased forty-one negatives from the shoot and, even though it had

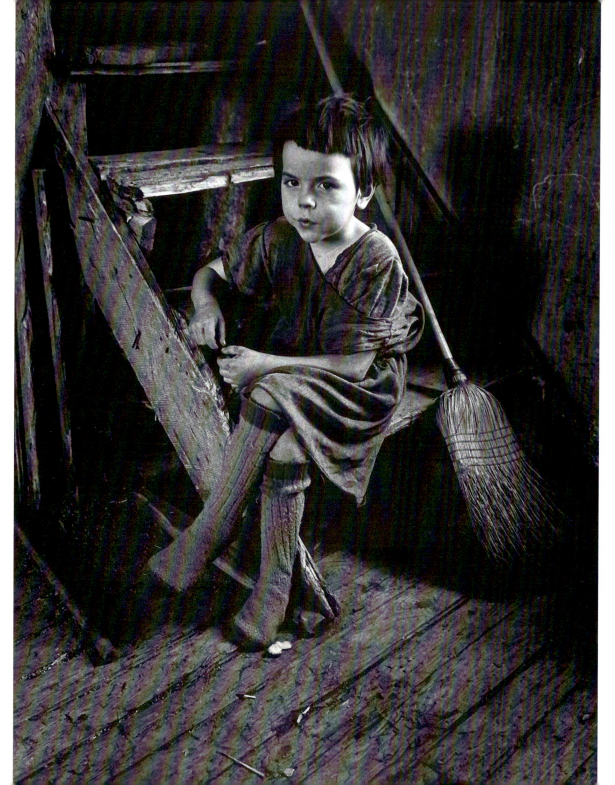

2.11 St Nil, Gaspé, 1965. Photograph, Michel Lambeth. (This image appears in *Photography / Photographie: Canada 1967*, 136. See fig. 1.24 for the cover image.)

not commissioned the images, went on to feature several in its exhibitions and publications.[73] Within the pages of *Image 2*, the original context – contemporary poverty in the Gaspé Penninsula – is all but erased. Instead, the photograph provides a sense of confrontation. Lambeth has adopted a close, low vantage point; the adult viewer does not survey the child from above or at the distance of surveillance but meets her gaze directly. She does not pose for the camera or enact the performance of childhood cuteness; instead, her hands on the step, her lips pursed, she scrutinizes us with what seems to be a sustained and thoughtful – perhaps even cynical – concentration.

The concept of the gaze is central to this image, as it is in much of Lambeth's work. The photograph calls to mind what Catherine A. Lutz and Jane L. Collins have usefully described, drawing on Lacan, as a complex "intersection of gazes," which, in anthropological and social documentary photography specifically, at once reveal, enact and contest power dynamics.[74] The image dramatically contrasts Lund's photograph of the young polio patient Dorothy Gifford discussed above, and particularly Dorothy's obedient gaze and the compositional enhancements of it. In Lambeth's image, the child's intelligent gaze, as well as her positioning at eye level with the presumed adult viewer, signals her as a discerning and autonomous subject. Any tendency to visually consume this child as a sweet innocent is denied: her determined, quizzical gaze appears to demand that we see and meet her on her own terms, equal terms. In short, she is an example of what Anne Higonnet has termed the "Knowing child." As Higonnet explains, "Unlike Romantic children who are arranged and presented as a delightful spectacle to be enjoyed, Knowing children are neither available or controllable. They themselves are looking at an inner world of the imaginary, or at the adult world."[75]

Yet, like the image of Dorothy Gifford, this photograph too serves as a nationalist emblem. Although *Image 2*, like subsequent publications in the same series, minimized text, an introductory essay by Monk assured that all the included photographs would be framed in Canadian nationalist terms. Her introduction proposes this, along with other *Image* volumes, as "both signpost and check-point, measuring and stimulating the development of the photographic arts in Canada."[76] Lambeth's depiction of the small girl from St Nil is thus presented as a distinctly Canadian aesthetic expression.

In the majority of Still Division images depicting children during the mid to late 1960s, not only in the *Image* series but also throughout the division's production, the Knowing child replaces the Romantic child. Children are no longer confined, as they were a decade earlier, to institutional settings; when they are shown in such settings, their body language and facial expressions undermine rather than offer deference to authority. In most representations, children are seen in the company of other children, or at least separated from adults and therefore presented as autonomous. These communities of children have displaced the institutionally contained children under the tutelage of adults even when at play (fig. 2.12). Stylistically, the images of this latter period reflect Lambeth's distaste for "gimmick, subterfuge [and] flippancy." They show us a reality that, although certainly mediated, seems more direct and spontaneous. Moreover, as in Lambeth's image of the child in St Nil, the characteristic god's-eye view of a decade earlier has been supplanted by vantage points that implicate the viewer in the scene chiefly through the use of the gaze. Finally, and again as seen in the Lambeth image discussed above, text has a less didactic, less direct relationship with the image.

If division photography of the 1940s through to the early 1960s translates an "expository mode" of cinematic documentary to still photographic form, we might argue that those of the mid to late 1960s correlate to what Bill Nichols and Julianne Burton have termed the "observational mode."

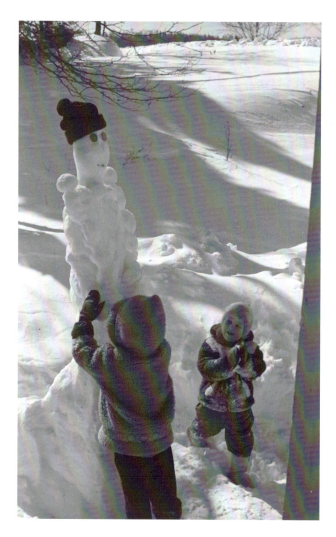

2.12 "Children playing in the snow as they build a snowman," March 1963. Photograph, Pierre Gaudard.

Reflecting films termed *cinema vérité* by Stephen Mamber and *direct cinema* by Erik Barnouw, the observational mode is exemplified by the films of Jean Rouch and Fred Wiseman. Observational documentary typically offers an exhaustive depiction of the everyday by using editing to replicate real time and, according to Nichols, to "convey the sense of unmediated and unfettered access to the world."[77] These characteristics are enhanced by the fact that observational cinema typically eschews voice-over narratives.

Many division photographs by the mid-1960s translate observational documentary's emphases on the unfettered, spontaneous, and unobtrusive into still photographic terms. Yet, as with earlier division images, the cinematic approach to documentary took new meaning in the still photographic form. The images produced by the division did not reflect the dramatic move toward collaborative work seen, for example, in the NFB's celebrated cinematic series *Challenge for Change*; division productions would remain more fully ensconced in a bureaucratic vision.[78] Moreover, the mobility and pliancy inherent in the photograph enabled images like Lambeth's to appear in and absorb variant contexts, to circulate widely and familiarly as a form of banal nationalism. Photographic images from the mid-1960s, with their direct confrontation and self-conscious aestheticization, demanded fuller attention from their viewers than the photo stories of years earlier, but that directness and attention was ironized within a banal, snapshot aesthetic.

The division in the 1960s would continue to use childhood as a loaded signifier of the nation, its aspirations, and citizenry. But by this time, the meaning of childhood had changed. Many division images, exhibitions, and publications from this period use depictions of children to signal the promise of the nation. By mid-decade the country was not only celebrating the past century of nationhood but also positing Canada as a youthful state just coming of age. Governmental rhetoric, including that made by the Still

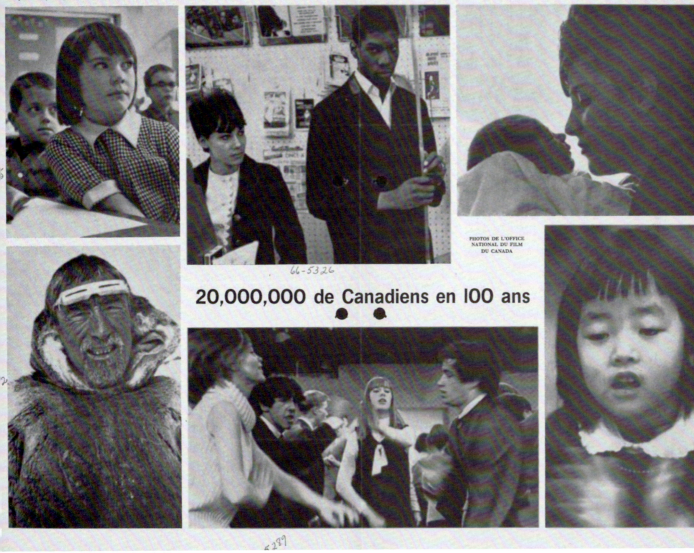

Un photo-reportage de l'Office National du Film No. 426

PHOTOS DE L'OFFICE NATIONAL DU FILM DU CANADA

66-5326

# 20,000,000 de Canadiens en 100 ans

2.13    Photo Story 426B, "20,000,000 de Canadiens en 100 ans," 27 September 1966. Photographs, Ted Grant, Michael Semak, Lutz Dille, Bruno Massenet, O.F. Dool.

Division, promoted Canada as a "land of youth" and promise, as in the 27 June 1964 photo story "Canada's Birthday Brings Thoughts of Tomorrow: Nation's Future Belongs to Them" (figs. 2.1 and 2.2). Unsupervised by adults, at play without responsibility, and utterly unconvinced by institutional authority, the young people depicted in division images of this time seem utterly unrelated to the obedient, orderly children of the decade before. Instead, as "Knowing children," they embody autonomy, freedom, and individuality. Again, the observational mode – technically and stylistically reflective of the values of autonomy, while still insisting upon the unimpeachable, indexical evidence of the image – provides an ideal means of visually organizing and promoting the notion of individualism.

This new stylistic approach in turn served as a vehicle for promoting nationalist values and policies leading up to and immediately following the country's centennial. Generally, it gave form to liberal individualist values at this key moment in the international Cold War. More specifically, it marked an ideal form to represent and promote the federal government's emergent multiculturalism policies. In centennial publications and exhibitions as well as photo stories, this new mode – often featuring images of children and youths – highlighted claims of Canadian cultural pluralism (fig. 2.13). As Eva Mackey has argued, "In the 1960s Canada, managing and representing forms of difference were central to the creation of national identity, and to the success of the nation-building project."[79] At times and in support of specific governmental agencies, multiculturalism was an explicit subject of the representations and directly promoted governmental programs. In others, Monk, division photographers, and staff were so fully immersed in the rhetoric of Canada as a benevolent, pluralist society that they replicated it visually and textually as a true picture of the country.

In the next chapters, I outline how division documentary photography – from the expository to the observational – was employed in a range of different themes. As in this case study of childhood as a signifier of the Canadian citizenry, close readings of labour, landscape, and portraiture reveal how the division employed the documentary image to serve the state.

# PART TWO

## Readings in the Archive

"Made in Canada" steel has fought on all world battlefronts in one form or another of mechanical destruction. Since war began quantities turned out have more than doubled to place Canada as the fourth greatest steel producer among the United Nations.

Canada was a "natural" to become a leading arsenal because of its geographical position and enormous resources. Existing manufacturing industries were expanded and converted; science helped build new ones like synthetic rubber and optical glass.

44

3.1   "Made in Canada," *Canada at War*, 1945. Photographs uncredited.

# "Made in Canada": Labour, Gender, and Class during the Second World War

The history of still photography at the National Film Board of Canada in the previous section was told from a somewhat distant perspective, looking out over three decades to reveal broader patterns in its institutional mandates and documentary style. But histories, of course, are also told at the micro level where, under close observation and analysis, the detailed textures and complexities of a period come into focus. This chapter and the two that follow each examine specific periods in this history through a discussion of a defining trope of those years.

This chapter addresses the theme of work in the NFB photographic archive, with particular attention to how the labouring body was pictured during the Second World War. When the NFB established a still photography service in 1941 in the midst of the war, it was engaged in a battle on the home front to bolster morale, encourage enlistment, and provide information on military projects.[2] While the division also promoted the military to Canadians at home (see, for example, figure 1.5, which documents an exhibition on the Canadian Air Force), I look specifically here at its promotion of wartime manufacturing. Over these years, industrial labour became a key subject in thousands of photographic images produced under the auspices of or in collaboration with the NFB.

They're deft hands strong and eager. They've seized the edges of a threatening breach and with their own power and will-to-do have pulled it together again. They've seized wheels and kept them turning. Machines and kept them humming.

*Women at Work*, 1943[1]

Although labour is the focus of this chapter's discussion, the images were made within the context of nation building, the division's key mandate throughout its history. Canadian participation in the war would consolidate a sense of national belonging for many citizens. Photographs depicting wartime workers produced under the auspices of the federal government, either directly by the NFB or through its association with the Wartime Information Board (WIB) or its predecessor, the Bureau of Public Information, rallied Canadians toward the war effort and, in so doing, attempted to instil a patriotic allegiance to the nation. As with most NFB still photographic production, these images of industrial labour were circulated widely through the press, in governmental publications, and in exhibitions, and as such appeared ubiquitously and familiarly as emanations of a photographic banal nationalism.

At the same time, photographs of wartime workers render visible "official" national attitudes toward gender and class. In addressing images of wartime production (including shoots devoted to specific factories manufacturing munitions and other military equipment), I suggest that close readings of these images reveal contemporary commercial promotional strategies. Some of the key photographers of wartime images had been seconded to government from private industry; in their new positions they adapted the same machine aesthetic they had used to promote the CNR, CPR, and other businesses. Accordingly, these images adopt the point of view of the manufacturer rather than the worker. They picture labourers not as skilled but as ancillary to the power of machinery and the government's overall war effort.

During the war the government of Canada – like nations around the globe – widely promoted the efforts of its industrial workers, including the thousands of women who entered the formal workforce. While officially sanctioning the transgression of conventional gender roles to augment the workforce, the visual record of this period also para-doxically reveals an insistence on exaggerated feminine representations. In short, as a group these photographs give visual form to tensions in this period around class and shifting gender roles.

## Picturing Industry on the Home Front

The NFB photographic archive is replete with thousands of images depicting domestic industrial production in aid of the war effort. Of approximately 25,000 photographs dating from the Second World War, about 5,480 were made as part of the Wartime Manufacturing series.[3] This substantial number was the result not only of the NFB's own production but also its incorporation of the WIB's photographic holdings and activities. The WIB was founded in September 1942 as a replacement and expansion of the Bureau of Public Information, including the latter's photographic branch.[4] Directly responsible to the prime minister, the WIB was charged with wartime coordination of all "information" campaigns, as propaganda was euphemistically known. In 1943, John Grierson became general manager of the WIB in addition to his responsibilities with the NFB.[5] The photographic record of war manufacturing at the two agencies complemented one another and effectively merged, the WIB requisitioning substantial amounts of work produced by NFB's Photo Services.[6] By 1944, the WIB had a detailed financial procedure for the regular requisition and display of Photo Services images.[7] Photographs produced by the NFB were distributed through the WIB's branch offices in Ottawa, Washington, New York, and Latin America, at fees of between 30 and 40 cents a print. Although the WIB used NFB photographs extensively, it also employed photographer Harry Rowed. Rowed worked so closely with the NFB that he would go on to head Photo Services at the war's end; NFB photographer Nicholas Morant later described the two agencies as "folded" together.[8] My discussion here combines these intertwined agencies'

photographic depictions of wartime industry, now housed at Library and Archives Canada under the NFB designation "War Records Manufacturing."[9]

Industrial production was critical to Canada's support of the allied war effort. The Department of Munitions and Supply and its influential federal minister, C.D. Howe, held extensive powers for the "making of all defence purchases, and the mobilization of industrial and other resources to meet war needs."[10] The department oversaw the commission of contracts to Crown corporations and the mass conversion of private industries to wartime production. To provide just one example of the scope of industry's involvement in the war effort, the Dominion Textile Company of Montreal, a leading textile manufacturer (then Quebec's largest industry) devoted fully 70 per cent of its production to military and essential wartime service.[11] By mid-1943, Howe announced in Parliament that his department had so far delivered over $4,500,000,000 of goods. He recited a litany of war-related industrial production in Canada:

Every week we are launching six or more vessels, either escort, cargo or patrol. Every week we are turning out 80 planes. Every week our automobile factories produce 4,000 motor vehicles and 450 fighting vehicles. Every week our gun plants make 940 heavy guns, barrels or mountings, and our small arms plants turn out 13,000 smaller weapons. Every week our ammunition factories make 525,000 rounds of heavy ammunition and 25,000,000 rounds of small arms ammunition. Every week our chemicals and explosives industry has an output of 10,000 tons. Every week our factories produce $4,000,000 worth of instruments and communications equipment.

We have launched 500 ships and delivered 8,000 aircraft. We have delivered 475,000 motor vehicles and 24,000 fighting vehicles. We have delivered 55,000 heavy gun barrels or mountings and 630,000 small weapons. We have produced 800,000 tons of chemicals and explosives. We have produced instruments and communications equipment to the value of $160,000,000.[12]

By war's end, the WIB would estimate the total military-related production, without general purchases, at roughly $8,550,000,000, a staggering amount in 1945.[13] The war was widely considered the key stimulus that transformed the Canadian economy into an emergent industrial force on the international stage after the stagnancy of the Depression and dependency on the export of raw materials.[14] At the same time, the country's trade patterns shifted from a dependence on British markets to those in the United States.[15]

The WIB and the NFB's Photo Service divisions were charged with photographically promoting accelerated industrial activity during the war. They met this mandate by producing and disseminating many thousands of photographic prints. In the midst of the war, the WIB sent out on a weekly basis approximately 1,500 prints of current subjects including the Canadian home front and Canadian military.[16] Many ran in Canadian publications;[17] their staffs diminished by military enlistment, editors were generally eager to accept ready-to-use images and copy offered by the WIB at no cost or a nominal fee. At a time when even the most benign criticism of the war effort could be censored,[18] the visual propaganda of governmental agencies like the WIB and NFB was almost indistinguishable from the editorial content of the private press. Government-made industrial photographs appeared in Canadian publications ranging from the *Financial Post* to Prince Edward Island's *Summerside Journal* to the upscale women's journal *Mayfair*.[19] Government propaganda photographs also illustrated the WIB's own publications, including *Canada at War*, a journal designed and illustrated by the NFB.[20] In these

3.2 "Here are the Tools Mr. Churchill! Canada's Fighting Dollars will provide the tools, equip her sons, to help finish the job," lithograph, 1941. Photographs uncredited.

varied publications, enhanced by their near-anonymous presentation, NFB wartime photographs served as forms of banal nationalism, naturalizing Canadian national identity and national commitment to the war effort.

War manufacturing images were also disseminated outside of publications, though here as well the banality of their ubiquitous dissemination made them effective vehicles for promoting national belonging and the war effort. A photograph by Nicholas Morant of artillery manufacture, made under the auspices of the NFB, for example, was the model for a fifty-cent stamp during the war.[21] Still photographs of war industries were also used in NFB filmstrips, circulated widely to the Canadian public. In addition, home-front industrial photographs filled government propaganda posters, including one in 1941 issued for the Department of Finance encouraging monetary support of the war, a campaign in part designed to reduce inflation (fig. 3.2). Five photographs of Canadian industrial production are featured under a portrait of the British prime minister. His familiar rallying cry, "Give us the tools, and we will finish the job," is referenced in the poster's title, "Here are the Tools Mr Churchill!" The images of industrial production make vivid the contribution of Canadian workers, while the text urges viewers to "Lend your Money to Canada!"[22]

The government's propaganda agencies also produced several photographic displays that circulated around the country. Photographs of female munitions workers were featured in a 1941 display, *Shells for Victory!*[23] Echoing the NFB's innovative Industrial Circuit program, established in 1943 to screen films for workers at plants across the country, Photo Services began erecting displays on worksites. In 1944, a series of eight displays entitled *Labour Presents Arms* were set up in trade union halls and factories as well as libraries, railway stations, and department store windows.[24] The same year saw the division preparing the exhibit *Five Years of War*

*Production in Canada* for display, including in the United States,[25] and mounting at the National Gallery of Canada the two-part exhibition of photo-murals, *This Is Our Strength: A Display of Photo Murals on Canada's Achievement in War and Her Potentialities for Peace.*[26]

In publications, postage stamps, filmstrips, and exhibitions, Photo Services' images of industry adhered to the government's manifold contemporary propaganda needs. The photographs were intended to boost morale, promote the Canadian economy within the country and internationally, attract new recruits, and advance Canadians' work toward the allied effort on the international stage. In this they complemented the NFB's wartime film productions including such documentary films as *Labour Front* (1943).[27] Many still photography shoots responded to specific contemporary concerns. Chief among them was worker recruitment; as industrial production increased and the available conventional workforce was reduced by military service, industry sought ever more workers.

Governmental photographs also promoted victory bonds and savings certificates to workers and encouraged workplace safety. An April 1944 photo shoot by Ronny Jaques at Small Arms Ltd. in Long Branch, Ontario (later part of the Toronto suburb of Etobicoke), for example, highlights workplace safety. Jaques frames images around large-scale posters promoting the use of goggles and discouraging workers from hasty work.[28] Other posters jingoistically promote the war with such slogans as "Every extra rifle we make brings Victory nearer!" and "Our front line is here. Let's go!"[29] Jaques shot these images as concerns over productivity, absenteeism, labour/management relations, and safety on the job were being voiced across the country.[30]

These propagandistic photographs depict a wide array of manufacturing in aid of the war. Among the most frequently depicted industries are armaments and munitions manufacturing, aluminium and steel production, shipbuilding (including launches and repairs), the production of military vehicles, clothing production for the military, construction and housing projects, lumbering and pulp production, and use of scientific research in industry.[31] Reflecting the geographical concentration of war industries at the time, most of the war manufacturing photographs depict factories in Ontario and Quebec. Lengthy shoots included those devoted to Small Arms Ltd. in Long Branch, the John Inglis Company in the Toronto area, the Aluminium Company of Canada in Kingston, the Ford Motor Company's Windsor plant, the Defence Industries Ltd. and Dominion Textile plants in the Montreal area, and Dominion Arsenals in Quebec City. While central Canada dominates the archive, naval production on the coasts was also the subject of shoots of, for example, shipyards in Vancouver as well as Pictou and Halifax in Nova Scotia.[32]

The thousands of extant WIB and NFB war manufacturing photographs can be organized usefully into two general groupings. The first depicts industrial production, with individual shoots typically organized around the location of one manufacturer or particular military equipment (tanks, small arms, etc.). Within these images, the assigned photographer or photographers would picture the factory as a whole, the military equipment it produced, production procedures, and the workers. Some shoots resulted in dozens of negatives, while others were far more modest and select. In this way, the NFB and WIB amassed a photographic archive documenting the work and products of Canadian wartime manufacturing.

As with all images in the NFB archive, these highly mobile photographs could subsequently be used to illustrate a wide range of often recontextualized themes. A second general grouping of images focuses more specifically on workers. In some factories, photographers made images of a variety of labourers, at times providing biographical information. In a few notable cases, they undertook lengthy shoots of

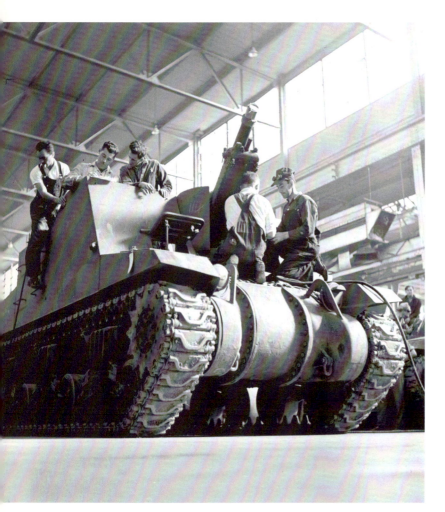

3.3 Angus tank production, Montreal, 1943. Photograph, Ronny Jaques.

particular workers singled out for attention, often as models in recruitment drives. Reflecting the innovative recruitment drives of the time, women were particularly prominent in such profiles.

## Machine Aesthetics and the Devaluation of Labour

A shoot featuring the Angus Shops of the Montreal Locomotive Works dating from summer of 1943 typifies the manner in which the NFB represented the first grouping of wartime manufacturing images, those devoted to production. The Angus facility was the subject of several government photographic promotions over the course of the war. The 1943 shoot includes a series of images made by NFB photographer Ronny Jaques, documenting the assembly of a tank by male workers on the factory floor (fig. 3.3). The photographer follows a group of dungaree-clad labourers as they install the tank's gun and caterpillar tracks. Most shots are taken from vantage points below and off to the side, providing optimal visual information about the military vehicle while reducing the scale of the labourers. The didactic factuality and unobtrusive vision reflects the NFB's contemporary adherence to expository documentary and its translation into still photographic form. At the same time, the perspective privileges the nation's productivity in support of war over the portrayal of individual labourers.

Images from the Angus shoot appear in the WIB's special pictorial editions of *Canada at War*, designed by the NFB and published monthly or bi-monthly between August 1940 and July 1945. The publication was aimed at both Canadian and US audiences.[33] An aerial view of tanks on the factory floor is montaged with an anti-tank gun in the edition of March 1944 (fig. 3.4).[34] Another image from the Angus shoot appeared, retrospectively, in the next special pictorial edition of the journal on February 1945 (fig. 3.5). This later edition was devoted to economic and social changes in the

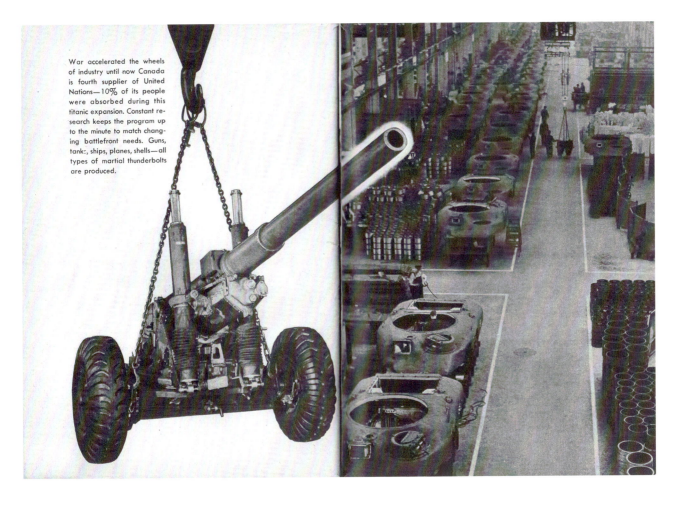

War accelerated the wheels of industry until now Canada is fourth supplier of United Nations—10% of its people were absorbed during this titanic expansion. Constant research keeps the program up to the minute to match changing battlefront needs. Guns, tanks, ships, planes, shells—all types of martial thunderbolts are produced.

country over the course of more than five years of war. It is filled with photographs as well as several hand-rendered diagrams; as a whole it reflects visual strategies employed in the pictorial press, coupling the authoritative power of the photograph with dynamic montage techniques and contrasting inks, effects that imbue the images with a sense of the modern. In a section devoted to industry, the image

3.4 "War accelerated the wheels of industry," *Canada at War*, March 1944. Photographs uncredited.

from the 1943 Angus shoot appears as part of a two-page spread. Here the photograph is no longer a document of machinery and a programmatic study of industrial procedure

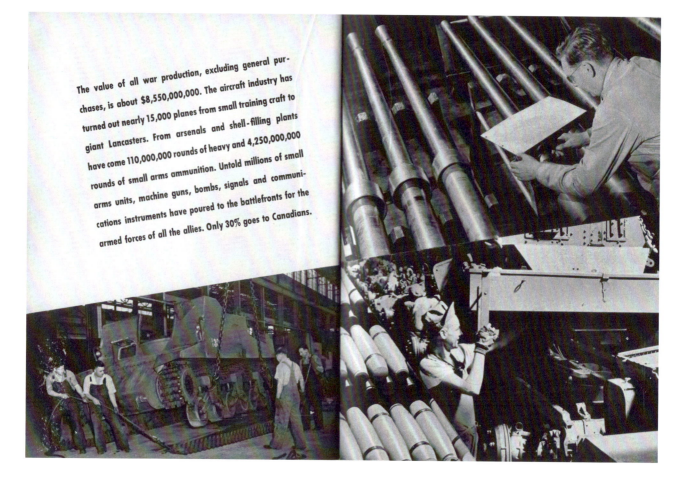

The value of all war production, excluding general purchases, is about $8,550,000,000. The aircraft industry has turned out nearly 15,000 planes from small training craft to giant Lancasters. From arsenals and shell-filling plants have come 110,000,000 rounds of heavy and 4,250,000,000 rounds of small arms ammunition. Untold millions of small arms units, machine guns, bombs, signals and communications instruments have poured to the battlefronts for the armed forces of all the allies. Only 30% goes to Canadians.

3.5   "The value of all war production," *Canada at War*, February 1945. Photographs uncredited.

but a testament to the enormous scope of Canadian wartime manufacturing and development of that capacity. Above the photograph, a lengthy caption tells the viewer: "The value of all war production, excluding general purchases, is about $8,550,000,000. The aircraft industry has turned out nearly 15,000 planes from small training craft to giant Lancasters. From arsenals and shell-filling plants have come 110,000,000 rounds of heavy and 4,250,000,000 rounds of small arms ammunition. Untold millions of small arms units, machine guns, bombs, signals and communications instruments have poured to the battlefronts for the armed forces of all the allies. Only 30% goes to Canadians."[35]

On the facing page is a montage of three images depicting a group of twenty-five pound bombs, a workman fitting the body of another vehicle, and another workman checking tank guns. Like the Angus photograph, all are cropped at a slight angle, lending the composition a sense of dynamism characteristic of the machine aesthetic dominating commercial industrial photography of the time. Layout, vantage point, sharp focus, relatively dramatic lighting, and accompanying text together emphasize the sleek geometric regularity and huge volume of the machinery and artillery depicted.

Running diagonally toward the viewer, the bombs and guns seem to go on infinitely, suggesting a high level of productivity, while the male labourers seem almost peripheral to the scene. Turned away from the camera, leaning into their work and truncated by harsh cropping, their bodies all but bond with the industrial equipment and military artillery they are handling. Visual equivalence is suggested between the modern power of industry and that of the male body. Yet, paradoxically, those same bodies are presented as secondary to mechanization, the sleek regularity of the geometricized and sharp-focused images effectively erasing the signs of toil.

Here my observations of the Second World War manufacturing photographic archive differ markedly from Malek Khouri's discussion of contemporary NFB films. In *Filming Politics: Communism and the Portrayal of the Working Class at the National Film Board of Canada, 1939–46*, Khouri argues that NFB films during wartime addressing working-class subjects constitute counter-hegemonic assertions. He contends that particularly in films prominently depicting working-class people and made between 1942 and 1945, the NFB reflected the Communist Party of Canada's support of the Popular Front against Fascism. Khouri suggests, for example, that films dealing with Labour-Management Committees, including *Partners in Production* (1944) and *Work and Wages* (1945), like the committees they promote, assert

the agency of the worker and promote the contemporary mandate of the Communist Party.[36]

In contrast, I suggest that the still photographs of industry produced under the auspices of the NFB and WIB often minimize the agency of the worker. The archival record suggests that Photo Services, working closely with the WIB, supported such programs as Labour-Management Committees in order to ensure high productivity and advance the government's wartime agenda; as Zoë Druick has noted, representations of labour-management cooperation in NFB films of the same period promoted "social concessions … made to labour in a return for political acquiescence."[37] Workers were central to this mission, and indeed within the photographic archive they are exceptionally prominent during the war. Yet their agency is diminished through subtle pictorial devices and their subsequent placement in publications like *Canada at War*. Often, these photographs emphasize abstract aestheticism over a realist depiction of labour; the emblematic and decontextualizing character of the still photograph enhances that effect.

Informed by a machine aesthetic that diminishes the act of labour and emphasizes regularity and dynamism, the WIB and NFB images reflect the photographic treatment of industry in contemporary commercial advertising. Many staff photographers, including Harry Rowed, the future head of the Still Division, had been experienced commercial and industrial photographers before entering the public service. The Bureau of Public Information (BPI) had been largely staffed by individuals with corporate marketing backgrounds, some with extensive work experience in the publicity department of the Canadian National Railway; the BPI's first two directors, Walter Thompson and G.H. Lash, had worked for CNR's publicity department for years, as had Rowed.[38] Rowed's corporate perspective, translated into a governmental view, is evident throughout his work for the WIB and NFB, the dynamic visual styles he had developed to

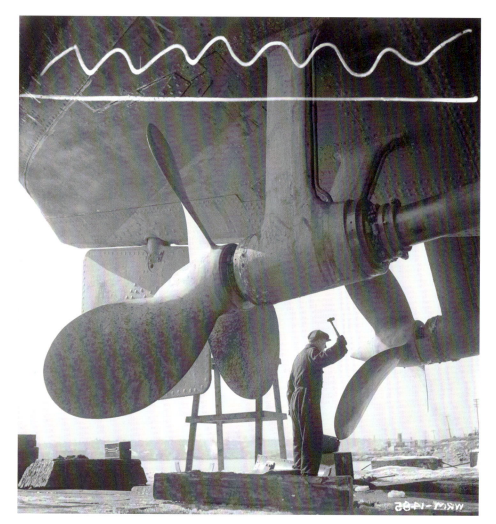

3.6 "A workman with a hammer repairs a ship's propeller at a Halifax shipyard," Halifax, April 1942. Annotations for photo cropping made by NFB staff. Photograph, Harry Rowed.

glamorize railroads, airlines, and other commercial businesses and industries now used in the service of the war effort.[39]

A series of photographs by Rowed depicting the Halifax shipyard in April 1942, for example, portrays ships from angles and proximities that both decontextualize and aestheticize the enormous vessels as they are readied for commissioning (fig. 3.6). Rowed or another staff member in Ottawa annotated these negatives, suggesting further cropping to emphasize the abstract beauty of the machinery. One

photograph depicts a worker attending to a ship's propellers on the dock. Consistent with photography of the time, the worker is diminished in scale in comparison to the propellers and the vast ship above. Annotations suggest cropping the top quarter of the image, thereby omitting the marks of welding on the upper ship and the hard labour in the task depicted; instead the photograph emphasizes the sublime industrial beauty of the propellers.

Such photographs in the archive visualize deskilling, a key effect of modern mass production. Simultaneously, they reinforce a sense of the citizen worker serving a greater cause, led by government and the war industries. In effect, a machine aesthetic frames the government's "official picture" of Canadian wartime industry, particularly in images focused on production. Promotional images, displays, and publications from a governmental perspective render the real toil of work in aestheticized and abstracted forms.[40]

## Women at Work

Some images in the archive of war records manufacturing photographs, however, contradict this pictorial diminishment of the worker. Many focus on detailed portrayals of individual labourers and groups; among them, over time, women are increasingly prominent (fig. 3.7).[41] Early in the war, governmental photographic promotionals reflect the dominance of men in industrial labour. The 1941 Department of Finance poster "Here are the Tools, Mr. Churchill!" for example, exclusively features men at work building ships, planes, armoured vehicles, and artillery. But even then the gender balance in Canada's factories was beginning to shift, and the photographic record reflects that historic change.[42] Women populate the WIB and NFB machine aesthetic images by the thousands. They appear attending to their work with discipline and precision, adhering to the latest safety regulations, and cheerfully undertaking the rote tasks of industrial

labour (figs. 3.8 and 3.9). These photographs document the phenomenal influx of women workers into industry while also encoding contemporary attitudes toward women. The images are remarkable because of the scale and pace of this transformation but also because industrial work usually exemplifies conventions of masculine brawn.

The dramatic increase in women's work outside the home was fostered by the National Selective Service (NSS) and its Women's Division. The NSS was founded in March 1942 and headed by Fraudena Eaton under the auspices of the Department of Labour specifically to redress a severe labour shortage during that crucial period of the war.[43] Women were identified as an untapped resource. As Prime Minister William Lyon Mackenzie King announced in a well-known August 1942 speech about the NSS, "womanpower" was essential to the war effort. Both "men and women," King emphasized, "are needed to make the machines, the munitions and weapons of war for our fighting men."[44] A month later, NSS director Elliott M. Little described the labour shortage in urgent tones as "acute" and "increasing every day as the war progresses, as our production of war material increases and as our enlistments in and call-up for the armed services swell."[45] While single women were initially targeted, by September 1942 the NSS extended its plea to married women.[46]

At this point, of course, thousands of women were already employed in essential war industries and demonstrating great aptitude for their work. One of the most celebrated examples was Elsie MacGill, a rare female aeronautical engineer who was charged with transforming the Canadian Car and Foundry Company of Fort William, Ontario, into a plant manufacturing Hawker Hurricane airplanes.[47] But while the government promoted the work of such exceptional female leaders, it was more concerned with hastening the participation of "ordinary" women workers. In his September 1942 statement, Little called for the inclusion

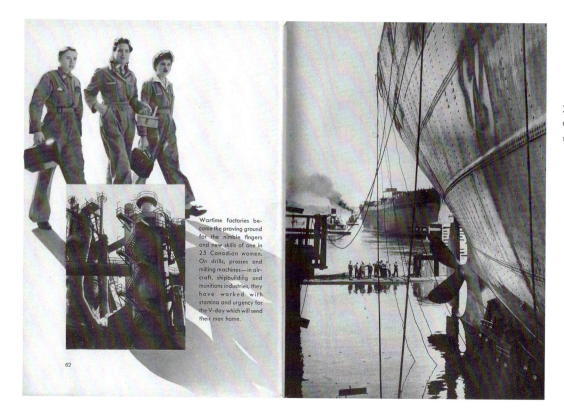

Wartime factories became the proving ground for the nimble fingers and new skills of one in 25 Canadian women. On drills, presses and milling machines—in aircraft, shipbuilding and munitions industries, they have worked with stamina and urgency for the V-day which will send their men home.

62

3.7 "Wartime factories," *Canada at War*, March 1944, Photographs uncredited.

of middle-class women: "The induction of women into industry is going to be steadily accelerated … We are past the stage where we only need in industry women who are working because they need the money. From now on as our armed forces expand and our munitions production grows accordingly, women who never had to work because of economic necessity should come forward and offer their services to industry in their own and the nation's interest. Not only will we need the single young women but also married women with the exception only of those with considerable family responsibilities."[48] Despite Little's call and the government's allusions to middle-class respectability, however, most women employed on the factory floors came from working-class backgrounds; for them, the war offered economic opportunities and heightened status.[49]

The NSS used extensive publicity campaigns in an attempt to persuade women (and men) of the urgency of the situation and to instil a sense of patriotic duty that would be fulfilled by enlisting in the formal workforce.[50] NFB and WIB images appeared throughout those campaigns.[51] A 1943 series entitled "War Workers with Interesting Pre War Jobs" profiled workers from diverse backgrounds; one of the women featured was Cecilia Butler, a former nightclub singer and dancer (see fig. 3.9).[52] But even before the heightened calls

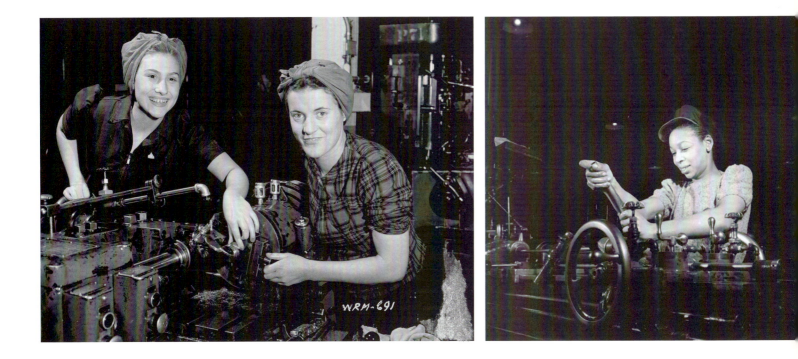

for women war workers in 1942 and 1943, these governmental divisions had been documenting female participation in war industries, often in response to specific current events and public concerns over women's new roles.

Earlier photographs of women include a 1941 series on the John Inglis Company's Bren gun facility, with a profile of "Bren Gun Girl" Veronica Foster. Before the lens of a government camera, Foster performs idealized woman-hood, middle-class identity, and patriotism as these values were understood in Canada during the war. She enacts competence as a labourer, dressing in practical clothing, heading off to work, and taking her place with other women and men on the factory floor (fig. 3.10). In stark – even comical – contrast, the remaining images present her in a hyper-feminized manner as a middle-class ingénue. In a

3.8 (*left*) "Women workers smile and pose with a machine at the John Inglis Co. Bren gun plant," Toronto, 8 April 1941. Photograph uncredited.

3.9 (*right*) "Cecilia Butler, former night club singer and dancer now employed as a reamer in the Small Arms Ltd. Section of the John Inglis Company munitions plant," Toronto, December 1943. Longer inscription: "War Workers with Interesting pre War Jobs – December 1943. Negro girl, Cecilia Butler of Lucan, Ont. Working on reamer at Small Arms. Negro girl workers are highly regarded in majority of munitions plants, display exceptional attitude for work of precision nature. Cecilia was former night club singer and dancer." Photograph uncredited.

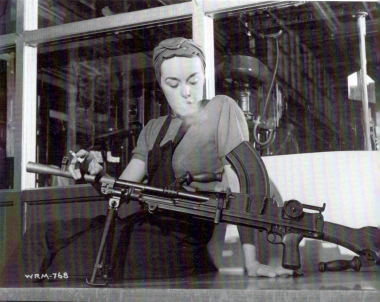

3.10 (*left*)   "Veronica Foster, employee of John Inglis Co. and known as 'The Bren Gun Girl,' walks on the exterior of the John Inglis Co. Bren gun plant," Toronto, 10 May 1941. Photograph uncredited.

3.11 (*right*)   "Veronica Foster, an employee of the John Inglis Co. Ltd. Bren gun plant, known as 'The Bren Gun Girl,' poses with a finished Bren gun at the John Inglis Co. plant," Toronto, May 1941. Photograph uncredited.

series of theatrically posed images, she is seen after work hours, now dressing for an evening out, adjusting a fashionable hat before a mirror, pausing to adjust a stocking while providing the camera with a view of her legs, and dancing with abandon at a local country club.

The camera's staging of popular contemporary codes of femininity extended to the factory. In a handful of images, Foster poses provocatively with a completed Bren gun, taking the stock posture of a pin-up girl: balanced on the edge of a table top with a cigarette in her hand, she blows out a cloud of smoke while giving the plant's signature firearm a sultry glance (fig. 3.11). The shoot seems aimed not only to supply cheesecake promotional images but also to boost morale among female workers, who often moved long distances and worked under harsh conditions.[53] By highlighting the social life around industrial work and glamorizing female workers, these photographs offered up wartime work not only as a patriotic sacrifice but also as an adventure.[54]

In 1942, the same year that the NFB produced the documentary film *Women Are Warriors*, it created a series of still

photographs by Harry Rowed featuring female workers at the Dominion Arsenals Plant in Quebec.[55] This shoot roughly coincided with concerns over the effects of women's work on family life; by this point in the war, the apparent licentiousness seen in the Veronica Foster images was no longer acceptable to the Canadian public.[56] The Dominion Arsenals shoot, focused on the three wholesome sisters, Céline, Roberte, and Hélène Perry, seems to have been directed specifically at French Catholic viewers, providing them with models for participation in the national war effort merged with religious piety. The sisters are shown together at work, relaxing at the beach and, notably, praying at bedtime. The didacticism of these images owes much to a still photographic version of expository documentary (fig. 3.12).

One of the NFB's most extensive photographic promotions of women's industrial work toward the war effort appeared in the 1943 publication *Women at War* (fig. 3.13).[57] Widely distributed, it demonstrates the effectiveness of still photographic work as a form of banal nationalism. The Maclean Publishing Company issued the volume in cooperation with the Department of Munitions and Supply and the NFB. It was prompted by another critical labour shortage, resulting in the increased targeting of married women with children as potential workers.[58] A reprint of three special issues of the upscale women's magazine *Mayfair*, this volume was aimed directly at a female readership and potential workforce; in effect, women were both its subject and audience. The publication includes over ninety brief articles or pictorial essays addressing women's war efforts.[59] With titles ranging from "Women Work on Monster 30-Ton Ram Tanks" and "Women Keep Planes Flying" to "Nurses," "Red Cross," and "Women in Banks Check 48 Million Ration Coupons," the editorial content offers an upbeat survey of many of Canadian women's contributions to the war. Advertising interspersed throughout includes promotions of such companies participating in wartime industries as the Canadian General

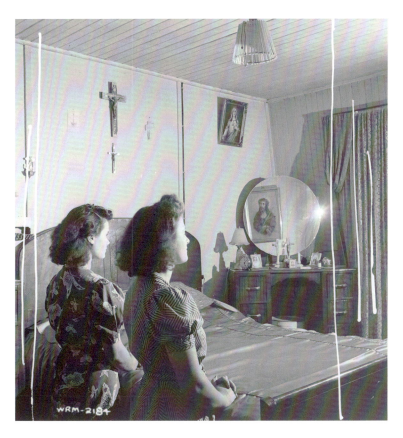

3.12 "Céline and Roberte Perry, two employees of the Dominion Arsenals plant, pray at their bedside before going to bed," Quebec City, 24 August 1942. Annotations for photo cropping made by NFB staff. Photograph, Harry Rowed.

Electric Company, Dominion Foundries and Steel Ltd., and Canadian Pratt and Whitney Aircraft Company, as well as those, including Helena Rubinstein and Chanel, aimed at affluent female consumers.

Although the volume reflects *Mayfair*'s up-market consumerism, the thrust of the publication is toward

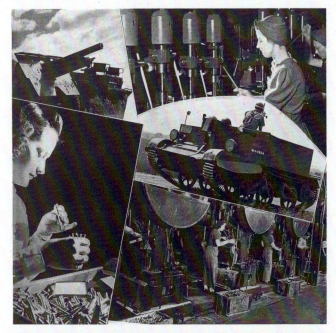

# Women at War

### CANADA'S INDUSTRY HARNESSES MEN, WOMEN AND MACHINES

CANADA'S women have gone to war. By the thousands they're in the active services; replacing fighting men. By tens of thousands they're producing the actual sinews of war. By the thousands of thousands they're pursuing essential work on the home front.

Can you feel it, Johnny Canuck? As you blast your death-spitting tank across the desert? In the grim hardness of metal and the stern, implacable precision of guns?

Can you feel it in the skies? In the sure, steady purr of engines and the ghastly whine of bombs? On the sea? In the confident roll of a ship or the potent roar of its cannon?

Can you feel the woman's touch? Because it's there. A million touches imprinted by a million hands. Hands that have peeled potatoes and pounded typewriters and poured tea.

They're deft hands, strong and eager. They've seized the edges of a threatening breach and with their own power and will-to-do have pulled it together again. They've seized wheels and kept them turning. Machines and kept them humming. They've molded bullets for Tunisia, filled bombs for Berlin.

They're quick hands and capable—young, old and in-between. And they're there with you as you fight. In the desert, in the skies, on the sea.

They're there with you in the battle. Watch for it, Johnny Canuck, and you'll feel it as you fight. The woman's touch.

3.13    "*Women at War*: Canada's Industry Harnesses Men, Women and Machines," *Women at War*, 1943. Photographs uncredited.

industrial production. Most of the editorial content and a substantial portion of the advertising address industry. *Women at War* is divided to reflect different areas of manufacturing. Pictorial essays promote the production of small arms, bombs, tanks, airplanes, and ships, in texts careful not to disclose names and locations. Throughout, they highlight women's contributions. The article "Women in War Plants Making Guns, Shells and Tanks" by contributor Lotta Dempsey crystallizes *Women at War*'s patriotic tone and direct appeal to Canadian women:

> You can't spend days and nights beside these girls on shift: eating with them in plant cafeterias; going with them to get cut fingers and throbbing heads treated in First Aid centres; watching them at plant meetings, sporting activities and dances; going home with them and shopping with them and to movies with them; reading their letters from husbands overseas and mothers back home and from children they've had to be separated from, without getting a pretty good idea of what they're like.
>
> It is important that you should know. Very important. Because if you're not one of them, you're going to find them setting the pace and marking the way in the world that lies ahead – they, and the girls who have put on His Majesty's uniform and the women who are out keeping the voluntary, auxiliary wheels of the war's work turning.[60]

Here Dempsey, like other contributors, stresses the sacrifices made by women war workers, effectively using the second person to call out to well-heeled readers to identify with "these girls."

The tone of personal identification and emotional appeal struck by Dempsey is rendered in photographic form throughout *Women at War*. Indeed, the message of

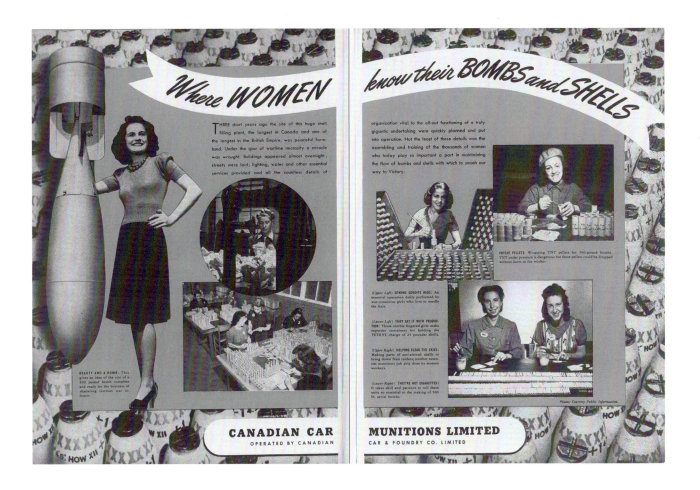

Where WOMEN know their BOMBS and SHELLS

THREE short years ago the site of this huge shell filling plant, the largest in Canada and one of the largest in the British Empire, was peaceful farm-land. Under the spur of wartime necessity a miracle was wrought. Buildings appeared almost overnight; streets were laid; lighting, water and other essential services provided and all the countless details of

organization vital to the all-out functioning of a truly gigantic undertaking were quickly planned and put into operation. Not the least of these details was the assembling and training of the thousands of women who today play so important a part in maintaining the flow of bombs and shells with which to smash our way to Victory.

POTENT PELLETS: Wrapping TNT pellets for 500-pound bombs. TNT under pressure is dangerous but these pellets could be dropped without harm to the worker.

(Upper Left) SEWING CORDITE BAGS: An essential operation deftly performed by war-conscious girls who love to needle the Axis.

(Lower Left) THEY SAY IT WITH PRODUC-TION: These nimble fingered girls make exploder containers for holding the TETRYL charge of 25 pounder shells.

(Upper Right) HELPING CLEAR THE SKIES: Making parts of anti-aircraft shells to bring down Nazi raiders; another essen-tial munitions job ably done by women workers.

(Lower Right) THEY'RE NOT CIGARETTES! It takes skill and patience to roll these units so essential to the making of 500 lb. aerial bombs.

Photos: Courtesy Public Information.

BEAUTY AND A BOMB: This gives an idea of the size of a 500 pound bomb complete and ready for the business of shattering German war in-dustry.

CANADIAN CAR MUNITIONS LIMITED
OPERATED BY CANADIAN CAR & FOUNDRY CO. LIMITED

women's war work as patriotism is conveyed largely through photographs. Although a few of the volume's advertisements are illustrated by hand-rendered graphics, *Women at War* is largely a photo textual publication. Editorial and advertising content privileges photographs as a means of promoting women's work outside the home in aid of the war effort. The photographs (in ads and articles alike) were produced by the NFB, which is credited in the publication; typically for

3.14 "Where women know their bombs and shells," Canadian Car Munitions Ltd. advertisement, *Women at War*, 1943. Photographs uncredited.

the time, no individual photographers are identified. One advertisement, for example, features a division photograph by Nicholas Morant from a May 1941 shoot depicting a female

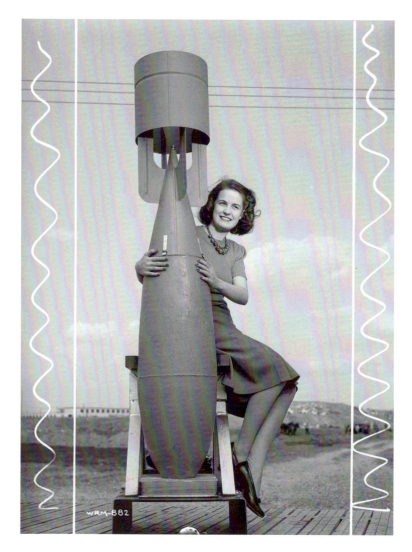

3.15    "Unidentified woman poses with a 'Bomb for Britain' at the Cherrier plant," Montreal, May 1941. Annotations for photo cropping made on the negative by NFB staff. This image was made at the same shoot as the photograph at the left of the advertisement shown in fig. 3.14. Photograph, Nicholas Morant.

munitions worker posed beside a bomb, visually punning the explosive device's phallic shape (figs. 3.14 and 3.15).

Photographs not only illustrate advertisements and articles: they also carry the narrative for much of the volume. *Women at War*'s thematic sections, each devoted to a different area of war production (naval guns, anti-tank guns, ammunition, etc.), usually comprise a sequence of photographs with brief captions. A six-page spread on the production of small arms, for example, has three to four photographs per page. While four photographs illustrate male supervisors or military figures testing equipment, most feature women operating milling machines or turret lathes or examining bayonets and gun barrels. Some illustrate women manufacturing Bren guns – including Veronica Foster, in two images at the lower left of a two-page spread (figs. 3.16 and 3.17).[61] It is the photographs rather than their brief, dry, and descriptive captions that grab viewers' attention. Although none of the sitters including Foster is identified by name, the images induce a sense of identification. Each female worker is shown in close-up, as if the reader is seated or standing next to her. The workers, however, do not meet our gaze; they concentrate on their work, embodying a sense of purposefulness and commitment. The effect of these images is therefore very different from the machine aesthetic emphasis on production and minimization of the worker. Here, guided by a mandate to recruit more women into industry, the editors personalize labour, creating figures who, although anonymous typologies, serve as credible models of industriousness and sacrifice.[62]

Throughout *Women at War*, and indeed throughout the war manufacturing photography archive, the images of women are unswervingly positive. They varnish the harsh realities of working in a factory far from home. In fact, women routinely encountered discrimination, as Pamela Sugiman observes in her study of labour in the Southern Ontario auto industry during the war.[63] Jean Bruce cautions,

SMALL ARMS

## Bren Gun is Marvel of Mechanical Ingenuity

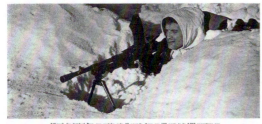

Although the finished Bren gun weighs only 20 pounds, there are 163 parts to it; 2,850 operations are necessary to manufacture each gun. Much ingenuity has gone into simplifying shape and production methods on parts so that number of operations is constantly being reduced, and cost accordingly

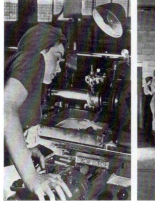

This young woman is operating a milling machine which cuts a groove in one of the parts. Over 600 machine tools are employed in the production of the Bren gun

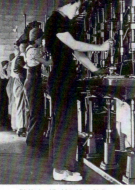

Girls (above) are drilling holes and "tapping" (making threads) in them. First girl operates 6 machines in succession; her left hand holds a "jig" which guides drill

SMALL ARMS

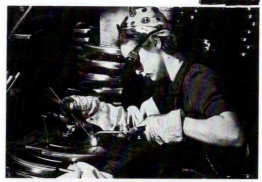

Asbestos gloves protect this girl's hands from flying sparks and heat. Goggles have filter glass to protect her eyesight from harmful rays in flame of oxy-acetylene torch used to melt welding rod (in right hand) and fuse it to the magazine in welding it up for a Bren gun

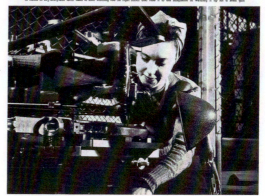

Engraving machine traces letters and figures which identify gun. Letters are traced from large master pattern; cutter reproduces them on small holes

When you look at the striking photographs of women working in munitions factories or in the armed forces, you have to remember that most were taken for specific purposes: to further the war effort by persuading other women to enlist in the services or to do their patriotic duty by working on an assembly line – or to convince the public at large that it was both essential and acceptable for women to do these things. As you might expect,

3.16　"Small Arms: Bren Gun Is Marvel of Mechanical Ingenuity," *Women at War*, 1943. Photographs uncredited.

these photographs project the same positive image that government posters and advertisements do, showing cheerful, resourceful women … You won't find pictures

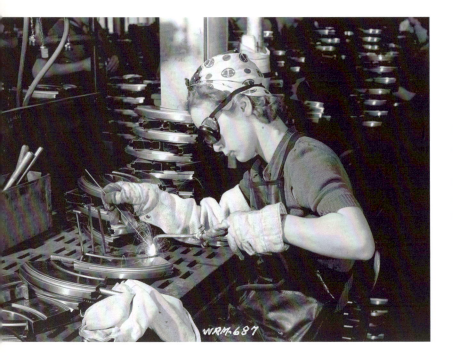

3.17    "Woman worker at the John Inglis Co. Bren gun plant welds Bren gun magazines," Toronto, 8 April 1941. Photograph uncredited.

of weary women in sweatshops, harassed housewives, or service women "out on the town."[64]

In two Westinghouse advertisements from a series titled These Are Tomorrow's Yesterdays,[65] for example, the photographic representation of women war workers is addressed explicitly. Covering two-page spreads, the ads combine text and photographic images. Both narrative advertisements project twelve years in the future to the summer of 1955. In one, we see a young boy ("Ritchie") composing a letter to his mother (fig. 3.18).[66] In a facsimile of childlike printing, which appears on the facing page, he gushes:

Am I ever proud of you! And do you know why?

Well, it's that picture of you, taken in the war plant during the World War. A lot of the fellows were looking through an old book in the school library and all of a sudden I saw your picture looking right out at me …[67]

Below is a sequence of four photographs of women in war industry plants.

The second Westinghouse ad from the series appears forty-two pages later. Again set in the summer of 1955 and featuring a handwritten letter, here the correspondence is from "Peggy" to her sister "Jen":

You'll never guess who I saw today. You … you in your Air Force uniform, back in 1943.

I saw you in the Public Library, in a big book called "Women at War." And it brought everything back to me so vividly that I found my eyes smarting and a lump in my throat …

They were grim days, Jen, but they were glorious purposeful days too. And it must be wonderful to feel that you shared in the Victory and in all that it has meant to us.

That's why I felt I had to sit down and write you this note … to thank you for the part you took in bringing about the happiness we've known. Your home and mine. Our husbands and our children. And the joy of living in a free world.

These ads, appearing in 1943, reflect a widespread contemporary war fatigue among Canadians who were beginning to look ahead to the postwar period. Like Women at War as a whole, the ads combine emotionally loaded language (drawing on the supposed sanctity of motherhood and family as well as the yearning of a projected nostalgia) with conventional assumptions about the indexicality of the photograph.

In suggesting that the photograph of his mother looks "right out" at "Ritchie" or prompts a lump in the throat and a tear in the eye of "Jen's sister," the ads invoke the photograph's character as a seemingly unmediated imprint of the people and things it represents. This effect is enhanced by the apparently direct didacticism of expository documentary translated into the form of still photographic mobility. The photographs thus directly and emotionally connect the viewer with tangible information about work in war industries and the more abstract concept of patriotic duty while naturalizing women's roles as mothers and wives.

3.18   "These are tomorrow's yesterdays," Westinghouse advertisement, *Women at War*, 1943. Photographs uncredited.

3.19 "Mrs. Jack Wright tucking her two sons Ralph and David into bed at the end of the day," Toronto, September 1943. Photograph uncredited.

These and many other photographic renderings of female munitions workers provide a telling record of gender attitudes of the time. While *Women at War* is filled with testaments to women's ability to take on roles conventionally coded as masculine, images in this publication and others produced by the NFB belie deep-seated tensions over gender. Here a closer reading of images depicting one female munitions worker is instructive. In September 1943, just as readers across Canada were poring over the pages of the newly published *Women at War* and in the midst of the NSS campaign encouraging mothers to undertake part-time work outside the home, an unidentified government pho-

tographer[68] produced an extensive shoot featuring a Mrs Jack Wright.[69] Never identified by her first name, she is seen in a series of photographs balancing the care of her two young sons with her work at a munitions plant in Toronto. A delicate, pretty young woman, she wears demure patterned dresses even at the beach. Many of the images feature Wright not on the job but with her sons, Ralph and David, in their tidy middle-class home. They are seen over breakfast, visiting with a neighbour, relaxing on the beach, and at bedtime (fig. 3.19). Staff inscriptions on several images classify them under the rubric "Canadian Families"; they would have been used to fill requests for illustrations of family life during wartime.[70] In fact, one shot from the series, of Mrs Wright shopping with her young sons, was featured in *Canada at War*'s pictorial edition in 1945 (fig. 3.20). The image was used to personalize a chart illustrating the government's stabilization of the cost of living during the war.[71]

On one hand, women were the intended audience of this series, presenting them with a model of a seemingly harmonious middle-class family led and supported (at least temporarily) by a working mother. On the other hand, the series responded to detractors in the House of Commons, across the country and beyond, who charged that children's welfare and women's morals were under threat when women left home to work.[72] In both cases, it suggested that the entrance into the formal workforce would not disrupt traditional gender roles.

The images of Mrs Wright and her sons present a harmonious balance of conventional domestic life and participation in the formal workforce through carefully enacted poses (with a stress on domestic settings) but also through subtle pictorial devices that invite the presumed viewer to identify with the scene. A seemingly all-seeing, paternalistic vantage point, following the conventions of expository documentary so prevalent in NFB films and still photographs of the time, allows the viewer what appears as an unobtru-

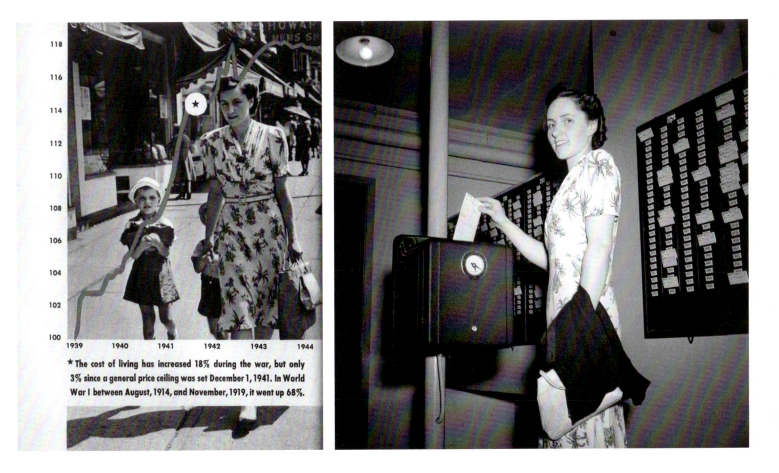

*The cost of living has increased 18% during the war, but only 3% since a general price ceiling was set December 1, 1941. In World War I between August, 1914, and November, 1919, it went up 68%.

sive, intimate glimpse into the family's life. The images are composed to highlight regularity and stability, with Mrs Wright nestled next to her sons. The images depicting her at work or en route to the munitions plant are quite different. A shot of her punching a time card, for example, presents her as dynamic (fig. 3.21). Pictured from below, she directly and purposefully meets the viewer's gaze as if inviting other women to identify with her experience.

3.20 (*left*)  "Mrs. Jack Wright is assisted in her shopping by sons Ralph and David," Toronto, September 1943. Photograph uncredited. *Canada at War* 43 (1945):66.

3.21 (*right*)  "Mrs. Jack Wright, a munitions plant employee, punches in to work at a time clock in the munitions factory," Toronto, September 1943. Photograph uncredited.

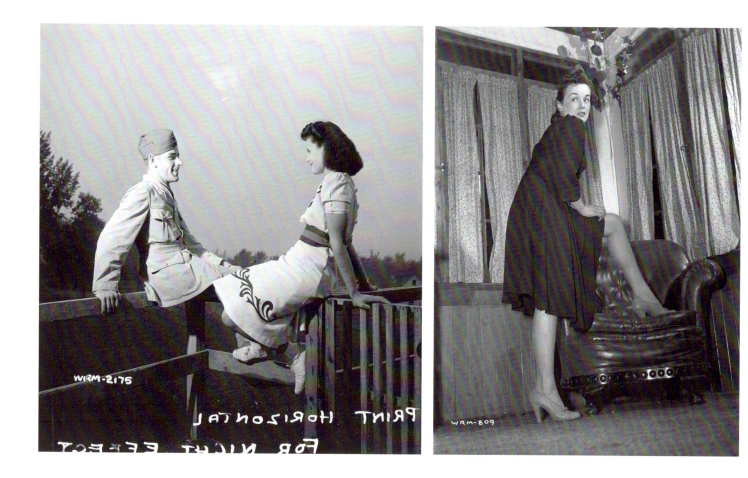

3.22 (*left*)  "Woman worker [Céline Perry] for the Dominion Arsenals Ltd. munitions plant has a date with her boyfriend," 24 August 1942. Annotations made on the negative by NFB staff. Photograph, Harry Rowed.

3.23 (*right*)  "Veronica Foster, employee of the John Inglis Co., and known as 'The Bren Gun Girl,' poses at the Glen Eagle Country Club," Toronto, 10 May 1941. Photograph uncredited.

The dual representation of gender in these images of female munitions workers is evident in visual references to a balance between work and traditionally feminine values, a motif that is repeated almost compulsively in the archive. It is seen, for example, in Harry Rowed's extensive photo shoot of the Perry sisters at the Dominion Arsenals plant in Quebec City. Rowed pictures the three women as the very models of wholesome femininity. We see them writing let-

ters home to their family back in Sainte-Foy, tending their cousin's kitchen garden, talking over a home-cooked meal with friends, and relaxing with their soldier boyfriends (fig. 3.22). But femininity in the NFB still photography archive is enacted most theatrically during the 1941 photo shoot discussed above featuring Veronica Foster. With its allusions to contemporary pin-ups and glamour, this early shoot is more sexually provocative than later photographic representations of female munitions workers (fig. 3.23). By 1943, the ever-greater numbers of women working in war industries was prompting unease about sexual impropriety among young women and the care of working women's children. Reflecting these concerns, later NFB/WIB images show more pious and domestically oriented women, as in the photo shoots on the Perry sisters and Mrs Jack Wright.

The calculated visualization of a femininity untainted by masculinized work supports Ruth Roach Pierson's and Jeffrey Keshen's contentions that the government's encouragement of women war workers and female members of the armed forces coexisted with widespread anxiety over a perceived threat to the gender hierarchy. As a body of images made under commission by the federal government, NFB photographs of women munitions workers reflect the government's conflicted attitudes of the day, at once endorsing war work for women and yet holding conventional gender roles as intractable. As I have suggested, a closer reading of the NFB's still photographic depictions of female workers also reveals how photography participated in the endorsement of conventional gender roles (fig. 3.24). Veronica Foster, Mrs Jack Wright, and the Perry sisters slipped on their dual roles as acceptable feminine models and hearty industrial workers as easily as a pair of stockings.

These women's ease in this bifurcated photographic representation of gender undermines the NSS's claims of the stability of gender roles and inadvertently reveals, as Judith Butler argues in regard to the lived renditions of identity,

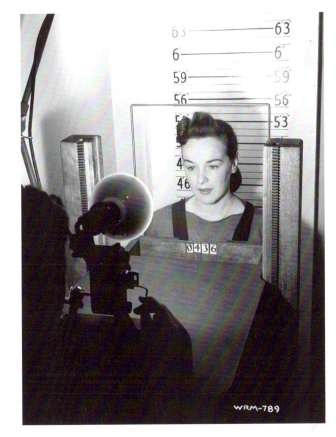

3.24    "Veronica Foster, employee of the John Inglis Co. and known as 'The Bren Gun Girl,' poses for photograph for John Inglis Co. Bren gun plant records and gate pass. Women are photographed in stockinged feet," Toronto, 10 May 1941. Photograph uncredited.

that if "gender identity is the stylized repetition of acts through time, and not a seemingly seamless identity, then the possibilities of gender transformation are to be found in the arbitrary relation between such acts, in the possibility of a different sort of repeating, in the breaking or subversive

3.25 "Constable Dolores Eitel, Hamilton, Ont., 1959."
Photograph, Gar Lunney.

repetition of that style."[73] Although as representational
forms these photographs do not constitute the acts of gender
performance that Butler analyses, nonetheless, like the "styl-
ized repetition of acts through time," photographic meaning,
too, is never intractable or fixed and is capable of trans-

formation. These works of "government realism," intended
to instil in women a sense of patriotic duty while simultan-
eously naturalizing conventional gender roles, have subse-
quently become powerful emblems of women's achievements
and resistance to a patriarchal order. They are the subject of
feminist scholarship including Pierson's ground-breaking
*"They're Still Women after All"* and more recent studies
by Keshen and Jennifer Stephen as well as such popular
accounts of the Canadian home front as Jean Bruce's *Back*

the *Attack!* and the 1999 NFB production *Rosies of the North*.[74] Like the iconic American image of "Rosie the Riveter," photographs of Canadian women munitions workers have come to signify women's changing roles and economic status in the twentieth century.

What became of the female war industry workers after the war? That question has been the subject of debate among scholars of Canadian women's history for a generation. Pierson contends that the remarkable economic advances made by women during the war were all by erased afterward when it became clear that they were "still women after all."[75] Pierson's (1986) work paved the way for more recent feminist and social historical accounts of women's postwar experience. These include studies by Joan Sangster, Veronica Strong-Boag, Franca Iacovetta, Pamela Sugiman, Valerie Korinek, and Jeffrey Keshen.[76] In *Saints, Sinners and Soldiers*, Keshen contests Pierson's thesis, arguing that, while women were not active in the formalized workforce in the same numbers they had been during the war, they nonetheless participated in paid employment outside the home at a rate that exceeded the pre-war period. The archive of NFB photographs made after the war and through the 1960s continued to display conflicted attitudes about women's roles outside the home. In the later 1940s through the 1960s, women are typically portrayed in conventional gender roles as wives, mothers, daughters, and caregivers; in other cases, they appear as familiar objects of desire, lending a mild sexual allure to government promotions through cheesecake poses. Still photographs of women in domestic situations were used to illustrate the NFB 1952 filmstrip *Women at Home*, and in 1956 the division issued an elaborate photo story on charm school for girls and another on a housekeeping school.[77] Women shown at work outside the home are more often than not in professions conventionally gendered as female – as, for example, stewardesses, teachers, and nurses. But the archive also features pictorials on exceptional women including geologist Dr Alice Wilson and Ottawa mayor Charlotte Whitton.[78]

In all, the archival record shows that long after the war the NFB remained ambivalent about women's place in the formalized workforce. A 1959 photo story profiling Dolores Eitel, a young constable with the police force in Hamilton, Ontario, is instructive. With barely veiled apprehension, it is titled "Women Invade Police Precincts." The story includes five images showing Constable Eitel on her way to work, discussing safety with school children, at target practice, and receiving instruction in suspect identification. But the final image in the visual narrative shows her pausing on her beat in front of a boutique to admire a wedding dress displayed in the window (fig. 3.25). The accompanying caption assures the reader, "The Hamilton Force requires women to resign following marriage."[79] Despite real advances made by real women of the time, figures like Constable Eitel were "still women after all," at least within the NFB photographic archive's "official" picture and at least until these images, like those depicting female munitions workers, can be reimagined.

## Picturing Labour in the Division Photographic Archive

Representations of industry, so prominent a trope during the Second World War, would all but disappear in the postwar years. During the immediate period of reconstruction, the division continued to document industry as part of its concern for soldiers' return to "Civvy Street,"[80] but that would soon change. As a federal organization charged with promoting Canada, Photo Services (later the Still Photography Division) continued to publicize the country's economy. One would, therefore, expect industrial production to figure prominently among the subjects pictured and promoted by the NFB; after all, the division's history – from the Second World War through the 1960s – coincided with Canada's

3.26 "Canadian steel foundries, Montreal, Quebec, 1969."
Photograph, Pierre Gaudard.

emergence as a major industrialized nation within the world
community. Over these years, the auto industry, steel manu-
facturing, and mass production of consumer goods in urban
factories employed ever-greater segments of the Canadian
populace. Yet a surprisingly limited number of photographs
featured industry after the mid-1940s. *The Canadian Picture
Index*, the guide to the division's image bank published in the
1960s, for example, included "industry" almost as an after-
thought as the twenty-sixth of thirty-five subject categories,
far behind such conventionally Canadian nationalist themes
as the land, agriculture, mining, and forestry. And within the
565 photo stories released by the division from 1955 to the
early 1970s, industrial production is almost entirely absent
until the mid-1960s.[81]

This apparent lack of interest in postwar Canadian indus-
try was an inevitable outcome of peacetime: simply put, there
was no longer a need to recruit new workers or promote Can-
ada's war effort. But, likely, it also reflects the NFB's desire to
mend fences with commercial photographers, who relied on
commercial industry as a key source of income. In 1946 the
Commercial and Press Photographers' Association of Canada
charged the NFB with unfair competition,[82] protesting that
the NFB's fee policy, which offered photographs free to most
publications and charged nominal fees to non-educational
commercial enterprises, constituted unfair competition.[83]
The film board acquiesced, tabling a Distribution Policy
for Still Pictures that established fee schedules reflecting
standard commercial rates.[84] Simultaneously, the number
of shoots the division devoted to industry diminished; the
scenes of factories that occupied photographers during the
war are rarely visible by the later 1940s. It would not be
until 1971, with the NFB's publication of Pierre Gaudard's
*Les Ouvriers* (fig. 3.26), that viewers of NFB still photography
images would see an extended photographic treatment of
Canadian workers in industry.[85]

The division turned away from industry to Canada's
natural resources, making thousands of photographs and
producing dozens of photo stories on agriculture, fisheries,
forestry, and mining. As the next chapter demonstrates,
pictorials on natural resources became a mainstay of the
division's work; as such, they contributed to a generalized
notion of the Canadian economy during the postwar years
as being built on the export of staples, and a Canada at once
pastoral and middle class.

# "For the Land … Has Always Held the Nation Together": Landscape, Race, and the Nation in the 1950s and 1960s

By the 1950s, the image of industry, a focus of the NFB Still Division's attention during the war, all but faded from view, to be replaced by the distinctive and diverse scenery of Canada. In the 1950s and '60s, landscape imagery became increasingly prominent in its photo stories, publications, exhibitions, and individual images, employed as a powerful emblem of Canadian nationhood. Depicted repeatedly and disseminated widely, landscape views exemplify the effect of "banal nationalism" in the division's work. Images of the land served not only as markers of Canadian identity but as sites for promoting economic status and enacting cultural and racial hierarchies.

In this chapter I argue that the division used landscape consistently during these middle years of its history as a particularly potent emblem of national identity through the assertion of a southern, largely Euro-Canadian domain. Photo stories of this time frequently presented the land as an analogue of economic prosperity, unleashed through Euro-Canadian technological expertise. Simultaneously, the stories presented landscape as a sign of a primitivized Aboriginal other. Similarly, in the centennial publications *Canada: A Year of the Land* and *Canada, du temps qui passe*, textual amendments, pictorial devices, and temporal positioning of the land construct an idealized, unified vision of

There we must look to the land and its secret cargo, if we are to learn the meaning of the nation and all its hopes and fears. For the land, its abundance and its splendour, not the statute books and legal contracts, has always held the nation together – the land and the strange things, visible and invisible, that we have built upon it.

Bruce Hutchison, *Canada: A Year of the Land*, 1967

4.1 "Dorwin Falls, Rawdon, Quebec," 1966, *Canada: A Year of the Land*. Photograph, Peter Phillips.

Canada while virtually erasing any contemporary Aboriginal presence.

## Landscape and Nation

Landscape as a marker of national identity is a familiar trope globally.[1] As Simon Schama has argued, "National identity … would lose much of its ferocious enchantment without the mystique of a particular landscape tradition: its topography mapped, elaborated, and enriched as a homeland."[2] Landscape renders the abstract concept of nationhood solid and seemingly permanent through allusion to topography and the environment. It is a powerful tool of nation building, in part because landscape representations literally "naturalize" what is a historically, socially, and politically contingent entity: the nation. Accordingly, landscape has long been among the most potent of shared symbols in the formation of the "imagined community" of nationhood. The term "landscape" can indicate either an actual physical environment or a representation of the land. In both uses, it is never an unmediated or "pure" experience of nature; instead, it views the "natural" through the lens of culture, consistently emphasizing visuality as a way of reordering the physical environment.[3] Among media commonly used in landscape representations, photography in particular has proven highly persuasive. Assumptions about photographic indexicality – the belief that camera-made images are direct imprints of the things they depict – effectively render landscape's reformation of the environment "natural."[4]

In Canada, nature has long circulated as *the* privileged symbol of national identity. As John O'Brian has demonstrated, landscape paintings, drawings, prints, and photographs in this country "remained dominant long after [landscape] had been demoted in the art of most other Western nations. It continues to be influential to this day. The Canadian fixation on wilderness is not easily dislodged."[5] During the decades following the Second World War, cultural critics often suggested that Canadian identity was determined in part by the country's enormous landmass and often severe climate. Arthur Irwin, head of the NFB during the mid-1950s, for example, claimed that Canadians were "molded" by "a stern and difficult land."[6] This geographical determinism was also evident in the influential writings of such figures as Northrop Frye, Margaret Atwood, and Gaile McGregor.[7] But it was in visual representations that landscape found its most popular and influential forms in Canada.[8] The country's signature visual emblems – the flag's prominent maple leaf, images of flora and fauna on coins and banknotes, canvases by Emily Carr, Tom Thomson, and the Group of Seven, and the NFB's own publications *Canada: A Year of the Land* and *Canada, du temps qui passe* – reflect what O'Brian has termed Canada's inherent "wildercentrism."[9]

The Canadian "fixation on wilderness" served – and continues to serve – the project of nationhood not only by "naturalizing" the Canadian state and providing readily identifiable and persuasive shared symbolism of an "imagined community" but also, paradoxically, through acts of omission. As W.J.T. Mitchell has argued, landscape can be "a place of amnesia and erasure, a strategic site for burying the past and veiling history with 'natural beauty.'"[10] The most iconic of Canadian landscape representations, works by Thomson and the Group of Seven, although depicting a seemingly untouched wilderness, were painted while Canada was growing increasingly urban and industrialized; moreover, they depict sites even then populated by cottagers and marked by decades of mining and lumbering. Yet, as numerous scholars have shown, these canvases rarely register the effects of modernization. More strikingly, they are typically devoid of any signs of humanity, including Aboriginal presence in these regions. As Jonathan Bordo has argued, "the Euro-Canadian view of wilderness" was "a cultural project

4.2  "Private Elbert Pieper of the U.S. Army stands sentry duty beside a trapper's cabin containing construction supplies for the Alaska Highway," 1942. Photograph, Nicholas Morant.

that articulated itself as a system of representation, intimately and inextricably linked to what [it] ignored – namely aboriginal presence."[11]

## Imaging the Land in the Division

While it would become prominent by the 1950s, landscape as an overt and symbolically loaded theme appears only tangentially in division photographic production of the war years and immediately after. During wartime, in addition to

the ever-present mandate for national cohesion, the NFB's efforts focused extensively on morale on the home front. Through 1945 and continuing to some degree during an extended period of postwar reconstruction in the late 1940s, the division largely addressed industry or social concerns. Accordingly, photographs of this period predominantly depict industrial sites or individuals engaged with war work or relief. Those vistas of the land that do appear are largely context for these military, industrial, and social themes.

One shoot of the war years deploying the rhetoric of landscape depicted the building of a highway between Alaska, Northern British Columbia, and Yukon Territory in 1942.[12] On 18 March of that year, Prime Minister William Lyon Mackenzie King and the US ambassador to Canada, Jay Pierrepont Moffat, signed an agreement to construct a highway from Fort St John in British Columbia to Alaska.[13] This overland route was intended to facilitate US transportation in the event of a Japanese attack on Alaska. As such, its construction was largely an American military operation. Some ten thousand US Army engineers, including thousands of African-American troops, and about six thousand American civilians, completed the 1,700-mile highway, mainly over rough and mountainous Canadian territory and through permafrost, in only eight months.[14] The engineering feat was named the Alcan Highway, combining the first letters of "Alaska" and "Canada" in acknowledgment of US-Canadian cooperation.[15] Aware of the route's future economic benefits, the Canadian government documented its construction by employing photographers from the Royal Canadian Air Force and Nicholas Morant, Harry Rowed, Jack Long, and Ronny Jaques from the NFB Photo Service.[16] Their images highlight the dramatic terrain of the region, its mountain ranges, and vast open stretches. Yet for the most part these are the backdrops for the daunting labour required to complete the highway or for the soldiers who undertook the work. Typical of the latter is Nicholas Morant's depiction of US Army

Private Elbert Pieper standing sentry outside a log hut housing construction supplies (fig. 4.2).[17] Mockingly adorned with signposts identifying this remote spot as the corner of Main and Broadway, it stands on barren ground, an army tent in the distance. Morant has framed the scene distantly to accentuate a sense of vast territory; at the same time the vista is intended to highlight the achievement of the construction project, taming the land for military and future economic progress.[18]

## Landscape and the Photo Story

By the 1950s, landscape would come into focus in Still Division work. A 1958 photo story "From Sea to Sea …," for example, cites historian Arthur Lower and states: "Canada … had sought and found a new consciousness – a national spirit – in the land which gave her birth."[19] Photo stories and individual photographs of this time promote tourism with romanticized depictions of the country's national parks and scenic destinations such as Percé Rock and Niagara Falls. Yet, surprisingly, these sites did not constitute the majority of landscape representations of the time. Instead, the division maintained the wartime tendency to picture the environment in productive terms, and so the land is often tied to an economic picture of the nation. This is particularly evident in photo stories, the division's chief vehicle for its ubiquitous and familiar banal nationalism over much of its history. Among the three predominant photo-story themes – individual or institutional achievement, the country's diverse cultural makeup, and natural resources – it is within the last group that landscape reappears time and again as a consistent visual element. In depicting forestry, agriculture, fisheries, and mining, these stories served to promote the Canadian economy within the country and internationally.

A brief discussion of one Still Division photograph from this period illustrates how the landscape images represented

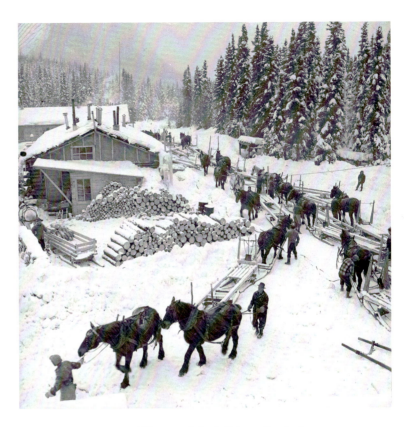

4.3 "Chantier Coopératif," Laurentide Park, Hébertville, Quebec, January 1955. Photograph, Gar Lunney.

economic abundance in the postwar period. During the winter of 1955, staff photographer Gar Lunney shot a lyrical view of a lumber camp in Quebec (fig. 4.3). Taken from an elevated vantage point, the image is of a trail of horses pulling wagons through snow to collect logs in the bush. It offers a vista of a productive and vast land. With no modern machinery in sight, it is a vision of rustic life. Here some of the standard devices of landscape representation – the distant and sharply perspectival view and the cropping of

treetops in the distance – emphasize a sense of capaciousness. The image demonstrates a certain cultural bias: it might be seen, for example, as a romanticization of the Canadian lumber industry by omitting vestiges of industrialization as well as evoking the work of painters like Cornelius Krieghoff and calling forth what Daniel Francis has termed a "folkloricization of Quebec culture."[20]

But it would be misleading to read Lunney's photograph in isolation. This image was one of seventy he shot in January 1955 at the Chantier Coopératif logging camp in Laurentide Park in Hébertville.[21] Its eventual public, too, would have experienced the image within the context of other images and words. It was made during the production of the NFB film *Chantier Coopératif* ("Lumberjack," in the NFB's English translation) and, like photographs of the same subject by Herb Taylor, may have been intended to supply stills for the film. But the photograph was also used prominently by the division in a 10 April 1956 photo story entitled "Still Number One Product" (fig. 4.4), promoting Canada's lumber industry. This story includes two images by Lunney (the lead image at upper left and another at lower right) along with four photographs by freelancer G. Milne. Here Lunney's photograph of horses hauling logs takes on a new appearance and meaning. In the most obvious manipulation, the negative has been flipped to better fit the standard format of NFB photo stories. Placed at the upper left of the layout, this image functions as "that number one picture in the photostory ... a stopper,"[22] as Lunney himself later termed it, and what his colleague Chris Lund described as the layout's "lead picture." That image now gracefully guides viewers toward the other images and text, directing them to perceive the whole as a coherent narrative. Five other images are featured in two registers; the two at top, including the image of horses at a camp, fill half the page, while the four below – including three by freelancer G. Milne and one by Lunney – are smaller vignettes. Two images of logging machinery (upper right and

lower left) were not made at Hébertville: taken by Milne, they are from an entirely different shoot. Within the photo story, however, these disparate images merge to accentuate the pure machismo of logging. In an inversion of the preceding chapter's discussion of women in industry, these images too show how the division depicted labour in gendered terms. Not only are the key protagonists "husky lumberjacks" (as the captions tell us) but machinery and the scale of their work is highlighted. One of Milne's photos offers a visual roster of the loggers' breakfast, an artery-clogging array of eggs, sausage, toast, pancakes, and more. The text separating the registers and providing additional captions for the smaller photographs "anchors" the message of logging's economic and physical enormity:[23] "Today, thirty-seven per cent of Canada is covered with vast stands of trees, and the forest industries, an annual $2 billion dollar operation, are still the barometer of Canadian prosperity. Operating from lumber camps and company logging towns from New Brunswick to British Columbia, an army of 230,000 bush-workers each year invades the snow-covered forests for cutting operations. The insatiable world demand for newsprint, lumber and pulp products keeps both lumbermen and engineers, racing at top speed to produce more wood ... Pulp and paper is Canada's leading industry, supplying more than half the world's newsprint needs." As in all photo stories, the context provided by words, images, and layout effectively guides readings of the landscape photograph at upper left. That solitary rustic scene has come to promote the nation's lumber industry as a prosperous, inherently masculine, and quintessentially Canadian undertaking.

In natural resources photo stories, dominant landscape views were pivotal to the messages they conveyed (figs. 4.5, 4.6). They arrested viewer attention while ostensibly providing credible information about the industry featured, offering geographical context and detailed visual data. Of course, they were also effective promotional devices. The sheer scale

72535

# Still Number One Product

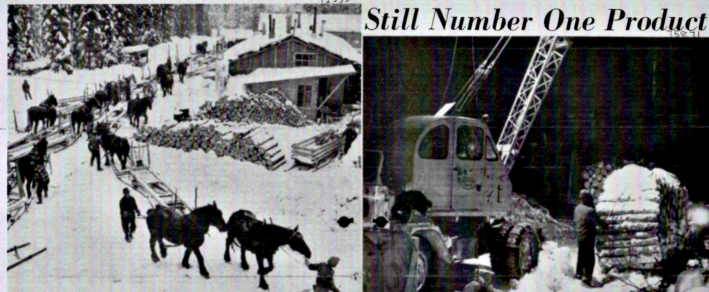

75871

75870

75869      75868

75876

72495

Though the jet age is upon us, wood is still the Number One product today, as it was 150 years ago when Napoleon's wars put Canadian pine in such demand that it started this nation growing on a solid foundation of wood. Today, thirty-seven per cent of Canada is covered with vast stands of trees, and the forest industries, an annual $2 billion dollar operation, are still the barometer of Canadian prosperity. Operating from lumber camps and company logging towns from New Brunswick to British Columbia, an army of 230,000 bush-workers each year invades the snow-covered forests for cutting operations.

The insatiable world demand for newsprint, lumber and pulp products keeps both lumbermen and engineers racing at top speed to produce more wood. In vast forest stands where 500-year-old trees tower as high as 200 feet into the air, logging methods are becoming more and more mechanized, and the bulldozer today is as much a symbol of modern logging as the axe and saw. Day and night production in woods operations is helped by this giant loading crane, here loading one cord of 4-foot logs onto truck. Pulp and paper is Canada's leading industry, supplying more than half the world's newsprint needs.

"The Logger", a new type machine developed by the Canadian Pulp and Paper Association in co-operation with paper companies, discharges its load of pulpwood logs down the steep banks of Ontario's Black River. With logging operations in 7 out of 10 provinces, the pulp and paper industry is first in employment with an annual $380 millions payroll.

Healthy appetites and hearty meals go hand in hand with strenuous bush work. To the husky lumberjacks, a good cook is the most important man in camp. Food above represents actual daily ration for one man, contains 5800 calories. Canadian pulp and paper companies spend an annual $20 millions on top quality food.

National Film Board Photos.

Pulpwood logs, ready for hauling, are checked by a government licenced scaler. Though still used in some northern woods operations, bush horses are slowly giving way to mechanized logging methods developed by Canadian pulp companies. Latest development is "The Logger", designed to speed pulpwood harvest from woodlands to mills.

In the great coniferous forests of Ontario, Quebec and New Brunswick, logging operations are carried out by 90 pulp and paper companies. Wood cut during winter is stacked near frozen lakes and rivers and in spring, skilled river-drivers herd an annual 12 million cords of pulpwood to mills in one of Canada's most spectacular industrial operations.

4.4    Photo Story 51, "Still Number One Product," 10 April 1956. Photographs, Gar Lunney (*upper left and lower right*) and G. Milne (*remaining four*); text uncredited.

63-6933    63-6942

## Le Canada, leader mondial d'un minéral
# L'amiante, magicien des minéraux

Quand le voyageur vénitien Marco Polo revint de ce qui est maintenant la Sibérie, il raconta une histoire bizarre à propos d'un tissu qui, "mis dans le feu", en ressortait intact et "blanc comme neige". Comme bien d'autres avant lui il avait, dès le 13e siècle, été témoin de la magie de l'amiante. Et voilà que depuis ces temps lointains, ce minéral que l'on qualifie à juste titre de magique vient jouer un rôle de première importance économique pour le Canada en le plaçant chef de file des producteurs mondiaux d'amiante.

Les mines canadiennes d'amiante ont expédié en 1962 plus d'un million de tonnes de fibres évaluées à près de $150,000,00. La mine canadienne la plus importante est la Jeffrey située à Asbestos dans les Cantons de l'Est au Québec. L'optimisme prudent des producteurs du Québec s'appuie sur une amélioration constante des ventes de fibres brutes

Des trous sont perforés en vue du dynamitage. La pelle mécanique, à l'arrière-plan, prend six verges carrées de matière.

aux Etats-Unis. Ces derniers absorbent chaque année plus de 50 pour cent de la production totale du Québec. Cet optimisme est également justifié par la vigueur soutenue des marchés d'outre-mer. Soixante pays à travers le monde achètent l'amiante canadien. Mais plutôt que de compter sur l'expansion normale des affaires pour compenser certains ralentissements possibles, les producteurs du Québec, qui représentent 95 p. cent de la production nationale d'amiante, se tournent avec réalisme vers les nouveaux usages de ce minéral.

PHOTO-REPORTAGE DE
L'OFFICE NATIONAL DU FILM

Il faut 48 bobines à tresser pour fabriquer cette matière à isolation sur laquelle travaille une ouvrière à Asbestos, Qué.

La mine à ciel ouvert Jeffrey, à Asbestos, dans la province de Québec, est la plus grande mine d'amiante du Canada, chef de file des producteurs d'amiante du monde.

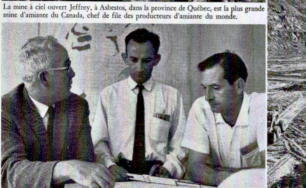

Ce sont ici trois des responsables de la mine Jeffrey d'Asbestos, Qué. De gauche à droite: H. H. Waller, surintendant, J.-D. Richard et Melvin Storrier, ingénieurs.

Des camions d'une capacité de 35 tonnes sont chargés à l'aide de pelles mécaniques électriques. Toutes les mines d'amiante canadiennes sont maintenant à ciel ouvert.

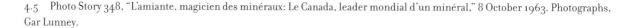

L'amiante brut est traité à Asbestos même. Concassé, il est séparé de ses fibres et mis en sacs de 100 livres.

4.5    Photo Story 348, "L'amiante, magicien des minéraux: Le Canada, leader mondial d'un minéral," 8 October 1963. Photographs, Gar Lunney.

# Le Canada possède 300,000 milles carrés d'eau douce

## L'eau potable, sang du Canada

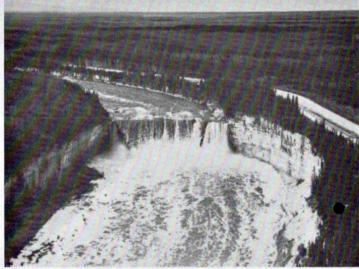

Les chutes Alexandra sur la rivière Hay dans les vastes Territoires du Nord-Ouest. Cette rivière se déverse dans le Grand Lac des Esclaves qui mesure 11,000 milles carrés et d'où le majestueux fleuve Mackenzie, long de 2,600 milles, prend sa source. (*en bas, au centre*)

C'est une caractéristique de notre espèce d'accepter les choses familières qui nous entourent comme si elles nous étaient attribuées de droit naturel ou divin. A ce sujet, le Canadien se rend-il compte que son pays possède le tiers des réserves d'eau potable du monde entier, soit 300,000 milles carrés d'eau douce. Se rend-il compte lorsqu'il se baigne, qu'il boit ou qu'il est à la pêche, que l'eau est un problème vital pour lui et que des spécialistes du gouvernement sont sans cesse aux aguets pour la protéger, pour la purifier. La consommation de l'eau au Canada dépasse toute imagination. Selon les spécialistes, une grande ville dépense 120 gallons d'eau par habitant par jour.

Ce n'est donc pas pour rien qu'un ancien député disait déjà que "l'eau potable est le sang du Canada". Aussi, sur le seul plan du prestige international du Canada, un ancien politicien n'avait-il pas dit que "l'eau potable est la meilleure arme que le Canada puisse posséder pour négocier la survie de son

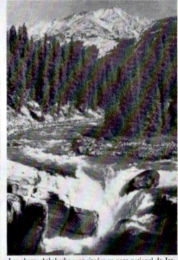

**PHOTO-REPORTAGE DE L'OFFICE NATIONAL DU FILM**

identité avec l'extérieur".

L'eau demeure donc une grande nécessité pour la survie d'une nation. Elle est nécessaire. On ne peut s'en passer. Aussi les efforts du gouvernement canadien sont-ils considérables en ce qui touche la conservation et l'amélioration d'une ressource naturelle aussi importante que l'eau.

Crépuscule sur le lac Coon dans la région des lacs Kawartha en Ontario. Cette scène se réédite à des milliers d'exemplaires de Terre-Neuve à l'île de Vancouver.

Torrent sinueux près du lac Bernie au Manitoba. Dans certaines régions du Canada, la superficie couverte par les nombreux lacs est presque égale à celle des terres.

Les chutes Athabaska sont situées au parc national de Jasper en Colombie-Britannique.    *texte: Gaston Lapointe*

4.6    Photo Story 423, "L'eau potable, sang du Canada: Le Canada possède 300,000 milles carrés d'eau douce," 16 August 1966, Photographs, George Hunter, Ted Grant, Chris Lund, Neil Newton; text, Gaston Lapointe.

of the sites depicted in virtually all natural resources photo stories signalled a sense of natural plenitude. The grand vista came to function as something of a pictorial analog to economic prosperity.

In addition, this emphasis on the image of the land met the NFB's and the division's overall mandate to construct a pictorial and textual rhetoric of national unity. These images achieve that lofty goal in several ways. Most obviously, they draw on the loaded symbolism of the land as a marker of national identity. In addition, they generally function as synecdoche: specific terrains come to stand in for the whole – not only the whole of an industry, such as the lumber industry, or a particular region of the country, but often the entire country. Photo stories regularly minimize specific references to site and date; accordingly, they are read as symbolic of the nation as a whole. Similarly when individuals are presented, they usually appear as relatively interchangeable archetypes. This suppression of specifics and emphasis on typologies also had more pragmatic ends: images that were not exclusively associated with a specific series of current events could be readily reused in different contexts. In short, as discussed earlier, they were inherently "mobile," and their effectiveness as forms of banal nationalism was in part dependent on that mobility.

While the landscape format in photo stories devoted to the country's natural resources proved useful to the division's promotion of a unified Canada, it was also the site for enacting mastery over the land. Much recent scholarship on the representation of the land has exposed the complex ways in which landscape as a category symbolizes and also enacts colonialist desire.[24] As W.J.T. Mitchell argues, "the representation of landscape is not only a matter of internal politics and national or class ideology but also an international, global phenomenon, intimately bound up with the discourses of imperialism."[25] By invoking landscape's scopophilic possession of territory, the division's photo stories "naturalize" governmental reminders of nationhood.

A 22 July 1957 photo story on farming, "Revolution on the Prairies" (fig. 4.7), for example, exploits the gaze and landscape motifs to assert a sense of natural abundance and to endorse agricultural technology. The arrangement of six photographs by Richard Harrington includes stills from the 1955 NFB film Prairie Profile commemorating Saskatchewan's Golden Jubilee.[26] The story revolves around the figure of Saskatchewan wheat farmer Ed Schiefner. Presented as an archetypal prairie farmer, Schiefner is featured in a prominent and deferential portrait at upper right. He is also seen over the course of a supposedly typical day, cutting wheat, stacking bales, and eating with his family. Images devoted specifically to the Schiefner family are augmented with those of a larger-scale farming operation and an aerial view of grain elevators at Port Arthur (now Thunder Bay), Ontario. The photographic gaze prominently exploits sweeping vistas and aerial views. This is particularly apparent in the top left perspectival view of the crop being cut on a seemingly endless plain (fig. 4.8) and in the lower right vista of grain elevators on Lake Superior. These images signal enormous scale and wealth but also the sheer power of modern machinery. (The accompanying captions stress the "mechanization" and "modern conveniences" available to prairie farmers.) At the same time, the views also provide a sense of scopic possession. The lead picture of Ed Schiefner, placed at the upper right, compounds this. He is viewed from below, a convention in portraiture that enhances the subject's stature and enacts viewer respect. The layout has been designed so that Schiefner seems to gaze across his land with a look of satisfied pride. We join him in that gaze, for his image functions as a surrogate for the viewer. Accompanying text augments the pictorial message of economic prosperity, the language emphasizing enormous scale through specific quantities and statistics, as in the photo story on lumber cited above. Here, Schiefner's 1,440-acre farm is noted, as is the Port Arthur storage facility with a "capacity in excess of 90 million bushels."

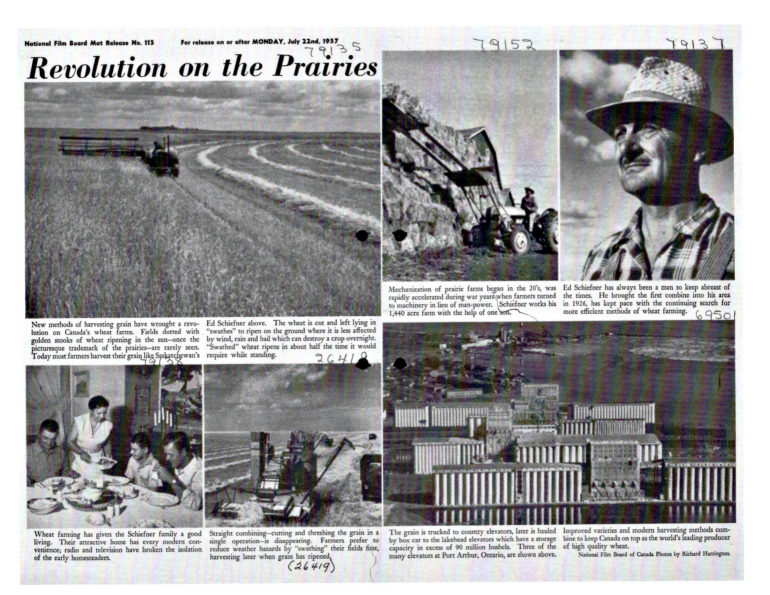

# Revolution on the Prairies

New methods of harvesting grain have wrought a revolution on Canada's wheat farms. Fields dotted with golden stooks of wheat ripening in the sun—once the picturesque trademark of the prairies—are rarely seen. Today most farmers harvest their grain like Saskatchewan's

Ed Schiefner above. The wheat is cut and left lying in "swathes" to ripen on the ground where it is less affected by wind, rain and hail which can destroy a crop overnight. "Swathed" wheat ripens in about half the time it would require while standing.

Mechanization of prairie farms began in the 20's, was rapidly accelerated during war years when farmers turned to machinery in lieu of man-power. Schiefner works his 1,440 acre farm with the help of one son.

Ed Schiefner has always been a man to keep abreast of the times. He brought the first combine into his area in 1926, has kept pace with the continuing search for more efficient methods of wheat farming.

Wheat farming has given the Schiefner family a good living. Their attractive home has every modern convenience; radio and television have broken the isolation of the early homesteaders.

Straight combining—cutting and threshing the grain in a single operation—is disappearing. Farmers prefer to reduce weather hazards by "swathing" their fields first, harvesting later when grain has ripened.

The grain is trucked to country elevators, later is hauled by box car to the lakehead elevators which have a storage capacity in excess of 90 million bushels. Three of the many elevators at Port Arthur, Ontario, are shown above.

Improved varieties and modern harvesting methods combine to keep Canada on top as the world's leading producer of high quality wheat.

National Film Board of Canada Photos by Richard Harrington.

4.7    Photo Story 115, "Revolution on the Prairies," 22 July 1957. Photographs, Richard Harrington.

4.8   Wheatfield, 1957. Photograph, Richard Harrington.

A sense of scopic possession is also apparent in numerous natural resources photo stories. From the 1956 photo story "Custom Built for Industry: Annacis Island, New Westminster, BC" to 1965's "The Rich Earth" / "Le blé canadien dans 50 pays" (see figs. 1.17 and 1.18) and "From the Fertile West: Golden Grain for Global Markets," landscape views regularly signify economic prosperity. These pictorials extol the land's great abundance while suggesting that those potential riches are unleashed only through technological expertise. At the same time, they imply that this expertise is the domain of Euro-Canadians, who are virtually the exclusive subjects of natural resources photo stories. Indeed, Aboriginal peoples are almost entirely excluded from photo stories depicting Canadian natural resources. Instead, Aboriginal subjects – even those about harvesting foods – are segregated into ethnographically oriented narratives.

A 1964 photo story on Arctic char fishing near Pelly Bay, just outside the Arctic Circle, in many respects typifies division representations of Aboriginal peoples (figs. 4.9 and 4.10). This pictorial features five photographs by freelancer Doug Wilkinson under the title "Age-Old Hunt for Fabled Fish of Canada's North: SAPOTIT – Where the Char Run Big." Each image portrays Inuit fishermen in their sapotit, a stone weir to confine fish, and with their catch. The contrast of this spread to "Revolution on the Prairies" is striking. Instead of grand vistas of the open prairie, we have claustrophobic views; instead of pictorial order, disarray; instead of emphasis on the latest in technology, the text points to "age-old" procedures and tools. Indeed, the images and accompanying text in the Pelly Bay photo story go to great lengths to emphasize the "primitive" character of Inuit tools and methods. We are once again introduced to a central protagonist, the fisherman Iteemangnak. His portrait (see fig. 4.10) too is featured prominently as a means of personalizing what is posited as a broader phenomenon. At the upper left directly below the title, Iteemangnak is, however, pictured at a less deferential angle than Schiefner. Rather than contemplatively surveying the land and thereby signalling a sense of domain over it, Iteemangnak looks toward – though not directly at – the viewer. Schiefner's serious countenance is replaced with an awkward smile. Iteemangnak appears as the object of the viewer's gaze, not, like Schiefner, a surrogate

National Film Board Photostory No. 365    For Release on or after TUESDAY, June 2, 1964

64-2338

## Age-Old Hunt For Fabled Fish of Canada's North

# SAPOTIT - Where The Char Run Big

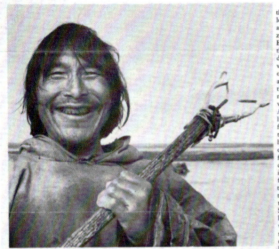

Eskimo hunter Iteemangnak, holding his fish spear constructed of musk-ox horn prongs bound onto a wooden handle with sealskin thongs, is delighted at his catch.

As the sky-circling sun of the arctic summer skims ever-lower during its midnight arc across the northern horizon, families of Canadian Eskimos head inland. With the sun's long, drawn out, day-by-day farewell giving warning of yet another far-off winter to be provided against, the hunters, living in the ways of their forefathers, make for the ice-cold rivers where the big fish gather. As glistening, sleek, fat-bellied arctic char leave ocean feeding grounds to shoal in the river waters, the Eskimos build stone walls in the icy current to trap the succulent fish. For days men toil waist deep in the frigid pools, piling rocks against the river's flow. When all is ready and the fish are trapped, hunters take their spears, wade among them in great excitement. Small fish and agile fish are lucky. Through holes in the weirs and by leaping the stones they break free to continue up-river. Numbed by the water's chill, the hunters drag their catch ashore for cleaning, set aside tasty fish bellies for future feasts, eat a few fish raw as they work away. Later,

placed in piles and covered by rocks, the fabled fish of the north—a staple food in times of want—is cached for the winter sustenance of man and dog.

**NATIONAL FILM BOARD PHOTOSTORY**

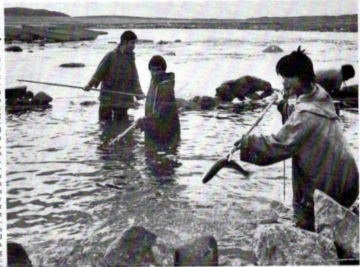

A dozen miles upstream from salt water, near Pelly Bay, 100 miles inside the Arctic Circle, Eskimos spear fish at a *Sapotit*—fishing site. Stone walls of trap must be rebuilt each year in icy water.

Iteemangnak, his wife Panneeak and their son pull catch to river bank for cleaning.

As char runs increase in size, catches of fish mount up in front of Eskimos' seal and caribou skin tents. Fish are cached under rock piles to await winter's need.

One of the women, with child on her back, at work spearing arctic char — a succulent fish of the salmon family that vies with its Atlantic cousin as a delicacy.

4.9   Photo Story 365, "Age-Old Hunt for Fabled Fish of Canada's North: SAPOTIT – Where the Char Run Big," 2 June 1964. Photographs, Doug Wilkinson.

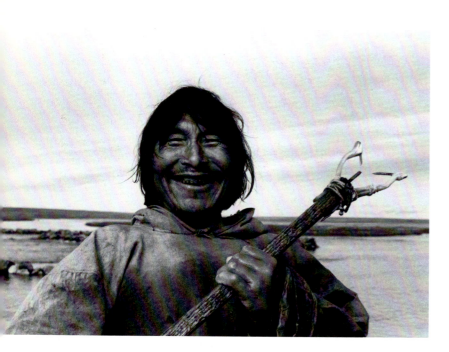

4.10   "Eskimo Fisherman Holding Fishing Spears," August 1963. (Inuk man identified in photo story as "Iteemangnak.") Photograph, Doug Wilkinson.

for "our" presence. Iteemangnak's fellow fishers are viewed from above and at somewhat of a distance – the division's standard vantage point of supposed objectivity, unobtrusiveness, and authority in its still photographic translations of expository documentary. In this case, the photographs diminish the apparent stature of the people portrayed while situating the implied, non-native viewers at a cultural remove, endowing them with a superior, caretaking role.

Here as in many other photo stories addressing Aboriginal subjects, First Peoples are associated with the land pictorially, textually, and temporally. However, rather than asserting domain over nature, like the Euro-Canadians depicted in natural resources photo stories, Aboriginal peoples appear

encompassed by terrain. The caption for the 1964 story featuring Iteemangnak states: "As the sky-circling sun of the arctic summer skims ever-lower during its midnight arc across the northern horizon, families of Canadian Eskimos head inland. With the sun's long, drawn out, day-by-day farewell giving warning of yet another far-off winter to be provided against, the hunters, living in the ways of their forefathers, make for the ice-cold rivers, where the big fish gather … For days men toil waist deep in the frigid pools." The Inuit fishers and their families portrayed here have become the objects of a controlling colonial gaze – enacted literally in visual terms and more metaphorically by text – as surely as the land and the sea. They are at one with the land, not so much human beings as anthropomorphized elements of nature itself.

This photo story situates Aboriginal peoples in and as nature but also at a distinct temporal remove from their presumed southern and Euro-Canadian viewers and from division staff. The title, "Age-Old Hunt for Fabled Fish of Canada's North," signals the temporal framing of Aboriginal culture at the outset. The modifier "age-old" suggests that this is not a contemporary scene but a glimpse into a past culture. This tendency to situate Aboriginal culture in the past occurs repeatedly in division pictorials.[27] A 2 May 1961 photo story on the Kainai Nation's Natoosi (Sun) Dance near Calgary, for example, includes five photographs of people referred to as the Bloods of the Blackfoot Confederacy (figs. 4.11 and 4.12). The story uses promotional stills for the NFB film *Circle of the Sun*.[28] A photograph of an encampment of tepees in panoramic landscape format fills the bottom register of the layout. The original image (see fig. 4.12) has been cropped dramatically to create the effect of a horizontal expanse. Like the depictions of Iteemangnak and the other Pelly Bay fishers, the image presents the Kainai as encompassed by the earth. The four remaining photographs depict band members in traditional dress singing or performing

*97133*    *97132*    *97118*

# *Blood Indians Dance to Natoosi*

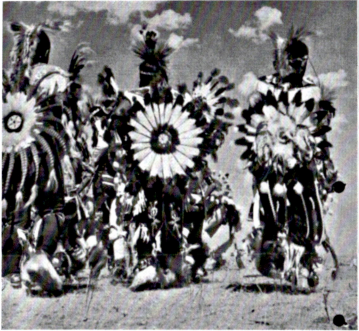

On the last day of the camp, the young come. Young boys dress up in the bright beads and colours of yesteryear. Old women pound ceremonial drums. Chiefs in white buckskins and full head-dress watch with silent pride.

Sun Dance—homage to Apistoki—the creator, to Sapaitapia—source of life, to Natoosi—the sun. In the deep summer of each year, the Blood Indians of Alberta hold their ritual dance. With rhythmical stomp and whirl, shuffle and leap, chant and drum beat, a culture comes to life, evoking a far-off time and space when vast herds roamed vast distances and lithe Indians astride arrow-swift horses brushed aside the wind and lived perhaps the freest life man has ever known.

National Film Board of Canada Photos by Erik Nielsen.

Below, the camp on the reserve near Calgary. The bands of the Blackfoot Confederacy once met in camp each summer to hunt buffalo for the year. Today, the Bloods are farmers and ranchers; their young braves win their spurs at rodeos.

In the main tepee in the centre of the camp the wail and chant of ancient songs rises and falls on the stillness of the summer night. Only the old, the initiated, the invited, are allowed here. The young Bloods sleep, lulled by an echo from the storied past.

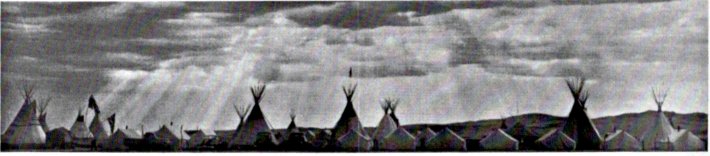

4.11    Photo Story 284, "Blood Indians Dance to the Natoosi," 2 May 1961. Photographs, Erik Nielsen.

4.13   *Canada: A Year of the Land*, 1967.

for example, offered the repeated geographical chant "north south east west … nord sud est ouest" to define the nation, while the Centennial Train coursing across the country drew attention to its dramatic terrain as a distinguishing national feature.[36] One of the most celebrated of the many centennial references to Canada's territorial expanse was the division's lavish book, in its English version, *Canada: A Year of the Land*, and in French, *Canada, du temps qui passe* (fig. 4.13 and see fig. 4.1).[37] The book and the exhibition of the same name interwove seductive colour images with the potent nationalism of landscape and temporal references to situate Canada as unified and stable. They replaced the photo story's emphasis on landscape as a signifier of economic potential with aestheticism. At the same time, their portrayal of an evacuated land idealized the nation and erased Aboriginal presence.

The division had never before undertaken a project on such a scale.[38] In July 1965, the Interdepartmental Committee on the Centennial Celebrations recommended to Treasury Board an allocation of $554,500 for the book, an amount that dwarfed the division's operating budget in the mid-1960s.[39] The same memorandum, apparently based on a draft written by Lorraine Monk, stressed the project's status: "This book is envisaged as the ultimate in a Centennial prestige publication. No such book has ever been produced in this country. [It] is to be a book worthy of presentation by our Prime Minister to any Head of State visiting Canada. We expect to draw upon the finest photographers, best writers, and most competent typographers to assist in the production of this book. It will, in effect, be the first time that the Government of Canada has considered producing a meaningful book about its own country which will have been executed with the highest degree of technical skill and fine craftsmanship."[40]

*A Year of the Land / Temps qui passe* was promoted widely in publicity and archival records as a "prestige" publication drawing on the "highest level of literary skills, photographic achievement, typography, layout and graphic design."[41] In invoking a sense of luxury, skill, and elevated status, Monk clearly sought to imbue the nation with those same values. The two volumes were, indeed, used quite directly to promote Canada on the international stage: 484 copies were given as presentation albums to such visiting dignitaries as Indira Gandhi, Chou En-lai, and Elizabeth, the Queen Mother.[42] Within Canada, a volume (along with copies of the division's other centennial publications) was presented to Pierre Elliott Trudeau when he became prime minister in 1968 (fig. 4.14).[43]

As with all division projects, this was a group effort; however, because of the enormous scale and high profile of the project, it was unprecedented in the large and skilled team who contributed to it. Within the division itself, Monk and

Norman Hallendy were chief contributors to the project, working together closely, with Hallendy credited as the curator of the exhibition version. Rather than rely on Chris Lund and Gar Lunney or other familiar division photographers, Monk and Hallendy sought out a new generation of photographers working largely in colour. They reached out to photographers in part through newspaper advertisements and personal contacts.[44] In total, seventy-six photographers contributed to *A Year of the Land / Temps qui passe*'s 260 images. Amateurs were included, but professional photographers dominated. John De Visser and Freeman Patterson were responsible for almost half the volumes' visual content, each contributing fifty-four images. Indeed, this exposure essentially launched Patterson's career as a popular landscape photographer.[45]

Monk recognized early on that achieving the "highest level of … typography, layout and graphic design" in the publications would necessitate going outside the division and the Queen's Printer, publisher of federal government documents. To this end, she hired Allan Fleming (fig. 4.15), already well known as an innovative designer with connections to the Liberal Party. At the time that he took on the commission, Fleming was vice-president and creative director of Maclaren Advertising in Toronto and a designer for such prominent and nationalist institutions as the Hudson's Bay Company and *Maclean's* magazine. But he was perhaps most familiar as a designer for CN Rail and responsible for its iconic logo.[46] His contributions were pivotal to the success of the division's ambitious project, and his involvement extended well beyond that conventionally undertaken by a book designer. He proposed the title of the English volume, *Canada: A Year of the Land*,[47] developed an initial sequencing of the images,[48] and even insisted on cuts to the French text.[49] In recognition of his extraordinary engagement, he was given equal credit with the authors in the volumes' front matter. In turn, he secured the involvement of the firm

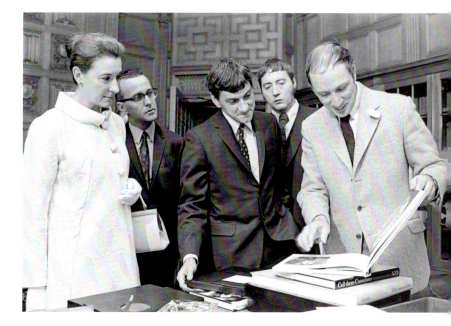

4.14 "Presentation of centennial books to Prime Minister Trudeau, May 1969." Photograph, Crombie McNeill.

Cooper & Beatty for typesetting and worked closely with the Carswell Printing Company, which had competed for the contract with several other firms.[50]

Monk commissioned Bruce Hutchison to write text for the English edition and Jean Sarrazin for the French. Hutchison was a well-known journalist affiliated with the *Vancouver Sun*. He had come to national prominence in the early 1940s with the publication of *The Unknown Country*, a book-length meditation on Canadian identity organized as a travelogue of the country.[51] Sarrazin, who coined the title for the French volume, was lesser known to division staff in Ottawa,[52] but his experience at Radio-Canada with programming aimed at introducing international audiences to Canada situated him well for this nationalist project.[53]

4.15 "Mrs. Lorraine Monk speaks with Officials of the Carswell Printing Company," 1967. (Allan Fleming and Lorraine Monk working on *Canada: A Year of the Land*.) Photograph, John Reeves.

Working to a tight deadline, this team produced *A Year of the Land / Temps qui passe* for the major centennial celebrations slated for Dominion Day, 1 July 1967. Officially the volumes were not launched until 29 August, at the opening of the project's exhibition. This vernissage, a lavish, black-tie affair officiated by Secretary of State Judy LaMarsh, also marked the initiation of the Government Photo Centre Picture Gallery on Kent Street in downtown Ottawa, the first exhibition space devoted to photography in Canada.

While popular accounts lauded the event and the Hallendy-curated exhibition as celebrations of Canadian achievement, full enthusiasm was reserved for the two publications.[54] Fittingly in "landscape" format, *Canada: A*

*Year of the Land* and *Canada, du temps qui passe* are twelve-by-fifteen-inch folios. Each contains almost 300 pages, comprised largely of photography; of the 260 photographs, 224 are in vivid colour, with an additional thirty-six black-and-white (gelatin silver) images interspersed dramatically among them. Reflecting their status as "prestige" publications, the volumes were bound in imported Sorrento linen and cased in a specially designed box. Each side of the box is embellished with a photographic reproduction from the volume, one depicting a winter vista and the other a sunny autumn day; both are by photographer John De Visser.[55] Although priced at a then-costly $17.35, the first edition of 25,000 quickly sold out.[56] While the lavishness of the production differs significantly from the more mundane presentation of division images in photo stories, the mass distribution of these picture books also served as banal nationalism, providing familiar markers of nationhood on a mass scale.

The titles, *Canada: A Year of the Land* and *Canada, du temps qui passe*, both play on the temporal. The organization of the volumes follows the annual cycle of seasons (and life); each of the four sections is introduced by text, followed by photographic reproductions. The reader is led from "Spring"/"Printemps" to "Summer"/"Été" to "Fall"/"Autumn" to "Winter"/"L'hiver." The pictorial content opens and closes with the same image – Chris Bruun's photograph of a duck on Boag Lake, Alberta, taking to the air or landing, depending on one's reading – underscoring the cyclical organization (fig. 4.16).[57] The temporal is marshalled effectively to assert Canada, the nation, as eternal and cohesive. This perspective is in sharp contrast to division photo stories of the 1950s and early '60s addressing Aboriginal peoples, which had the effect of othering their subjects by denying "coevalness." Here Hutchison's English text announces that "the spring does not change. The land does not change nor the fierce life within it."[58] Hutchison evokes a sense of the

Canadian land, and therefore the Canadian nation itself, as eternal. Sarrazin also lyrically conjures a sense of Canada as eternal: "C'est le sacre du printemps. Le baptème de l'année nouvelle, l'eau lustrale qui coule enfin. 'La debacle,' s'écrient les Canadiens quand le grondement se rapproche … La vie reprend son fil."[59]

Such universalizing references to the cycle of the seasons are underscored by the design of the text. In selecting the typeface Lucia (fig. 4.17), a form of Spencerian script, Fleming argued that what this letterform "requires of the reader is a slowing down of his reading pace. [*A Year of the Land / Temps qui passe*] is essentially a non-verbal book with a small amount of mood-setting text. It is a book to be perused, not gobbled. And for that reason I do not feel the normal demands of instant legibility apply."[60] Rather than providing "instant legibility," the typeface slows the process of reading, thereby emulating and enhancing the sense of the eternal at the core of the book's textual and pictorial content.

Monk's decision to organize the volumes temporally occurred early in the process. As with other centennial projects (see chapter 5), she may have been influenced by Edward Steichen's *The Family of Man* (1955), designed around the course of a life cycle. Another clear source for the book's organization and aesthetic is *In Wildness Is the Preservation of the World*, featuring photographs by Eliot Porter and the verse of David Henry Thoreau.[61] This 1962 Sierra Club coffee-table book follows a seasonal cycle and features sublime colour photographs to promote environmental preservation; at the same time, as Finis Dunaway has shown, the book "imagines nature as a space that lies outside the fell clutch of humanity."[62]

*A Year of the Land / Temps qui passe* uses similar discursive strategies in the service of nation building. In a 1965 letter to Hutchison, Monk stated quite explicitly that using the temporal as a basic organizing principle was intended to foster a sense of cohesive national identity:

*Winter*

*In the wintertime, and only then, the Canadian sees the full dimension of his country, reduced to essentials.*

4.16   "Boag Lake, Alberta," June 1966, *Canada: A Year of the Land*. Photograph, Chris Bruun.

4.17   "Winter," *Canada: A Year of the Land*.

My preference for arranging the photographs by season or month, rather than by region, is that I like to see pictures of Spring in Vancouver sitting side by side with pictures of Spring in St. John's, Newfoundland – or a winter shot from Tisdale, Saskatchewan, coming hard

on the heels of a winter shot of Joliette, Que. In this way, I would hope, the viewer would relate to the country as a whole – rather than concentrating on his own particular province or region. In so many picture books on Canada, the illustrations have run like a C.P.R. track right across the country from east to west, so that the man in Newfoundland is left with the indelible impression that British Columbia is a heck of a long way away. One of the purposes of the book is to help Canadians feel a sense of identity with all other parts of the country and I think this is only possible if we break the provincial or regional layout of pictures so often employed in the past.[63]

By minimizing specific – and potentially regionalizing – references, the volumes' overall temporal organization reflects the NFB's long-standing mandate of promoting and fostering national cohesion. Like the natural resources photo stories discussed earlier in this chapter, the centennial landscape books conjure a sense of a harmoniously and idealistically unified Canada.

The use of the temporal to serve the project of nationhood calls to mind Benedict Anderson's assertion that the nation creates coherence in part through simultaneous time: "The idea of a sociological organism moving calendrically through homogeneous, empty time is a precise analogue of the idea of the nation, which also is conceived as a solid community moving steadily down (or up) history. An American will never meet, or even know the names of more than a handful of his 240,000,000-odd fellow Americans. He has no idea of what they are up to at any one time. But he has complete confidence in their steady, anonymous, simultaneous activity."[64] By arranging *A Year of the Land / Temps qui passe* temporally, by season, Monk and her collaborators not only mitigate regionalism but also offer the experience of time as a commonality for the nation. In effect, the volume offers

up "homogeneous, empty time" as an analogy to the NFB's idealized model of a cohesive Canadian nation.

But it is in the volumes' landscape images that the use of the temporal and the potent symbolism of landscape is most seductive. Indeed, as Fleming noted, *A Year of the Land / Temps qui passe* is an "essentially … non-verbal book."[65] Each of the four quadrants is sequenced around the narrative of a season's passage, while also arranged formally to highlight the sensual experience of colour and visual form. The book's inherent formalism reflects the modernist turn that Monk made in the 1960s, while also effectively homogenizing the country's terrain so that "the viewer would relate to the country as a whole – rather than concentrating on his own particular province or region."[66] Signalling the cyclical and homogenizing effect, the volumes begin and end with Bruun's image of a duck taking flight. Moreover, although photographs make up the core of the volumes, the seventy-six photographers are barely acknowledged. No cut-lines or captions appear; instead an appendix and an insert provide lists of the photographs, each identified with statistical detachment simply by location and photographer's name.[67] The dates of the negatives are also omitted; this too has a homogenizing effect on the volume and the nation it represents.[68] By relegating many dozens of contributing photographers to an addendum, *A Year of the Land / Temps qui passe* is rendered as a singular, unified visual statement rather than the work of many potentially disparate visions. In this way again the volumes reflect the NFB's overall mandate to visualize a sense of national coherence or unity.[69]

A discussion of the final and culminating seasonal quadrant illuminates the volumes' use of landscape and temporal motifs. Hutchison pronounces winter as the quintessentially Canadian season: "Far more than spring, summer or autumn, winter makes the Canadian what he is, a northern creature exposed to cold for half his short spell on earth, whetted and toughened, outwardly and inwardly by brutal

temperature. Winter is the distinguishing, paramount fact of Canada, a writ running further than any statute. It penetrates all life, human, animal and vegetable. It shapes the nation's basic disposition and balances its spirit level."[70] Hutchison continues for ten more pages discussing winter sports and diversions as well as the harshness of a generalized North during this season. Sarrazin too invokes a sense of the harshness of winter as a defining characteristic of Canadian identity, now in starkly gendered terms: "L'homme canadien se trouve seul, face à la neige, sans recours, sans issue, sans fuite possible; seul, face à cette maîtresse abusive, dominatrice, ravageuse, qui lui barre l'horizon, qui prend tout et ne demande rien."[71] In effect, both authors evoke an imagined Canadian psyche defined and toughened by winter conditions.

The photographs that follow are sequenced to narrativize seasonal change, emphasize pure sensual experience, and construct a unified, idealized image of Canada. After the text, "Winter"/"L'hiver" opens with Bruce Weston's colour photograph of trees dusted by an early snowfall in Wascana Park, Regina (fig. 4.18).[72] The images that follow depict frost on foliage and peaceful prairie settings seen through a light snowfall, then crescendo to Freeman Patterson's dramatic image of a snow squall on the David Thompson Trail, Alberta (fig. 4.19). Bleeding to the edges of the page, this colour photograph epitomizes the formal properties of most images in this quadrant. Unlike the saturated colour seen in images selected for fall or summer, here the falling snow has the effect of muting the tonal and chromatic range. The composition is framed around a cabin, its steady perpendiculars contrasting the dynamic haze of snow etching diagonally across the picture plane.

Snow and ice dominate these images, rendering the land still and reduced to bare forms, as in Roloff Beny's image of a sunset over Great Slave Lake in the Northwest Territories, Peter Phillips's view of a frozen Dorwin Falls in

4.18   "Wascana Park, Regina," 1966, *Canada: A Year of the Land*. Photograph, Bruce Weston.

4.19 "David Thompson Trail, Alberta," September 1964, *Canada: A Year of the Land*. Photograph, Freeman Patterson.

Rawdon, Quebec, and T.W. Hall's image of bull and cow elk in Kootenay, BC (fig. 4.20 and see 4.1).[73] The final nineteen images in the quadrant reintroduce colour and a human imprint into the Canadian landscape. Freeman Patterson's image of a lone tree in West Saint John, New Brunswick, punctuates the quadrant: still wearing autumn colours against the spring snow, the sapling indicates a return to warmth and vibrancy that is underscored in the volume's final image, the recurrent photograph of a duck taking flight signalling the cyclical continuum.[74]

Few of the sites depicted in the sixty images in this quadrant are widely recognizable. As in the volume as a whole, the emphasis is on generic yet idealized scenes. Moreover, as Monk insisted in her 1965 letter to Hutchison,

the sequence does not lead the viewer on a clear geographical route across the country but is ordered by formal properties. An eccentric path takes the reader from Saskatchewan to British Columbia, across the prairies and on to Quebec, only to return to Alberta and continue back and forth across the country. Following Monk's intent, the sequence thus offers up a unified rather than regionalized vision of Canada.

While Hutchison's and Sarrazin's texts primarily address the seasonal experiences of the people of Canada, the pic-

4.20   "Kootenay, B.C.," October 1965, *Canada: A Year of the Land*. Photograph, T.W. Hall.

torial content has been virtually evacuated of all humanity. "Winter"/"L'hiver," for example, does reference a human presence, particularly toward the end of the section, in the images announcing the imminent arrival of spring; however, strikingly few people are depicted. Moreover,

the dozen images including evidence of human habitation often simply allude to people in muted ways: at a distance, in views of industry or housing without any individuals visible or blurred under a haze of snow or a screen of trees. Indeed, among division staff and collaborators, *A Year of the Land / Temps qui passe* was known for its virtual omission of people.[75]

This erasure of human presence, like the decision to eschew regional references, not only effectively homogenizes the nation but presents it from a settler perspective. As Eva Mackey has argued, during the second half of the twentieth century nature was often presented in Canadian nationalist discourse in terms of its harshness. In the work of Margaret Atwood and Northrop Frye published in the early 1970s, being lost in the wilderness and surviving that travail was offered up as an essential Canadian experience.[76] While Canadian "wildercentrism" is evident throughout *A Year of the Land / Temps qui passe*, the volumes' images equally emphasize a land cultivated and tamed by European settlement in recurrent renderings of neatly groomed wheat fields, scenic mountain paths, and fishing settlements. In short, while the sublime is evident among the images, as a whole they ascribe to a picturesque view in which "nature" has been tamed either by settlement or through the pictorial coding of the composition.[77] Numerous images of horses and horse-drawn carriages, for example, explicitly evoke a settler history and position it as Canada's central narrative.

The text too asserts and naturalizes a settler reading of the Canadian land. Hutchison opens the English version, and the story of Canada, with a vignette of Samuel de Champlain's landing:

The ice broke at last and Samuel de Champlain gazed eastward down the rivers but he saw no sail, no rescue for his hungry garrison. In the autumn twenty-seven companions had camped with him beside the cliff of Quebec. Now "only eight remained and half of them ailing." So came the first spring to the first men who called themselves Canadians.

Since 1609 many springs have come and gone, and with them human events not finally measured in our time. The nation founded by Champlain has changed and marks, this year, the first century of its political union, but the spring does not change. The land does not change nor the fierce life within it.[78]

Here again referencing the temporal as a means of aggrandizing the nation, Hutchison roots the Dominion of Canada in seventeenth-century European explorations. In correspondence with editors of his text, he acknowledged that this statement ignores centuries of Aboriginal cultures, yet insisted that an earlier draft remain with only minor adjustments. As he wrote to division staff, "I see the danger of the phrase … 'the first men who could call themselves Canadians.' But it will spoil the essay at the start if we try to introduce some unwieldy phrase such as Europeans from across the Atlantic etc. I think the difficulty can be overcome by dropping the word 'could.' Then the copy would read …. 'the first men who called themselves Canadians.' This is accurate, and inoffensive. For assuredly the French settlers, not the Indians, called themselves Canadians. The Indians called themselves by many different tribal names."[79]

The pictorial content echoes this textual erasure of an Aboriginal presence. In the rare instances when there is a reference to people in the images, it is usually in allusions to Euro-Canadian settlement: vacant architecture, distant views of cities and towns, fences, livestock, distant, or distant views of individuals on horseback or in the wilderness. Only five of the volumes' 260 images allude directly to Aboriginal culture; all five represent Aboriginal peoples in the North, signalling the prominence of the North within Canadian nationalist mythology (discussed in detail in

chapter 6). Exemplifying these rare allusions to Aboriginal culture is Doug Wilkinson's photograph of two tents on Ellesmere Island. The people who pitched these shelters are not seen. Instead, in horizontal landscape format, the scene fixates on formal composition, the peaked tents visually echoing distant cliffs and perspectively stressing the vastness of the North. With this depiction of "traditional" Aboriginal ways of life, this image, like those in the photo stories discussed earlier in this chapter, temporally situates native peoples in the ethnographic present; at the same time, the erasure of their actual, coeval presence renders the Canadian land within the terms of a settler narrative.

For the Still Photography Division, the land was a potent marker of Canadian identity, one in which national attitudes toward the earth, economics, and race were deeply inscribed. *A Year of the Land / Temps qui passe* exemplifies the use of landscape imagery as emblems of Canadian national identity. The rich colour reproductions printed in folio scale carry the reader across the Rocky Mountains, the Arctic, the Atlantic Coast, vast Prairie fields, and the craggy terrain of the Canadian Shield. Rarely populated, always sumptuous, these images recreate Canada as an untouched, sublime land. At the same time, like all Still Division undertakings, the volumes were engaged with the project of nation building, attempted in part through the effects of banal nationalism. In commemorating the country's centennial, these lavish picture books offer up a vision of a cohesive Canada.

With those sweeping vistas of grand terrains, the Still Division effectively conveyed a sense of the country's natural plenitude and Euro-Canadian expertise in unleashing those riches. As Mitchell argues, the land is presented "as a place of amnesia and erasure, a strategic site for burying the past and veiling history with 'natural beauty.'"[80] Too often what is erased from the memory of the land is Aboriginal presence and culture.

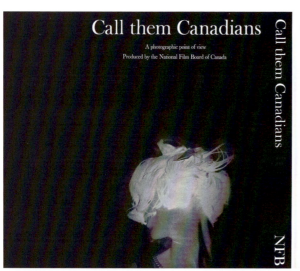

Call them Canadians

A photographic point of view

Produced by the National Film Board of Canada

Call them Canadians

NFB

Call them Canadians

A photographic point of view

Produced by the National Film Board of Canada

5.1 (*above*)
Cover, *Call Them Canadians*,
1968. Photograph, Vitturio
Florence.

5.2 (*below*)
Title page and facing page,
*Ces visages qui sont un pays*,
1968. Photograph, Michael
Semak.

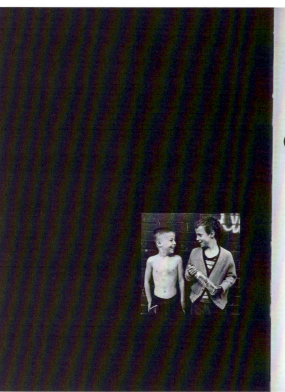

Ces visages qui sont un pays

# "*Ces visages qui sont un pays*": Portraiture, Citizenship, and Linguistic Identity in Centennial Canada

On the hundredth anniversary of Confederation, while *Canada: A Year of the Land* and *Canada, du temps qui passe* celebrated a nation seemingly without people, the Still Photography Division was also at work on a series of centennial projects that focused directly on Canada's citizenry. The division's two large-format picture books, *Call Them Canadians* and *Ces visages qui sont un pays* (figs. 5.1 and 5.2), as well as the Expo 67 installation *The People Tree* (fig. 5.3), are populated by hundreds of images depicting Canadians. Lorraine Monk intended the projects as "counterparts" to the centennial landscape volumes, but they also signalled a new aesthetic in the division's work and a change in how citizenry was imagined at official levels. Exemplifying the division's translation of observational documentary into the ubiquitous banal nationalism of its still photographs, these likenesses show Canadians in seemingly candid moments at leisure or at work and were encountered by viewers in direct yet commonplace circumstances. At the same time, the faces reflect an emergent federal bilingualist and multiculturalist rhetoric. Cumulatively, the projects offer an ostensible portrait of the Canadian people at that pivotal moment in the country's postwar history.

This chapter, the final of the three close readings of visual tropes within the division's history, explores those

Canada's artists have been called "a nation of landscape painters." The same could be said of its photographers. The scenic clichés such as Percé Rock – maritime fishing villages – prairie wheat fields – Rocky Mountains – have been photographed ad nauseam. As one critic asked when he viewed the latest photographic study of Canada to go on sale (Peter Varley's recent book on Canada), "Where are the People?" A book documenting the people of Canada in all their racial and ethnic variety – illustrating all age groups – all economic and social backgrounds – all the multitude of occupations and activities – would help set the record straight. The book would contain the finest photographs which could be assembled by drawing on the photographic files and resources of our top photographers all across the country. It would be an honest, candid look at the many faces of Canada. – No Indians in tribal dress posing for tourist dollars – no "new Canadians" in native dress. Whereas [*Canada: A Year of the Land* and *Canada, du temps qui passe*] capture the beauty and vitality of the land, this [new] book, in many ways the counterpart to [those volumes], will portray the people.

Lorraine Monk, budget request, 3 June 1965

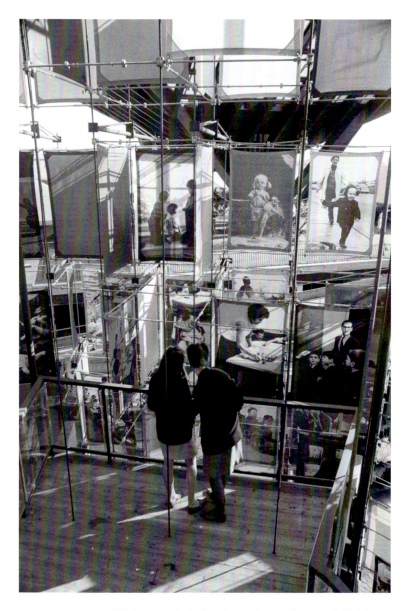

5.3    "Viewers inside the People Tree," 1967. Photograph, Ted Grant.

imbrications of portraiture, citizenship, and nationhood in Centennial Canada, examining how the division drew on and refashioned the semiotically loaded form of the portrait to serve the project of nation building. The chapter opens with a discussion of portraiture throughout the division's archive in order to position this key trope within the division's history; my argument then turns to a detailed analysis of how the division used portraiture in its contributions to the centennial celebrations and Expo 67. *The People Tree* and the centennial publications *Call Them Canadians* and *Ces visages qui sont un pays* – the three projects in which the division exploited the image of the citizen most fully – together provide telling records of governmental attitudes to class, ethnicity, and linguistic identity. More than portraying a people, they serve as a self-portrait of the imagined community of Canada at its centenary as the government was beginning to posit new models of normative citizenry.

## Portraiture and the Nation

From within the Still Division's vast archive, hundreds of thousands of faces look out from photo stories, publications, exhibition displays, and the pages of the *Picture Index* (*Répertoire des photos du Canada* in its French edition) (fig. 5.4), beckoning us to join them in the division's jingoistic celebration of the Canadian nation. Indeed, within the archival system developed during the 1960s, "people," or "*la population*," and "faces" stand out as among the largest subject fields. This is hardly surprising; as an agency mandated in part to engage the Canadian citizenry in the project of nation building, the division turned to the country's people not only as a primary audience but also as the subjects of its nationalistic gaze.

The division's myriad depictions of Canadians can be organized instructively into two broad categories. The first might be termed "true" portraits. These depict specific,

5.4   Section "La Population," *Répertoire des photos du Canada / Canadian Picture Index*. Photographers uncredited.

WR-142

79904

59059

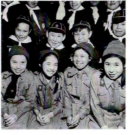

96294

87073

87187

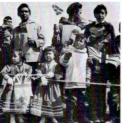

90341

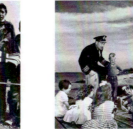

76178

96311

90311

94183

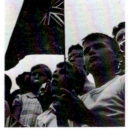

89259

historical individuals or groups of individuals; they reflect what Joanna Woodall terms "naturalistic portraiture": "a physiognomic likeness which is seen to refer to the identity of the living or once-living person depicted."[1] I use this first category here to demarcate images of *known* people, typically those explicitly identified by name. In contrast, the second category describes those photographs of people left anonymous. In some respects, these are not portraits proper, for the identities of the figures they depict were never known or were later effaced; the images do not explicitly "refer to the identity of a lived, historic individual." As Richard Brilliant categorically asserts, "Real faces without names … should not be considered portraits."[2] Yet the medium of analogue photography, in which the camera traces an encounter with an actual person or persons, belies their anonymity. Further, within the division archive, these images consistently draw on many of the conventions of portraiture, including compositional elements such as frontal or profile views and an emphasis on the close-up. And in their focus on the face as a central marker of humanity, they reference liberal humanist notions of individual autonomy. But because the identities of the actual people depicted remain unknown, these photographs serve the division as *typologies* rather than testaments to specific individuals' existence.

Still, the designations of "true portraiture" and typology are by no means fixed. The Still Division regularly reissued images of known individuals without identifications in order to represent abstract cultural values or governmental initiatives and policies. Indeed, the taxonomic structure of its archive facilitates the transformation of the particularized – whether specific, named individuals or institutions or geographic locales – into nationalist generalizations. This process is seen clearly in the *Picture Index* (see 5.4), which was designed to facilitate the use of the archive while reproducing its organizational system. Among the more than thirty categories of images included in each issue of the index, "*La Population*," or "People," features hundreds of faces selected from the archive, many of them identified in the division's extended records. But within these catalogues, each is marked simply by a registrarial number, with additional information about the location and the date of the negative in an appendix. Stripped of names, occupations, family connections, and other personal attributes, these images have been packaged to serve more readily as idealized national types. The inverse – the later recognition and identification of anonymous people depicted by the division – has also occurred over the archive's decades of use, with researchers, family, and community members providing biographical context to some of the faces.[3] But these discoveries and reattributions are rare. The more common trajectory for the division's representations of Canadians is from personal specificity to generalized nationalist symbolism.

The division's production of "true" portraits included some of its most "banal" work. Over the course of its history, the division was, for example, charged with producing hundreds upon hundreds of identity portraits for various branches of government.[4] They included over 1,300 passport photographs made between 1946 and 1953 for various members of government and their families.[5] These routine, formulaic images of ministers and civil servants indicate how widely the camera has been used as a tool of direct social management. As John Tagg argues, "The photographic apparatus … is in effect a composite device in which the bureaucratic administrative technologies of the archive were coupled to the mechanics of identificatory capture built into the operating system of the picturing machine."[6] The sheer numbers also reflect the division's lowly status as a mere "service" to the government for most of its history. In its capacity as Canada's "official" photographer, the division also produced numerous portraits of such dignitaries as Elizabeth II, governor generals Vincent Massey and Georges Vanier, and all sitting prime ministers (fig. 5.5). Through official

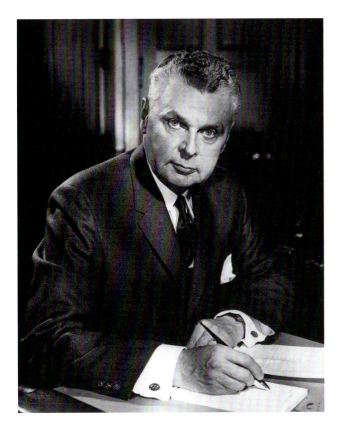

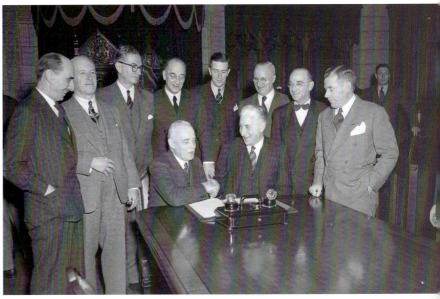

5.5 (*left*)   Prime Minister John G. Diefenbaker, 1957, Ottawa. Photograph, Gar Lunney.

5.6 (*right*)   "Newfoundland and Canadian Government delegation signing the agreement admitting Newfoundland to Confederation. Prime Minister Louis S. St. Laurent and Hon. A.J. Walsh shake hands following signing of agreement," December 1948. Photograph uncredited.

portraits, the division routinely recorded for posterity state visits, the opening of Parliament, and historically significant legislative events. In turn, these portraits were made widely available through the government and in the press, continually reminding Canadians of their national belonging, in these ubiquitous examples of banal nationalism. Newfoundland's admission into Confederation in 1948, for example, was documented through a group portrait taken at the signing of the constitutional decree by Prime Minister Louis St

Laurent and the chairman of the Newfoundland delegation, A.J. Walsh (fig. 5.6).

Official portraiture of dignitaries and legislative events were typically performative collaborations between sitter and photographer. Dignitaries usually selected how they would be seen, often effectively "wearing" their public roles for the camera. For example, in the group portrait referred to above, St Laurent and Walsh are seated at the centre of the picture plane, other delegates surrounding them. The casual

# Insulin's Co-Discoverer
# Dr. Charles H. Best

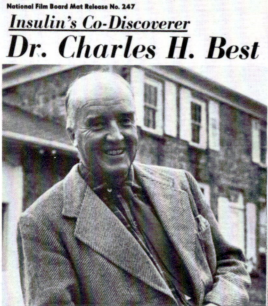

A man of impressive vigour and charm, Dr. Best has endeared himself to his colleagues and to the hosts of students attracted to his laboratory. Above, at his Nassaqweya farm with 8-months-old grandson Charles Stewart Best.

With his wife, Margaret, and pet poodle "Dochel" in the living room of their Toronto home.

In the lab, with Dr. G. R. Williams, he checks one of many experiments being conducted at Best Institute.

The lives of 18 million diabetics throughout the world have been saved and lengthened because of the dramatic discovery of insulin in 1921 by the youthful Canadian research team of Frederick Banting and Charles Best. Bold vision, uncompromising intellect and devoted teamwork combined to conquer a hitherto fatal disease and a new era in medical research was begun. Dr. Best, a dedicated science graduate of 23 at the time he worked on the great experiment which resulted in the isolation of the hormone insulin and the demonstration that it could be used to control the blood sugar content of diabetic patients, went on to become a world authority on insulin and an eventful career in the realm of scientific research which has brought him a battery of honours and awards unparalled in Canadian medical history. Born in Maine, U.S.A., in 1899, the son of native Nova Scotians (whose ancestors came from England at the time of the founding of Halifax in 1749) Charles Herbert Best entered the University of Toronto in 1916 receiving his first in a long series of academic degrees in 1921. He has been honoured by 19 Universities in the Western world, among them the Universities of Paris, Amsterdam, Edinburgh, Melbourne, Uruguay, Chile and Peru. His distinctions range from the first Canadian fellowship in the Pontifical Academy of Scientists (limited to a membership of 60 scientists throughout the world) to first honorary president of the Canadian Diabetic Association and honorary Admiral of the Texas Navy. Dr. Best served in the artillery in the first world war and as director of medical research for the Canadian navy in the second world war. For his work on a method of drying and storing blood for military purposes he was created a Commander of the British Empire in 1944.

After a busy day, Dr. Best leaves the Charles H. Best Institute of Physiology which he has headed since its opening in 1953. In addition to research on insulin and diabetes the Institute is engaged in projects on cancer, thrombosis and liver damage.

Dr. Best has written so many papers on insulin he has lost track of the number. Above, he discusses a recent publication with Dr. James Campbell. In all, it is estimated some 80,000 papers have been published in the field since insulin was discovered 39 years ago. Dr. Best manages to keep abreast of them all — a formidable task which he takes in his stride.

National Film Board of Canada Photos by Gar Lunney.

5.7    Photo Story 247, "Insulin's Co-Discoverer: Dr. Charles H. Best," 2 February 1960. Photographs, Gar Lunney.

symmetry of the scene and the congratulatory smiles pictorially reproduce the notions of agreement or accord. Here as in numerous other cases, the group portrait functioned as an official stamp, seeming to seal the agreement while rendering legislation in personalized form.

The division also used true portraits in more elaborate ways to personalize and promote the nation. Photo stories, for example, regularly featured photo-textual portraits of exceptional Canadians. While a few of these were state dignitaries, most of these laudatory portrayals were reserved for Canadians who had made contributions to the sciences and the arts – including such varied researchers as the anthropologists Vilhjalmur Stefansson and Marius Barbeau, the geologist Alice Wilson, and the endocrinologist Hans Selye. A photo story of 2 February 1960 on Dr Charles Best (fig. 5.7), who with Frederick Banting discovered insulin, typifies science pictorials from the late 1950s and early '60s. This layout of six photographs by staff photographer Gar Lunney, accompanied by text, is dominated by a portrait of Best, casually leaning on a fence outside his home and smiling at the camera (fig. 5.8). Typical of most photo stories, this "lead picture" is at the upper left, guiding the viewer to "read" the images and texts in a conventional western format. This portrait of Best establishes him as an approachable and yet heroic everyman; the same effect is evident in two other photographs depicting him with a grandchild and his wife. The remaining three photographs show the renowned researcher in the lab and at his institute. As with most division productions' consistent flagging of national identity, Best's achievement in medical science is seen through a nationalistic lens: insulin is described in the text as the discovery of a "Canadian research team." In short, the work of scientists like Best is presented as synecdoche, their accomplishments made to stand for the achievements of the nation.

Later in the 1960s, photo stories addressing scientific achievements often featured groups of scientists, but again

5.8   Charles H. Best, 1959. Photograph, Gar Lunney.

these drew on the heroizing effect of portraiture. A 4 May 1965 photo story entitled "La recherche et la mise en valeur au Canada" ("Research and Development Grows in Canada" in the English version), for example, promotes various fields of scientific research in Canada (fig. 5.9). The text announces, "afin de soutenir la concurrence des autres nations industrialisées sur les marchés du monde, le Canada est-il lancé dans un programme intense de recherches scientifiques et industrielles."[7] Five photographs by Ted Grant show researchers in Ottawa at Northern Electronic and Atomic Energy of Canada Ltd., among other venues. Four of these images repeat what would become a convention in the division's heroic portrayals of scientists: the close-up view of a researcher studying his or her work. In these images, that

# La recherche et la mise en valeur au Canada

Aux laboratoires de Recherches et de Perfectionnement de la Northern Electric, à Ottawa, Judy Wall examine un petit transistor qui a été fixé sous un microscope.

*Photos de Ted Grant*

L'application des connaissances scientifiques au procédé de la production est un facteur primordial de l'expansion économique du Canada. Aussi, afin de soutenir la concurrence des autres nations industrialisées sur les marchés du monde, le Canada est-il lancé dans un programme intense de recherches scientifiques et industrielles. Conscient de sa situation privilégiée, il sait que son avenir dépend surtout de son aptitude à tirer parti des progrès technologiques. Les tâches dans lesquelles sont lancés ses chercheurs sont herculéennes, chacun donnant le meilleur de lui-même, que ce soit dans une station reculée de l'Arctique ou encore dans un laboratoire de la Capitale. Fiers de leur mission, ils veulent réussir et faire triompher leur pays. L'industrie canadienne en général est présentement en train d'instituer des services de recherches poussées et prend de plus en plus conscience des avantages qu'elle peut en retirer. A part le Comité du Conseil privé sur les recherches scientifiques et industrielles, comité qui détient la plus haute autorité en matière de sciences, les gouvernements provinciaux, de qui relèvent l'enseignement et les ressources naturelles, contribuent également au maintien des recherches dans les universités. Sept provinces ont maintenant établi ou ont aidé financièrement à établir des conseils de recherches ou des organismes qui distribuent bourses et subventions.

Tom Somogyi, de la Northern Electric, étudie les relations de l'électricité et du gaz.

65-377

A l'Atomic Energy of Canada Ltd., on se sert de pincettes et de miroirs pour la manipulation de substances radioactives venant d'un appareil de thérapeutique pour le rechargement.

**PHOTO-REPORTAGE DE L'OFFICE NATIONAL DU FILM**

Phyllis O'Grady vérifie un schéma de circuit.

Ci-dessous:Recherches métallurgiques à la Direction des mines à Ottawa.

65-402

5.9    Photo Story 389A, "La recherche et la mise en valeur au Canada," 4 May 1965. Photographs, Ted Grant.

gaze, usually averted from the camera and intent on materials that remain unrecognizable or obscured from the viewer, imbues these heroized scientists with a sense of the rarified and inaccessible.

Figures from the world of the arts were also singled out for laudatory portrayals in photo stories of the 1950s and 1960s. Among these, a number of Aboriginal artists, including the Inuit artist Kenojuak, Northwest Coast carver Ellen Neel, and the Blood (or Kainai) painter Gerald Feathers, were highlighted in pictorials that at once exoticized the artists while endorsing assimilation. Other photo stories featured such diverse figures as painters A.Y. Jackson and Harold Town, sculptor Frances Loring, pianist Margaret Ireland, singer Monique Leyrac, cartoonist Len Norris, writer Thomas Raddall, and photographer Yousuf Karsh. The 27 May 1958 photo story on Karsh (fig. 5.10) is composed using the formula seen in the pictorial on Best: an individual portrait at the left dominates, establishing Karsh, seen focusing his camera, as the hero of the piece, while four smaller images show him at work and leisure. But unlike many of the layouts on scientists, in the large positioning shot Karsh meets the gaze of the viewer, as if capturing our image on film. The remaining four small images are composed by division photographer Chris Lund to emphasize Karsh's own gaze: he is seen from dynamic angles looking over the shoulder of a darkroom technician or his wife, as well as sitting, commenting to his secretary and listening to his wife. In each of these supporting images, Karsh seems to be directing those around him, pointing out to them what only he can see. This emphasis on Karsh's gaze calls attention to the photographer's own supposedly "revelatory mode of portraiture." According to Richard Brilliant, the revelatory portrait seeks "to discover some central core of personhood as the proper object of ... representation ... that invisible core of self";[8] for Joanna Woodall, this form of portrait constitutes "the artist's special insight into the sitter's inner or ideal self."[9] Accompanying

text in this photo story reinforces the pictorial heroization of Karsh. Identified as an Armenian immigrant to Canada, he is designated as "one of the master portrait photographers of the world" and claimed for the nation as a "celebrated Canadian."

As Brilliant has argued, the portrait – whether a government promotional image like those included in the photo stories discussed here or a revelatory portrayal, like Karsh's own celebrated work – is "essentially denotative."[10] That is to say that even while the portrait is a form of representation that participates in the fabrication of identity, it always points to the existence of its referent, "a real, named person [who] seems to exist somewhere within or behind the portrait."[11] In this way, the portrait conventionally suggests stable, autonomous, Cartesian identity. Photographic indexicality – the photograph's character as a seemingly direct, unmediated form of representation – appears at once to parallel and enhance the portrait's denotative claims. Perhaps for this reason the photograph has effectively supplanted all other media in the making of portraits; if we seek out portraits as direct connections to those they depict, what media could be more adept than a form of representation that on its surface seems to exist as an index of its referent, the sitter? The portrait's allusions to wholeness and stability also render it a compelling metaphor of national cohesion. In several photo stories and other publications, portraiture is invoked to suggest the nation as a unified and autonomous entity. A 16 May 1961 photo story on that year's census, subtitled "Canada Sits for Her Portrait," and a 15 February 1966 photo story on aerial photography of the country, subtitled "Full-Face Portrait of a Nation," for example, both use the metaphor of the portrait to suggest the Canadian nation as a singular entity.[12]

And yet, while the photographic portrayal suggests "a real, named person ... somewhere within or behind the portrait," in the end it is of course never a direct, unmediated imprint

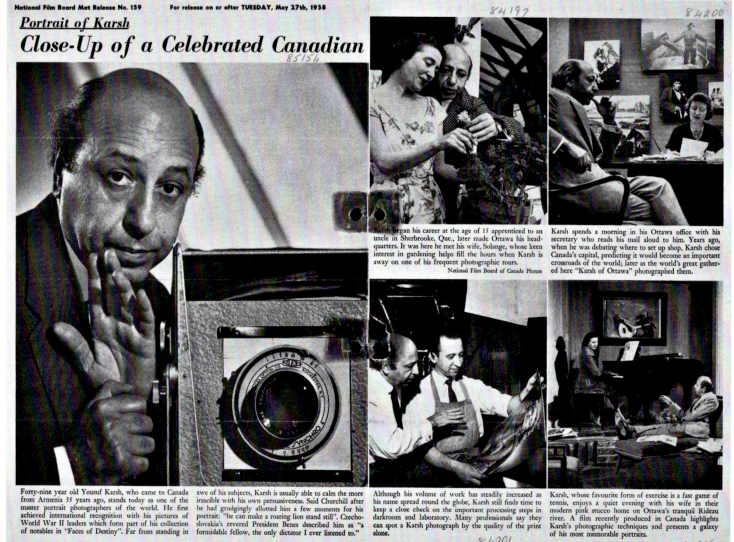

*Portrait of Karsh*
## Close-Up of a Celebrated Canadian

*84197*    *84200*

*85154*

Karsh began his career at the age of 15 apprenticed to an uncle in Sherbrooke, Que., later made Ottawa his head-quarters. It was here he met his wife, Solange, whose keen interest in gardening helps fill the hours when Karsh is away on one of his frequent photographic tours.

National Film Board of Canada Photos

Karsh spends a morning in his Ottawa office with his secretary who reads his mail aloud to him. Years ago, when he was debating where to set up shop, Karsh chose Canada's capital, predicting it would become an important crossroads of the world; later as the world's great gathered here "Karsh of Ottawa" photographed them.

Forty-nine year old Yousuf Karsh, who came to Canada from Armenia 35 years ago, stands today as one of the master portrait photographers of the world. He first achieved international recognition with his pictures of World War II leaders which form part of his collection of notables in "Faces of Destiny". Far from standing in awe of his subjects, Karsh is usually able to calm the more irascible with his own persuasiveness. Said Churchill after he had grudgingly allotted him a few moments for his portrait: "he can make a roaring lion stand still". Czecho-slovakia's revered President Benes described him as "a formidable fellow, the only dictator I ever listened to."

Although his volume of work has steadily increased as his name spread round the globe, Karsh still finds time to keep a close check on the important processing steps in darkroom and laboratory. Many professionals say they can spot a Karsh photograph by the quality of the print alone.

Karsh, whose favourite form of exercise is a fast game of tennis, enjoys a quiet evening with his wife in their modern pink stucco home on Ottawa's tranquil Rideau river. A film recently produced in Canada highlights Karsh's photographic techniques and presents a galaxy of his most memorable portraits.

*84201*    *84198*

5.10   Photo Story 159, "Close-Up of a Celebrated Canadian: Portrait of Karsh," 27 May 1958. Photographs, Chris Lund and unattributed; text uncredited.

of the sitter. As Eduardo Cadava and Paola Cortés-Rocca have argued, the portrait, which they term photography's "genre *par excellence*," does not so much trace the subject as *multiply* him or her. By seeming to duplicate the self, photographic portraiture then "constitutes a radical and absolute destabilization of the Cartesian subject."[13] In short, photographic portraiture at once suggests the promise of a Cartesian ideal of the unified, stabilized self while constantly undermining its realization.

The second category of human likenesses, the division's numerous typological portrayals of Canadians, underscores those tensions between the apparent assertion of autonomous, cohesive individual identity and its destabilization. These images are characterized by the lack of any identifying information: they are faces without names attached. For Brilliant, naming is crucial in signalling individual subjectivity: "A proper name identifies that individual and distinguishes him or her from all others. It is a general condition to have a personal name, whether public or private, but the persons named are every one of them individual and singular."[14] Within the division archive of hundreds of thousands of human images, countless people appear unidentified. Some depict those whose names were never sought out or known by the photographer or other division staff, while others were initially identified by the photographer but have been disassociated from their names and biographical information by subsequent placement and reuse. In this way, they follow the archive's familiar trajectory from the specific to the general. Stripped of identification, they come to stand for an abstract concept, a broad group, or the nation as a whole.

Unidentified images were used most flagrantly and consistently by the division in its portrayals of Aboriginal peoples. In individual images and photo stories, First Peoples' names were often excluded from the records. Instead, those depicted are made to stand for an entire Aboriginal nation or group, while simultaneously signi-fying indigeneity or Otherness in general. Indeed, as I discuss in the following chapter, the act of renaming and the effacement of names are key strategies in the process of colonization enacted on First Peoples.[15] Because of the centrality of names to subjectivity in western discourse, renaming (typically, giving Aboriginal people European or Christian names) is a powerful gesture of both acculturation and assimilation. In turn, the refusal to acknowledge individual names denies them the basic status of autonomous individuals.

## Centennial Faces

The typological portrayals long commonplace in the division's visual treatment of Aboriginal peoples were to become a mainstay of its depictions of Canadians in general during the mid-1960s. They appeared in photo stories of the time (see fig. 2.13, for example) but particularly in three of the division's major centennial projects. In *The People Tree, Call Them Canadians*, and *Ces visages qui sont un pays*, typological portrayals were central to the division's presentation of changing models of Canadian identity. With these three ambitious ventures, the division constructed a multifaceted image of an idealized Canadian citizenry that reflected the federal government's emergent bilingualist and multiculturalist rhetoric. At the same time, the forms of portraiture were effective in flagging Canadian nationalism.

In the early 1960s, Lorraine Monk began developing a project featuring photographs of Canadians under the broad rubric "People of Canada." This undertaking was meant to appear alongside the division's other proposed centennial projects and particularly to complement its centrepiece, *Canada: A Year of the Land / Canada, du temps qui passe*. In a 19 August 1963 memo to Grant McLean, then acting government film commissioner, Monk initially proposed a series of travelling exhibitions. These would include a

93342

93344

# Spotlight on Manitoba Mosaic

Canada has long been a bilingual country. The French and English languages and cultures are distinct and enduring. Yet, Canada is a land of many cultures. During the latter part of the nineteenth century numerous immigrants came to this country. Since World War II, nearly two million skilled immigrants have made Canada their home. In contrast to earlier settlers who came to the farmlands of Canada, today's immigrant usually makes his home in Canada's large industrial centres. A year after their arrival, the average immigrant family earns an income of five thousand dollars.

At the turn of the century, Winnipeg, Manitoba, was host to many immigrants who were just beginning their life in Canada. To serve their needs foreign language newspapers were published. Today, four major newspapers in German, Croatian and Ukrainian inform new Canadians of current affairs and help them adjust to their new surroundings.

Manitoba is unique in the variety of national groups that have settled here and maintained their distinctive cultures through songs, dances and national costumes. Each summer a folk festival is held in Winnipeg where communities from the prairie provinces, representing seventeen national groups, come together. Colourful costumes, exotic music and intricate dance steps create a kaleidoscope of sights and sounds. Irish jigs, Ukrainian kozaks, Polish kujawiaks, Greek kalamatinos and Western square dances fashion part of a mosaic that takes place in Winnipeg's Kildonan Park. It brings together people from all parts of the country, increasing their understanding of the rich and varied cultures of other nations found within the communities of Canada. 93337

Polish dancer Linejan Krol of the Polish Sokol Choir and Dancers.    National Film Board of Canada photos by Chris Lund.

Miss Ruby Hosaki, one of the dancers of the Manitoba Japanese Association, poses in a whirl of gay parasols.

93340

93338

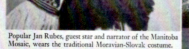

Popular Jan Rubes, guest star and narrator of the Manitoba Mosaic, wears the traditional Moravian-Slovak costume.

Miss A. Pensak from the Ukrainian chorus. In the photo to the left, Meros Leckow performs the Ukrainian Kozak.

93351

Bonnie Janice Douglas — one of a million children born to new Canadians since 1945.

Marcia Corrin, member of Israeli Choir.    93335

Petite Shirley Bjornason of the First Lutheran Church Choir wears the Icelandic national costume.

93343

Dancer Dino Pappas represents the Greek Orthodox Youth of America.    93345

5.11    Photo Story 268, "Spotlight on Manitoba Mosaic," 20 September 1960. Photographs, Chris Lund.

"Many peoples – One country." It was to be a "candid camera look at the many ethnic groups who make up Canada: Jews, French-Canadians, Italians, Ukranians, Chinese, Negroes, etc., etc."[38]

## Expo 67 and *The People Tree*

The division's work on the centennial portrait project was not only informed but also interrupted by federal initiatives motivated by emergent bilingualist and biculturalist rhetoric in the management of the country's citizenry. In May 1965, the Office of the Commissioner General (OCG) for Expo 67, the World's Fair to be held in Montreal during the centennial year, began contracting work from the division for its displays.[39] In May 1965, OCG staff wrote to Monk requesting suggestions for photographers to contribute to *The People Tree*, an installation for the Canadian precinct of the fair. For several weeks the division collaborated with the OCG, largely by helping to select images. But that working relationship proved difficult, and division staff expressed dissatisfaction with the choices made by OCG staff. By June, division staff had taken over responsibility for photographic content.[40]

The installation was to be a highly visible component in Canada's contributions to Expo (figs. 5.3, 5.12, and 5.13). Located at the far end of the fair grounds on Île Notre Dame, the Canadian Pavilion, which was already being constructed in 1965, would include a series of individual buildings dedicated to the provinces and to various Canadian industries. In addition, this sector included the Indians of Canada Pavilion, a tepee-shaped structure with exhibitions organized by a group of Aboriginal peoples led by Chief Andrew Tanahokate Delisle of the Kahnawake (Mohawk) First Nation.[41] At the heart of the Canadian precinct, organizers planned an open plaza dominated by a large structure in the form of an inverted pyramid, called the Katimavik – "meeting place" in the Inuktitut language. An arts centre and fourteen

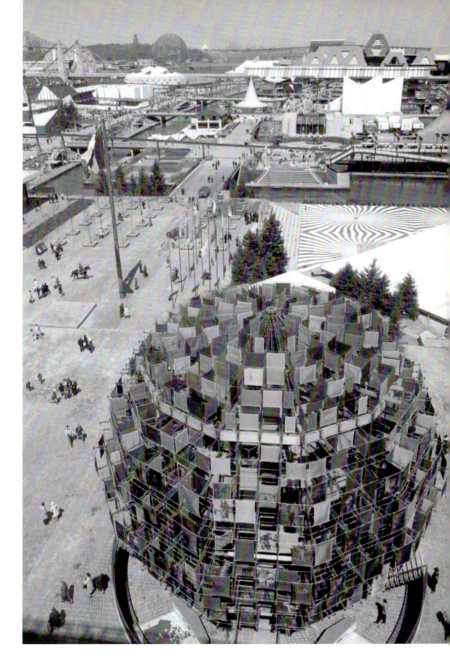

5.12    "View of the People Tree," 1967. Photograph, Ted Grant.

pyramidal roofs would surround the Katimavik; those roofed structures housed a series of thematic exhibitions on different aspects of Canadian society.[42] *The People Tree*, a six-storey-high spherical structure encasing a spiral staircase, was to stand prominently at the entrance of the Katimavik. As Jean Boyer, chief designer of the "People Area" of the Canadian Pavilion described it, "Within the Canadian Pavilion at the 1967 World Exhibition, will be an area depicting the significant facets of the Canadian people today. Crowning this particular area, aptly named 'The People,' will be a 70 [foot] high 'maple tree.' Suspended from this 'tree' will be several hundred photographic close-ups of Canadians seen in their various occupations."[43]

*The People Tree* remained true to the division's initial proposal to create a "Canadian *Family of Man*"; indeed, Steichen's exhibition would prove influential in several pavilions at Expo 67, including the National Film Board's cinematic display, *Labyrinth*, and the Christian Pavilion.[44] And while *The People Tree* was certainly a more spectacularized presentation than any of the division's previous work, it still served as another incidence of banal nationalism, flagging national belonging through naturalized representations.

Boyer and his colleagues designed *The People Tree* to reference Canada's new flag. In 1965, the maple leaf flag replaced the British Union Jack and the Canadian Red Ensign (a flag associated with the British Commonwealth), which had both been used as Canada's official emblems to that date.[45] In inaugurating the maple leaf flag amidst vocal dissent, Prime Minister Lester B. Pearson introduced it as a symbol of pluralist unity: "This ceremony today is not a break with history but a new stage in Canada's forward march from a group of separate and scattered and dependent colonies, to a great and sovereign Confederation stretching from sea to sea and from our Southern border to the North Pole ... As the symbol of a new chapter in our national story, our Maple Leaf Flag will become a symbol of that unity in our country

without which one cannot grow in strength and purpose; the unity that encourages the equal partnership of two peoples on which this Confederation was founded; the unity also that recognizes the contributions and the cultures of many other races."[46] In stressing the new flag as "a symbol of that unity in our country without which one cannot grow in strength and purpose," Pearson and his supporters indicated the government's desire both to distance itself from Britain and to assert a sense of national cohesion or unity while recognizing Canada's increasing cultural plurality.[47]

The OCG drew on the nationalist symbolism of the maple in its designs for *The People Tree*, exploiting the botanical metaphor with near-obsessiveness. The structure included four tiers. The lowest level, the "soil," illustrated external influences on the people of Canada including mass media. The "roots" spread out in four directions, with accompanying subterranean exhibitions on urban living, ethnic diversity, cultural duality, and labour. The single trunk, filled with crests of national organizations, was meant to signify national unity. Finally, the structure culminated in colourful splendour with the "leaves," intended to represent the individual people of Canada.[48] In the vivid reds and oranges of autumn, the "leaves" were made up of about fifteen hundred vertical three-by-five-foot nylon panels.[49] Approximately seven hundred of the panels would be embellished with photographic images. This visual component was to be complemented by a soundtrack of voices with accents from across the country.[50]

The pavilion's montage-like audio-visual design reflected tastes at Expo generally, but here again, in its mosaic-like form, it served more pointedly as a signifier of pluralism. The OCG naturalized the prominent use of nationalist symbolism with statistical data. It initially proposed the installation as a statistically accurate audio-visual index of Canadian society. In this way, officials suggested that its prime audience of Canadian visitors could identify with the

images and sounds directly and personally. As the project outline described it, "Canadian people follow diverse personal, occupational and recreational activities. The people, both male and female, are of various ages, and reside in the various regions of Canada. The 'Leaves' of the tree in the People Area will be seven hundred photographs of the Canadian People, five feet by three feet in size, and the choice of photographs in accordance with age, sex, activity and region of residence will be in proportions statistically reflective of the most up-to-date data available from the Dominion Bureau of Statistics."[51]

This characterization was later reiterated by one of *The People Tree*'s organizers from the OCG, Mairuth Sarsfield, who also described the project's ambitions in proto-multiculturalist terms: "We wanted to tell the people of Canada what they were really like ... People walked through the leaves of the tree, so we had the leaves of the tree as the faces of people and, instead of the wind coming through, we had the murmur of Canadian tongues and voices: not only dialects and languages, but also Ottawa valley English [and] the Prairies way of saying the same things. So we were able to show the diversity of Canada in a way that seemed very pleasant to people."[52] The attention to the simulated viewer interaction with these representations (in both visual and aural forms) of idealized citizens rendered national belonging natural and familiar.

The task of selecting images for the project fell to division staff member Dunkin Bancroft.[53] Bancroft and the division balked at OCG's statistical rigidity and demanded some flexibility in image choice. Nonetheless, they were guided in part by the commission's conceptual outline. It suggested that the "foliage" or photographically illustrated "leaves" illustrate "our ways of living." This component of the installation was to "answer the often-asked questions: (1) What are the Canadian People like? (2) What does the Canadian do with his time? (3) Is he as hard-working as is thought?"[54]

Bancroft responded to those questions by choosing images from the division archive as well as commissioning five photographers from across the country – Chuck Diven of Vancouver, Walter Petrigo of Calgary, Lutz Dille of Toronto, Marcel Cognac of Montreal, and Robert (Bob) Brooks of Nova Scotia – to make images of people in their home regions.[55] Chosen in part to reflect the regional diversity of the country, these photographers were guided explicitly by Bancroft, again following directives from the OCG, to depict Canadians "objectively ... at work and at leisure." In his correspondence with the photographers, Bancroft reflected the precepts of observational documentary rendered into still photographic terms. He insisted, for example, that "the photographer should be the innocent bystander in these activities, and not interfere with or direct [subjects]. We look for unposed, realistic pictures under existing light (no flash, please)." Again following federal guidelines, Bancroft also encouraged the use of a vertical format so that when blown up to five by three feet, "at least one person [would appear] life-size."[56] Like the OCG, the division sought to manufacture a sense of direct and seemingly authentic encounter between visitor and image.

When Expo opened on 28 April 1967, the Canadian Pavilion became a key destination for the fair's millions of visitors. And the resplendent *People Tree* drew many of them. In a broadcast from the fair, CBC Radio's Bob McGregor called "the very colourful *People Tree*" a "popular attraction."[57] The *Toronto Star*'s Robertson Cochrane proclaimed it a "visual highlight" of Canada's contributions, while *Canadian Magazine* termed a visit to the installation "a warm experience."[58]

The photographic component dominated the installation visually and in terms of emotional impact. Aglow in the summer sun and illuminated after dark, the warm-hued "leaves" provided a beacon for the Canadian Pavilion visible to visitors riding Expo-Express, the fair's light rail service, or walking among the throngs across Île Notre Dame. The

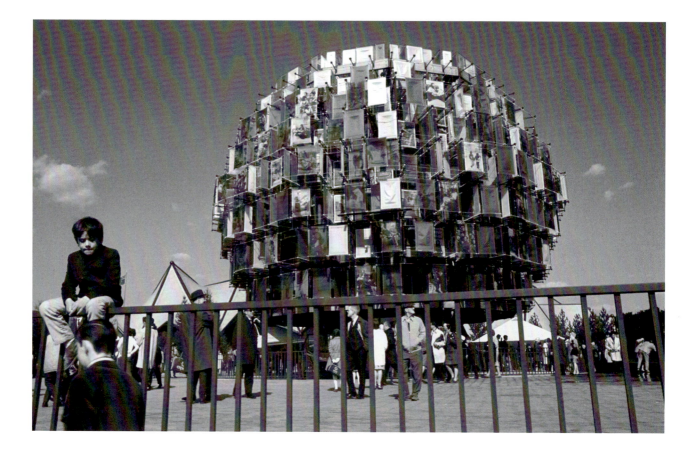

5.13   "Canada Pavilion at Expo 67," Montreal, 1967. Photograph uncredited.

three-dimensional montage of panels reflected Expo's over-all predilection for collage-like design while adding colour to Canadian Pavilion's otherwise steely environment. Climb-ing among the photographs (see fig. 5.3), voices from the soundtrack ringing in their ears, visitors were intended to experience a sense of recognition.[59] Organizers like Sarsfield

suggested that the structure would put a human face on the abstract concepts of nationhood and citizenship by encour-aging viewers to identify with the vocal strains filtering through the structure and the people portrayed in the photo-graphic images. The reflective surface of the photographic transparencies literalized this identification between viewer and image: visitors saw their own faces reflected back to them as part of this multivalent portrait of citizenry. The June 1967 issue of *Canadian Magazine* remarked on the intense personal identification encouraged by its design: "The

People Tree is not just a structure hung with picture panels, but a warm experience, as the many faces of Canada meet the gaze from their scarlet and gold panels, seeming to enfold you in brotherly embrace."[60] Visitors were welcomed in this embrace of national belonging; by rendering Canadian citizenship visible, audible, and emotional, it generated a sense of direct, seemingly "natural," connection between individual and the nation. At the same time, the mosaic-like format personalized the abstract concept of modern, plural-ist Canadian citizenship.[61]

Yet a closer look at the images shows that *The People Tree* was less than fully inclusive. Though colourful at a distance, under the closer inspection afforded by a survey of known images, the leaves were culturally monochromatic and reveal how federalist attitudes about the Canadian citizenry were rendered in visual terms. Following OCG guidelines, the extant images all depict people either at leisure or work (figs. 5.14, 5.15, 5.16). "Leisure" includes scenes of children at play in urban centres, rural families relaxing at home, upscale cocktail parties, and women shopping. The major-ity of these images depict middle-class white Canadians relaxing or engaging in consumer activities. Moreover, they reveal a deep-seated bias in favour of nuclear families and conventional gender roles; women are often seen in the role of mothers and family caretakers, buying groceries, cooking, and caring for children.

The thematic framing of the Canadian populace is also coded in terms of class and federal economic aspirations. By presenting Canadian life as divided between leisure and work activities, *The People Tree* represents Canada as both affluent and industrious. In effect, it promotes the country and its citizens on the world stage of Expo as a modern and economically advanced state. At the same time, in presenting these figures without names, regional locations, or any other identifying characteristics, it positions them as typologies for an idealized Canadian citizenry.

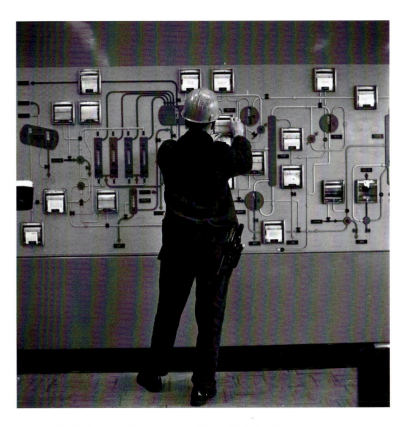

5.14   "Man in the control panel room of Imperial Oil's refinery at Dartmouth," December 1965, *The People Tree*. Photograph, Bob Brooks.

The cohesive subject matter chosen by Bancroft and the division was reinforced by technique and stylistic character-istics of the images. Most of the known images employ sim-ilar scale and proportions according to Bancroft's directive in order to show at least one figure per frame in roughly life size. Achieved in part through photographers' framing, this format was also the result of the vertical cropping of images focusing on individuals or groups. Like the photographs

5.15 (*left*)  "View of woman shopping in a millinery store in Montreal," August 1965, *The People Tree*. Photograph, Pierre Gaudard.

5.16 (*right*)  "View of visitors touring an art gallery in Yorkville, Toronto," October/November 1965, *The People Tree*. Photograph, Lutz Dille.

in *The Family of Man*, *The People Tree*'s approximately seven hundred images were developed and printed in the same lab, assuring a high degree of visual uniformity. This was, of course, accentuated by the coloured vertical panels, which had the effect of further homogenizing the presentations. Moreover, not only the subjects but photographers too were unidentified. And while a discerning viewer might divine the location or occupation of some subjects, these were not

explicitly noted, even though Bancroft endeavoured to represent most of the country's regions. Indeed, as in *Canada: A Year of the Land* and *Canada, du temps qui passe*, the designers appear to have made an effort to avoid potentially factitious regionalizing references.

The very style in which the images were shot was remarkably consistent. Here again following Bancroft's guidelines, the panels consistently deployed the tenets of an observational documentary gaze, the photographers acting as "innocent bystanders" to "convey the sense of unmediated and unfettered access to the world."[62] Couples embrace on a park bench, women sit in a hair salon, and labourers pause for lunch, all apparently unaware of the camera recording these intimate moments. As Leslie Brown, commissioner general for the Canadian Pavilion, remarked, "Some of them are so much at leisure that you wonder if they objected to having their photos taken."[63] Framing of the images, too, reinforces that consistent sense of the spontaneous characteristic to observational documentary: the photographs typically eschew central, symmetrical compositions in favour of arrangements that seem off-balance and therefore give the appearance of being swiftly shot.

In their efforts at creating stylistic and technical consistency in *The People Tree*, the division and the OCG rendered Canadian citizenry at the country's centenary in cohesive, unified form. While the semiotic message of the mosaic-like collage of images implied pluralism, a closer look at the images reveals an emphasis on middle-class values of industriousness and consumerist activity. *The People Tree* suggested the Canadian nation as a cohesive, harmonious family. In this it was in marked contrast to another prominent photographic display in the Canadian precinct of Expo 67 at the Indians of Canada Pavilion. In addition to a display of contemporary Aboriginal art, Chief Andrew Tanahokate Delisle and the other organizers of this pavilion mounted an extensive photomontage on contemporary Aboriginal life that

included unvarnished references to generations of subjugation.[64] According to Randal Rogers, in contradistinction to the official Canadian pavilions, the Indians of Canada Pavilion "told the national story from the perspectives of Native people, not as a celebration of Canadian national diversity but primarily as a problem of adaptation to the nation."[65] There, as Susan Schuppli has shown, the Native body (so often the object of curiosity and a marker of colonial privilege at world's fairs) was deployed instead to confront visitors with "years of systematic discrimination and abuse."[66] At the Indians of Canada Pavilion, cracks in the seamless portrait of an idealized citizenry were made plainly visible.

### *Call Them Canadians* and *Ces visages qui sont un pays*

While Dunkin Bancroft focused on the Expo installation, other division staff developed the "People of Canada" book project, along with other centennial undertakings. The volumes would come to be known in their English and French editions as *Call Them Canadians* and *Ces visages qui sont un pays* (see figs. 5.1, 5.2). Although they were produced autonomously by the division, these volumes were nonetheless shaped in part by the proto-multiculturalist rhetoric that the division was exposed to through Expo as well as routine associations with the federal government, particularly the Department of Citizenship and Immigration. As division staff selected and commissioned images for *The People Tree*, they simultaneously borrowed some of those photographs for the centennial book project.

On 26 July 1965, a budget of $158,500 was allocated to cover both French and English publications. The sum was less than one-third of the $554,500 provided for *Canada: A Year of the Land* and *Canada, du temps qui passe*; however, the project was no modest undertaking. Considering that the division's total budget for 1966 was only $172,876, the "People of Canada" budget was still a boon.[67] Appearing

in the year following the country's centennial, the new volumes built on the division's newly minted reputation for high-quality photo books. (See fig. 4.14 for an image of Prime Minister Trudeau being presented with all of the centennial publications.) As in all division productions, priority was given to visual content; text was intended to be ancillary or complementary.[68] Photographs were amassed first from images in the division's archive; the emphasis was on recent photography depicting a contemporary Canadian milieu, largely from the late 1950s and '60s. Subsequently, a call was issued to photographers across the country for this as well as the other centennial publications.[69] Work was then purchased or commissioned from selected photographers to "fill in" what Monk perceived to be "gaps."[70]

While the people volumes were never projected to have the same "prestigious" cachet as the landscape publications, they were, arguably, more aesthetically innovative. Indeed, the photography in these volumes announced the division as a promoter of a new style of photographic *expression*, which I have associated in these pages with the transcription of observational documentary into still photographic form. At the same time, this more seemingly direct and spontaneous approach reflected a widespread interest at the time in street photography and the development of a "new documentary" mode in the work of such figures as the American photographers Diane Arbus, Garry Winogrand, and Lee Friedlander, with whom division staff and photographers would likely have been familiar. In total, images by forty-four photographers would be selected for the "People of Canada" project. Though they include the work of such stalwarts as Chris Lund (see, for example, 5.21, an image that also appeared in Photo Story 13, a pictorial on the Grenfell Mission in Newfoundland), the volume is dominated by a less polished "snapshot aesthetic," with the photographers Lutz Dille, Michael Semak, John Max, and Pierre Gaudard most extensively represented.

Though both volumes were organized around their innovative visual content, they also featured poetic verse. The division's French writer, Gaston Lapointe, worked with A.M. Beattie, an English literature professor at Carleton University, and Guy Sylvestre, a parliamentary assistant librarian, to select writers. Their short list included Jay MacPherson, Phyllis Gotlieb, Gwethalyn Graham, and Dorothy Livesay for the English volume and Anne Hébert, Cécile Chabot, Eugène Cloutier, Jean Desraspes, and Pierre Perreault for the French.[71] In the end, with Monk insisting on women writers ("le choix d'une femme de lettres pour la rédaction du volume 'Peuple du Canada'"),[72] they selected Miriam Waddington and Rina Lasnier. Waddington was a faculty member at York University; Sylvestre praised her extensive publication record and characterized her as an "accurate observer of nature and society, both urban and rural."[73] Lapointe promoted Lasnier as "a great name in Canadian poetry."[74] Again reflecting the prominence given to image over text, the two poets were commissioned to produce work in response to images supplied by the division.

*Call Them Canadians* and *Ces visages qui sont un pays* are far less luxurious volumes than *Canada: A Year of the Land* and *Canada, du temps qui passe*. In fitting contrast to the landscape books' horizontal orientation, they appear in portrait format, measuring slightly over twelve inches by nine inches, encased in a photographic dust jacket and bound austerely in black, the title printed in white only along the spine. Rather than the lavish colour of the landscape volumes, they feature black and white photographs (reproductions based on gelatin silver prints). The effect is of a more candid and therefore intimate glimpse of Canada than that seen in the nearly theatrical landscape books.

Again reflecting the proto-multiculturalist rhetoric espoused by authorities associated with the Centennial Commission and Expo 67, the division promoted the books throughout the production process in pluralist terms. By

1965 they were being described, with stunning hyperbole, as "documenting the people of Canada in all their racial and ethnic variety – illustrating all age-groups – all economic and social backgrounds – all the multitude of occupations and activities."[75] Monk would echo this description for years to come. In an interview conducted in 1977, for example, she recalled that with these two books, the division "tried to cover all Canadians: Every ethnic group, every economic group, every geographic location, every occupational group, [with] at least one photograph … that people could identify with it."[76] This claim of absolute inclusivity, though naïve or perhaps just wildly overstated, nonetheless indicates that the film board's overall mandate of fostering national cohesion through regional and cultural awareness remained at the core of Monk's intents for this project.

A close reading of the English volume suggests that it, of the two, more faithfully reflects the federal rhetoric the division then espoused, and reveals how Monk and the division conceptualized the Canadian citizenry and expressed this new model of Canadian identity stylistically. Throughout, allusions to portraiture are central to the volume's assertion of a Canadian citizenry that was at once pluralist and cohesive.

Narrative structure is an essential component of *Call Them Canadians*. While *The People Tree* allowed for a greater degree of viewer choice, a publication generally directs the reader or viewer more than an exhibition. *Call Them Canadians* opens with eight full pages of photographs (two of them bled across two-page layouts) preceding the formal title page, signalling the importance of the image to its narrative. In an editor's preface, notably brief and in discreet white typeface on a black page, Monk states: "The poems by Miriam Waddington, which were especially written for this book, have been arranged to set the mood or theme for the series of pictures that are grouped about them. No direct reference or relationship is intended between the actual persons in the pictures

and the thoughts conveyed in the poetry. The poems were not written as caption material, but only to reveal, in another artistic medium, some further aspect of the human story."[77]

Despite Monk's emphasis on the visual, text frames the images. Waddington's poetic verse and Monk's telling though brief preface set the tone for readers. Monk in particular provides the reader with clues to what Stuart Hall refers to as the "preferred interpretation of the message" or the "official" reading:[78] "Here are the Canadians … young and old, anxious and serene, the lonely and the loved ones. Here for the first time in the history of our country is an intimate photographic look at the people of Canada."[79] With this opening statement, Monk imprints multiculturalist nationalism on the volume; she characterizes it as an inclusive and yet intimate portrayal of the Canadian people.

In her first verse, paired with Michel Lambeth's image of an infant in a crowd staring quizzically back at the camera, Waddington too turns to the question of Canadian identity (fig. 5.17). But here as in much of her verse in this volume, she treats the nationalist project of which she is a part in ironic terms:

> What is a Canadian
> anyway? A mountain, a maple
> leaf, a prairie, a Niagara fall,
> a trail beside the Atlantic, a
> bilingualism, a scarred mosaic,
> a yes-no somehow-or-other maybe
> might-be should-be could-be
> glacial shield, grain elevator,
> empire daughter imperial order of
> man woman child or what? (p. 15)

*Call Them Canadians* responds to Waddington's question with 247 images of individuals or groups. Photographers seem to be credited as something of an afterthought. The

5.17 "Little girl watching the photographer as the crowd behind her watches the Grey Cup Parade," May 1965, *Call Them Canadians*. Photograph, Michel Lambeth.

volume lists the forty-four photographers in the opening pages but only provides image credits in an index. None of the photographs is accompanied by identifying information. The various faces are organized around the stages of life as

lived in Canada. Indeed, the structure underlying *Call Them Canadians* reflects a loosely cyclical biological model. Most of the opening images depict children and youth, followed by successive stages of adulthood, with a return to images of childhood. Images of children, as throughout the division's history (see chapter 2), are employed as recurrent signifiers of idealized Canadian citizenry and the nation's future. (Interestingly, old age and references to death are represented in scant few images in the book and are generally addressed – euphemistically – by references to organized religion and spiritual contemplation.)

Monk has clearly taken Steichen's *Family of Man* as a model for the volume's narrative structure, but, as in *The People Tree*, the biological cycle has been employed as an organizing principle to construct a *portrait* of a cohesive Canada. *Call Them Canadians* presents itself as a portrait of Canadian citizenry. Leafing through, we follow this idealized and imagined citizen from infancy into adulthood within the community of the nation (figs. 5.18, 5.19, 5.20, 5.21). The faces that dominate every page evoke the portrait's conventional status as a signifier of stable, autonomous identity. In effect, the form of the portrait is invoked as a metaphor for the unified nation – the underscoring aim of all Still Division work.

And yet, of course, these images are not "true portraits." They lack the specificity afforded by personal identification, typically achieved through naming and precise textual description. Monk's preface is explicit about the anonymity of the images: "The book deliberately refrains from identifying people by their geographic locale or ethnic origin for this is not a socio-economic study or a statistical review. There is not even a record of where the photograph was taken. It does not matter. The photographic moment alone is supreme."[80] For Monk, like many modernist commentators on photography, that "photographic moment" is universal. It levels all society to the image, and here, more specifically, to the scopic regime of the state. In short, the anonymous

or unidentified images provide a telling metaphor for one of nationhood's central demands of its citizenry: to identify oneself firstly as a subject of the state. Within the multicultural rhetoric espoused by the Canadian government in the 1960s (and since) – imprinted through this publication – that message is pointed (fig. 5.22).

If *Call Them Canadians* proposed a model of the idealized citizen and cohesive nation, what of its joint publication, *Ces visages qui sont un pays*? It too is filled with images of Canadians from the division archive coupled with poetry – in this case by the Québécoise poet Rina Lasnier. Indeed, for the most part the same images appear in the two volumes. Yet otherwise the two publications are in marked contrast, with distinct text, sequencing, and layouts.

*Ces visages qui sont un pays* credits each photographer prominently beside his or her image. Again in contrast to the

5.18 (*left*)  "Claudia, Montreal, Quebec," 1965, *Call Them Canadians*. Photograph, Nina Raginsky.

5.19 (*right*)  "Market, Place Jacques Cartier, Old Montreal, Quebec," 31 October 1960, *Call Them Canadians*. Photograph, Jeremy Taylor.

English publication, it is organized in discrete sections. In total, thirty-two titles, crafted by Lasnier, divide the images and, along with photographic captions, provide connotative layers of meaning. These titled sections include "Au commencement …," "Première solitude," "Poètes du quotidian," "Les Petits riens," and "Mon Pays vivant" (figs. 5.23, 5.24, 5.25). In general the arrangements and texts celebrate – in fairly sentimental terms – the rhythms of daily life. In

5.20 (*left*)   "Jewish market, Toronto," 1964, *Call Them Canadians*. Photograph, Lutz Dille.

5.21 (*right*)   "Grenfell Mission, Newfoundland," 1951, *Call Them Canadians*. Photograph, Chris Lund.

this way, *Ces visages*, like its English language counterpart, reflects the division's widespread tendencies toward banal nationalism. Yet, by dividing images into numerous sections, it suggests a more multi-vocal nation than the unified, coherent model proposed in *Call Them Canadians*. Moreover, the plethora of language filling the book – including captions for virtually every image – lends each photograph a sense of specificity denied in the English publication. While these

photographs again are not, strictly speaking, portraits (they evoke portraiture but remain unidentified), nonetheless the textual attention paid to each suggests the specificity of their subjects and allows each to stand autonomously.

How did this volume come to take such a different form from its English counterpart? Originally, Monk planned to produce one bilingual picture book with French and English verse appearing somewhat apart from the images. To this end – though, notably, before the layout was finalized – photographs were distributed to the two poets. Lasnier worked with the images intensely for months, and rather than producing occasional text, as Waddington did, she created verse for each image. Moreover, she developed her own image sequences and thematic categories, becoming increasingly active in (and demanding about)

5.22 (*left*)   Untitled. ca. 1966, *Call Them Canadians*. Photograph, John Reeves.

5.23 (*right*) "Teenagers at the Canadian National Exhibition," ca. 1964, *Ces visages qui sont un pays*. Photograph, Michael Semak.

image selection. When it became apparent that she was in effect developing a wholly different publication, Monk diplomatically asked her to revise her writing to conform to the original plan. Lasnier refused, dismissing a division staff member's suggestion that "pictures speak for themselves." She adamantly argued that minimizing text would "deaden the book"; it would be a "mere parade of faces."[81] Under pressure of looming deadlines, Monk eventually pleaded with the Queen's Printer and was granted permission to print *Ces visages qui sont un pays* as a separate publication.

Clearly, Lasnier was concerned with securing publication for all of the text she had written for the project. At the same time, in challenging the terms that Monk had established – though failed to communicate adequately – she developed a counter-narrative to that of *Call Them Canadians*. While still dedicated to a nationalist project, *Ces visages qui sont un pays* resists the concept of the photograph as a universal language. Instead, I suggest, Lasnier proposes a more complex, multivalent image of nationhood, which does not insist on national cohesion.[82] A sense of multiple identities emerges

5.24 (*left*)   Untitled, 1965, *Ces visages qui sont un pays*. Photograph, Lutz Dille.

5.25 (*right*)   "Mistassini Indian men playing cards, on the Mistassini reservation in Northern Quebec," 1965, *Ces visages qui sont un pays*. Photograph, John Max.

pictorially and textually. Moreover, the book's integration of identifying information (about photographers and titles of images, for example) and its fragmentation into multiple sections suggest multiple points of view and change the experience of perusing the book through the open-ended rather than the closed, cohesive narrative suggested by *Call Them Canadians* in its stricter adherence to a *Family of Man* format.

In commissioning, sequencing, and disseminating images for *Call Them Canadians* and *The People Tree*, the Still Photography Division drew on and refashioned the semiotically loaded form of the portrait to serve the project of nationhood. The portrait's status as an optimum signifier of stable, unique (Cartesian) identity rendered it an effective metaphor for the cohesive, unified nation, a message central to the division's mandate. Ironically, using images that may not be portraits in a strict sense provides another metaphor for one of nationhood's central demands of its citizenry: to identify oneself firstly as a subject of the nation. But photography and its presentation can also be a forum for resisting hegemonic models. Rina Lasnier's interventions undermined the subtle use of the portrait as metaphor of nation. Instead, she transformed *Ces visages qui sont un pays* into a counter-narrative to the division's "official picture" of Canadian nationhood.

# PART THREE

## Revisiting the Archive

# Lessons with Leah:
## Rereading the Photographic Archive from the North

On 16 June 2004, Leah Idlout d'Argencourt Paulson, an Inuk writer, editor, and translator living in Iqaluit, spoke with me by phone about some images from the NFB Still Photography Division's archive.[2] We talked specifically about a photo story made in the late 1950s featuring three photographs taken in Resolute Bay on Cornwallis Island, today part of the Territory of Nunavut (figs. 6.1 and 6.2). As we spoke, Leah looked at a copy in Iqaluit while I examined another in Ottawa. Through photographs, captions, and brief text, this photo story recounts the experience of a young Inuk woman teaching English to a group of Inuit youth with the aid of the RCMP. In one image we see her waiting for her charges at the door to their makeshift schoolhouse, while in the two additional photographs she oversees their work in the classroom. Couched in the rhetoric of national progress, the captions provide statistical evidence of Inuit betterment through conventional southern education like that afforded by this homespun school in Resolute Bay.

I did not hesitate initially to read this pictorial as a federal promotion of Aboriginal assimilation into western and southern life. After all, the photo story focused on and lauded efforts by an Inuk teacher and her students to master one of the two prevalent languages of southern Canada. But during our conversation in 2004, Leah Idlout (as she is commonly

Counter-narratives of the nation ... continually evoke and erase [the nation's] totalizing boundaries ... [disturbing] those ideological maneuvers through which "imagined communities" are given essentialist identities.

Homi K. Bhabha[1]

# English Lessons with Leah

83/42

There was no school at bleak Resolute Bay, 560 miles inside the Arctic circle when Leah returned to her people after 2 years in a tuberculosis sanatorium. While away, the young Eskimo girl had learned to read and write English and, encouraged by the interest of youngsters who lived in the tiny 13-house settlement, Leah decided to hold some classes of her own. The experiment was encouraged by the local member of the Royal Canadian Mounted Police who provided a small warehouse which served as a school and here for 2 years Leah and her young friends studied together.

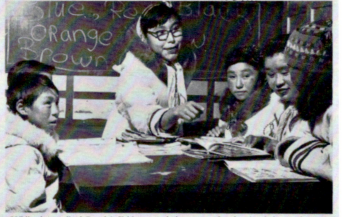

While almost all of Canada's Eskimo population can read and write their own language, only about 10% can read and write English. This percentage is expected to rise sharply as the number of pupils in Canada's northland, which has grown from 450 to 1300 in 10 years, continues to increase. Leah (right, above) hopes eventually to qualify as a teacher's aid.

83/40

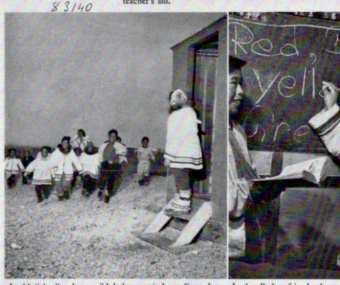

83/41

Leah's "class" makes a wild dash to get indoors. Some days as many as 23 children, ranging from toddlers to teenagers, turned up for lessons.

National Film Board of Canada Photos by Ted Grant

Leah tells her friends about the many fascinating things she saw during her stay "down south". Eskimo children are very anxious to learn about the white man's life as well as their own storied past.

6.1   Photo Story 162-L, "English Lessons with Leah," 17 June 1958. Photographs, Ted Grant.

known) did not see the same images that I saw or read the same texts and subtexts that seemed so clearly inscribed on the page before me. Instead she greeted this pictorial with delight; it provided an opportunity to recollect old friends and family while energetically recounting the challenges and pleasures of life in the High Arctic almost fifty years ago. As you will have deduced, Leah Idlout was that idealistic novice schoolteacher in the 1958 photo story. The images and story, which she had never seen before, prompted her to talk about Inuit culture and her long-ago efforts to teach English lessons through Inuit ways. Where I read a story of government-encouraged assimilation, she experienced the reaffirmation of community history and Inuit cultural resilience.

How can one body of images prompt two such disparate responses? My conversation with Leah Idlout underscores how malleable photographic meaning is. Photographs, like those in this photo story, can – within a range – take on varying significance according to the subject position of the viewer and the context of viewing. While this book as a whole is principally concerned with unearthing the "official picture," the perspectives of the NFB's Still Photography Division, a federal agency mandated to promote Canadian nationalism, photographic meaning is informed but never entirely constrained by the original intent of the maker or guiding institution. And in turn, the photographic archive, the repository of images, can provide an invaluable resource for the consolidation of multiple, coexisting narratives.

This chapter returns to theoretical considerations of the photographic archive first raised in the introduction. The discussion that follows continues to explore how the photographic archive developed by the Still Division strives to constitute a cohesive sense of nation and achieves this in part through the effects of "banal nationalism." But this chapter also explores the division's "official picture" from the perspective of some of those it takes as its subjects, specific-

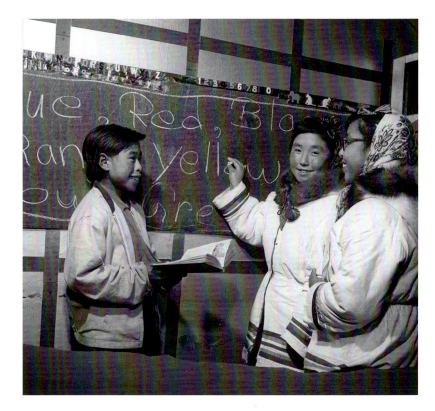

6.2  "Image of Inuit children and teacher, Leah Idlout, Resolute Bay, NWT [Nunavut], 1958." Photograph, Ted Grant.

ally introducing how memory work can productively reframe an official model of national identity. As a case study, it focuses on images of the North and Inuit interventions into the photographic archive.

In exploring tensions between "official" discourses of the nation and cultural memory, I revisit Allan Sekula's influential ideological critique of the photographic archive, which was addressed in the introductory chapter and underscores much of this book. I contrast his work with recent initiatives

developed in collaboration with the Ottawa-based Inuit school Nunavut Sivuniksavut, including Project Naming, a collaboration with Library and Archives Canada, and a project I am collaborating on with Nunavut Sivuniksavut in consultation with Project Naming. Through the recovery and recontextualization of photographs depicting Aboriginal peoples ("visual repatriation"), Inuit students and elders locate in repositories of nationalist and imperialist images, including those produced by the division, sites from which to reclaim Aboriginal subjectivity. For them, the photographic archive provides what Marita Sturken terms a "technology of memory," a body of representations through which individual and cultural memory can be negotiated.[3] In employing memory work, this initiative (along with others by various Aboriginal scholars, artists, and community groups) offers models of what Homi K. Bhabha has termed "counter-narratives of the nation," the rearticulation of nationhood through the strategies of "cultural difference."[4]

## The Division Looks North

The photographs and photo story that Leah Idlout and I discussed reflected the NFB's long-standing fascination with the North. The film board's cinematic divisions produced various documentaries on the region, including Doug Wilkinson's popular 1952 film *Land of the Long Day*[5] (see fig. 6.14). The Still Division, too, looked northward throughout its history, particularly during the 1950s and after; among its photo stories is one from 20 February 1962 that references Wilkinson's film in its title (fig. 6.3).[6] While the division seems to have been at pains to represent all areas of the country equitably following population distribution, the Arctic and sub-Arctic were exceptions. Out of 565 photo stories in the division's archive produced between 1955 and 1971, over sixty, or more than 10 percent, referenced these regions.

During the same years, the division also contributed photographs to popular and governmental publications on the Arctic as well as stills from film productions.[7] As part of its series of photo kits made with the Queen's Printer, for example, the division produced *People of the High Arctic* in cooperation with the Department of Northern Affairs and National Resources, a set of thirty-one captioned photographs dating from about 1958 (fig. 6.4).[8] The division was also routinely called upon to document official visits to the North, including Governor General Vincent Massey's 1956 northern tour, captured by staff photographer Gar Lunney (fig. 6.5). As Lorraine Monk remarked in a later interview, "It tended to be very popular in the Film Board to go up north and document the Eskimos … There was a kind of cult of photographing the Eskimo."[9] This widespread dissemination of northern images as key visual symbols of Canada reflects the division's banal nationalism.

The division's preoccupation with picturing the Arctic and the Inuit in the 1950s and '60s coincided with increased government interest in the region. Under John Diefenbaker, Canada's prime minister from 1957 to 1963, the federal government developed extensive programs to exploit natural resources in that vast region.[10] In 1958, Diefenbaker famously announced, "I see a new Canada – a Canada of the North," signalling a heightened economic, political, and symbolic role for these broad regions.[11] He subsequently established Roads to Resources, an ambitious initiative that encouraged the exploitation of natural resources in the Arctic while addressing concerns over Canadian sovereignty in the region.[12]

But the Still Division's fascination with the Arctic and sub-Arctic should also be seen within the rubric of a broader cultural phenomenon, reflecting the central place that the idea of the North holds in the national imagination. In her capacious study *Canada and the Idea of North*, Sherrill Grace maintains that the North is "fundamental" to imagined

National Film Board Photostory No. 305   For Release on or after TUESDAY, February 20, 1962

# Play in the Land of the Long Day

Traditional Eskimo games like building miniature igloos and sleds, imitating husky dogs, playing hunters or, as above, dancing in a circle, have been supplemented by tricycles, model airplanes, other toys from the south. New ways of play will help Eskimo children adjust to the changing world of the arctic.

Though he still lives in the age-old winter snow house of his people, this little boy is most likely as familiar with airplane types as boys the world over.

Little leaguers in Canada's far north have big advantage over other ball players — there's no shortage of space for baseball diamonds in the arctic. Boy at Frobisher Bay, above, wears catcher's mitt and mukluks.

*Rub-a-dub-dub, three men in a tub, we're off to catch a seal.*

*Last one's a polar bear!* Eskimo children at Resolute Bay rush out to play during recess in the local school. Children of the north have long been noted for carefree, happy-go-lucky spirit.

Eskimo baby enjoys playtime with his grandmother. She delights him with typical baby toy and old Eskimo way of child care — great patience, little discipline, devoted attention.        National Film Board of Canada Photos

Eskimo youngsters take a quick dip in what may be Canada's most northern swimming hole.

Pauloosee — junior sheriff of Baffin Island. It takes more than a little snow to stop a boy playing cowboys in Canada's arctic.

6.3   Photo Story 305, "Play in the *Land of the Long Day*," 20 February 1962. Photographs, Gar Lunney, Ted Grant, Bud Glunz, Jean Roy, Doug Wilkinson, and Rosemary Gilliat.

## Au Grand nord canadien

# EXPLOration 67

Ce scientifique à l'allure de clown, Ralph Swinwood, combat le froid.
*Ci-dessous:* on dresse la charpente de la tente.

"*Pénètre-toi de la grandeur de la patrie ainsi qu'elle se révèle à tes yeux jour après jour, aime-la. Et lorsque tu en perçois la grandeur, souviens-toi qu'elle la doit à des hommes courageux qui connaissaient leur devoir, appliquaient à l'action leurs sens de l'honneur et même s'ils échouaient dans quelque entreprise, n'auraient jamais privé le pays de leur énergie mais la lui consacraient comme leur plus belle offrande*".

—*Périclès.*

Ce que Périclès a dit, cinq cents ans avant J.-C., sans doute le répéterait-il aujourd'hui pour ceux qui ont fait ce que le Canada est et promet d'être. Alors que le monde entier est réuni sur le sol canadien et que partout retentissent les mots "Cen-

tenaire" et "Expo 67", des hommes qui pourraient bien être groupés sous le titre d'"Explo 67" explorent et scrutent la partie de la plate-forme continentale polaire située en bordure de l'océan Arctique, près des îles Reine-Elisabeth. L'étude poussée que ce groupe de scientifiques fédéraux accomplit là-bas apporte et apportera de précieux renseignements sur l'hydrographie, la géologie, la gravité, les levés sismiques, le géomagnétisme, etc. Ils affrontent, à l'heure du Centenaire de la Confédération canadienne, la tâche exigeante et écrasante de maintenir le Canada à l'avant-garde du progrès mondial et d'en faire une force de plus en plus puissante pour le plus grand bien de l'humanité.

—*Gaston Lapointe*

PHOTO REPORTAGE DE L'OFFICE NATIONAL DU FILM

Bien que loin des îles de l'Expo 67, à 250 milles de la terre ferme, sur l'océan gelé, les scientifiques canadiens n'oublient pas qu'il y a un Centenaire. *Ci-dessous:* on perfore l'océan en vue d'expériences.

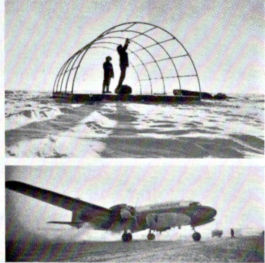

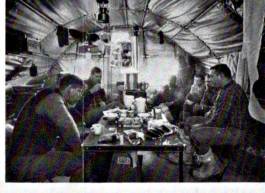

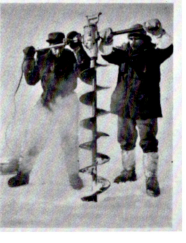

L'équipe de recherches sismiques à l'heure du lunch avant de retourner aux explosions expérimentales. A gauche: un avion *Nordair* arrive à Mould Bay. — *Photos: Ted Grant.*

6.6   Photo Story 444B, "EXPLOration 67: Au Grand nord canadien." Photographs, Ted Grant; text, Gaston Lapointe.

68-12986    68-13051

Gord LeLiever, prospecteur-géologue, en travail dans la région de Coppermine.

*A gauche:* Le matériel de *Panarctic* transporté à bord d'un *Hercules.*

*Ci-dessous:* Pour peupler sa solitude, un géologue adjoint se sérénade à Cambridge Bay, Ile Victoria.

Le premier ministre Trudeau au camp de Drake Point, Ile Melville, centre des activités de *Panarctic.*

OCÉAN ARCTIQUE

HUILE

MÉTAUX

Ile Melville

Coppermine

Great Bear Lake    ONF

Carte indiquant les principales régions d'exploration.

Le dynamitage, un des points importants de l'exploration pétrolifère.

*Ci-dessous:* M. Roger-A. Blais, géologue conseil, de Montréal, au travail à son des maringouins.

### Sociétés et Gouvernement en exploration

# Mise en valeur du Grand Nord

L'industrie minérale du Canada a vécu, en 1967, une autre année remarquable. On a établi de nouveaux records tant pour l'ensemble que pour les grands secteurs de la production. La prospection de nouveaux gisements ainsi que l'exploration et la mise en valeur de concessions se sont poursuivies dans toute l'étendue des provinces et des territoires. Certains gisements très importants sont entrés en production tandis que plusieurs autres doivent commencer à produire cette année et au cours des quelques années à venir.

La nouvelle la plus spectaculaire de l'année, touchant le thème de ce reportage, annonçait en Chambre des communes la création de *Panarctic Oils Limited,* consortium composé d'importantes sociétés pétroliè-

res et minières du Canada. Profitant des dispositions du Programme d'aide à l'exploration minière dans le Nord, cette nouvelle société canadienne engage au moins 20 millions de dollars afin de réaliser, dans les îles de l'Arctique canadien, un programme d'exploration

PHOTO-REPORTAGE DE L'OFFICE NATIONAL DU FILM

pétrolière réparti sur trois ans. Le gouvernement du Canada s'est joint à *Panarctic.* L'industrie et le gouvernement ont établi ainsi un mode unique de collaboration en vue d'entreprendre les travaux d'exploration voulus pour mettre en valeur le potentiel d'une région de conformation géologique inusitée. *Panarctic* aura des inté-

rétées 44 millions d'acres de terrain pétrolifère, par suite d'une série d'accords conclus avec les premiers détenteurs de permis.

C'est ainsi qu'une soixantaine de petites sociétés, dont la plupart sont canadiennes, bénéficieront des travaux d'exploitation exécutés sous les auspices d'actionnaires canadiens.

*Panarctic* est donc un programme unique qui réunit, d'une part, un grand nombre d'intérêts du secteur privé et, d'autre part, le gouvernement sous une seule organisation capable de réaliser, dans le Nord, des économies d'une singulière importance. Cette nouvelle conception de la mise en valeur autorise de grands espoirs en ce qui concerne l'essor de l'économie des régions septentrionales. — Gaston Lapointe

*—photos de Ted Grant*

6.7    Photo Story 476A, "Mise en valeur du Grand Nord: Société et gouvernement en exploration," 31 August 1968. Photographs, Ted Grant; text, Gaston Lapointe.

# Canada's Northern Citizens

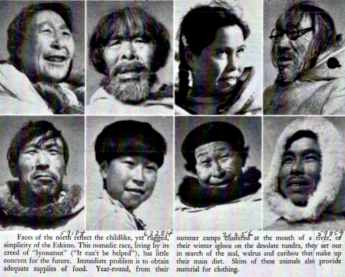

During the Eastern Arctic's short summer months Eskimos, like this family at Sugluk, P.Q., pitch their sealskin and canvas tents at the mouth of a river where heavy runs of fish in July and September will ensure good supply of food to carry them through the long winter.

Despite his contact with white man, and new goods which fur trading has brought him, the Eskimo is still a primitive man. Here, in the warm confines of their winter igloo, a Baker Lake family is engaged in fashioning traditional sealskin clothing and snow-knives to the accompaniment of gramophone music.

Faces of the north reflect the childlike, yet rugged, simplicity of the Eskimo. This nomadic race, living by its creed of "Iyonamut" ("It can't be helped"), has little concern for the future. Immediate problem is to obtain adequate supplies of food. Year-round, from their summer camps clustered at the mouth of a river, or their winter igloos on the desolate tundra, they set out in search of the seal, walrus and caribou that make up their main diet. Skins of these animals also provide material for clothing.

In a little-known, poorly-mapped area embracing some 872,000 square miles north of the treeline, Canada's 9,600 Eskimos carry on a centuries-old culture that is a successful adaptation of the limitations of their environment. With the advent of the white man, the Eskimos turned to fur trapping, enriching Canada's economy with a wealth of furs. But an economy which now depends on the fluctuations of the fur fashion market has brought problems as well as benefits to Eskimos like this Chesterfield Inlet family. Sparked by field men of the federal Department of Northern Affairs, a rapidly-developing Eskimo handicraft industry is helping to ease economic problems.

NATIONAL FILM BOARD PHOTOS

6.9    Photo Story 035, "Canada's Northern Citizens," 29 November 1955. Photographs: Wilfred Doucette, George Hunter, Bud Glunz, Jean Roy, Doug Wilkinson; text, uncredited.

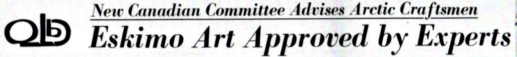

# New Canadian Committee Advises Arctic Craftsmen
# Eskimo Art Approved by Experts

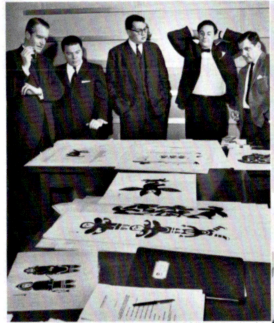

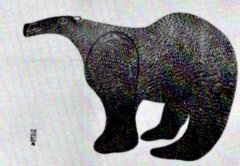

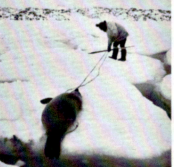

Artistic talents of Eskimo women, resulting in top-quality, money-making designs have brought significant change in community life. No longer appraised by old standards of skill in lamp trimming, skin curing, cooking, many gifted women are esteemed for art work. Highest-priced print in this year's show is *Big Bear*, ($85) by Lucy of Cape Dorset. To make prints from original drawings the designs are carefully transferred to flat-surfaced stones which are used as printing blocks. Other technique calls for cutting stencils from sealskin. Many tools used in graphic work are home-made by Eskimos.

Age-old method of harpoon hunting — part of everyday northern life and vital for obtaining food, clothing, heating and cooking oil — is subject of much Eskimo art.

Hunters out on sea ice are still daily part of arctic life. Traditional, primitive way of existence helps Eskimo art remain unique, honest in creation.

Pitseolak, has several prints in 1962 exhibit.

Kenojuak's work is sought after by international collectors, art museums. *National Film Board of Canada Photos by B. Korda*

Centuries of living with relentless nature has taught Canada's Eskimos the value of co-operation. One form of share and share alike in today's changing arctic is the West Baffin Eskimo Co-operative, operated by and for Eskimo artists and craftsmen. Headquarters are at Cape Dorset on the south coast of bleak Baffin Island — trading point for over 300 Eskimos. Here, wandering groups of Eskimos in from the hunting grounds for a brief period, sell the primitive art they have created. To maintain the high quality of graphic art stemming from the imagination, folklore and way of life of native inhabitants, the Eskimo co-operative requested advice from art critics in Canada's south. Result: a down-to-earth, critical look at Eskimo graphic art by an independent, voluntary group of six experts. Forming the Canadian Eskimo Art Committee (above) are, from left: Alan Jarvis, former director, National Gallery of Canada, M. F. Feheley, Toronto art collector, Dr. E. Turner, director, Montreal Museum of Fine Arts, Paul Arthur, noted typographer and art critic, and Norman Hallendy, designer and editor. Julien Hébert, industrial designer, is not present. Their task: to examine new graphic art designs, evaluate artistic merit, help keep this aspect of arctic culture fresh and appealing, suggest selling prices and generally advise Eskimo artists and the federal department of Northern Affairs on Eskimo art. Destined for public showing at the annual exhibit of Eskimo Art in April are 83 prints selected by the committee, the first to bear their seal of endorsement, ᐅᖅ, Eskimo syllabics for approved.

Kiakshuk's art is inspired by mythology.

Lucy, creator of prize print *Big Bear*.

Prints by Parr appear for first time in 1962.

Advice of Canadian Eskimo Art Committee will ensure that graphics reaching the public in the future, as originals, prints or greeting cards, will be of highest quality.

6.10   Photo Story 308, "New Canadian Committee Advises Arctic Craftsmen: Eskimo Art Approved by Experts," 3 April 1962. Photographs, Chris Lund, Ted Grant, B. Korda, Doug Wilkinson, Gar Lunney; text uncredited.

bulk of division images depicting Aboriginals, however, in that Leah is identified by name. Notably, though, only her first name is given. Although before European contact Inuit did not have surnames, by 1958, many – including Leah Idlout and her family – had adopted them.[30] Consistent with the format of many division photo stories, the layout is dominated by a positioning shot or lead picture. Here we are shown Leah leaning over a table toward the camera to instruct a group of five students. The other two photographs show her greeting students and looking on as they work at the chalkboard (see fig. 6.2). Accompanying text tells us that after spending two years at a tuberculosis sanatorium, Leah was encouraged by the Royal Canadian Mounted Police to teach classes in English; again, all whites, including local members of the RCMP and the photographer, Ted Grant – remain absent yet paradoxically omnipresent figures of authority. Captions bemoan that although "Eskimo children are very anxious to learn about the white man's life … only about 10% of them can read and write English." Not only is Leah's work therefore praised for encouraging assimilation but the implication is that First Peoples' deepest desire is to achieve linguistic and cultural fluency in southern society.

At the same time, subtle pictorial strategies seem to confer the mantle of benevolent caretakers on the images' assumed (southern and white) audience. Like most division images of the time, these photographs reflect aspects of expository documentary, as discussed in chapter 2. Although intimate, they present the scene from a seemingly unobtrusive, yet all-seeing vantage point that is – as I have argued – coded in terms of race. This god's-eye view is the visual equivalent of those familiar voice-overs in most NFB documentary films of the time, often performed in the sonorous tones of Lorne Greene.[31] Similarly, this seemingly anonymous vantage point positions the viewer at once apart from the scene and yet in elevated judgment of it, an effect of spatio-temporal distancing typical of division representations of Aboriginal

people in general. These and many other images of Aboriginal peoples produced by the NFB and other agencies adopt elevated vantage points, diminishing the stature of their subjects.[32] Like the texts described above, vantage point constructs not only the photograph's subjects but its viewers as well. In short, pictorials such as this example reflect what Eva Mackey has identified as a broad tendency for images of Aboriginal people to be "mobilized … [to] construct [Canada] as gentle, tolerant, just and impartial."[33]

The history surrounding this group of images and the conditions of their production reveals just how overt that desire was to "construct" the nation and federal agencies as benevolent. Tiny, remote Resolute Bay, where Leah's classroom stood, had been the subject of much discussion in Ottawa and across Canada. In the 1950s, the Canadian government relocated several Inuit family groups from Port Harrison (today known as Inukjuak on Hudson's Bay and Pond Inlet on Baffin Island to two areas in the High North: Resolute Bay on Cornwallis Island and an area on southern Ellesmere Island around Grise Fiord. As Frank Tester and Peter Kulchyski argue in their ground-breaking study *Tammarniit (Mistakes)*: "The relocation reveals the attitudes many Canadians held towards an emerging and incomplete welfare state. These attitudes affected Inuit considerably, as they were translated into concerns about Inuit welfare and concerns about Arctic sovereignty. Two areas of totalization converged: the state's concern for establishing territorial integrity and its concern for managing Inuit within the norms of Canadian society and economy."[34]

In establishing settled communities in the Arctic Islands, the Canadian government attempted to assert its domain in the face of US presence in the region and ongoing Cold War tensions. Inuit were made to serve as "human flagpoles."[35] Most of the resettled families at Resolute Bay and Grise Fiord came from Port Harrison (Inukjuak) and were ill-prepared for life in the High Arctic.[36] Unable to hunt in their familiar

ways and isolated from extended families, they suffered greatly.[37] At the same time, the establishment of settlements and residential schools, not just at Resolute and on southern Ellesmere Island but in various regions of the North, marked an effort to assimilate Inuit populations into southern Canadian life. While these policies were partly motivated by concern over their physical welfare, the immediate and long-term effects have been ruinous. Indeed, today, many Inuit leaders see a causal relationship between governmental and church policies in the North decades ago and social ills among Inuit today. As former Nunavut premier Paul Okalik has stated, the relocations, the establishment of settled communities, and residential schools "irreparably [disrupted] life among Inuit."[38]

The Canadian government countered these tragedies with publicity staunchly presenting the settlement of communities as successful efforts at asserting Canadian domain in the North and improving the welfare of Inuit through assimilation. Among news items appearing was a photographically illustrated *Globe and Mail* story of 11 July 1957 about the Resolute Bay school.[39] But the Still Division was especially closely tied to the promotion of governmental programs and initiatives. About 1958, for example, it produced *People of the High Arctic*, the series of thirty-one educational photo texts made, as noted earlier, in cooperation with the Department of Northern Affairs and National Resources, the federal agency responsible for the governance of the Arctic and overseeing the controversial relocations (see fig. 6.4). The set endorsed governmental initiatives in the High Arctic, stressing it as a vulnerable region and endorsing Inuit assimilation into mainstream Canadian life. The final photograph in the set features a photograph by Wilfred Doucette dated 1953 and depicting, according to Library and Archives Canada records, Constable Minkyoo of the Twin Glacier RCMP Detachment working on a house at Alexandra Fiord (fig. 6.11). The caption in the photo set describes the scene: "The Eskimo

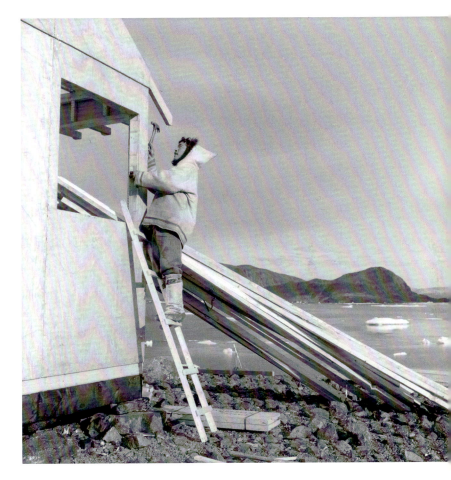

6.11 "Eskimo constable Minkyoo attached to the Twin Glacier Detachment of the Royal Canadian Mounted Police (R.C.M.P.) works on one of the pre-fabricated buildings erected for the post," Alexandra Fiord, NWT [Nunavut], August 1953. Photograph, Wilfred Doucette.

is helping to build the New North. The old, more primitive, conditions are changing with the every-increasing activity and the Eskimo is, in most cases, successfully adapting to the new way of life."[40] Most Canadians in the South would have only seen the smiling faces of such governmental promotions or placements in the media rather than the tragedy that was actually unfolding.

"English Lessons with Leah" was part of this campaign, implicitly endorsing and promoting contemporary governmental policies in the High Arctic. Ted Grant made images and notes for this photo story while accompanying the Eastern Arctic patrol of the government icebreaker and supply ship *d'Iberville*. He also shot images for a story on the *d'Iberville* itself, extolling the work of government vessels in the North.[41] In effect, Grant was a civil servant aboard a government vessel; his choice of themes was therefore informed, if not conscripted, by the mandate of the *d'Iberville*'s staff and the federal Department of Northern Affairs and National Resources. Back in Ottawa, other division staff responded to contemporary northern policy to produce text and edit images to put these policies in the most positive light despite the increasing hardships experienced by the resettled Inuit families, including that of Leah.[42] And, in turn, the photo story and other positive images of the North produced by the division were disseminated widely in the commonplace forms of banal nationalism. In these mass-distributed photographs, Inuit were in effect used not only as human flagpoles in the assertion of political domain but also as props in the government's public relations campaign.

## Viewing the Photographic Archive from the North

Close readings of images and pictorials depicting the North – like the analysis of "English Lessons with Leah" and other division images above – reflect an approach adopted throughout most of this book, one that is modelled after Allan Sekula's treatment of the photographic archive.[43] According to Sekula, the archive creates a coherence of the individual components of its holdings; ultimately each photograph and photo story in the division archive, for example, becomes part of an overarching narrative of nation building.[44] By imposing unity and by relying on the "illusory neutrality" of a seemingly objective organizational system and the apparent authority of the indexical image, the photographic archive masks the real power underscoring the division's role as a photographic chronicler of federal policy and a vehicle for naturalizing its views.[45]

Sekula's work provides a useful theoretical model for reading the Still Division archive as a discursive strategy that reifies the concept of Canadian nationhood. It demonstrates how power – here the power of a southern model of national identity – is naturalized. Yet this model also has its limits. Although Sekula intends to explore the archive from the position of those it takes as its subjects, he simultaneously reinscribes conventional hierarchies. Indeed, Sekula's approach to the photographic archive generally focuses so intently on institutional authority that it unwittingly reproduces hegemony. As Elizabeth Edwards and Christopher Morton charge, Foucauldian readings of the photographic archive (like Sekula's) "effectively silenced precisely those voices – the indigenous, the 'Other,' the disempowered – that they were intended to valorize."[46]

A compelling approach to the photographic archive that usefully augments Sekula's method is now being developed by a wide variety of Aboriginal communities, scholars, and artists – the same people who, following ideological readings, have long been subjugated by the authority of the archive of nation. Working alone or in dialogic relationships with western anthropologists and archivists, they have extensively employed "visual repatriation." Within recent anthropological studies, visual repatriation has become an increasingly prominent mode of study aimed at facilitating

greater Aboriginal agency in the recording of indigenous histories and challenging Eurocentric cultural analysis – including Eurocentric notions of photographic meaning.[47] Similarly, archivists and other scholars have turned to visual repatriation as a means of reasserting Aboriginal identity within and through the archive.[48]

In the archive (and the photographic archive, specifically), Aboriginal peoples and their collaborators are identifying cracks in the imperialist edifice of nation and, more surprisingly, sites from which to reclaim native memory. Employed by many cultural groups internationally, these interventions vary greatly. Within the broader context of North American Aboriginal culture, they include academic writing, art, photography, and curatorial practice by such figures as Gerald McMaster, Gerald Vizenor, Hulleah J. Tsinhnahjinnie Theresa Harlan, Sherry Farrell Racette, and Jeff Thomas, as well as the development of various community-based archives.[49] Although Aboriginal interventions take diverse forms, they are all motivated by the dual mission of affirming community history and interrogating the archive as a vestige of neocolonialism.[50] In this way, the photographic archive has been mined for invaluable information about families, community members, and historic figures, while its imperialist origins are simultaneously critiqued.

This work reflects aspects of "photo-elicitation." First developed by the photographer and anthropological researcher John Collier, photo-elicitation is the use of photographs in interviews to gather information by prompting memory and directing the interview subject's attention.[51] It has subsequently become a staple in cultural anthropology's arsenal of research tools. According to Douglas Harper, photo-elicitation adds "validity and reliability to a word-based survey."[52] But photo-elicitation can be problematic; Elizabeth Edwards, for example, has argued that the use of photographs in anthropological interviews exemplifies the colonial encounter, a "largely a one-way flow from inform-

ant to ethnographer."[53] In contrast, visual repatriation is initiated by Aboriginal groups or in close collaboration with them. It aims, in the words of Onondaga photographer and curator Jeffrey Thomas, "to find a new agency for the photographs and … uncover the voice of the people posed before the cameras."[54]

Among visual repatriation projects originating with northern Aboriginal communities in Canada is a notable intervention in the photographic archives by the Ottawa-based Inuit school Nunavut Sivuniksavut (translating from the Inuktitut as "Nunavut's Future")[55] and Library and Archives Canada (LAC).[56] Project Naming was established in 2001 by Murray Angus and Morley Hanson, founding faculty members of Nunavut Sivuniksavut, in partnership with LAC and the Nunavut Department of Culture, Language, Elders and Youth, to connect Inuit with their history through images (fig. 6.12). Although working collaboratively with governmental archives, the ongoing endeavour nonetheless effectively challenges dominant models of Canadian nationhood by exploiting new communications technologies and the indexical authority of the photographic image to augment community memory and assert a self-defined model of the North and Aboriginal subjectivity.[57]

Project Naming seeks to identify some of the thousands of Inuit depicted in images from the LAC's photographic collections in Ottawa.[58] Most Aboriginal subjects in the collections, which include Still Division holdings from 1941 to 1962, are unidentified and therefore often stand as anonymous cultural "types" rather than historic individuals. By attempting to identify as many individuals as possible, Project Naming seeks both to enhance Inuit cultural history and to give agency to Nunavummiut, the people of Nunavut. In addition, the project solidifies connections between Nunavut youth and elders and provides a forum for making community history vivid to youth. From its inception, the time sensitivity of this project was recognized: with each

6.12   Project Naming website.

elder's passing, first-hand knowledge about Inuit culture passed too.[59]

Out of the LAC's extensive holdings, photographs dating from between the 1920s and the early 1960s were selected for study. This range represents a period familiar to present day elders and also coincides with a widespread colonization of the North and Christian conversion of the Inuit. The images came from several different fonds, including those of the Department of Indian and Northern Affairs, the Department of National Health and Welfare, the Donald Benjamin Marsh Collection, the Richard Harrington Collection, and the National Film Board.[60]

The first phase of Project Naming was initiated in spring 2001 and addressed about five hundred photographs taken by Richard Harrington in the community of Igloolik (also

Iglulik) from 1948 to 1952.[61] The collaborators were encouraged by the success of the first phase, which identified fully three-quarters of the people in the images. Subsequently the project has explored the history of such communities as Arviat (formerly Eskimo Point), Kinngait (also known as Cape Dorset), Kugluktuk (formerly Coppermine), and several other locales. As a result of this effort, elders have been able to identify people in hundreds of previously anonymous images and discuss their memories of them with the youth conducting the interviews.[62]

Digital technology has been pivotal to Project Naming. Each photograph selected for research from LAC collections was digitized to allow for the dissemination of images, often never seen before in Nunavut, via CDs, laptops, and the web. Since October 2004 the project has existed as a web exhibition, with all of the material available in Inuktitut, English, and French.[63] In this widely accessible format, it serves, according to Murray Angus, as "Nunavut's family photo album."[64]

Research for Project Naming has been decidedly intergenerational. The job of eliciting identifications of the photographs from elders initially fell to dozens of Inuit youth. Most of these researchers were Nunavut Sivuniksavut Training Program students in their late teens. They spoke with elders in their home communities during school holidays. In cases where no one from a given locale was enrolled at the school, a community centre or school in that area was contacted and asked to find youth to conduct interviews. The naming sessions were at times private encounters at elders' homes or large community gatherings. In February 2003, for example, the community centre of Arviat was used for a large gathering where photographs were projected onto a big screen and audience members shouted out names of those they recognized.[65]

Youth researchers were each given a laptop loaded with archival images depicting the selected community, and a

binder with prints of the images, along with a standardized series of questions developed by the students with Murray Angus and Morley Hanson. Elders responded to images viewed on the screen. While additional questions were permitted, and elders often elaborated extensively, each researcher asked the following questions about the images: "Do you know who this is in the picture? Do you know where it was taken? Can you describe what is happening in the picture? What was life like for Inuit back then?" The researcher made notes to each response and asked the elder to confirm the spelling of the photographic subjects' names in English, Inuktitut, and Innuinaqtun.[66] It is important to note that Project Naming does not include full oral histories. The collaborating organizations prioritized identifications over additional cultural information. Accordingly, records or detailed notes of the encounters between youth and elders were not made.

Even though the recorded information left by Project Naming is limited, its long-term impact on Nunavummiut in general and on its intergenerational participants specifically has been profound. Indeed, the project's young researchers attest to the ways that visual repatriation has connected them to older generations and made the past come alive. Mathewsie Ashevak, for example, in a statement written in February 2004, enthusiastically recalled conversations in Kinngait (also known as Cape Dorset) with his grandmother, the celebrated artist Kenojuak Ashevak, his step-grandfather, Pauta Saila, and Saila's wife, Petalusie Saila, in December 2003: "It was so exciting showing these Elders the pictures – it was almost like taking them back to the days when they were young. When I clicked on each picture, I watched their eyes. As they recognized an individual, they would have a big smile on their faces. They acted as if these pictures were taken just yesterday … Before now, I had not talked much with Elders. This experience was new to me, and I really enjoyed it. Each time they named a person in the picture, it made me want to go back to the time that they remembered."[67]

For elders, these encounters have at times been intensely emotional, often marking their first glimpses in decades of long-departed family and community members. In one interview from 2001, the elder Tagurnaaq identified an undated Harrington photograph from Igloolik of a beautiful young woman as "Kunuk," to whom he had been married.[68] He paused to recall how much he had loved her. During her research session for Project Naming, elder Helen Konek identified herself as the young girl seated in a family portrait. Pictured with her are her father, Piqanaaq, her mother, Paalak, and her siblings, Nanauq, Pukiluk, and Kinaalik, from Saningayuaq near Padlei in 1949 or 1950.[69] Often elders provided genealogical information, retracing the threads of familial relations between sitters and their extended kin. This detailed family information contrasts to the cursory titles, with their emphasis on geographic locale and typological ethnographic information, that were originally assigned to these images. A Harrington photograph dating from 1952 or 1953 at Igloolik, for example, was known for decades simply as "Eskimo [later Inuit] hunter pulling in two captured seals, Igloolik, N.W.T." Through Project Naming, this image has been renamed: "Qulaut. He was the son of Uqajuittuq, the husband of Kuuttikuttuk, and the father of George Qulaut."[70] A photograph depicting two men standing stiffly inside a building, taken in 1953 at Repulse Bay by J.C. Jackson, had rested in the LAC collection for years as "Customers at the Trading Post."[71] But when Nunavut commissioner Peter (now Piita) Irnik saw the photograph, he recognized a relative (fig. 6.13). Working with Project Naming participants, he revised the caption to read: "René Inuksatuajjuk (*left*) and his friend, Peter Katokra (*right*). René Inuksatuajjuk is Nunavut Commissioner Peter [Piita] Irnik's adopted brother's grandfather. Both men are from Naujaat, and the photograph was taken at the Hudson's Bay

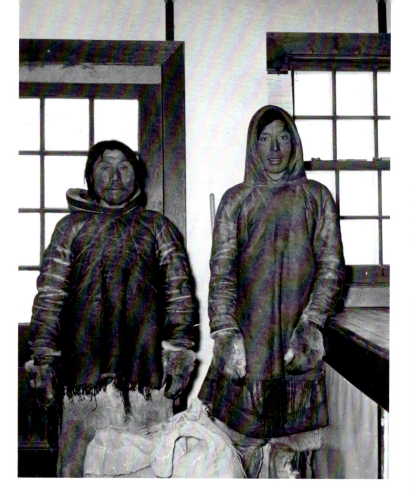

6.13   J.C. Jackson, "Customers at the Trading Post," 1953. Project Naming citation, "Customers at the Trading Post René Inuksatuajjuk (*left*) and his friend, Peter Katokra (*right*)," 1953, e002213392, LAC. "René Inuksatuajjuk is Nunavut Commissioner Peter Irnik's adopted brother's grandfather. Both men are from Naujaat, and the photograph was taken at the Hudson's Bay Company Store in the spring. The men are wearing 'atigis' (caribou clothing with hair against their skin). The Hudson's Bay Company was not heated; therefore the manager and staff would have to wear their heavy parkas while working. Peter Katokra's first wife was Genova (Kadslajuuqaaq), who died many years ago. Peter Katokra is still living in Naujaat-Repulse Bay." Photograph, J.C. Jackson.

children played before television was widely accessible, former technologies used in travel, housing, and hunting, and older musical entertainment.[73] Project Naming helps to keep such traditions alive. More recently, Project Naming has been using the web itself as an instrument for gathering and disseminating identifications. According to Beth Greenhorn, the LAC archivist responsible for Project Naming since about 2005, "the project has branched out, and I have collaborated with various individuals and other organizations, including the Qikitani Truth Commission, Inuit Heritage Trust, the Nanisiniq Arviat History Project, the Kitikmeot Heritage Society, and Inuit Tapiirit Kanatami, to name just a few."[74] Subsequently, Project Naming has used podcasts and the social networking site Flickr to reach Inuit audiences. One of its most successful public outreach initiatives is the "Do You Know Your Elders?" feature published in English and Inuktitut in the *Nunavut News / North* and *Kivalliq News* since September 2007.[75] Again, the result has been to enhance Inuit knowledge – now through the web, social media, and the press.

Company Store in the spring. The men are wearing 'atigis' (caribou clothing with hair against their skin). The Hudson's Bay Company was not heated; therefore the manager and staff would have to wear their heavy parkas while working. Peter Katokra's first wife was Genova (Kadslajuuqaaq), who died many years ago. Peter Katokra is still living in Naujaat-Repulse Bay."[72]

In other cases, elders commented on the myriad ways that life had changed in the North. They described the games

Project Naming uses the photograph in a manner that differs significantly from that employed by Sekula and

other contemporary scholars of photography. Rather than questioning the photograph's status as an indexical sign, a position central to my discussion of the division as a whole and something of an orthodoxy in photography studies, it invokes what might aptly be termed a "strategic indexicality," a concept closely associated with second-wave feminism to characterize a tactic for fostering group cohesion by referencing (yet critiquing) broad, stereotypical characteristics. For community members, these photographs – often the only remaining visual records of certain individuals – are much more than mere documentary records. As Elizabeth Edwards has said, in Aboriginal visual repatriation projects, "Photographs are active in the dialogue, become social actors, impressing, articulating and constructing fields of social actions and relations, as [John E.] Stanton … argues, powerful stimuli for the maintenance of indigenous knowledge."[76] Nineteen-year-old Jenna Kamingoak of Kugluktuk (formerly Coppermine) in the western Arctic, for example, was moved when an elder pointed to a photograph from the 1950s and announced, "That's your grandma!"[77]

Recent conceptualizations of memory inform Project Naming. Within the now-voluminous Memory Studies literature, memory is understood foremost as a form of representation. The emphasis on memory as representation signals its subjective, provisional, and imaginative character.[78] Rather than assuming the possibility of a straightforward retrieval of past "fact," memory is characterized as the ways that the past is narrated, depicted, and understood in the present. In short, Memory Studies concerns itself centrally with the ways that we make sense of the past in our lived experience today.[79] Memory work is not only grounded in the present but also opens up a space for multiple readings of the past. In so doing, it contests the notion of a singular and intractable telling of the past, instead proposing a model of multivocality. Finally, as Susannah Radstone has argued, Memory Studies also balances out or contests the extremes of poststructuralist theory, particularly its ahistorical nature, "abandonment of the subject," and emphasis on the constituted.[80] For Aboriginal communities, then, Memory Studies offers a means of asserting agency in spite of historical discourse's effective erasure of their presence and poststructuralism's dismissal of the subject position.

Photography holds a privileged place in discussions of memory. Indeed, the photograph may be the single object that most people – particularly in the West – associate most closely with remembering. Since the advent of affordable and easily operated camera equipment at the turn of the twentieth century, taking photographs of key events, friends, and family has become a near-obsessive activity. Collected in albums or electronic files, they are used as mnemonic devices, often with the assumption that the photographic image wholly encapsulates a past. Memory Studies has also adopted the photograph as a central object of analysis. However, rather than a passive, unmediated vessel of the past, its scholars propose it as a key site for the active production of memory. As Annette Kuhn argues, photographs "have a part in the production of memories, offering us pasts which in one way or another reach into the present, into the moment of looking at a picture."[81] Similarly, Sturken characterizes the camera image as a significant "technology of memory," an object "through which memories are shared, produced, and given meaning."[82]

Project Naming reflects key aspects of memory work. The initiative uses the photograph as a "technology of memory" through which community, family, and individual identity is negotiated. At the same time, in framing these images within a contemporary context, the project reflects the characterization of memory as a reading of the past in the present.

In its exercise of memory work applied to a reconsideration of a national archive, this visual repatriation project also reflects aspects of Homi K. Bhabha's discussion of the narrative address of nationhood in the well-known essay

"DissemiNation: Time, Narrative, and the Margins of the Modern Nation."[83] Bhabha credits Benedict Anderson's critique of nationhood and nationalism with "paving the way" for his own postcolonial and deconstructivist reading of the nation and more specifically of the narrative of nationhood.[84] In Bhabha's view, Anderson identifies the nation as a fundamentally ambivalent force by demonstrating that it is not the fixed, trans-historical, intractable, and socially cohesive institution claimed by essentialist understandings of nationhood, but instead "imagined." Yet Bhabha criticizes Anderson for portraying a homogenizing, "collective voice of the people" in the simultaneous time of national belonging.[85] Instead, Bhabha suggests, "the people must be thought in a double-time; the people are the historical 'objects' of a nationalist pedagogy, giving the discourse an authority that is based on the pre-given or constituted historical origin or event; the people are also the 'subjects' of a process of signification that must erase any prior or originary presence of the nation-people to demonstrate the prodigious, living principle of the people as that continual process by which the national life is redeemed and signified as a repeating and reproductive process."[86]

Bhabha argues that "the people are the articulation of a doubling of the national address, an ambivalent movement between the discourses of pedagogy and the performative."[87] The pedagogical "founds its narrative authority in a tradition of the people … encapsulated in a succession of historical moments that represents an eternity produced by self-generation" while the performative "intervenes in the sovereignty of the nation's self-generation by casting a shadow between the people as 'image' and its signification as a differentiating sign of Self, distinct from the Other or the Outside."[88] This tension between the pedagogical and the performative Bhabha sees as an example of "cultural difference," a strategy or form of intervention that "re-articulate[s] the sum of knowledge from the perspective of the signifying singularity of the 'other'" and, in this way, effectively de-totalizes cultural authority – including, centrally, the authority of the nation.[89] Drawing directly from nationalist discourse itself, cultural difference re-articulates dominant culture's effects through the voices of those it takes as its Others. Accordingly, by demonstrating how readily the authority of the nation – its "official picture" – can be subverted, these strategies call into question the very idea of the nation as a cohesive, univocal entity.[90]

The act of naming, central to Nunavut Sivuniksavut's intervention, demonstrates how "cultural difference" can operate. Naming has both a loaded imperialist history and specific cultural associations for Inuit. It has long been recognized as key to the process of colonization.[91] Naming or renaming individuals and geographical sites has the effect of recasting them in the cultural and linguistic hues of the colonizer while simultaneously erasing indigenous cultural associations.[92] As such, it is also closely tied to Edward Said's concept of "imagined geographies."[93] The plethora of English names formerly identifying locales in the Arctic – for example, Frobisher Bay, Cornwallis Island, and Baffin Island – asserted British possession. Similarly, Christian missionaries' extensive efforts to give the Inuit biblical names, the Canadian government's demeaning campaign to assign an identifying number to each Inuk, and the absence of Inuit names in the LAC photographic collection all attest to an erasure of Inuit culture.[94]

But as well as an imperialist legacy, the act of naming has potent meaning within Inuit culture. As John Bennett and Susan Rowley have stated, "Three essential parts made a human in the Inuit view: body, soul, and name. A nameless child was not fully human; giving it a name, whether before or after birth, made it whole. Before contact with outsiders, Inuit did not have family surnames. Instead, each person's name linked him or her to a deceased relative or family friend."[95] By reintroducing names to photographs

in the national archives, Project Naming reclaims those intergenerational connections and reasserts Inuit culture. It achieves this act of cultural assertion by "re-articulating" two key effects of imperialist culture: the institutional (and archival) photograph and the act of naming. (The establishment of the territory of Nunavut and the extensive reintroduction of Inuktitut names to the region is a broader example of this cultural reclamation.) If, as I have argued, the Still Division's archive reified the concept of a coherent Canada, strategies of cultural difference – as enacted here in the visual repatriation of photographs and interventions into the photographic archive by Project Naming – destabilize it. They point instead to the liminality of the sign of nation.

## Counter-Narratives of the Nation: Inuit Rereadings of the NFB Still Photography Division

How might lessons learned from Project Naming be applied to a study of the Still Division archive? This northern initiative suggests viewing the archive as a technology of memory, a site where cultural memory is negotiated rather than a bureaucracy in which a dominant view is imposed. In an ongoing initiative called Views from the North, which I am undertaking collaboratively with Nunavut Sivuniksavut and Library and Archives Canada's Project Naming, students are applying some of the same techniques initially developed in the project to the division archive. The results are available online and will be linked to the Project Naming site.[96] Begun in 2005, this research program differs from (but as a collaboration, also complements) Project Naming in one important aspect: rather than only gathering names, students also conduct longer, recorded interviews with elders about individual photo stories and photographs. In effect, the interviews serve as partial oral histories organized around the elders' perceptions of archival photographs.[97] Images – and the findings of the interviews – are finally returned to those

they depict. Through this process, the project offers new insights into how nationhood has been imagined officially and how it might be reimagined by those it takes as its subjects, like Leah Idlout.

Leah Idlout has long been familiar with the role played by many Inuit for a governmental camera. Her father, Joseph Idlout, a celebrated hunter from northern Baffin Island, became well known among southern Canadians during the 1950s, around the time that "English Lessons with Leah" appeared. He had been the subject of Doug Wilkinson's NFB film *Land of the Long Day*, and the Canadian two-dollar bill featured an image of him hunting (fig. 6.14). But as Barry Greenwald demonstrates in the 1990 documentary film *Between Two Worlds*, Joseph Idlout also felt the intense pressure of these conflicting cultures and expectations.[98] Today his daughter lives in Iqaluit and works as an Inuktitut/English translator, an apt profession for a person who has spent much of her seven decades negotiating the spaces between the North and South as well as those between Aboriginal and Euro-Canadian worlds.

In our 2004 conversation, Leah Idlout talked about the 1958 NFB photo story in which she was featured.[99] For her, revisiting this pictorial after forty-six years prompted a flood of associations. Indeed, she later went on to participate in Project Naming, providing identifications and contextual information. In the rich weave of her memory, it became an opportunity for discussing her continuing or lost connections with people in the images, changes in living conditions in the North, relations with Anglican missionaries, and life for children in the harsh environment of the resettled community of Resolute Bay in the 1950s. Above all, it prompted her to consider how her teaching was collaborative – a collaboration that parallels that which occurs in a visual repatriation project. "We learned together. As we went along, I learned from them what to teach, what their interests were. At the time, most of our fathers were hunters. They wanted to

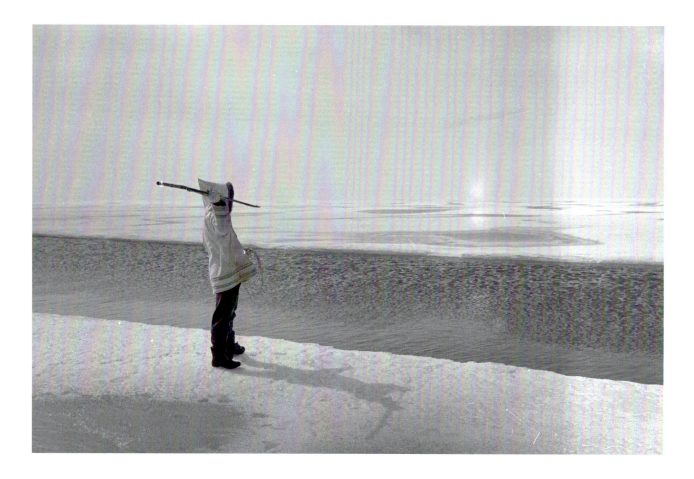

6.14 "An Inuit man [Joseph Idlout] preparing to throw a harpoon at a sinking seal," Pangnirtung, NWT [Nunavut], October 1951. Original caption, 1951: "Eskimo Idlouk prepared to throw harpoon at sinking seal which, in summer season, float only about half a minute after being shot." (Image also appears as plate 7 in *People of the High Arctic* photo set. For other images from the set, see also figs. 6.4 and 6.11.) Photograph, Doug Wilkinson.

talk about hunting. The Nanuq, what is called the Polar Bear ... walrus and seal. Sometimes, they would make me say it in English. That's how we were learning ... They were very curious and anxious to learn ... I was learning with them."[100] Like Leah Idlout's classroom, visual repatriation, an example of the destabilizing strategy of cultural difference, offers a space for shedding light on experiences those official models of nationhood or ideological readings of the archive obscure.

# CONCLUSION

When I pried open a few old file-cabinet drawers filled with photographic prints and index cards several years ago, I entered into a vast but largely forgotten archive, the repository of the National Film Board of Canada's Still Photography Division. In some 250,000 photographs, hundreds of photo stories, and myriad publications, negatives, card catalogues, distribution ledgers, board minutes, legislation, and correspondence, I discovered a complex composite picture of Canada during the Second World War and the decades immediately following. As my research continued, I discovered a division staff attentive to the communicative and expressive possibilities of photography and driven to promote Canada through them in an agency that worked within and at times around governmental mandates and bureaucracy. Above all, I found a vivid and multilayered visualization of Canadian identity during those years.

In *The Official Picture*, I have suggested that the Still Photography Division made a significant contribution to Canadian nation building from the 1940s through the 1960s. In producing and distributing hundreds of thousands of photographs and related texts, the division disseminated a compelling, multifaceted image of Canada as a coherent nation. Many of these images were made by long-time staff photographers Chris Lund and Gar Lunney, but the division's

archive is also filled with the work of other staff photographers and some of Canada's finest freelancers; among their ranks were Harry Rowed, Ronny Jaques, Ted Grant, George Hunter, Richard Harrington, Pierre Gaudard, Michel Lambeth, and Lutz Dille.

From munitions worker Veronica Foster performing for a government camera in 1941 to photo stories featuring polio patient Dorothy Gifford, Saskatchewan wheat farmer Ed Schiefner, and teacher Leah Idlout, as well as the hundreds of anonymous faces peering out from Expo 67's *People Tree*, the division archive pictured thousands of Canadians. They were both subjects and audience for its pictorial celebration of Canadian nationhood. And these images came to life due in part to the shared visual language of national symbolism and the authority of the documentary image. In its photographs of Canadians or such emblems of Canadian identity as wilderness and the North, the division created an officially imagined portrait of the nation. I have tried, in focusing on specific case studies – photographic representations of childhood, labour, landscape, citizenry, and the North – to look in depth at how those nationalist representations took form. With this book, I wanted to return an important yet long-neglected agency to public attention and show the compelling images, resonant iconography, ubiquitous

presentation, and complex governmental relations that were the basis of its work.

In my explorations of the Still Division archive, I also encountered a pervasive sense of the familiar and the routine. Early in my research I read through the division's 565 photo story mat releases from the 1950s and 1960s and transcribed a number of their texts.[1] A friend, watching me frenetically type, asked why. Weren't they basically all the same? I responded, perhaps a bit defensively – but what researcher does not at some level identify with and feel compelled to defend her material? – with examples of the visual inventiveness of the division's photography and with platitudes about the importance of scrutinizing documents to find the subtle ways that style, rhetoric, values, policies, and governmental initiatives took form and changed. And yet I had to admit that in one sense she was right. Despite the captivating images and their reflection of a changing political landscape, the photo stories, products of weekly or bi-monthly standardized effort, *did* have an undeniable sameness. That sameness was also evident in much of the visual archive as a whole, with its consistently jingoistic language, repeated visual motifs, standardized publications, and recurrent formats. But as I continued to work, I came to recognize that sameness or routine was, paradoxically, a significant, even remarkable aspect of the division's production.

This book has argued that the Still Photography Division produced a form of "banal nationalism" – a term, as I have noted throughout, that refers to the routine reception of markers of national identity. I do not mean to suggest that the division's work is "banal" in the sense of limited skill and interest; indeed, as I hope I have shown, it produced some of the most seductive, technically skilled, innovative, and beautiful media images in Canada at the time. The social psychologist Michael Billig coined the term "banal nationalism" to define the commonplace and almost unnoticed flaggings of national identity that occur within established western states.[2] The term, he says, "suggests that nationhood is near the surface of contemporary life ... [its] routinely familiar habits of language will be continually acting as reminders of nationhood. In this way, the world of nations will be reproduced as *the* world, the natural environment of today ... Small words, rather than grand memorable phrases, offer constant, but barely conscious, reminders of the homeland, making 'our' national identity unforgettable."[3]

Billig calls for attention to those "small words" that fill the "surface" of daily life. It is in such unremarkable lived experiences, he suggests, that national identity takes hold as firmly as in the exceptional moments celebrated in nationalist narratives. In this way, the concept of banal nationalism reflects not only the core concerns of social psychology but also an insistence that "culture is ordinary," Raymond Williams's familiar aphorism that encapsulates a key orientation of cultural studies and much social historical scholarship.[4]

It seemed to me that photographs at times function as ordinary "small words." Ubiquitous, highly mobile, and often considered "middlebrow,"[5] photography is rendered all but invisible by popular assumptions about the neutrality and indexicality of the documentary photograph as well as, paradoxically, by its omnipresence. Media photographs sometimes seem to function like computer screensavers, always visible and yet in the background of our attention. I have suggested that it was through the sheer ubiquity and mobility of its photographs, as well as assumptions on photographic authority and the familiarity of their forms and iconography, that the Still Division contributed to nation building in Canada from the 1940s to the early 1970s. Typically, these images – often appearing without a photo credit or with minimal identification of the photographer, author of accompanying texts, or the National Film Board – reminded the Canadian public of national belonging in a manner that was accepted unquestioningly and "unmindfully." (In these ways, although bound by the same mandate and bureaucracy as the

NFB's cinematic units, Still Division photography addressed audiences in a very different manner than the film board's contemporary documentary films.)

Across that history, the style and form in which contemporary Canada was imagined in the division's "official picture" changed. From the 1940s on, division images' explicit didacticism rendered in visual form a sense of paternalistic authority of the state, and their nearly anonymous and ubiquitous presentation naturalized and reinforced that message widely. By the mid-1960s, however, the division promoted more loosely expressive depictions of Canadian life that acknowledged the subjective positioning of the photographer. In turn, these photographs, exhibitions, and publications, as I have argued, lend visual form to the concept of liberal individualism. At the same time, the turn toward expressive photography in the mid-1960s would give rise to a different mandate at the division; by the early 1970s it would cease to be a visual propagandist for the state, instead becoming a national collection of expressive photography. But until that time, division photographs in all forms and styles in effect functioned to normalize an "official picture" of Canada and offer up an image of it as a coherent nation.

While my concern in *The Official Picture* has been quite specific, the implications for this work extend beyond the case study discussed here to illuminate the subtle and ubiquitous ways that nationalist sentiments (including competing nationalist narratives) are reproduced and how the photograph contributes to those effects. Until a few years ago, historical studies of Canadian nation building addressing the Second World War and the following decades often focused on major actors, events, and monuments. In recent years, social historians in Canada have been turning their attention increasingly to quotidian experience, exploring how gender, class, culture, and racialized identity are enacted through popular culture.[6] The specific study of nationalism in Canada, too, has more recently looked

to everyday experience, at times taking a "cultural turn" in order to explore, in the words of Barbara Lorenzkowski and Steven High, "how Canadians 'internalized' notions of national identity, how they incorporated them into their everyday lives and material worlds, and how they constructed a sense of Canadian-ness in inter-cultural encounters."[7] That scholarship has yielded valuable examinations of how the Canadian "quest for a cohesive identity"[8] was experienced in relation to popular, material, and consumer culture.[9] In this way, those studies, too, have located nationalism "near the surface" of life. Yet the question of how routine inundation normalizes and reinforces national identity – in short, how banal nationalism takes shape – has only been explored to a limited degree.[10]

In historical and contemporary analysis, we need to start looking closely at those commonplace and unremarkable encounters with markers of Canadian nationhood that reproduce national identity. Discussions of reception – how citizens and others engage with and challenge persistent reminders of nationhood, along the way formulating their own ways of identifying national belonging – will clearly be vital. But banal nationalism can also be traced through those vestiges of material culture, consumer culture, and the media that form the nearly unnoticed backdrop of our lives.[11] As I have suggested throughout, popular mass media photographs are a particularly rich vein to mine for these familiar flaggings of national belonging in the later twentieth century.[12] In this respect, *The Official Picture* also reflects recent scholarly interest in the vital role that visuality in general played in Canadian life and national identity formation during the period.[13]

Today, photographic images still flag Canadian nationhood. In 2011, the Government of Canada's official website, for example, is announced through a montage banner of photographic images that trace the country's geographic expanse, punctuated by the verticality of a few select

monuments presented as national symbols.[14] From left to right, the banner carries the viewer from the West Coast and totem poles to the Rocky Mountains, to an inukshuk, a prairie wheat field, Toronto's CN Tower, the Peace Tower in Ottawa, the Château Frontenac in Quebec City, and an East Coast lighthouse. The montage draws visual correlations between Aboriginal culture, natural terrain, urban monuments, and the state, as though these were essential and almost interchangeable components of Canadian identity. The images in this long band overlap and melt into one another, in effect literalizing Benedict Anderson's familiar reference to the nation as originating in "a deep, horizontal comradeship."[15] The website also echoes the key mandate and mode of the Still Division during the period addressed in this book: to visualize a cohesive Canada in a format at once highly visible and unremarkable. The message embedded in the banner is absorbed by the site's thousands of visitors readily and yet almost unconsciously, like the reiteration of those small, seemingly insignificant words that perform national identification.

At the same time, in the twenty-first century such visual representations must compete with the plethora of atomized images across the web. As a result, there is today no singular photographic source for the inundation of Canadian nationalism on the scale of the Still Division. Instead, perhaps the mantle of reinforcing Canadian nationalism has been passed to the CBC and Radio Canada's multidisciplinary productions, which – through the constancy and familiarity of disembodied radio voices, recognizable logos, repetitive television promotionals, and web presence – inundate viewers and listeners with references to Canadian nationhood, in effect framing all experience and expression within national borders.

In its examination of photography's place in the formation of Canadian national identity from the 1940s to the 1970s, *The Official Picture* has also insisted on seeing media photographs not as singular and discrete representations but as a multiplicity. Photojournalism, editorial photographs, advertising images, and other images disseminated through the media – including those produced by the Still Division – are organized into archives and image banks and circulate widely as a mass of constantly shifting images rather than works individually contemplated in the model of art historical analysis. Media photographs are rarely experienced in such a singular manner: photographers, particularly photo-journalists, typically shoot dozens or more images to arrive at one "keeper"; editors work from that mass of files or negatives. Viewers look at media photographs as a multivalent experience in which photographs are seen in the context of other images and texts. In short, the experience of photography is one of multiplicity, with individual images moving in and out of focus against a background of a myriad of other cultural signs. In this way, most photographs (and mass media photographs in particular) make meaning in a manner distinct not only from images viewed in the darkened, fully absorbing space of the movie theatre but also from singular works given hushed, reverent attention in a museum. (Once the division transformed itself into a national collection of expressive photographs in the 1970s, it too began addressing its viewers in a different manner, and in turn its viewers experienced photographs in that more contemplative, fully focused manner familiar to the space of the gallery and museum.) In these pages, I have tried to stress that popular photographs, like those produced by the division through the 1960s, are less easily contained, and slip in and out of the background of attention. As such, they live within and respond to the experience of routine daily life more fully than most other representational forms. Accordingly, my approach to the photograph reflects recent treatments of the photographic archive[16] and the nexus of photography and memory,[17] as well as important new scholarship emerging from studies in communications and rhetoric[18] –

explorations of photographic mobility that acknowledge how media images exist in a network and provide us with rich understandings of photography as a social practice.

Photographic mobility and malleability also allow images to be read and reread in variant ways. As Leah Idlout's experience (and the experience of Inuit involved in Project Naming) in rereading archival images from an Inuk perspective demonstrates, archives – including photographic archives – are not only the raw materials of historical investigation but also exist in the present as artifacts through which we narrate the past today; they make sense of our present lives in relation to a past.[19] But Leah Idlout and those involved in Project Naming are not the only ones to reimagine the division's "official picture." Images from its photographic archive continue to be used in new ways that reflect life in the twenty-first century. Photographs of women munitions workers have become emblems of the dramatic changes in preceding generations of women's lives; landscape imagery has taken on the contexts of new environmental concerns; and the division's many portraits have accrued the meanings of multiculturalist policy in Canada over the past forty years. Indeed, this is the project of cultural history writ large and of this specific study: not to re-enter a past but to reactivate it, as a whole culture, through contemporary sensibilities. Examining the specifics of the past – in this case, the workings and products of a government agency – allows the past to be read anew as well as allowing us to ponder how national identity is naturalized today and the role that media photographs, those almost unnoticed "small words" that reiterate nationalism, may play in it.

The history I have offered here is one that largely scrutinizes the "official picture" or institutional perspective of the Still Photography Division. Unearthing that history will, I hope, open those cabinets up for other readings of the archive.

NOTES

INTRODUCTION

1  At the time of writing, that collection is under the aegis of the
National Gallery of Canada.
2  In this introductory chapter, for clarity's sake, I refer to this
agency as the Still Photography Division, the name attached to
it by the late 1950s (or for brevity's sake, the Still Division, or
simply "the division"). As I outline in detail in chapter 1, how-
ever, it was originally known as Photo Services, renamed the
Stills Photography Division in 1951, and subsequently the Still
Photography Division (SPD).
3  Determining the precise number of unique still photographic
images in the NFB archive has proved to be a Sisyphean
task. Over the course of the film board's history as a produ-
cer of still photographs and custodian of a still photography
archive, it absorbed other collections – notably that of the
Canadian Government Motion Picture Bureau and the Wartime
Information Board (WIB) – amassed numerous images in
addition to commissioning work, changed its own number-
ing system, and saw its collection dispersed. It is now divided
between two different institutions, Library and Archives
Canada (LAC) and the Canadian Museum of Contemporary
Photography (currently a part of the National Gallery of
Canada). Subsequent changes in cataloguing and organization
at both institutions (and occasional overlap between them)
have rendered the calculation of a precise number of the SPD's

production an even more intricate mathematical problem. The
LAC holds about 320,000 "photographic items"; however, LAC
archivist Jill Delaney notes that these include prints, negatives,
multiple copies, and other materials. Andrew Rodger, a retired
LAC archivist, estimates that the NFB amassed about 100,000
negatives from 1945 to 1961 in addition to images accumulated
from the Canadian Government Motion Picture Bureau and
about 25,000 negatives made during the war, including those
produced with the WIB. In turn, CMCP holds 144,000 NFB
negatives. Based on my own survey of the NFB's annual reports,
the current records of both the LAC and CMCP and in consulta-
tion with Jill Delaney, Andrew Rodger, the former CMCP (now
National Gallery of Canada) registrar Sue Lagasi, and CMCP
associate curator Andrea Kunard, I estimate that the holdings
number somewhere between 250,000 and 300,000 unique
images. I have adopted the more conservative, lower end of that
scale because archival records suggest that some of the items
included in that accounting may be duplicates.

By necessity, then, these figures, although based on detailed
knowledge of the archive, are estimates. But as the custodians
of the collection concur, an informed estimate is all that is
reasonably possible. At the same time, the incalculability of the
SPD archival holdings reflects a defining aspect and source of
authority in many large archives: their amorphousness. In the
case of the SPD, the seeming shapeless enormity of its archive
helped to naturalize its vision of Canada. Just as the edges of

this archive itself have been hard to delineate, so too were its images at once ubiquitous yet not recognized during its most productive years. As such, acknowledging that we cannot know exactly the size of the holdings is, paradoxically, a more accurate historical statement about the SPD archive. Thanks to Andrew Rodger, Jill Delaney, Sue Lagasi, and Andrea Kunard for getting out their calculators and comparing numbers (Andrew Rodger, email correspondence with author, 16 January 2012 and 3 March 2012; Jill Delaney, email correspondence with author, 19 January 2012; Andrea Kunard, email correspondence with author, 19 March 2012; and Sue Lagasi, email correspondence with author, 29 March 2012).

4 Couvrette, "National Film Board Stills [sic] Division"; Couvrette, "A Report on the Still Photography Division."

5 Langford, introduction to *Contemporary Canadian Photography from the Collection of the National Film Board*.

6 Wickens-Feldman, "The National Film Board of Canada's Still Photography Division."

7 Rodger, introduction to "The Wartime Information Board and Photography"; "Some Factors Contributing to the Formation of the National Film Board of Canada."

8 Kunard, "Promoting Culture through Photography."

9 I have also drawn on other publications addressing later periods in the division's history. These include the photographer Sandra Semchuk's personal reflection of the division for the artist-run journal *Parallelogramme* and Melissa Rombout's 1991 analysis of the division's construction of national identity in later publications. While not directly relevant for the period addressed in this book, these articles have provided me with an expanded context. See Semchuk, "National Film Board Still Photography Division"; Rombout, "Imaginary Canada."

10 Accordingly, the references below are selective and represent a small sampling of that larger body of scholarship.

11 Ellis, *John Grierson: A Guide to References and Resources*; see also Ellis, *John Grierson: Life, Contributions, Influence*.

12 Grierson, "The Documentary Idea: 1942."

13 McKay, *History of the National Film Board of Canada*.

14 Among the numerous publications by these scholars are Morris, "'Praxis into Process'"; Morris, "Re-Thinking Grierson"; James,

*Film as a National Art*; Jones, *Movies and Memoranda*; Evans, *In the National Interest*; Evans, *John Grierson and the National Film Board*; Nelson, *The Colonized Eye*.

15 Marchessault, "Reflections on the Dispossessed"; Low, *NFB Kids*; Khouri, *Filming Politics*; Druick, *Projecting Canada*; Waugh, Baker, and Winton, *Challenge for Change*.

16 Wickens-Feldman, "The National Film Board of Canada's Still Photography Division"; Bourdieu et al., *Un art moyen*.

17 Billig, *Banal Nationalism*. I am indebted to Peter Hodgins as well as Katie Cholette for introducing me to the concept.

18 Lunney, interview by Charity Marple, 7 May 1996, CMCP.

19 For a comparison of the division's and the National Gallery of Canada's collecting practices, see Kunard, "Promoting Culture through Photography."

20 For an historiographical discussion on the treatment of media workers, see Hardt and Brennan, *Newsmakers*.

21 For discussions on Canadian contemporary photographic practice, see Langford, *Scissors, Paper, Stone*, and Cousineau-Levine, *Faking Death*. Although neither study addresses in depth on the SPD during its later years, both focus on the photographs and photographers who were at the heart of that collection at the time and in the years after.

22 The wording I have employed to describe the division is echoed in the archival record. In 1950, for example, it was referred to at the NFB as the government's "chief official photographic agency." LAC, RG53, sub-series R1196-14-7-E, Minutes of Board Meeting (18 October 1950), NFB, appendix I, 3. T-12773, microfilm. Further, as Andrea Kunard has shown, in a 1960 report civil servant John Sangster recommended that the Still Division serve as the nation's "official photographer." Although Kunard argues that this was not a role explicitly stated in the film act, this book argues that throughout its history as a visual propagandist for Canadian nationhood, the division implicitly served in this capacity. John Sangster, "Summary Report on Still Division, National Film Board of Canada," non-paginated, CMCP NFB SPD, quoted in Kunard, "Promoting Culture through Photography," 298.

23 LAC, RG53, 2, Minutes of Board Meeting, National Film Board of Canada (18 October 1950), appendix 1, 3.

24 Both of the film acts (1939 and 1950) that defined the NFB as a whole and were applied at the time or later to the Still Photography Division specifically, as well as the order in council approving the specific transfer of photographic services to the NFB, underscored it as a "service for the use of all departments." Privy Council, Order-In-Council, LAC, RG2, A1a, vol. 1727, PC 6047 (8 August 1941), reel T-5135; Canada, *An Act to Create a National Film Board, Statutes of Canada*, 1939: 101–5; Canada, *An Act Respecting the National Film Board, Statutes of Canada*, 1950, I: 567–74.

25 On 23 January 1947, for example, an order in council was issued compelling the National Parks Bureau to cease production of films and photographs. The NFB continued to monitor fellow departments; in this specific case, NFB minutes register a complaint that the Parks Bureau had not complied. LAC, RG2, A1a, vol. 1962, PC 256 (23 January 1947), reel T-5194, microfilm; LAC, RG53, 2, Minutes of Board Meeting, National Film Board of Canada (25 March 1947, 10), microfilm.

26 The Oxford English Dictionary's most pertinent definition of the adjectival use of "official" clarifies this common use: "4. a. Derived from, or having the sanction of, persons in office; authorized or supported by a government, organization, etc.; hence (more widely) authoritative; formally accepted or agreed" (online edition, 2009).

27 Foucault, *The Archaeology of Knowledge*; Richards, *The Imperial Archive*.

28 Foucault, "The Eye of Power," in *Power/Knowledge*, 155, quoted in Tagg, *The Disciplinary Frame*, 23.

29 This is one-third of Foucault's definition of the term. In addition, he sees the concept secondarily as the tendency in the West for governmental power to become pre-eminent, and thirdly, the gradual process through which justice becomes "governmentalized." Foucault, "Governmentality," 102.

30 Gordon, "Governmental Rationality: An Introduction," 3.

31 Tagg, *The Disciplinary Frame*; Tagg, *The Burden of Representation*, 153–83.

32 Druick, *Projecting Canada*, 23, 27. In an unpublished study, Andrea Kunard has also argued that the NFB's photographic archive, like its filmmaking production, manifests a specific example of governmentality and the management of the Canadian citizenry ("Promoting Culture through Photography," 11, 204–5).

33 Delanty and Kumar, *Sage Handbook of Nations and Nationalism*, 2.

34 Billig, *Banal Nationalism*, 19, 37.

35 Smith, *Myths, Memories and the Nation*, 5.

36 Written shortly after the Second World War, this statement may allude to Canada's status as a chief ally of Britain early in the war. Canada entered the international conflict in the fall of 1939, more than two years before the United States.

37 Irwin, "What It Means to Be a Canadian," 132–3.

38 Evans, *In the National Interest*, 28.

39 Irwin's argument may have been informed by the influential literary scholar Northrop Frye's contemporary writings on Canadian literature and cultural identity. Frye's various writings on Canadian poetry and literature were later collected in *The Bush Garden*. This geographically deterministic characterization of Canadian identity remains surprisingly compelling for many people. Frye's argument has been perpetuated most influentially by Margaret Atwood and Gaile McGregor. See Atwood, *Survival*; McGregor, *The Wacousta Syndrome*. For a critical treatment of this approach, see Mackey, "'Death by Landscape,'" 125–30.

40 Anthony D. Smith defines primordialism: "Early explanations of nationalism … greatly influenced by organic varieties of nationalism. Nations were seen as the natural and primordial divisions of humanity, and nationalism was thought to be ubiquitous and universal … For the primordialists, the key to the nature, power, and incidence of nations and nationalism lies in the rootedness of the nation in kinship, ethnicity, and the genetic bases of human existence" (*Myths and Memories of the Nation*, 33–4).

41 The modernist nationalism paradigm has also been challenged by the concept of "ethno-symbolism." As proposed by Anthony D. Smith, "ethno-symbolism" is a theoretical model that attempts to account for "pre-existing cultures and ethnic ties of the nations that emerged in the modern epoch," a phenomenon ignored by the modernist theorists. Smith's model provides a compelling way of understanding the emergence of ethnic

Foster was promoted from director of Creative Stills to director of Stills Production and Distribution during the summer of 1943. LAC, RG53, 2, Minutes of Board Meeting. NFB (21 October 1941 and 16 April 1946), microfilm. LAC, RG53, 1, "Statement of Expenditures and Unexpanded Balance, 1 April to 30 September, 1943." See also McKay, *History of the National Film Board of Canada*, 25.

14 In fact, national unity and the war effort were not mutually exclusive concerns. In a well-known speech of 7 April 1942, Prime Minister William Lyon Mackenzie King asked for public support in a national security plebiscite, in part by invoking the possible threat to national unity should the government not be given a freer hand in enacting the country's wartime responsibilities. King, "Address on the National Security Plebiscite."

15 Canada, *An Act to Create a National Film Board*, 103.

16 A 10 June 1940 *Hamilton Spectator* article, for example, attributes to Grierson that films "could help to unify the nation and bridge the gaps between federal and state [sic] authorities." "National Films Are Distributed to Show Effort," *Hamilton Spectator*. The film board's annual reports regularly reiterate variants on this statement. The 1944–45 report, for example, announces that NFB films "have been designed to promote a sense of national unity and a mutual understanding between the many groups which go to make up the Canadian nation." Almost twenty years later, in the 1962–63 report, the NFB would again state its chief goal as "the production and distribution of films in the national interest ... films designed to interpret Canada to Canadians and to other nations." NFB, *Annual Report*, 1944–45, 1; NFB, *Annual Report*, 1962–63, 3.

17 Lunney, interview by Charity Marple, 7 May 1996, CMCP NFB SPD Archive.

18 Numerous NFB documents assert that the NFB was initiated to respond to domestic situations, despite the fact that its efforts were dominated by war-related production during its early years. As Marjorie McKay states in the NFB's in-house history, "the Film Board pre-dated the war and its concept was essentially a peacetime one" (*History of the National Film Board of Canada*, 2).

19 Evans, *John Grierson and the National Film Board*, 113.

20 Ibid., 169–70.

21 John Grierson had been appointed general manager of the Wartime Information Board in January 1943. Rodger, "The Wartime Information Board and Photography"; LAC, RG53, 2, Minutes of Board Meeting, NFB (12 January 1943), microfilm.

22 LAC, RG2, A1a, vol. 1843, PC2364 (4 April 1944), microfilm reel T5164.

23 LAC, RG53, 2, Minutes of Board Meeting, NFB (6 November 1945), microfilm; NFB, *Annual Report*, 1947–48. Also cited in Jones, *Movies and Memoranda*, 45.

24 "Newfoundland: Cameraman Sheds Light in Blackout," *Globe and Mail*, 2 June 1943; Foo, "Highlights: Photographer's Showcase, Nicholas Morant."

25 Carter, "George Hunter."

26 Sarah Stacy, photo archivist, LAC, conversation with the author, 24 June 2006.

27 Lund, "Chris Lund: Words and Images" (interview).

28 Foo, "Highlights: Photographer's Showcase, Harry Rowed (Henry Newton Rowed)."

29 By spring 1946, Rowed too would resign for a more lucrative position in the private sector. LAC, RG53, 1, "Statement of Expenditures and Unexpanded Balance," 1 April to 30 September 1943; LAC, RG53, 2, Minutes of Board Meeting, NFB (16 April 1946), microfilm.

30 "Newfoundland: Cameraman Sheds Light in Blackout."

31 Lund, "Chris Lund: Words and Images" (interview).

32 LAC, RG53, 2, Minutes of Board Meeting, NFB (28 October 1941; 13 March 1945), T-12772, microfilm; NFB, *Annual Report*, 1944–45, 16–17.

33 LAC, RG2, A1a, vol. 1843, PC2364 (4 April 1944), microfilm reel T5164.

34 LAC, RG53, 1, "Progress of Reorganization and Extension of Facilities at the National Film Board" (1942).

35 LAC, RG53, 2, Minutes of Board Meeting, NFB (8 June 1943), microfilm.

36 LAC, RG53, sub-series R1196-14-7-E, microfiche of images, NFB nos. 10389-10400.

37 LAC, RG53, sub-series R1196-14-7-E, file 36, microfiche of images, NFB no. 1987-054.

38 McAllister. *Terrain of Memory*; "Archive and Myth."

39 LAC, RG53, sub-series R1196-14-7-E, file 36, microfiche of images, NFB no. 1987-054. "Loyalty to the British Empire Is Taught to These Second- and Third-Generation Japanese-Canadian Children," 1942, British Columbia, photographer: Jack Long, NFB no. 1964-087, C-067492.

40 In cataloguing their holdings, the NFB and WIB used the prefix WRM (War Records Manufacturing) to designate these industrial images. Rodger, "The Wartime Information Board and Photography."

41 By 1946, Grierson would become director of Mass Communication and Public Information at UNESCO. Ross McLean replaced him as film commissioner. Ellis, *John Grierson: Life, Contributions, Influence*, 216, 218–23.

42 McKay, *History of the National Film Board*, 66–9; Langford, introduction to *Contemporary Canadian Photography from the Collection of the National Film Board*, 9.

43 Ralph Foster, then head of the Graphics Division, explained in a memo of 9 March 1944 to Grierson that photographs were supplied free to newspapers, magazines, and other editorial publications "on an informal basis." A $1 copyright fee per picture was charged for illustrations in a commercial publication without an educational role and a $15 fee per picture was charged to advertisers. LAC, RG53, 2, Ralph Foster, memo to John Grierson, 9 March 1944, microfilm. See also Langford, introduction to *Contemporary Canadian Photography*, 9; McKay, *History of the National Film Board of Canada*, 66–9.

44 According to minutes, a meeting was held in February 1947 with managing editors of Canadian dailies, who expressed satisfaction with the new rates. Minutes of 84th Board Meeting, NFB, LAC, RG53, 2, Minutes of Board Meeting, NFB (16 April 1946; 19 March 1946; 2 July 1947; 24 March 1948), T-12772, microfilm.

45 NFB, *Annual Report*, 1947–48, unpaginated.

46 An evaluation of budgetary cuts is more difficult to make because of corporate reorganization during the 1950s moving the Still Photography Division from Graphics to Production. NFB, *Annual Report*, 1953–54, 5.

47 The reduction of staff was constant for several years. After employees were cut by one-fifth from 1945–46 to 1946–47,

staff further diminished from thirty-five to thirty-one between the 1950–51 and 1951–52 fiscal years. The following year, dramatic cuts would reduce staff to twenty-two personnel. NFB, *Annual Reports*, 1946–47, 1; 1951–52, 9; 1952–53, 9.

48 McKay, *History of the National Film Board of Canada*, 66; NFB, *Annual Report*, 1945–46, 26.

49 LAC, RG2, A1a, vol. 1962, PC256 (23 January 1947), reel T-5194, microfilm. LAC, RG53, 2, Minutes of Board Meeting, NFB (25 March 1947, 10), microfilm.

50 The film board also actively attempted to curtail photographic activity in other departments, which they saw as competition. LAC, RG53, 2, Minutes of Board Meeting, NFB (1949, 3; 1950, 14–15), T-12772, microfilm.

51 Malak Karsh (1915–2001), one of the most prominent photographers working in Ottawa during the second half of the twentieth century, was a regular freelancer for the division. Professionally, he used his first name only, perhaps to distinguish himself from his celebrated brother, Yousuf Karsh.

52 NFB, *A Capital Plan*. The Graphics Services' booklet was designed and produced by the National Film Board in November 1948. While most of its photographs are uncredited, two are identified as the work of Malak. Others are attributed to his brother, Yousuf Karsh. Canada, *Planning Canada's National Capital*.

53 NFB, *Annual Report*, 1945–46, 19.

54 This was achieved in part through the development of a forty-two page subject catalogue of Still Division images. NFB, *Annual Report*, 1947–48, unpaginated.

55 In 1947, for example, NFB minutes list two "photo releases," as photo shoots or photo stories were then sometimes called, which dealt with veterans' civilian employment: a dolls' hospital established by a veteran in Hamilton, Ontario, and a West Coast duck farm owned by two former WRENs. LAC, RG53, 2, Minutes of Board Meeting, NFB (5 November 1947), appendix 6, 4, T-12772, microfilm.

56 See, for example, the following designed by Graphics Services though without photographic illustrations: WIB, *Canadian Affairs Reconstruction Supplements: The Pulp and Paper People*, 1945; WIB, *Your Own Business on Civvy Street*, 1945.

57 NFB, *The Road to Civvy Street*, director and producer, Vincent Paquette, 1945.

58 LAC, RG53, 2, Minutes of Board Meeting, NFB (18 October 1950), appendix 1, 3, T-12773, microfilm.

59 The Royal Commission on National Development in the Arts (the Massey Commission) was initiated in April 1949 and, although its final report appeared in 1951, its initial recommendations influenced the National Film Act of 1950. According to the commission's 1951 report, the Toronto management consultants J.D. Woods and Gordon prepared an initial commissioned report on the NFB, which subsequently applied some of its recommendations. Canada, *Report on the Royal Commission on National Development in the Arts, Letters and Sciences, 1949–51*, chapter 19: "The National Film Board," 306–13. See also Litt, *The Muses, the Masses and the Massey Commission*.

60 In its recommendation the Massey Commission rejected complaints about the NFB competing with commercial photographers. Canada, *Report on the Royal Commission on National Development in the Arts, Letters and Sciences, 1949–51*, 310.

61 Canada, *An Act Respecting the National Film Board, Statutes of Canada*, 1950, I, 567.

62 Ibid., 570.

63 Ibid., 569. This phrasing has subsequently become closely identified with the film board. For example, it served as the title of Gary Evans's well-known 1991 monograph on postwar activity at the NFB, *In the National Interest*.

64 Arthur Irwin replaced Ross McLean in 1950. For Arthur Irwin's essentialist definition of Canadian identity, see Irwin, "What It Means to Be a Canadian," as quoted in the introductory chapter. See also Evans, *In the National Interest*, 12–13.

65 NFB, *Annual Report*, 1950–51, 3.

66 NFB, *Annual Report*, 1954–55, 5.

67 Evans, *In the National Interest*, 23; McKay, *History of the National Film Board*, 83.

68 The name change was effective 28 February 1951. LAC, RG53, 2, Minutes of Board Meeting, NFB (16 April 1951), unpaginated, T-12773, microfilm. Subsequently, and for the purposes of this book, the unit became the Still Photography Division.

69 NFB, *Annual Report*, 1950–51, 1; *Annual Report*, 1955–56, 10.

70 During the 1950s, for example, other photographers included Herb Taylor, Guy Blouin, Bernard Atkins, Jean Gainfort Merrill, Jack Long, Bill McClelland, Irving Dooh, Frank Royal, Sam Tata, André Sima, "Newton," Bruno Engler, Jim Lynch, Bob Lansdale, Bill Lingard, Cliff Buckman, Ron Demers, Bob Brooks, Erik Nielsen, Rudi Wolf, and B. Korda. Card catalogue of photographic shoots and photo stories, CMCP NFB SPD Archive.

71 Grant interview by Charity Marple and author, 1997, CMCP.

72 LAC, RG53, 2, Minutes of Board Meeting, NFB (1953, 13), T-12774, microfilm.

73 John Ough and Hélène Proulx Ough, in discussion with the author and Robert Evans, 18 November 2003.

74 LAC, RG53, 2, Minutes of Board Meeting, NFB (12 October 1950), appendix, "A Report on the Location of the National Film Board," chart B.

75 LAC, RG53, 2, Minutes of Board Meeting, NFB (16 April 1951), appendix 3b, unpaginated, T-127743, microfilm.

76 NFB, *Annual Report*, 1954–55, 22; *Annual Report* 1955–56, 3–6; LAC, RG53, 2, Minutes of Board Meeting, NFB (12 October 1950), appendix, "A Report on the Location of the National Film Board."

77 Evans, *In the National Interest*, 17–19, 22.

78 In fact, the Graphics Division's annual report to the film board for the 1946–47 fiscal year terms External Affairs' Information Service as the "largest sponsor" of NFB photographs. NFB, Graphics Division, Annual Report to the Board 1946–47, LAC, RG53, 2, Minutes of Board Meeting, NFB (2 July 1947), unpaginated.

79 NFB, *Annual Report*, 1950–51, 1; *Annual Report*, 1957–58, 3.

80 Ough and Proulx Ough in discussion with the author and Robert Evans, 18 November 2003.

81 LAC, RG53, 2, Minutes of Board Meeting, NFB (1948, 3); 18 October 1950, appendix 1, 10; 16 April 1951, appendix 3, 1, 5, T-12773, microfilm.

82 This phrasing is repeated in reports to the NFB in 1951 to 1952, but board minutes from 1948 on indicate that these "day-to-day" departmental assignments dominated the division's work.

LAC, RG53, 2, Minutes of Board Meeting, NFB (16 July 1951), appendix 8, 1, T-12773, microfilm.

83 Photo Services, as it was then called, was described in 1950 as "the chief official photographic agency for the federal government. It produces, processes and distributes photographs and photo stories for all government departments. A central library makes these photographs and photo stories available for the illustration of government information in Canada and abroad, supplies photographs in support of films, and provides the basic material for filmstrips. This Section maintains a photo laboratory which enlarges the scope of photographic services for all departments, avoids duplication of equipment, and reduces overhead on technical staff." LAC, RG53, 2, Minutes of Board Meeting, NFB (18 October 1950), appendix 1, 3, T-12773, microfilm. The division had long been worried about competition from other governmental departments producing their own promotional images. See, for example, LAC, RG53, 2, Minutes of Board Meeting, NFB (25 March 1947, 10). T-12772, microfilm.

84 NFB, *Annual Report*, 1957–58, 15; *Annual Report*, 1958–59, 18.

85 Monk, interview by Lilly Koltun, 4 February 1977, LAC.

86 Sekula, "The Body and the Archive," 17.

87 According a report appended to the 1 April 1951 NFB meeting, for example, during the 1950–51 fiscal year, eight bilingual photo displays were produced by the division; they were presented first at the NFB offices at 225–7 Sparks Street, Ottawa, and later circulated to regional NFB offices through the Distribution Division. LAC, RG53, 2, Minutes of Board Meeting, NFB (1 April 1951), appendix 3, 3, T-12773, microfilm; NFB, *Annual Report*, 1944–45, 13; *Annual Report*, 1954–55, 20. NFB photographs were also used in the production of the television programs *Grenfell Mission* and *Operation Ballot Box* on life in Labrador for broadcast on 9 August 1953. LAC, RG53, 2, Minutes of Board Meeting, NFB (1954), appendix 1, 42.

88 A 5 May 1952 report to the NFB projecting the division's activities for the next fiscal year, for example, uses the term "photo journalistic." LAC, RG53, 2, Minutes of Board Meeting, NFB (5 May 1952), appendix 7a, 22.

89 NFB, *Annual Report*, 1958–59, 18.

90 NFB, *Annual Report*, 1959–60, 20.

91 LAC, RG53, 2, Minutes of Board Meeting, NFB (1954), 20th Board Meeting, (1954, 25–6); 21st Board Meeting, 2.

92 The kits are usually not dated, but the archival record indicates that they were initiated during the 1954–55 fiscal year and ran until 1963 when the series on West Coast fisheries was printed (NFB, *Annual Report*, 1958–59, 18). Following the practice of reusing images in different contexts, some of these images also appeared elsewhere. Some of the images from the photo kit on the RCMP or La Gendarmerie royale du Canada (fig. 1.14), for example, also appeared in Photo Story 079, "R.C.M.P. Group on Tour: Musical Ride World Famous," 6 November 1956; photographs, Chris Lund and Guy Blouin; text uncredited.

93 According to Brian J. Low, and as referenced in chapter 2, children were prominent in the NFB's cinematic efforts following the Second World War to readjust the country to peacetime. Yet, as I argue, the division's educational efforts were aimed largely at adults (Low, *NFB Kids*, 65–6).

94 "The text *directs* the reader through the signifieds of the image, causing him to avoid some and receive others; by means of an often subtle *dispatching*, it remote-controls him towards a meaning chosen in advance." Barthes, "The Rhetoric of the Image," 40 (emphasis in the original). For key discussions of how text and image operate in photojournalistic images, also see Barthes, "The Photographic Message," and Mitchell, "The Photographic Essay: Four Case Studies."

95 The 1944–45 annual report, for example, describes a format for window displays with six large photographs "concisely captioned to tell a complete story" (18).

96 LAC, RG53, 2, Minutes of Board Meeting, NFB (2 July 1947), unpaginated.

97 LAC, RG53, 2, Minutes of Board Meeting, NFB (12 October 1950), appendix, "A Report on the Location of the National Film Board," chart B.

98 "Winter on the Farm," *Weekend Picture Magazine*, 4–7; "Sudbury's Polio Clinic," *Weekend Picture Magazine*, 2–5. Also cited in Hanna, *Walter Curtin*, 16.

99 Kunard reports that this photo story was entered in the *British Journal of Photography*'s 1963 competition for its 1964 annual ("Promoting Culture through Photography," 283).

100 By the 1970s, the division had ceased to produce the mat releases, instead returning to simply supplying a thematic grouping of images.

101 LAC, RG53, 2, Minutes of Board Meeting, NFB (16 April 1951), appendix 9, 5, T-12773, microfilm.

102 From mid-1969 until April 1971, the division also issued twenty-one thematic photo sets without a mat release layout. In this, it returned to its practice of supplying images for publications to design their own photographic essays. CMCP NFB SPD Archive, Photo Story records.

103 However, the division did produce approximately sixty photo story mats in smaller, single-page layouts (ibid.).

104 Ough and Proulx Ough in discussion with the author and Robert Evans, 18 November 2003.

105 Lunney, interview by Charity Marple, 7 May 1996, CMCP.

106 Lund, "Chris Lund: Words and Images" (interview).

107 Lunney, interview by Charity Marple, 7 May 1996, CMCP.

108 Ibid.

109 Monk, interview by Lilly Koltun, 20 October 1976, LAC.

110 Lund, "Chris Lund: Words and Images" (interview); Lunney, interview by Charity Marple, 7 May 1996, CMCP; Ough and Proulx Ough in discussion with author and Robert Evans, 18 November 2003; Grant interview by Charity Marple and author, 1997, CMCP; Reeves interview by author, 1997, CMCP; Marshall interview by author, 1997, CMCP.

111 One notable exception was the Expo *People Tree*, as discussed in chapter 5. On this, see also Langford, introduction to *Contemporary Canadian Photography*, 9; Kunard, "Promoting Culture through Photography," 331–7. Photographers such as Dorothea Lange, Walker Evans, Ben Shahn, and Arthur Rothstein were supplied with detailed instructions – many of which they opted to ignore. For detailed discussions of the FSA and photography, see Stryker, "The FSA Collection of Photographs," 349–54; Stange, *Symbols of Ideal Life*, 89–131; Tagg, *The Burden of Representation*, 153–83; and Trachtenberg, "From Image to Story," 43–73.

112 Sue Lagasi, registrar, CMCP, personal correspondence with the author, 11 June 2012.

113 See photo stories "Western Canadians and West Africans in Joint Project: Sowing Seeds of Knowledge and Friendship," 437A (28 February 1967); "Search for Secrets 'neath Sable's Shifting Sands," 450A (29 August 1967); "Studying Canada's Teeming Trillions," 451 (12 September 1967); "For Canadians a Year in a Hundred," 459 (28 December 1967). The last, a year-in-review piece, recycled Ough images from Photo Story 437A; "Still the Biggest Show on Earth: Man and His (Wonderful) World," 473A (20 July 1968); "Federal Scientists to Study Moon Samples," 498 (July 1969); "Charting Canada's Vacation Waterways," 499 (August 1969); "Rue du Trésor, Québec," 517 (April 1971). CMCP NFB SPD Archive, Photo Story records.

114 Ough, John, untitled and unpublished memoir, Ottawa, 2003.

115 NFB, *Annual Report*, 1956–57, 14.

116 McCaffrey, "Textile Industry." The images by Malak depict a machine-tender at a mill in Valleyfield, Quebec (NFB #88312) and an unidentified textile worker (NFB #88314). These were used along with three other Malak photographs and one photograph by the commercial photographers Arnott and Rogers in Photo Story 208 (5 May 1959).

117 The exhibition is shown in a shoot by Chris Lund. The division archive describes this shoot: "Photos show members of the Progressive Conservative Party looking at an NFB Photo story display during a meeting held in the Château Laurier." LAC, RG53, sub-series R1196-14-7-E, NFB SPD negative nos. 66-13498, 66-13499, 66-13500. Also cited in Kunard, "Promoting Culture through Photography," 198.

118 NFB, *Annual Report*, 1955–56, 10.

119 CMCP NFB SPD Archive, Lorraine Monk to Grant McLean, "Draft Proposals for '66–'67 Estimates" (9 August 1965).

120 Hallendy interview by author and Robert Evans, 19 November 2003.

121 Langford, introduction to *Contemporary Canadian Photography*, 9–10.

122 Greenhill, *Early Photography in Canada*. A later revised version was published fourteen years later: Greenhill and Birrell, *Canadian Photography, 1839–1920*. For a discussion of the historiography of photo studies in Canada, see Kunard and Payne, "Writing Photography in Canada."

123 Ough, John, untitled and unpublished memoir, Ottawa, 2003.

124 Hallendy interview by author and Robert Evans, 19 November 2003.

125 Ibid.

126 Ibid.

127 Langford, introduction to *Contemporary Canadian Photography*, 9; NFB, *Annual Report*, 1963–64, 16–17; *Annual Report*, 1964–65, 19.

128 Hallendy interview by author and Robert Evans, 19 November 2003.

129 CMCP NFB SPD Archive, "Proposed Program for the National Capital, 29 June to 5 July 1967," and "Proposed Program for July 1967."

130 Langford, introduction to *Contemporary Canadian Photography*, 12. See also LAC, RG53, 10, Canadian Pavilion at Expo 67. The 1967 exhibition's catalogue would become the second volume in the division's *Image* series. See *Photography: Canada 1967*.

131 Kunard, "Promoting Culture through Photography," 308.

132 Rombout, "Imaginary Canada."

133 Hallendy interview by author and Robert Evans, 19 November 2003.

134 NFB, *Bytown International 1967*.

135 Hallendy interview by author and Robert Evans, 19 November 2003.

136 The ten volumes in NFB's *Image* series were published by the Queen's Printer between 1967 to 1971.

137 See Gaudard, *View*; Semak, *View*; Dessureault, "Pierre Gaudard"; Kunard, *Michael Semak*.

138 Hallendy interview by author and Robert Evans, 19 November 2003.

139 An engaging but unpublished account of the shift toward aesthetics at the division is Latulippe's "Le 'Tournant artistique.'"

140 "Rue de Trésor, Québec," 517 (April 1971). This, like all the photo stories produced in 1971, appeared without a layout. Instead, the division returned to the practice of submitting a series of thematic images for publications to choose from, accompanied by a text.

141 The 1971–72 annual report terms the unit the "Still Photo Division" (34).

142 Langford, introduction to *Contemporary Canadian Photography*, 12.

143 Roytblat, "A Guide to National Film Board Photographic Materials and Finding Aids."

144 NFB website, http://www.nfb.ca/history/1970-1979/#year-1976 (accessed 11 June 2012).

145 The 1971–72 annual report terms the unit the "Still Photo Division" (33).

146 The 1972–73 annual report also terms the unit the "Still Photo Division" (39).

CHAPTER TWO

1 Grierson, "The Documentary Idea: 1942," 113.

2 Tagg, *The Disciplinary Frame*, 55.

3 Anderson, *Imagined Communities*, 6.

4 Foucault, "Governmentality," 102.

5 Druick, *Projecting Canada*, 23.

6 Indeed, during the nineteenth and early twentieth century, preceding any prominent use of self-consciously artistic camera work, all photographs were conventionally considered vehicles of factual information. Accordingly, the "documentary" designation was meaningless or redundant before the 1920s. As Solomon-Godeau succinctly notes, "the documentary concept is historical, not ontological" ("Who Is Speaking Thus?" 169).

7 Tagg, *The Disciplinary Frame*, 62–74.

8 These tendencies, of course, drew from turn-of-the-century social reform policies and cultural attitudes. Jordan, *Machine-Age Ideology*, 4–6, 13, 155–84.

9 Druick, *Projecting Canada*, 49–54; Aitken, *Film and Reform*, 51–8.

10 Druick, *Projecting Canada*, 54–7.

11 Morris, "Praxis into Process," 276; "Re-thinking Grierson," 21–56.

12 "That duty [of exploring the 'materials of citizenship'] is what documentary is about. It is, moreover, documentary's primary

service to the state." John Grierson, "The Documentary Idea: 1942," 113.

13 Tagg, *The Disciplinary Frame*, 57.

14 Ibid., 71.

15 Ibid., 67.

16 Stott, *Documentary Expression and Thirties America*.

17 Peirce, "What Is a Sign?," 4–10. As noted in the introductory chapter, the loose application of Peirce's model has been the object of much critical debate. See Elkins, *Photography Theory*, 220–43; Lefebvre and Furstenau, "Digital Editing and Montage," 93–5.

18 Stott, *Documentary Expression and Thirties America*; Tagg, *The Disciplinary Frame*, 90–1.

19 A critical reassessment of photography's privileged relationship to the "real" has been the subject of much scholarship that has emerged since the late 1970s and has dramatically transformed thinking about the medium. Among the many important texts on this – perhaps central – characteristic of the photographic representation are Barthes, "The Photographic Message," and Sekula, "The Invention of Photographic Meaning." For an influential assessment of this critique, see Batchen, *Burning with Desire*.

20 Grierson, *Grierson on Documentary*, 11.

21 Tagg, *The Disciplinary Frame*, 55.

22 This is one-third of Foucault's definition of the term. In addition, he sees the concept secondarily as the tendency in the West for governmental power to become pre-eminent and thirdly as the gradual process through which justice becomes "governmentalized" ("Governmentality," 102).

23 Druick, *Projecting Canada*, 101.

24 Low, *NFB Kids*.

25 Ibid., 3.

26 Ibid., 77.

27 An exception to this is the series of photo sets developed for classroom use in 1954 and the division's occasional supply of photographic illustrations for school textbooks. See chapter 1 and LAC, RG53, 2, Minutes of Board Meeting, National Film Board of Canada, 1954, 20th Board Meeting, 25–6; 1954, 21st Board Meeting, 2.

28 Bazin, "The Ontology of the Photographic Image" (p. 8 cited here). Bazin's characterization is echoed decades later in Barthes's influential *Camera Lucida* in which the photograph is related to death.

29 Metz, "Photography and Fetish." See also Campany, *Photography and Cinema*, 11.

30 Barthes, *Camera Lucida*.

31 See Deleuze and Guattari, *A Thousand Plateaus*, 13; Deleuze, *Cinema 2*; Sutton, "Immanent Images," 311–12.

32 Sutton, "Immanent Images," 313–14.

33 At the Still Photography Division, for example, staff and freelance photographers were regularly assigned to undertake regional "tours" of the country to amass generic images for the photo library. See Card Catalogue of Photographic Shoots, CMCP NFB SPD Archive.

34 Sekula, "Photography between Labour and Capital," 194.

35 Campany, *Photography and Cinema*, 44.

36 Sutton, "Immanent Images," 313–14.

37 Billig, *Banal Nationalism*.

38 LAC, RG53, 2, Minutes of Board Meeting, NFB (8 June 1943), microfilm.

39 Chris Lund, "Mrs. E. Marr, physiotherapist, with Dorothy Gifford, 2 ½, at the walking bars in the polio clinic, Sudbury General Hospital, Sudbury, Ont.," LAC, RG53, sub-series R1196-14-7-E, negative 65093 (copy negative PA116675).

40 Rutty cites the rate of infection as almost 9,000 per population of 100,000 ("The Middle-Class Plague," 277–314).

41 Public Health Agency of Canada, http://www.phac-aspc.gc.ca/tmp-pmv/info/polio_e.html.

42 Jacques Lacan, *The Four Fundamental Concepts of Psycho-Analysis*, 82, quoted in Tagg, *The Disciplinary Frame*, 76–7.

43 LAC, RG53, sub-series R1196-14-7-E, NFB collection, negatives 6508–65115. The other images in this shoot depict nurses in training and tending to child patients as well as one sequence of a couple visiting their young son at the clinic.

44 LAC, RG53, sub-series R1196-14-7-E, NFB collection, negative 65093 (copy negative PA116675).

45 Lund, "Chris Lund: Words and Images" (interview).

46 "Canada Will Start Trials of Polio Vaccine April 18," Photo Story 003 (7 April 1955).

47 Rutty, "Forty Years of Polio Prevention!"

48 LAC, RG53, sub-series R1196-14-7-E, NFB collection, negative no. 51859A. The caption accompanying the negative reads, "Chief technician Bernard Messier, with one of the monkeys used for experiments in medicine at the University of Montreal." The photo story mentions the Institute of Microbiology and Hygiene in Montreal, but this image does not seem to depict that centre.

49 Barthes, "The Rhetoric of the Image," 40.

50 Many division images appear to have been made on assignment for specific governmental agencies and departments. However, in this case, archival records do not indicate who initiated or commissioned Lund's original shoot at the Sudbury Polio Clinic. I thank Sue Lagasi and Tim Campbell of the CMCP for checking this information.

51 "Sudbury's Polio Clinic," 2–5. I am indebted to Sarah Stacy, photography archivist at LAC, for drawing my attention to this photo story.

52 "Sudbury's Polio Clinic," 3.

53 Gleason, Normalizing the Ideal.

54 "Canada Exports 'Merry Christmas': Yule Tree Industry Boom," Photo Story 136 (17 December 1957).

55 Higonnet, Pictures of Innocence, 23.

56 "Spring in Canada: A Time of Discovery," Photo Story 283 (18 April 1961).

57 "The Five Year Road to a D.D.S.: 175 Graduate Annually," Photo Story 048 (20 March 1956); "Montreal's Institute of Cardiology: Designed Exclusively to Serve the Heart," Photo Story 196 (10 February 1959).

58 "Farmers Reap Sweet Harvest: Biggest Crop in History," Photo Story 195 (3 February 1959); "Rabbit Industry Booms in Lakehead Area," Photo Story 038 (27 December 1955).

59 "Canadian Mink Reigns Supreme: Where Elegance and Fashion Meet," Photo Story 134 (3 December 1957); "The Pampered Chinchilla," Photo Story 042 (24 January 1956).

60 Payne, A Canadian Document.

61 Lund, "Chris Lund: Words and Images" (interview). In a 1984 essay, Martha Langford suggested that "stylized" may have been more apt than "stilted." Langford, introduction to Contemporary Canadian Photography from the Collection of the National Film Board, 8.

62 Nichols, Representing Reality, 34–8.

63 See Adams, The Trouble with Normal; Gleason, Normalizing the Ideal; Korinek, Roughing It in the Suburbs.

64 Finkel, Social Policy and Practice in Canada, 149.

65 NFB, Annual Report, 1968–69, 10.

66 Lambeth, "Statement on Photography," 29.

67 Gaudard, View.

68 Introduction by Lorraine Monk to Photography: Canada 1967, unpaginated.

69 Ibid.

70 The image appears on p. 136. Sutnik, Michel Lambeth: Photographer, 11–27; Torosian, Michel Lambeth: Photographer.

71 "Lowly Broom Now $16 Million Canadian Industry," Photo Story 047 (13 March 1956).

72 Lambeth, quoted in Sutnik, Michel Lambeth, 45.

73 Ibid.

74 Lutz and Collins, Reading National Geographic, 187–216.

75 Higonnet, Pictures of Innocence, 210–11.

76 Monk's introduction to Photography: Canada 1967.

77 Nichols, Representing Reality, 43.

78 Waugh, Baker, and Winton, Challenge for Change; NFB, Annual Report, 1968–69, 5; Druick, Projecting Canada, 128–32.

79 Mackey, House of Difference, 63.

CHAPTER THREE

1 Hodgins et al., Women at War.

2 Saouter, "Persuader, Manipuler."

3 The "WR" series includes copies of NFB wartime propaganda posters and images devoted to the various branches of the military (navy, army, air force); the NFB also produced numerous images of Canadian life at home during the war. Copy of original captions for WRM series 1–5480, finding aid no. 80,

vol. 4, accession no. 1971-271, "Original Captions"; Rodger, "The Wartime Information Board and Photography."

4 The Bureau of Public Information was established on 5 December 1939, less than three months after Canada officially entered the war on 10 September 1939. Following Germany's invasion of Poland on 1 September, Britain and France had declared war on 3 September 1939. Keshen, *Saints, Sinners and Soldiers*, 17–18.

5 Grierson had been appointed general manager of the WIB in January 1943. Rodger, "The Wartime Information Board and Photography"; LAC, RG53-2, Minutes of Board Meeting, NFB (12 January 1943), microfilm.

6 NFB, *Annual Report*, 1944–45, 16–18.

7 LAC, RG36-31, vol. 15, Wartime Information Board Fonds, Distribution Section, 1 Dec. 1944, files 8-22-2, 8-22-4: 15 November 1944 memo from G.W. McCracken to Mr Andrew, Mr Draper, Major Garneau, and Mr Herbin, LAC; 10 November 1944 memo from Mr R.D. Boyd, administration, WIB, to section chiefs and staff regarding requisitions for printing and photos from the NFB; 1944 National Film Board requisition numbers.

8 LAC, RG53-2, microfilm, NFB, Statement of Expenditures and Unexpended Balance, 1 April to 30 September 1943; Garden, *Nicholas Morant's Canada*, 133.

9 The following discussion is based on that collection and is indebted to the research of archivist Andrew Rodger ("The Wartime Information Board and Photography").

10 The department was established by an act of Parliament in September 1939 following the declaration of war. The act conferred on the new department extensive powers for war-related purchases and the reorganization of the nation's industries. C.D. Howe, *The Industrial Front*, 6–7. According to Andrew Rodger in correspondence with the author, 3 September 2009, "in a finding aid for RG24 (Department of National Defense) there is evidence that the government – through the army – did a pretty extensive survey of Canadian industry in 1938–39 in order to know what existed and what could be converted to war production."

11 LAC, R1351-0-6-E, Dominion Textile Company fonds.

12 C.D. Howe, address to Parliament, 11 June 1943, quoted in Cragg, "Howe Recites Growth of Arms Output."

13 WIB, *Canada at War: Special Pictorial Edition on War-Changed Canada* (1945), 50.

14 Keshen, *Saints, Sinners and Soldiers*, 43.

15 WIB, *Canada at War* (1945), 58.

16 LAC, R1196-15-9-E, WIB [graphic material]; Rodger, "The Wartime Information Board and Photography."

17 In May 1941, for example, the WIB photographed a group of weekly newspaper editors on a private tour of the Otis Fenson Plant in Toronto as part of their annual conference. The documentation of their visit, ostensibly to promote war industries to them, was itself used as propaganda. LAC, RG53, sub-series R1196-14-7-E, WRM 844.

18 LAC, RG36-31, vol. 7, file 2-6-1, Press Censorship, 30 November 1944 from W. Eggleston, director, Department of National War Services, Directorate of Censorship. Marked CONFIDENTIAL – NOT FOR PUBLICATION.

19 "Canadian Arms for the Navy," *Financial Post*, 29 April 1944; "Canada Delivers the Goods," *Summerside Journal*, 23 January 1941.

20 WIB, *Canada at War*. The WIB's other regular publication, *Canadian Affairs*, a twice-monthly bulletin for the Canadian Army Services, was not illustrated in its regular editions.

21 Garden, *Nicholas Morant's Canada*, 152.

22 Included among these at upper left (just below the portrait of Churchill) is an image by an unidentified photographer for the NFB depicting an "Army vehicle (Universal Carrier) being driven up a slope at the Ford Motor Co." in Windsor, Ontario, March 1941, LAC, NFB, Still Photography Division fonds, accession no. 1971-271, item WRM 508 or MIKAN no. 3195684.

23 Photograph documenting the *Shells for Victory* display, Ajax, Ontario, 1941, LAC, RG53, sub-series R8604-0-4 E (Alexandra Studio Collection), PA 115550. Reproduced in Bruce, *Back the Attack!*, 56.

24 "Labour Present Arms: A Series of Eight Photo Displays," 1944, LAC, RG53, sub-series R1196-14-7-E, CA.2.2003-1081.

25 NFB, *Annual Report*, 1944–45, 17; Kunard, "Promoting Culture through Photography," 371.

26  NFB, *This Is Our Strength*.

27  *Labour Front*, NFB World in Action series, 1943. For a detailed discussion of films addressing labour during the Second World War, see Khouri, *Filming Politics*.

28  See for example, "General View of Women Workers Producing Components with the Poster Advising, 'Haste Makes Waste' on the Small Arms Ltd., Long Branch Munitions Plant," April 1944, Long Branch, Ontario, photographer, Ronny Jaques, LAC, RG53, sub-series R1196-14-7-E, scan no. e000762120; and "Workman Richard Chowns of Humber Bay, Ont. Works Burring and Cleaning Sten Breech Blocks for Inspection at the Small Arms Ltd. Plant," April 1944, Long Branch, Ontario, photographer, Ronny Jaques, LAC, RG53, sub-series R1196-14-7-E, scan no. e000762134.

29  See for example, April 1944, Long Branch, Ontario, photographer, Ronny Jaques, LAC, Photothèque collection, NFB no. 10209.

30  *Partners in Production: A Report of Labour-Management Production Committees in Canadian Industry*; "Cause and Cure of Absenteeism," *Toronto Daily Star*, 28 April 1943.

31  Rodger, "The Wartime Information Board and Photography"; Foo, "Canadian War Industry during the Second World War."

32  LAC, finding aid 80, vol. 4, NFB Still Photography Division War Records Catalogue. Montreal was also prominent as a site for naval production.

33  As Susan DesRoches has shown, Canadian propaganda posters actually served as models for US campaigns ("Weapons on the Wall," 93).

34  WIB, *Canada at War*, special pictorial edition, no. 34, March 1944, 58–9.

35  WIB, *Canada at War*, no. 43, February 1945, 50.

36  Khouri, *Filming Politics*, 149–52; *Partners in Production*, directed by Stanley Hawes, 1944; *Work and Wages*, directed by Guy Glover, 1945. For a critique of Khouri's book, see Finkel, "Review: Filming Politics," 263–6.

37  Druick, *Projecting Canada*, 26.

38  DesRoches, "Weapons on the Wall."

39  Rowed, for example, had previously worked for Canadian National Railways and Trans-Canada Airlines, and Morant had also been a commercial photographer with the CPR. Garden, *Nicholas Morant's Canada*; Foo, "Highlights: Photographer's Showcase, Harry Rowed (Henry Newton Rowed) (b. 1907)."

40  My colleague Joan Schwartz suggests another possible reading: the diminution of workers might also indicate the strength of the whole (nation) rather than the individual.

41  Image to the right on p. 63: Nicholas Morant, "View of a Ship Being Towed back to Harbour by a Tugboat after Its Successful Launch," June 1943, Montreal, LAC, NFB, Still Photography Division fonds, accession no. 1971-271, item: e000761444.

42  This is, of course, not to say that women were utterly new to work in industry; working-class women have always contributed to the formalized economy. But the sheer numbers of women, particularly middle-class women, now entering the formalized workforce was novel. Sugiman, *Labour's Dilemma*; Sangster, *Earning Respect*.

43  Stephen, *Pick One Intelligent Girl*; Pierson, *Canadian Women and the Second World War*, 18.

44  His speech was aimed at expanding the Canadian labour force. King, "Canada and the War: Manpower and a Total War Effort," broadcast 19 August 1942.

45  Little, "Facing Realities," address delivered before the Canadian Congress of Labour, Ottawa, 15 September 1942, 4.

46  Pierson, *"They're Still Women after All,"* 24–8; Stephen, *Pick One Intelligent Girl*, 27–32.

47  Cooke, "Using Material Culture to Document Women's Second World War Home Front Experiences"; NFB, *Rosies of the North*.

48  Little, "Facing Realities," 4.

49  See Keshen, *Saints, Sinners and Soldiers*, chapter 6.

50  Pierson, *"They're Still Women after All,"* 26, 41–8.

51  Among the images used in the campaigns were those actually made before the advent of the NSS but employed later for its cause. Beyond the scope of this paper is a discussion about contemporary NFB films of women workers. Key works include *Women Are Warriors*, directed by Jane Marsh, 1942, and *Before They Are Six*, directed by Gudrun Parker, 1943; Nash, "Images of Women in NFB Films," 319–24.

52  The extended caption for this image reveals racist attitudes of the day. It reads: "War Workers with Interesting Pre War

Jobs – December 1943. Negro girl, Cecilia Butler of Lucan, Ont. Working on Reamer at Small Arms. Negro girl workers are highly regarded in majority of munitions plants, display exceptional attitude for work of precision nature. Cecilia was former night club singer and dancer." LAC, NFB, Still Photography Division fonds, accession no. 1971-271, item: e000761869.

53   For a first-person account of a young woman's experience in wartime industry, see Lutz, "Dorothy Lutz," 75–9. The shoot may also have been intended to counter earlier charges of corruption at the Inglis Company.

54   Evans, *John Grierson and the National Film Board*, 96; Stephen, *Pick One Intelligent Girl*, 48; Keshen, *Saints, Sinners and Soldiers*, 41.

55   *Women Are Warriors*, directed by Jane Marsh, 1942; Nash, "Images of Women in the National Film Board," 262, cited in Keshen, *Saints, Sinners and Soldiers*, 156.

56   Keshen, *Saints, Sinners and Soldiers*, 158.

57   Hodgins et al., *Women at War*.

58   Pierson, *Canadian Women*, 11–12.

59   The issues appeared in May, June, and July 1943. Ibid., 19.

60   Dempsey, "Women in War Plants Making Guns, Shells and Tanks," 11.

61   Image at lower left is a cropped print of "Veronica Foster, an Employee of John Inglis Co., Known as 'The Bren Gun Girl,' Inspects a Lathe at the John Inglis Co. Bren Gun Plant," unknown photographer, May 1941, Toronto, LAC, NFB, Still Photography Division fonds, accession no. 1971-271, item: WRM 774 or PA-129380. Image at upper right is a cropped print of "Woman Worker at the John Inglis Co. Bren Gun Plant Welds Bren Gun Magazines," unknown photographer, 8 April 1941, Toronto, LAC, NFB, Still Photography Division fonds, accession no. 1971-271, item: WRM 687 or e000760327. Image at the lower right is a cropped print of "Woman Munitions Worker Operates Drill at the John Inglis Co. Bren Gun Plant," unknown photographer, May 1941, Toronto, LAC, NFB, Still Photography Division fonds, accession no. 1971-271, item: WRM 687 or e000760327; LAC, NFB, Still Photography Division fonds, accession no. 1971–271, item: WRM 794 or e000760427. Image

second from lower left cropped print of "Women Munitions Workers Operating Drills at the John Inglis Co. Bren Gun Plant," unknown photographer, 10 May 1941, Toronto, LAC, NFB, Still Photography Division fonds, accession no. 1971-271, item: WRM 801 or e000760434.

62   See chapter 5 for a discussion of typological portrayals in the NFB photographic archive.

63   Sugiman, *Labour's Dilemma*, 65.

64   Bruce, *Back the Attack!*, ix.

65   Hodgins et al., *Women at War*, 72–3, 116–17.

66   Pierson, *"They're Still Women after All,"* 132–3.

67   The ad replicates awkward penmanship meant to suggest the child's own hand. "Ritchie" continues the letter with "I guess we'll never realize how much we owe you and all the 'Women at War' who helped our dads and uncles fix up the kind of world we have to-day."

68   Some of the images are credited to Louis Jaques, then a darkroom technician for the NFB and photographer Ronny Jaques's brother. Correspondence from Andrew Rodger, 3 September 2009.

69   With the institution of a tax break for two-income couples in 1942, there had already been some governmental encouragement of mothers entering the formal work force. Keshen, *Saints, Sinners and Soldiers*, 149.

70   LAC, RG36-31, vol.15, WIB Fonds, file 8-22-6 MEMOS/TELEGRAMS. At war's end in mid-March 1945, for example, the WIB's Washington office requested images of Canadian families. W.M. Crockett to E.G. Smith, 14 March 1945, inf 390.

71   WIB, *Canada at War*, no. 43 (1945): 66. Image, "Mrs. Jack Wright and Her Two Sons Ralph Wright and David Wright Assist Her with Her Shopping," unknown photographer, September 1943, Toronto, LAC, NFB, Still Photography Division fonds, accession no. 1971-271, item: WRM 3851 or MIKAN 3196968.

72   Nash, "Images of Women in National Film Board," 359–414.

73   Ibid., 520.

74   Bruce, *Back the Attack!*; Keshen, *Saints, Sinners and Soldiers*; Stephen, *Pick One Intelligent Girl*; *Rosies of the North*, directed by Kelly Saxberg, 1999.

75  Pierson, *"They're Still Women after All."*

76  Keshen, *Saints, Sinners and Soldiers*, 150, 167–71; Strong-Boag, "Canada's Wage-Earning Wives," 5–25; Korinek, *Roughing It in the Suburbs*; Sangster, *Earning Respect*; Iacovetta, *Such Hardworking People*; Iacovetta, *Gatekeepers*; Sugiman, *Labour's Dilemma*.

77  "Women at Home," from a series of photographs subtitled in the NFB archive "Life in Canada," 1952, photographer, Gar Lunney, PA-150865; "'Charm' Schools: A $2 Million Business," Photo Story 043 (7 February 1956); "Housekeeping School," Photo Story 80 (13 November 1956).

78  "Dr. Alice Wilson: The World Is at her Feet: Canada's Leading Lady of Geological Science," Photo Story 320 (18 September 1962); "Canada's Charlotte Whitton: 'No Angel but a Good Mayor,'" Photo Story 346 (10 September 1963).

79  "Women Invade Police Precincts," Photo Story 207 (28 April 1959).

80  See, for example, such WIB publications as *Vocational Training on Civvy Street* and *Your Own Business on Civvy Street*.

81  One exception is a 1965 photo story promoting the New Brunswick economy and including images of industry. Photo Story 401A (19 October 1965) "NEW ... New Brunswick," photographs and text uncredited. Reproduced with the permission of the Minister of Public Works and Government Services Canada (2012). LAC/NFB fonds, accession no. 1971-271; container 2000791575.

82  McKay, *History of the National Film Board*, 66–9; Langford, introduction to *Contemporary Canadian Photography from the Collection of the National Film Board*, 9.

83  LAC, RG 53-2, microfilm. NFB papers, Ralph Foster memo to John Grierson, 9 March 1944. See also Langford, introduction to *Contemporary Canadian Photography*, 9; McKay, *History of the National Film Board*, 66–9.

84  LAC, RG 53-2, Minutes of 71st Board Meeting, NFB (16 April 1946), T-12772, microfilm; Minutes of 70th Board Meeting, NFB (19 March 1946), T-12772, microfilm. According to minutes, a meeting was held in February 1947 with managing editors of Canadian dailies, who expressed satisfaction with the new rates. LAC, RG 53-2, Minutes of 84th Board Meeting, NFB (2 July 1947), T-12772, microfilm; Minutes of 93rd Board Meeting, NFB (24 March 1948), 2–3, T-12772, microfilm.

85  Gaudard, *Les Ouvriers*, Image 10, NFB; Dessureault, "Pierre Gaudard." *The People Tree*, the Expo 67 installation discussed in chapter 5, also pictured working-class life in some detail but, as I argue, generally from a middle-class perspective.

CHAPTER FOUR

1  The literature on landscape and nationalism is of course vast and beyond the scope of this chapter to address in full. Some of the key works have emerged out of cultural geography, art history, and cultural studies. They include Cosgrove, *Social Formation and Symbolic Landscape*; Cosgrove and Daniels, *The Iconography of Landscape*; Daniels, *Fields of Vision*; Bermingham, *Landscape and Ideology*; Mitchell, *Landscape and Power*.

2  Schama, *Landscape and Memory*, 15.

3  For an insightful discussion of these aspects of landscape in contemporary painting, see Halkes, *Aspiring to the Landscape*.

4  For important discussions of landscape and the photograph, see Schwartz and Ryan, *Picturing Place: Photography and the Geographic Imagination*.

5  O'Brian, "Wild Art History," in O'Brian and White, *Beyond Wilderness*, 21.

6  Irwin, "What It Means to Be a Canadian," 132–3.

7  Frye, *The Bush Garden*; Atwood, *Survival*; G. McGregor, *The Wacousta Syndrome*.

8  Osborne, "The Iconography of Nationhood in Canadian Art," 162–78.

9  O'Brian, "Wild Art History," 21.

10  Mitchell, "Holy Landscape: Israel, Palestine, and the American Wilderness," in Mitchell, *Landscape and Power*, 262–3.

11  Bordo, "Jack Pine," 98–108, 125–6.

12  Coates, *The Alaska Highway*.

13  LAC C-015135, R10383-1-8-E, inscription on photographic reproduction, William Lyon Mackenzie King fonds.

14  Smith, "The Black Corps of Engineers and the Construction of the Alaska (Alcan) Highway," 22.

15  "Opening Day for the Alcan Highway," CBC Radio recording of 20 November 1942.

16  LAC, LAC, RG53, sub-series R1196-14-7-E, finding aid 80, typed records of "Alaska Highway Captions," WR-335 to WR-2596.

17  LAC, LAC, RG53, sub-series R1196-14-7-E, copy negative PA-113220, "Private Elbert Pieper of the U.S. Army Stands Sentry Duty beside a Trapper's Cabin Containing Construction Supplies for the Alaska Highway."

18  "Postwar Markets Take Form: U.S. and Canada Plan to Develop Regions Opened by Alcan Highway," 28.

19  "Canada Celebrates 91 Years of Confederation: From Sea to Sea a New Spirit," Photo Story 163 (24 June 1958).

20  Francis, *National Dreams*.

21  Other scenes included views of local scenery, a number of shots of the logging camp's chief cook at work, the camp's employment office, and loggers seen marking and cutting trees as well as relaxing. LAC, RG53, sub-series R1196-14-7-E, NFB negative nos. 72492–72561. The caption originally accompanying the image discussed in detail reads: "Chantier Cooperatifs – Hébertville, P.Q. Film Coverage. Logging sleds at Chantier Cooperatif #2, Logging camp at Depot Picobat in Laurentide Park about 85 miles north of Québec City, P.Q. G. Lunney 1/55," LAC, RG53, sub-series R1196-14-7-E, negative no. 72535.

22  Lunney, interview by Charity Marple, 7 May 1996, CMCP.

23  Barthes, "The Rhetoric of the Image," 40

24  Notable texts include Bermingham, *Landscape and Ideology*; Mitchell, *Landscape and Power*; Bright, "Of Mother Nature and Marlboro Men," 125–43.

25  Mitchell, "Imperial Landscape" in Mitchell, *Landscape and Power*, 9.

26  Druick, *Projecting Canada*, 64.

27  Among the photo stories employing this trope are "Huron Village: Historic Past Captured," Photo Story 31 (25 October 1955); "Thunderbird Park, B.C.: Totem Poles Preserved for Posterity," Photo Story 113 (9 July 1957); "Relic of Canada's Fur Trade Days: Mighty Canoe Built for Posterity," Photo Story 132 (23 November 1957).

28  Thanks to Jim Opp for drawing my attention to the film. The photographs are credited to Erik Nielsen, who co-produced sound for the film *Circle of the Sun*, directed by Colin Lowe, 1960.

29  "Blood Indians Dance to Natoosi," Photo Story 284 (2 May 1961); for an important recent collaboration with the Kainai nation over photographs, see Brown and Peers with members of the Kainai Nation, *"Pictures Bring Us Messages."*

30  Fabian, *Time and the Other*, 31.

31  For a recent reconsideration of these issues and discussion of more self-reflexive fieldwork practice, see James and Mills, *The Qualities of Time*.

32  Key among these devices is the use of the "ethnographic present," the tendency to describe the subject's culture in the present tense. While on the surface this may seem to acknowledge coexistence or coevalness, paradoxically, it does the opposite. In Fabian's example, "the X are matrilinear," for instance, projects broad generalities onto an entire culture and, like the use of historicizing terms, suggests that the X culture is inherently static (*Time and the Other*, 80–7).

33  Ibid., 105–41.

34  Houle, "The Spiritual Legacy of the Ancient Ones," 61.

35  Vastokas, "Landscape as Experience and Symbol in Native Canadian Culture," 59.

36  See also Berger, "The True North Strong and Free," 3–26.

37  In order to be inclusive, in this chapter I refer to the two volumes together as *A Year of the Land / Temps qui passe* unless referencing the texts specifically.

38  Initially, Monk proposed an exhibition to the NFB head office. When that proposal was rejected, she turned to the Centennial Commission and proposed publications that she felt they were more likely to support. Monk, interview by Lilly Koltun, LAC.

39  Memorandum, "Authority for the Printing of Governmental Centennial Publications," 26 July 1965, *A Year of the Land / Temps qui passe* files, NFB SPD Archive, CMCP. In its annual report for the 1966–67 fiscal year, the NFB reported expenses for "Photo Services" (the film board maintained the bureaucratic termin-

ology for the division) as $172,876 in 1966 and $237,834 in 1967. NFB, *Annual Report*, 1966–67, 44.

40 Because the same wording appears in files drafted by Monk and division staff, it seems clear that the descriptions in this document were initiated in-house. Memorandum on Authority for the Printing of Governmental Centennial Publications, Roger Duhamel, Queen's Printer, to Secretary of State, Treasury Board, 8 September 1965, *A Year of the Land / Temps qui passe* files, NFB SPD Archive, CMCP.

41 Payne, "Designing Nature and Picturing Prestige," 53–71; memorandum, NFB, SPD, to Mr Ingalls, Centennial Commission, 26 January 1965, *A Year of the Land / Temps qui passe* files, NFB SPD Archive, CMCP; memorandum, Gaston Lapointe to Lorraine Monk, 28 August 1964, ibid.

42 Originally, plans were also made to produce a presentation album in an edition of two hundred reserved for the Prime Minister's Office to present to dignitaries. It was envisioned as a suitably grand object. On 30 May 1967, Allan Fleming, the book's designer, wrote to Lorraine Monk suggesting that the "exclusive" or presentation copies be covered with "fine grain black morocco leather, preferably padded underneath. I would like to gold dye stamp the name of the recipient on one side and the name of the book on the other, both to be centered and both in A.T.F. Baskerville typeface." Allan R. Fleming, Maclaren Advertising Co., to Lorraine Monk, NFB, 30 May 1967, *A Year of the Land / Temps qui passe* files, NFB SPD Archive, CMCP; "Specification for Project 1: Prestige Book 'Image of Canada,'" undated memorandum; Sir Martin Gilliat, Clarence House, London, letter to Maurice W. Maxwell, vice-chairman, Associated Book Publishers, 12 January 1968.

43 Memorandum, NFB Still Photography Division to Mr. Ingalls, Centennial Commission, 26 January 1965, *A Year of the Land / Temps qui passe* files, NFB SPD Archive, CMCP. In 1968, Yves Forest, parliamentary secretary to the president of the Privy Council, reported that the final costs of production were $433,478.15 and its total revenues from sales were $425,000. E.S. Coristine to Hugo McPherson, NFB, 4 December 1968, ibid. Earlier the division had been allotted $554,500 for

the book. Memorandum on Authority for the Printing of Governmental Centennial Publications, Roger Duhamel, Queen's Printer, to Secretary of State, Treasury Board, 8 September 1965, ibid.

44 Mackie, "A New Look at Canada," 18.

45 In a later interview, Monk narrated her role in finding Patterson and promoting him (interview by Lilly Koltun, LAC).

46 Crawley and Fleming, "The Fleming Files," 55–6, 59–61, 67, 69–70.

47 Early on, the English volume had been referred to as "Image of Canada." Fleming proposed four titles to replace this: "1. CANADA the land year; 2. CANADA a year of the land; 3. CANADA cycle of the land; 4. CANADA a cycle of the seasons." He then qualified them: "I must say I like the matter-of-factness of #2." Allan Fleming to Lorraine Monk, 7 July 1966, *A Year of the Land / Temps qui passe* files, NFB SPD Archive, CMCP.

48 Fleming developed lists with detailed sequences of all four sections of the books: "Here, finally, are the lists. You might lay them out in a spread form and have a look. At this point I'm ready to listen to anything *anyone* wants to say about adding or subtracting. I'm starting to see these things in my sleep" (emphasis in original). Allan R. Fleming to Lorraine Monk, 15 August 1966, Allan R. Fleming papers, York University. In comparing these lists with the publication itself, it can be seen that numerous changes were made by division staff.

49 Allan R. Fleming to Lorraine Monk, 30 May 1967, *A Year of the Land / Temps qui passe* files, NFB SPD Archive, CMCP.

50 Among the firms who lost the commission was Southam-Murray. Their account representative, Donald W. Purves, wrote to Fleming to request reimbursement for the almost $2,000 the company had incurred in developing printing techniques to Monk's specification. Donald W. Purves to Allan Fleming, 23 May 1967, Allan R. Fleming papers, York University.

51 Hutchison, *The Unknown Country: Canada and her People*. For a popular contemporary evaluation of Hutchison, see McGregor, *Canadians*, 17–27.

52 Gaston Lapointe to Lorraine Monk, 17 October 1966, *A Year of the Land / Temps qui passe* files, NFB SPD Archive, CMCP.

53  Jean Sarrazin to Gaston Lapointe, 29 September 1965, ibid.

54  Kritzwiser, "The Camera Captures Canada," 16; "La première Galerie de photographie inaugurée au Canada," 6.

55  Plate 158, Toronto, Ontario, and Plate 245, Charlottetown, Prince Edward Island, *A Year of the Land / Temps qui passe* files, NFB SPD Archive, CMCP; undated memorandum in Allan R. Fleming's hand, "Specifications," ibid.

56  Undated press release, *A Year of the Land / Temps qui passe* files, NFB SPD Archive, CMCP. Elsewhere the price is listed as $25. R.M. Ferguson, R.M. Ferguson and Co., to Mary Edgerton, MacLaren Advertising Co., 15 December 1966, Allan R. Fleming papers, York University.

57  Plates 1 and 260, Chris Bruun, Boag Lake, near Edmonton, Alberta, *A Year of the Land / Temps qui passe* files, NFB SPD Archive, CMCP.

58  Hutchison, "Spring," *Canada: A Year of the Land*, unpaginated.

59  "This is the rite of spring. The christening of the new year, the holy water flowing at last. Canadians cry, what misfortune, when the roar of the water approaches … Life returns on track" (author's translation).

60  "Notes for the Queen's Printer from Al Fleming re: Lucia Script," [Allan R. Fleming], undated memorandum, *A Year of the Land / Temps qui passe* files, NFB SPD Archive, CMCP. Not everyone concurred with Fleming. In a 7 October 1967 review, William French of the *Globe and Mail* dismissed the typeface as "not only pretentious but hard to read" ("A Camera Panegyric to Canada," 17).

61  Porter, *"In Wildness Is the Preservation of the World."*

62  Dunaway, *Natural Visions*, 164.

63  Initially, Monk and the division had contemplated organizing the volumes by month, as referenced in this letter from Monk, but that was quickly abandoned in favour of a seasonal format. Lorraine Monk to Bruce Hutchison, 25 October 1965; Lorraine Monk to Bruce Hutchison, 30 September 1965, *A Year of the Land / Temps qui passe* files, NFB SPD Archive, CMCP.

64  Anderson, *Imagined Communities*, 31.

65  Photographic plates were produced by the Graphic Litho Plate Company for the Carswell Printing Company of Toronto. The printers opted to undertake the more costly procedure of pro-ducing plates from 35mm transparencies to achieve richer images. Colour images were printed from four separations, while black and white images used two. Letter, G.F. Hoy, general manager, Carswell Printing Company, Toronto, to John Ough, 18 September 1967, *A Year of the Land / Temps qui passe* files, NFB SPD Archive, CMCP.

66  Lorraine Monk to Bruce Hutchison, 25 October 1965, ibid.

67  Archival records show that the longer descriptive titles originally assigned to images were distilled to geographical placement in the final publication. The image by Chris Bruun that opened and closed the volume, for example, initially titled "Coot Flying over Boag Lake, Alberta," was simply "Boag Lake, Alberta" in the final publication. 66-8163K-C, *A Year of the Land / Temps qui passe* files, NFB SPD Archive, CMCP.

68  By far the majority of the images in the volume were made in the mid-1960s. However, Monk, Hallendy, and Fleming also sampled from the division archive for occasional black and white (gelatin silver) images dating from the 1940s and 1950s.

69  In this way, the volumes also reflect the homogenizing effects used by Edward Steichen in *The Family of Man* exhibition and catalogue, as shown by Eric Sandeen in *Picturing an Exhibition*.

70  Hutchison, "Winter," *Canada: A Year of the Land*, unpaginated.

71  "The Canadian man finds himself alone, facing the snow, without recourse, without possible escape; alone, facing this abusive mistress, this devastating dominatrix, who blocks the horizon, taking everything and asking nothing" (author's translation).

72  Plate 201, Bruce Weston, Wascana Park, Regina, Saskatchewan, *A Year of the Land / Temps qui passe* files, NFB SPD Archive, CMCP.

73  Plate 235, Roloff Beny, Great Slave Lake, Northwest Territories, and Plate 241, Peter Phillips, Dorwin Falls, Rawdon, Quebec, ibid.

74  Plate 259, Freeman Patterson, Off Fisherman's Road, West Saint John, New Brunswick; Plate 260, Chris Bruun, Boag Lake, near Edmonton, Alberta, ibid. As noted above, the final image (Plate 260) also opens the volume (Plate 1).

75  See, for example, Lorraine Monk, memorandum to Mr R.B. Ingalls, Centennial Commission, 3 June 1965, NFB SPD Archive, CMCP.

76 Mackey, "Death by Landscape"; Mackey, "Becoming Indigenous."

77 DeLue and Elkins, *Landscape Theory*.

78 Hutchison, "Spring," *Canada: A Year of the Land*, unpaginated.

79 Bruce Hutchison to Lorraine Monk, 24 April 1967, *A Year of the Land / Temps qui passe* files, NFB SPD Archive, CMCP.

80 Mitchell, "Holy Landscape," 262–3.

CHAPTER FIVE

1 Woodall, introduction to *Portraiture: Facing the Subject*, 1.

2 Brilliant, *Portraiture*, 54–5.

3 The later identification of anonymous images is addressed more extensively in chapter 6, which examines Inuit images in the Still Division archive and their recent reclamation.

4 Ough and Proulx Ough in discussion with the author and Robert Evans, 18 November, 2003.

5 These routine portraits were made under the "PP" series and catalogued separately by the division. LAC, RG53, sub-series R1196-14-7-E, finding aid 80, accession no. 1971-271, vol. 13 – passports.

6 Tagg, *The Disciplinary Frame*, 15.

7 "To compete with other industrialized nations in the world market, Canada has launched an intensive program of scientific and industrial research" (author's translation). The English version of this photo story, written by John Ough, promotes Canada even more unequivocally. It reads: "Emerging as one of the leading industrial nations of the world, Canada is embarked on a new era of research and development."

8 Brilliant, *Portraiture*, 67.

9 Woodall, *Portraiture*, 5.

10 Brilliant, *Portraiture*, 46.

11 Ibid.

12 This metaphoric use of portraiture was evident also in a 1959 publication, Bennet et al., *The Face of Canada*, that the division contributed to extensively .

13 Cadava and Cortés-Rocca, "Notes on Love and Photography," 8. Also cited in Hughes, "Game Face," 10.

14 Brilliant, *Portraiture*, 46.

15 Carter, "Naming a Place," 402–6; Trachtenberg, *Reading American Photographs*, 119–63.

16 Memorandum, Lorraine Monk to Grant McLean, 19 August 1963, *Call them Canadians / Ces visages* files, NFB SPD Archive, CMCP.

17 Ibid.

18 Sandeen, *Picturing an Exhibition*, 99.

19 Kunard, "Promoting Culture through Photography," 147.

20 For an innovative discussion of the reception of *The Family of Man*, see Stimson, *The Pivot of the World*, 59–103.

21 Steichen, *The Family of Man*, unpaginated.

22 Sandeen, *Picturing an Exhibition*.

23 Barthes, "The Great Family of Man," 100–2; Phillips, "The Judgment Seat of Photography"; Sekula, "The Traffic in Photographs," 15–25.

24 At this point the division proposed five publications: "Image of Canada," the landscape volume; "The Parliament Buildings"; a series of "pocket books illustrating the major cities of Canada"; a series of colour transparencies depicting "Canadian spectacles"; and the "People of Canada" volumes. Memorandum, Norman Hallendy to Lorraine Monk, 16 December 1964, NFB SPD Archive, CMCP.

25 At this time, a preoccupation with picturing the Canadian citizenry was not exclusive to the NFB Still Photography Division. For a discussion of *Weekend Magazine*'s photographic treatments of Canadians, see Stacy, "The Economic Nationalism of *Weekend Magazine*."

26 Statistics Canada census tables.

27 Owram, *Born at the Right Time*, 309.

28 This was a marked increase from the 548,000 new immigrants arriving between 1941 and 1951, though far less than the 1,550,000 new immigrants recorded arriving between 1901 and 1911 with similar high numbers of immigrants in the 1910s and 1920s. Statistics Canada census tables.

29 Knowles, *Forging Our Legacy*.

30 Mackey, *The House of Difference*, 53.

31 Day, *Multiculturalism and the History of Canadian Diversity*, 149.

32 Ibid., 152.

33 Canada, Department of Citizenship and Immigration, *Report of the Department of Citizenship and Immigration for the Fiscal Year Ended March 31, 1950*, cited in Day, *Multiculturalism and the History of Canadian Diversity*, 170.

34 "Spotlight on Manitoba Mosaic," Photo Story 268 (20 September 1960).

35 Day, *Multiculturalism and the History of Canadian Diversity*, 178–9.

36 Druick, *Projecting Canada*, 135–8.

37 Mackey, *The House of Difference*, 67.

38 The document has an addendum written in ink in an unknown hand above: "PLEASE PUT IN OTHER ETHNIC GROUPS." This brief note both indicates the division's clumsy attempts to be inclusive while also indicating a lack of familiarity with the basic ethnic makeup of the country. Memorandum, Lorraine Monk to Grant McLean, 19 August 1963, *Call them Canadians / Ces visages* files, NFB SPD Archive, CMCP.

39 The division, for example, also contributed photographs by Chris Lund for the *Man and His World International Exhibition of Photography*. Norman Hallendy to Philip J. Pocock, project officer, Photography Exhibition, Canadian Corporation for the 1967 World Exhibition, 21 May 1965, People Tree files, NFB SPD Archive, CMCP.

40 T.C. Wood, creative director, commissioner general, Canadian Government Participation 1967 Exhibition, to Lorraine Monk, 8 June 1965, People Tree files, NFB SPD Archive, CMCP.

41 "Expo 67's Indians of Canada." *Expodition*, CBC Radio Archives, 4 August 1967, http://archives.cbc.ca/programs/243-14916/page/2/ (accessed 18 August 2009); Rogers, "A Perfectly Spaced-Out Nation," 10.

42 Among them were exhibitions titled *The Growth of Canada, Challenges to Canadians, Resources, Transportation and Communications*, and *The Changing Times*. Canadian Corporation for the 1967 World Exhibition, *Expo 67 Information Manual*, section 26, 4.

43 Jean Boyer, chief designer, The People Area, commissioner general, Canadian Government Participation 1967 Exhibition, to Lorraine Monk, 13 May 1965, People Tree files, NFB SPD Archive, CMCP.

44 Highmore, "Phantasmagoria at Expo 67," 134; Gagnon, "The Christian Pavilion at Expo 67," 152–3.

45 According to the federal department Canadian Heritage, the Red Ensign was modified by a 1924 order in council. It was authorized for use on Canadian governmental buildings in 1945. Canadian Heritage, "First 'Canadian Flags.'"

46 Pearson, "Address on the Inauguration of the National Flag of Canada," 15 February 1965.

47 In discarding this central visual vestige of British Canada, the government was trying to forge a symbol that was inclusive of all Canadians, particularly Quebecers, for many of whom the Union Jack was an ever-present sign of subjugation. Fraser, "A Canadian Flag for Canada," 64–80; Mackey, *The House of Difference*, 55–8.

48 Memo, Canadian Government Participation, 1967 Exhibition, "The People: General Concept, Exhibit Description, and Thematic Outline," 28 July 1965, People Tree files, NFB SPD Archive, CMCP.

49 Sloan, "Postcards and the Chromophilic Visual Culture of Expo 67," 182–3.

50 Sarsfield, "Personal Recollection of *The People Tree*, Expo '67."

51 For the commission, clearly photography was an unproblematically indexical medium useful for provided seemingly verifiable visual facts. Monk and her staff disagreed, insisting on more flexibility in selecting images. Memo, Canadian Government Participation, "The People: General Concept, Exhibit Description, and Thematic Outline," 5, 28 July 1965, People Tree files, NFB SPD Archive, CMCP.

52 Sarsfield, "Personal Recollection of *The People Tree*, Expo '67."

53 Memorandum, Dunkin Bancroft to Lorraine Monk, 2 September 1965, NFB SPD Archive, CMCP.

54 Memo, Canadian Government Participation, "The People: General Concept, Exhibit Description, and Thematic Outline," 23, 28 July 1965, People Tree files, NFB SPD Archive, CMCP.

55 Dunkin Bancroft, correspondence to Marcel Cognac (Montreal), 22 November 1965; to Walter Petrigo (Calgary), 3 September 1965; to Lutz Dille (Toronto), 3 September 1965; to Chuck Diven (Vancouver), 3 September 1965; Chuck Diven (Vancouver), correspondence to Dunkin Bancroft, NFB SPD, 6 December 1965; Dunkin Bancroft, correspondence to Robert

Brooks (Yarmouth, Nova Scotia), 12 November 1965. The correspondence indicates that photographers were still requested to attend to statistical representation of age and gender.

56 Dunkin Bancroft, correspondence to Marcel Cognac (Montreal), 22 November 1965; to Walter Petrigo (Calgary), 3 September 1965.

57 "Canadian Maple, Expo Style," *Expodition*, CBC Radio Archives, 7 July 1967.

58 Cochrane, "Pavilion Mirrors Our Image: It's Big, It's Lusty, It's Canada," *Toronto Star*, 22 April 1967, 8; "The Wondrous Fair," *Canadian Magazine*, 17 June 1967, n.p.

59 Archival documents from the planning stages of *The People Tree* confirm that this intense identification was an explicit goal: an early conceptual outline for the installation projected, "The visitor to the People Area will get 'a hand-shake view' of the Canadian people, by viewing the 'leaves' from walkways leading to the top of the tree and others leading to the bottom. These walkways are symbolic of the branches on which the leaves grow, and are the approaches whereby the visitor will get to know who Canadians are and what Canadians do." Memo, Canadian Government Participation, "The People: General Concept, Exhibit Description, and Thematic Outline," 28 July 1965, 5, NFB SPD Archive, CMCP.

60 "The Wondrous Fair," n.p.

61 For an alternative reading of *The People Tree*, see Kunard, "Promoting Culture through Photography," 331–7.

62 Dunkin Bancroft, correspondence to Marcel Cognac (Montreal), 22 November 1965; to Walter Petrigo (Calgary), 3 September 1965.

63 "Canadian Maple, Expo Style," *Expodition*, CBC Radio Archives, 7 July 1967.

64 Canadian Corporation for the 1967 World Exhibition, *Expo 67 Information Manual*, section 71, 1; Canadian Corporation for the 1967 World Exhibition, *Expo 67: Memorial Album*, 121.

65 Rogers, "A Perfectly Spaced-Out Nation," 10

66 Schuppli, "Expo 67: Take Two," 4; Kröller, "Expo '67: Canada's Camelot?" 40–1.

67 Memorandum, Authority for the Printing of Governmental Centennial Publications, 26 July 1965, NFB SPD Archive, CMCP; NFB, *Annual Report*, 1966–67, 44, NFB Papers, LAC.

68 Memorandum, Lorraine Monk to R.B. Ingalls, Centennial Commission, 3 June 1965, NFB SPD Archive, CMCP.

69 Draft form letter to photographers, Lorraine Monk, 20 September 1965, NFB SPD Archive, CMCP.

70 Monk, interview by Lilly Koltun, LAC.

71 Memorandum, Gaston Lapointe to Lorraine Monk, undated (probably early fall 1965), NFB SPD Archive, CMCP.

72 Lorraine Monk to Roger Duhamel, Queen's Printer, 25 October 1965, NFB SPD Archive, CMCP.

73 Lapointe, quoted in Lorraine Monk to Roger Duhamel, Queen's Printer, 25 October 1965, NFB SPD Archive, CMCP.

74 Memorandum, Gaston Lapointe to Lorraine Monk, undated (probably early fall 1965), NFB SPD Archive, CMCP.

75 Memorandum, Authority for the Printing of Governmental Centennial Publications, 26 July 1965), NFB SPD Archive, CMCP.

76 Monk, interview by Lilly Koltun, LAC.

77 *Call Them Canadians*, 12. This brief commentary is signed simply "L.M."

78 Hall, "The Determination of News Photographs," 67.

79 *Call Them Canadians*, 12.

80 Ibid.

81 Rina Lasnier to Lorraine Monk, 10 February 1966, NFB SPD Archive, CMCP.

82 My thinking about these publications has developed in part through discussions with Andrea Kunard. For her fascinating discussion of them, see her "Promoting Culture through Photography," 308–15.

CHAPTER SIX

1 Bhabha, "DissemiNation," 300.

2 Leah Idlout d'Argencourt Paulson is an accomplished woman who has been an editor of *Inuit Today* magazine as well as a writer of memoirs and stories. See Idlout, "The Little Arctic Tern, the Big Polar Bear," and "Wonderful Life"; Idlout d'Argencourt, "C.D. Howe."

3 Sturken, *Tangled Memories*, 9.

4 Bhabha, "DissemiNation," 300.

53  Edwards, "Talking Visual Histories," 87.

54  Payne and Thomas, "Aboriginal Interventions into the Photographic Archives," 113.

55  For more on Nunavut Sivuniksavut, see Angus and Hanson, "The New 'Three Rs.'"

56  Among other notable northern interventions in the photo archive is the photo database established by the Prince of Wales Northern Heritage Centre (hereafter the PWNHC) in Yellowknife, NWT. The PWNHC established an online repository of some 30,000 photographs dating from about 1900 to the 1970s, selected from the Northwest Territories Archives. Although not exclusively devoted to Aboriginal history in the Northwest Territories, the PWNHC's mandate does stress its commitment to preserving "the history and culture of the Dene, Inuvialuit, [and] Métis [peoples]." Photographs in the database originated as governmental records, church documents, or personal photographic artifacts. Now these images are readily accessible at http://pwnhc.learnnet.nt.ca/databases/photodb/htm. As with Project Naming, digital technology has been critical to the form and success of the PWNHC photographic database. Through the web, these images are made accessible to geographically vast and diverse communities. The PWNHC encourages site visitors to correct or amend information in the database. In addition, it has established community and school partnerships facilitating use of the database photographs in the classroom.

57  D. Smith, "From Nunavut to Micronesia."

58  "Project Naming," http://www.collectionscanada.ca/inuit/.

59  Nunavut Sivuniksavut, *Project Naming, Phase I: Igloolik*.

60  Greenhorn, "Photographs from the North."

61  Ibid.

62  "Project Naming," *Canku Ota*, 4 May 2002.

63  "Project Naming," http://www.collectionscanada.ca/inuit/.

64  Boswell, "Vintage Snapshots of Inuit History," *Ottawa Citizen*, 21 May 2004, 21.

65  "Project Naming," http://www.collectionscanada.ca/inuit/.

66  Nunavut Sivuniksavut, "Guides for Student Researchers."

67  Ashevak, "Project Naming."

68  "Project Naming," LAC, PA-146084.

69  "Project Naming," LAC, PA-147241.

70  "Project Naming," LAC, PA-129874.

71  "Project Naming," LAC, reproduction no. e002213392.

72  Ibid.

73  Among the specific images they discussed are, respectively, "Project Naming," LAC, PA-114667, PA-147273, PA-146578, PA-129586, and PA-147249.

74  Beth Greenhorn, email correspondence with author, 14 June 2012.

75  Ibid. "Do You Know Your Elders?" was developed by Greenhorn with the Northern News Services.

76  Edwards, "Talking Visual Histories," 88.

77  Boswell, "Vintage Snapshots of Inuit History."

78  Hodgkin and Radstone, introduction to *Contested Pasts*, 2; Huyssen, *Twilight Memories*, 2–3; Klein, "On the Emergence of Memory in Historical Discourse."

79  Kuhn, *Family Secrets*; Radstone, introduction to *Memory and Methodology*, 12.

80  Radstone, introduction to *Memory and Methodology*, 11.

81  Kuhn, "A Journey through Memory," 183.

82  Sturken, *Tangled Memories*, 9, 11.

83  My thoughts on this essay by Bhabha have been enriched by conversations with Erin Macnab. See Macnab, "Passages between Cultures"; Papastergiadis, "Reading DissemiNation."

84  Bhabha, introduction to *Nation and Narration*; Huddart, *Homi K. Bhabha*, 105.

85  Bhabha, "DissemiNation," 309.

86  Ibid., 297.

87  Ibid., 300.

88  Ibid., 299.

89  Ibid., 312.

90  Young, *Colonial Desire*.

91  Carter, "Naming a Place"; Trachtenberg, *American Photographs*.

92  Payne, "Through a Canadian Lens," 427.

93  Said, "Invention, Memory and Place."

94  Greenhorn, "Project Naming: Always on Our Minds."

95  Bennett and Rowley, *Uqalurait*, 3.

96  A cybercartographic atlas, *Views from the North* (www.views-fromthenorth.ca), was designed by Carleton University's

Geomatics and Cartographic Research Centre in collaboration with the author.

97 For a detailed discussion of the project, see ibid.; Payne, "'You Hear It in Their Voice.'"

98 *Between Two Worlds*, directed by Barry Greenwald, 1990.

99 The visual repatriation project I am involved with as a part of Project Naming as a whole engages Inuit youth to interview Inuit elders. However, for this initial contact, I interviewed Leah Idlout Paulson. As noted, however, she has continued to partici-pate in Project Naming, talking with Inuit students.

100 Idlout Paulson, interview by author, 16 June 2004.

CONCLUSION

1 This work was facilitated immeasurably by Robert Evans, who later developed a database of the photo stories.

2 In limiting his discussion to established states, Billig signals that the drive toward nationalism in emerging states takes dif-ferent forms.

3 Billig, *Banal Nationalism*, 93.

4 See Williams, "Culture Is Ordinary."

5 Bourdieu et al., *Un art moyen*.

6 For an excellent collection of important examples of recent social historical writing in Canada, see Opp and Walsh, *Home, Work and Play*.

7 Lorenzkowski and High, "Culture, Canada, and the Nation," 6.

8 Hillmer and Chapnick, "An Abundance of Nationalisms," 6.

9 For important recent scholarship on Canadian nationalisms, see Lorenzkowski and High, special issue of *Histoire sociale / Social History*; Hillmer and Chapnick, *Canadas of the Mind*.

10 Serrano, "'Flagging the Nation'"; Piroth, "Popular Music and Identity in Quebec"; Palmer, "From Theory to Practice."

11 For a few valuable discussions from differing perspectives of how the iconography and marketing of consumer culture repro-duce a model of Canadian identity, see Hodgins, "A Truly Comic History"; Rudy, "Manufacturing French-Canadian Tradition"; Carstairs, "'Roots' Nationalism"; Hastings, "Branding Canada."

12 In this, the present study reflects the social historical approach to photography in Canada that has been developed through Library and Archives Canada. For an assessment of LAC's influ-ence, see Kunard and Payne, "Writing Photography in Canada," 232–5.

13 See Opp and Walsh, *Home, Work and Play*; Whitelaw, Foss, and Paikowsky, *The Visual Arts in Canada*.

14 Canada, Government of Canada website, http://www.canada.gc.ca/home.html.

15 Anderson, *Imagined Communities*, 6.

16 See, for example, Merewether, *The Archive*; Smith, *American Archives*.

17 See, for example, Langford, *Suspended Conversations*; Kuhn, *Family Secrets*.

18 See, among others, Hariman and Lucaites, *No Caption Needed*.

19 See, for example, Morton and Edwards, *Photography, Anthropology and History*; Peers and Brown, *Museums and Source Communities*.

*Pierre Vinet. Image 9.* Edited by Lorraine Monk. Ottawa : National
    Film Board of Canada 1971.
*Polyptyque deux / Polyptych Two. Image 7.* The work of Montreal
    photographer Normand Grégoire. Edited by Lorraine Monk.
    Toronto: Martlet Press 1970.
*A Review of Contemporary Photography in Canada. Image 6.* Edited
    by Lorraine Monk. Toronto: Marlet Press 1970.
*Seeds of the Spacefields: A Sequence of Ten Dreams / Cela commença
    par un rêve et ce fut la création: Une série de dix rêves. Image 5.*
    Edited by Lorraine Monk. English poetry, Penelope
    (pseud.); poésie française, Alain Horic. Toronto: Martlett
    Press 1969.
– Photo Sets. Ottawa: Queen's Printer, ca. 1954–63.
– *Photography: Canada 1967.* Ottawa: Queen's Printer 1967.
– *Stones of History: Canada's Houses of Parliament.* Ottawa: Queen's
    Printer 1967.
– *Témoin d'une siècle: Le palais du parlement canadien.* Ottawa:
    Queen's Printer 1967.
– *This Is Our Strength: A Display of Photo Murals on Canada's
    Achievement in War and Her Potentialities for Peace.* Presented at
    the National Gallery of Canada, 16 March–3 April 1945. Ottawa:
    Wartime Information Board and Displays Division, National Film
    Board of Canada.
– *A Time to Dream / Rêveries en couleurs.* Ottawa: Queen's Printer
    1971.
National Film Board, in cooperation with the Department of
    Northern Affairs and National Resources. *People of the High Arctic.*
    Photo set. Ottawa: Queen's Printer 1958.

OTHER GOVERNMENT PUBLICATIONS

Canada. *An Act to Create a National Film Board. Statutes of Canada,*
    1939: 101–5.
– *An Act Respecting the National Film Board. Statutes of Canada,* 1950,
    1: 567–74.
– Department of Citizenship and Immigration. *Report of the
    Department of Citizenship and Immigration for the Fiscal Year Ended
    March 31, 1950.* Ottawa: King's Printer 1951.

– Department of Northern Affairs and National Resources.
    *Canadian Eskimo Art.* Ottawa: Edmond Cloutier, Queen's Printer
    1955.
– Government of Canada website. http://www.canada.gc.ca/
    home.html (accessed 29 September 2011).
– *Partners in Production: A Report of Labour-Management Production
    Committees in Canadian Industry.* Ottawa: Industrial Production
    Co-operation Board, 1944.
– *Planning Canada's National Capital.* Ottawa: Federal District
    Commission 1948.
– *Report on the Royal Commission on National Development in the Arts,
    Letters and Sciences, 1949–51.* Ottawa: Edmond Cloutier, Printer to
    the King's Most Excellent Majesty, 1951.
    http://www.collectionscanada.ca/2/5/h5-442-e.html
    (accessed 20 August 2009).
Canadian Corporation for the 1967 World Exhibition. *Expo '67
    Information Manual.* Ottawa: Canadian Corporation for the 1967
    World Exhibition 1967.
– *Expo '67: Memorial Album.* Montreal: Thomas Nelson & Sons 1968.
Canadian Heritage. "First 'Canadian Flags.'" http://www.pch.gc.ca/
    pgm/ceem-cced/symbl/df5-eng.cfm (accessed 21 August 2009).
Howe, C.D. *The Industrial Front.* Ottawa: Department of Munitions
    and Supply, 1 January 1942.
Knowles, Valerie. *Forging Our Legacy: Canadian Citizenship and
    Immigration, 1900–77.* Canada: Public Works and Government
    Services 2000. http://www.cic.gc.ca/english/department/legacy/
    (accessed 5 February 2007).
Public Health Agency of Canada. "Polio (Poliomyelitis)."
    http://www.phac-aspc.gc.ca/tmp-pmv/info/polio-eng.php
    (accessed 2 September 2009).
Statistics Canada. Population and Growth Components (1851-2001
    Censuses). http://www40.statcan.ca/l01/cst01/demo03-eng.htm
    (accessed 5 November 2008).
Wartime Information Board. *Canada at War.* Ottawa: Wartime
    Information Board, 1940–45.
– *The Pulp and Paper People: Canadian Affairs Reconstruction
    Supplement 4.* Ottawa: Edmond Cloutier, Printer to the King's
    Most Excellent Majesty, 1945.

— *Vocational Training on Civvy Street*. Ottawa: Edmond Cloutier,
Printer to the King's Most Excellent Majesty 1945.
— *Your Own Business on Civvy Street*. Ottawa: Edmond Cloutier,
Printer to the King's Most Excellent Majesty 1945.

INTERVIEWS

Curtin, Walter. *View*. Canadian Photographer Series. Audiovisual
presentation. Director and producer, Martha Hanna; sound,
Clement Leahy; assistant producer, Sue Lagasi. Canadian
Museum of Contemporary Photography 1985.
Gaudard, Pierre. *View*. Canadian Photographer Series. Audiovisual
presentation. Executive producer, Lorraine Monk; producer,
Pierre Dessureault; sound, Clement Leahy; assistant producer,
Sue Lagasi. Canadian Museum of Contemporary Photography
1980.
Grant, Ted. Interview by Charity Marple and author. Canadian
Museum of Contemporary Photography 1997.
Hallendy, Norman. Interview by author and Robert Evans, Carp,
19 November 2003.
Idlout Paulson, Leah. Interview by author, 16 June 2004.
Lund, Chris. "Chris Lund: Words and Images." *View*. Canadian
Photographer Series. Audiovisual Presentation. Executive pro-
ducer, Martha Langford; producer, Pierre Dessureault; research,
Martha Hanna; sound, Clement Leahy; assistant producer, Sue
Lagasi, NFB, SPD 1982.
Lunney, Gar. Interview by Charity Marple. 7 May. Canadian Museum
of Contemporary Photography, NFB, SPD 1996.
Marshall, Jack. Interview by author. CMCP 1997.
Monk, Lorraine. Interviews by Lilly Koltun. CD-ROM. LAC, Ottawa.
October 1976–June 1977.
Ough, John, and Hélène Proulx Ough, in discussion with the author
and Robert Evans, 18 November 2003.
Reeves, John. Interview by author. CMCP 1997.
Semak, Michael. *View*. Canadian Photographer Series. Audiovisual
presentation. Executive producer, Lorraine Monk; producer,
George Baczynski; technical assistance, Clement Leahy; produc-
tion assistant, Edna Varrin. CMCP 1980.

NFB FILMS

*The Accessible Arctic*. Directed by David Bairstow. 1967.
*Before They Are Six*. Directed by Gudrun Parker. 1943.
*Between Two Worlds*. Directed by Barry Greenwald. 1990.
*A Capital Plan*. Directed by Bernard Devlin. 1949.
*Chantier coopératif*. Directed by Jean Palardy. 1955.
*Circle of the Sun*. Directed by Colin Low. 1960.
*Labour Front*, World in Action series. No director identified. 1943.
*Land of the Long Day*. Directed by Douglas Wilkinson. 1952.
*Partners in Production*. Directed by Stanley Hawes. 1944.
*Prairie Profile*. Directed by Gordon Burwash. 1955.
*The Road to Civvy Street*. Directed by Vincent Paquette. 1945.
*Rosies of the North*. Directed by Kelly Saxberg. 1999.
*Women Are Warriors*. Directed by Jane Marsh. 1942.
*Work and Wages*. Directed by Guy Glover. 1945.

OTHER SOURCES

Adams, Mary Louise. *The Trouble with Normal: Postwar Youth and the
Making of Heterosexuality*. Toronto: University of Toronto Press
1997.
Aitken, Ian. *Film and Reform: John Grierson and the Documentary Film
Movement*. London and New York: Routledge 1990.
Alia, Valerie. *Names and Nunavut: Culture and Identity in Arctic
Canada*. New York: Berghahn Books 2006.
Althusser, Louis. "Ideology and Ideological State Apparatuses:
Notes towards an Investigation." In *Lenin and Philosophy*, trans-
lated by Ben Brewster, 127–86. London: New Left Books 1971.
Anderson, Benedict. *Imagined Communities*. London: Verso 1983.
Angus, Murray, and Morley Hanson. "The New 'Three Rs.'" In "The
Voice of Nunavut." Special issue, *Our Schools / Our Selves* 20, no. 4
(Summer 2011): 31–51.
Ashevak, Mathewsie. "Project Naming." Library and Archives
Canada, February 2004. http://www.collectionscanada.gc.ca /
inuit/020018-1101-e.html (accessed 23 August 2009).
Atwood, Margaret. *Survival: A Thematic Guide to Canadian Literature*.
Toronto: Anansi Press 1972.

Deleuze, Gilles. *Cinema 2: The Time-Image*. Translated by Hugh Tomlinson and Robert Galeta. Minneapolis: University of Minnesota Press 1994.

Deleuze, Gilles, and Félix Guattari. *A Thousand Plateaus: Capitalism and Schizophrenia*. Translated by Brian Massumi. Minneapolis: University of Minnesota Press 1987.

DeLue, Rachel, and James Elkins. *Landscape Theory*. London and New York: Routledge 2008.

Dempsey, Lotta. "Women in War Plants Making Guns, Shells and Tanks." In *Women at War*, edited by Herbert Hodgins, David B. Crombie, Eric Crawford, and R.B. Huestis, 1011. Montreal and Toronto: Maclean Publishing 1943.

DesRoches, Susan. "Weapons on the Wall: An Exploration of Canadian War Posters of the Second World War and Images of National Belonging." Unpublished paper, 2009.

Dessureault, Pierre. "Pierre Gaudard: Photographe documentaire." *Ciel Variable* 88 (Spring–Summer 2011): 48–55.

Diefenbaker, John G. "A New Vision." Lecture, Civic Auditorium, Winnipeg, Manitoba, 12 February 1958. http://www.canadahistory.com/sections/documents/ Primeministers/diefenbaker/docs-thenorthernvision.htm (accessed 22 August 2009).

Druick, Zoë. *Projecting Canada: Government Policy and Documentary Film at the National Film Board*. Montreal and Kingston: McGill-Queen's University Press 2007.

Dunaway, Finis. *Natural Visions: The Power of Images in American Environmental Reform*. Chicago: University of Chicago Press 2005.

Dyer, Richard. *White*. London: Routledge 1997.

Edensor, Tim. *National Identity, Popular Culture and Everyday Life*. Oxford and New York: Berg 2002.

Edwards, Elizabeth. "Photographs and the Sounds of History." *Visual Anthropology Review* 1, nos. 1–2 (2005): 27–46.

– "Talking Visual Histories: An Introduction." In *Museums and Source Communities: A Routledge Reader*, edited by Laura Peers and Alison K. Brown, 83–99. London and New York: Routledge 2003.

Elkins, James, ed. *Photography Theory*. London and New York: Routledge 2007.

Ellis, Jack. *John Grierson: A Guide to References and Resources*. Boston: G.K. Hall 1986.

– *John Grierson: Life, Contributions, Influence*. Carbondale and Edwardsville, IL: Southern Illinois University Press 2000.

Emerling, Jae. "The Archive as Producer." *Photography: History and Theory*. London: Routledge 2012.

"Eskimo Girl Starts Her Own Packing Box Schoolhouse." *Globe and Mail*, 11 September 1957, section 3.

Evans, Gary. *John Grierson and the National Film Board: The Politics of Wartime Propaganda*. Toronto: University of Toronto Press 1984.

– *In the National Interest: A Chronicle of the National Film Board of Canada from 1949 to 1989*. Toronto: University of Toronto Press 1991.

"Expo 67's Indians of Canada." *Expodition*. CBC Radio Archives, CBC Canada. 4 August 1967. 10:56 minutes. http://archives.cbc.ca/ programs/243-14916/page/2/ (accessed 18 August 2009).

Fabian, Johannes. *Time and the Other: How Anthropology Makes Its Object*. New York: Columbia University Press 1983.

Finkel, Alvin. Review of *Filming Politics: Communism and the Portrayal of the Working Class at the National Film Board of Canada, 1939–46*, by Malek Khouri. *Canadian Historical Review* 89, no. 2 (2008): 263–6.

– *Social Policy and Practice in Canada: A History*. Waterloo: Wilfrid Laurier University Press 2006.

Fleischhauer, Carl, and Beverly W. Brannan, eds. *Documenting America, 1935–43*. Berkeley: University of California Press 1988.

Foo, Cynthia. "Canadian War Industry during the Second World War: Highlights from the Collection." Library and Archives Canada. http://www.collectionscanada.gc.ca/war-industry/ 025010-2000-e.html#ind (accessed 3 June 2009).

Foucault, Michel. *The Archaeology of Knowledge and the Discourse on Language*. Translated by A.M. Sheridan Smith. New York: Pantheon 1972.

– "Governmentality." In *The Foucault Effect: Studies in Governmentality*, edited by Graham Burchell, Colin Gordon, and Peter Miller, 87–104. Chicago: University of Chicago Press 1991.

– *Power/Knowledge: Selected Interviews and Other Writings, 1972–77*. Edited by Colin Gordon. Brighton, UK: Harvester Press 1980.

Francis, Daniel. *National Dreams: Myth, Memory, and Canadian History*. Vancouver: Arsenal Pulp Press 1997.

Fraser, Alistair B. "A Canadian Flag for Canada." *Journal of Canadian Studies* 25, no. 5 (1990–91): 64–80.

French, William. "A Camera Panegyric to Canada." *Globe and Mail*, 7 October 1967.

Frye, Northrop. *The Bush Garden: Essays on the Canadian Imagination*. Toronto: House of Anansi 1971.

Gagnon, Monika Kin. "The Christian Pavilion at Expo 67." In *Expo 67: Not Just a Souvenir*, edited by Rhona Richman Kenneally and Johanne Sloan, 143–62. Toronto: University of Toronto Press 2010.

Garden, J.F. *Nicholas Morant's Canada*. Revelstoke, BC: Footprint 1998.

Geertz, Clifford. "Thick Description: Toward an Interpretive Theory of Culture." *The Interpretation of Cultures*. New York: Basic Books 1973.

Geller, Peter. "Bringing the North into the Mainstream of Canadian Life: Technological and Cultural Encounter in the National Film Board's Northwest Frontier." In *The North in Film*, edited by A.W. Plumstead, 53–64. North Bay: Nipissing University 1999.

– *Northern Exposures: Photographing and Filming the Canadian North, 1920–45*. Vancouver: University of British Columbia Press 2004.

Gellner, Ernest. *Nations and Nationalism*. London: Blackwell 1983.

Gleason, Mona. *Normalizing the Ideal: Psychology, Schooling, and the Family in Postwar Canada*. Toronto: University of Toronto Press 1999.

Goldberg, Vicki, ed. *Photography in Print: Writings from 1816 to the Present*. Albuquerque: UNM Press 1990.

Gordon, Colin. "Governmental Rationality: An Introduction." In *The Foucault Effect: Studies in Governmentality*, edited by Graham Burchell, Colin Gordon, and Peter Miller, 1–52. Chicago: University of Chicago Press 1991.

Grace, Sherrill E. *Canada and the Idea of North*. Montreal and Kingston: McGill-Queen's University Press 2001.

Greenhill, Ralph. *Early Photography in Canada*. Oxford: Oxford University Press 1965.

Greenhill, Ralph, and Andrew Birrell. *Canadian Photography, 1839–1920*. Toronto: Coach House 1979.

Greenhorn, Beth. "Photographs from the North: Library and Archives Canada Collections." Project Naming. Library and Archives Canada. http://www.collectionscanada.gc.ca/inuit/020018-1300-e.html (accessed 16 September 2008).

– "Project Naming: Always on Our Minds." *Museums and the Web* 2005. http://www.archimuse.com/mw2005/papers/greenhorn/greenhorn.html (accessed 16 September 2008).

Grierson, John. "The Documentary Idea: 1942." In *Grierson on Documentary*, edited and introduced by Forsyth Hardy, 111–21. London and Boston: Faber & Faber 1979.

– "Flaherty's Poetic Moana." *New York Sun*, 8 February 1926.

Grygier, Pat Sandiford. *A Long Way from Home: The Tuberculosis Epidemic among the Inuit*. Montreal and Kingston: McGill-Queen's University Press 1994.

Halkes, Petra. *Aspiring to the Landscape: On Painting and the Subject of Nature*. Toronto: University of Toronto Press 2006.

Hall, John A. "Structural Approaches to Nations and Nationalism." In *The Sage Handbook of Nations and Nationalism*, edited by Gerard Delanty and Krishan Kumar, 34–9. London: Sage 2006.

Hall, Stuart. "The Determination of News Photographs." *Working Papers in Cultural Studies* 3 (Autumn 1972): 53–85.

Hanna, Martha. *Walter Curtin: A Retrospective*. Ottawa: Canadian Museum of Contemporary Photography for the Corporation of the National Museums of Canada, 1985.

Hariman, Robert, and John Louis Lucaites. *No Caption Needed: Iconic Photographs, Public Culture and Liberal Democracy*. Chicago: University of Chicago Press 2007.

Hardt, Hanno, and Bonnie Brennan. *Newsworkers: Towards a History of the Rank and File*. Minneapolis: University of Minnesota Press, 2005.

Harlan, Theresa. "Indigenous Photographies: A Space for Indigenous Realities." In *Native Nations: Journeys in American Photography*, edited by Jane Alison, 233–45. London: Barbican Art Gallery 1998.

Harper, Douglas. "Talking about Pictures: A Case for Photo Elicitation." *Visual Studies* 17, no. 1 (2002): 13–26.

Hastings, Paula "Branding Canada: Consumer Culture and the Development of Popular Nationalism in the Early Twentieth Century." In *Canadas of the Mind: The Making and Unmaking of*

Liversidge, Douglas. *The First Book of the Arctic*. New York: Franklin Watts 1967.

Loiselle, André. *Cinema as History: Michel Brault and Modern Quebec*. Toronto: Toronto International Film Festival Group 2007.

Lorenzkowski, Barbara, and Steven High. Introduction to "Culture, Canada, and the Nation / Culture, Canada et nation," edited by Barbara Lorenzkowski and Steven High. Special issue of *Histoire sociale / Social History* 39, no. 77 (May 2006).

Low, Brian J. *NFB Kids: Portrayals of Children by the National Film Board of Canada, 1939–89*. Waterloo, ON: Wilfrid Laurier University Press 2002.

Lutz, Catherine A., and Jane L. Collins. *Reading National Geographic*. Chicago: University of Chicago Press 1993.

Lutz, Dorothy. "Dorothy Lutz." In *Equal to the Challenge: An Anthology of Women's Experiences during World War II*, edited by Lisa Banister, 75–9. Ottawa: Department of National Defence 2001.

Lysyshyn, James. *National Film Board of Canada: A Brief History*. Ottawa: NFB 1977.

Macdonald, Gaynor. "Photos in Wiradjuri Biscuit Tins: Negotiating Relatedness and Validating Colonial Histories." *Oceania* 73, no. 4 (June 2003): 225–42.

Mackey, Eva. "Becoming Indigenous: Land, Belonging, and the Appropriation of Aboriginality in Canadian Nationalist Narratives." *Social Analysis* 42, no. 2 (1998): 149–78.

– "'Death by Landscape': Race, Nature, and Gender in Canadian Nationalist Mythology." *Canadian Women's Studies* 20, no. 2 (2000): 125–30.

– *The House of Difference: Cultural Politics and National Identity in Canada*. London: Routledge 1999.

Mackie, Lenore. "A New Look at Canada." *Photographic Society of America Journal* 33, no. 9 (September 1967): 17–21.

Macnab, Erin. "'Passages between Cultures': Exhibition Rhetoric, Cultural Transmission and Contemporaneity in Two Exhibitions of Contemporary Middle Eastern Art." Master's thesis, Carleton University, 2011.

Marchessault, Janine. "Reflections on the Dispossessed: Video and the 'Challenge for Change' Experiment." *Screen* 36, no. 2 (Summer 1995): 131–46.

McAllister, Kirsten Emiko. "Archive and Myth: The Changing Memoryscape of Japanese Canadian Internment Camps." In *Placing Memory and Remembering Place in Canada*, edited by James Opp and John C. Walsh, 215–46. Vancouver: UBC Press 2010.

– *Terrain of Memory: A Japanese Canadian Memorial Project*. Vancouver: UBC Press 2010.

McCaffrey, Gordon. "Textile Industry on Upswing … How Long?" *Toronto Daily Star*, 23 June 1959, 12.

McGregor, Gaile. *The Wacousta Syndrome: Explorations in the Canadian Landscape*. Toronto: University of Toronto Press 1985.

McGregor, Roy. *Canadians: A Portrait of a Country and Its People*. Toronto: Penguin 2007.

McKay, Marjorie. *History of the National Film Board of Canada*. Ottawa: NFB 1964.

McMaster, Gerald. "Colonial Alchemy: Reading the Boarding School Experience." In *Partial Recall: Photographs of Native North Americans*, edited by Lucy Lippard, 77–88. New York: New Press 1992.

McQuire, Scott. *Visions of Modernity: Representation, Memory, Time and Space in the Age of the Camera*. London: Sage 1998.

Merewether, Charles. *The Archive*. Documents of Contemporary Art series. London and Cambridge, MA: Whitechapel and MIT Press 2006.

Metz, Christian. "Photography and Fetish." *October* 34 (Autumn 1985): 81–90.

Mitchell, W.J.T. "Holy Landscape: Israel, Palestine, and the American Wilderness. In *Landscape and Power*, edited by W.J.T. Mitchell, 262–3. Chicago: University of Chicago Press 2002.

– "Imperial Landscape." In *Landscape and Power*, edited by W.J.T. Mitchell, 1–34.

– ed. *Landscape and Power*. 2nd ed. Chicago: University of Chicago Press 2002.

– "The Photographic Essay: Four Case Studies." In *Picture Theory: Essays on Verbal and Visual Representation*. Chicago and London: University of Chicago Press 1994.

Morris, Peter. "'Praxis into Process': John Grierson and the National Film Board of Canada." *Historical Journal of Film, Radio and Television* 9, no. 3 (1989): 269–82.

—  "Re-Thinking Grierson: The Ideology of John Grierson." In *Dialogue: Canadian and Quebec Cinema*, edited by Pierre Véronneau, Michael Dorland, and Seth Feldman, 21–56. Montreal: Mediatexte 1987.

Morton, Christopher A., and Elizabeth Edwards. Introduction to *Photography, Anthropology and History: Expanding the Frame*. Farnham, UK: Ashgate Press 2009.

Mowat, Farley. *The Desperate People*. Boston: Little Brown 1959.

*Nanook of the North*. Silent documentary film, directed by Robert Flaherty, 1922.

Nash, Teresa. "Images of Women in NFB Films during World War Two and the Post War Years, 1939–49." PhD diss., McGill University, 1982.

"National Films Are Distributed to Show Effort." *Hamilton Spectator*, 10 June 1940. http://collections.civilisations.ca/warclip/pages/warclip/ResultsList.php (accessed 19 August 2009).

Nelson, Joyce. *The Colonized Eye: Rethinking the Grierson Legend*. Toronto: Between the Lines 1988.

"Newfoundland: Cameraman Sheds Light in Blackout." *Globe and Mail*, 2 June 1943. http://collections.civilisations.ca/warclip/objects/common/webmedia.php?im=5103237 (accessed 3 June 2009).

Nichols, Bill. *Representing Reality: Issues and Concepts in Documentary*. Bloomington, IN: Indiana University Press 1991.

Nickel, Douglas R. "History of Photography: The State of Research." *Art Bulletin* 83, no. 3 (September 2001): 550.

Nunavut Sivuniksavut. *Project Naming, Phase I: Igloolik*. CD-ROM. April 2002.

—  "Guides for Student Researchers." 2001–continuing.

O'Brian, John. "Wild Art History." In *Beyond Wilderness*, edited by John O'Brian and Peter White, 21–38. Montreal and Kingston: McGill-Queen's University Press 2007.

O'Brian, John, and Peter White, eds. *Beyond Wilderness: The Group of Seven, Canadian Identity, and Contemporary Art*. Montreal and Kingston: McGill-Queen's University Press 2007.

Okalik, Paul. "What Does Indigenous Self-Government Mean?" Lecture given at Brisbane, Australia, on 13 August 2001. Reprinted on the Government of Nunavut website http://www.gov.nu.ca/english/premier/press/2001/isg.shtml (accessed 21 September 2007)

O'Leary, Brendan. "On the Nature of Nationalism: An Appraisal of Ernest Gellner's Writings on Nationalism." *British Journal of Political Science* 27, no. 2 (April 1997): 191–222.

"Opening Day for the Alcan Highway." *Here on This Day: November 20, 1942*. CBC Radio Archives. CBC Canada. 9:45 minutes. 20 November 1942. http://archives.cbc.ca/on_this_day/11/20/ (accessed 21 August 2009).

Opp, James, and John C. Walsh, eds. *Home, Work and Play: Situating Canadian Social History, 1840–1980*. Don Mills and Oxford: Oxford University Press 2006.

—  *Placing Memory and Remembering Place in Canada*. Vancouver: University of British Columbia Press 2010.

Osborne, Brian S. "The Iconography of Nationhood in Canadian Art." In *The Iconography of Landscape*, edited by Dennis Cosgrove and Stephen Daniels, 162–78. Cambridge: Cambridge University Press 1988.

Ough, John. Untitled and unpublished memoir. Ottawa, 2003.

Owram, Doug. *Born at the Right Time: A History of the Baby Boom Generation*. Toronto: University of Toronto Press 1996.

Palmer, Catherine. "From Theory to Practice: Experiencing the Nation in Everyday Life." *Journal of Material Culture* 3, no. 2 (1998): 175–99.

Papastergiadis, Nikos. "Reading DissemiNation." *Millenium: Journal of International Studies* 20, no. 3 (1991): 507–19.

*Partners in Production: A Report of Labour-Management Production Committees in Canadian Industry*. Ottawa: Industrial Production Co-operation Board 1944.

Payne, Carol. *A Canadian Document: The National Film Board of Canada's Still Photography Division*. Ottawa: Canadian Museum of Contemporary Photography 1999.

—  "Designing Nature and Picturing Prestige: Allan Fleming's Work on *Canada: A Year of the Land* and *Canada, du temps qui passe*." Special issue on Allan Fleming, edited by Martha Fleming. *DA: A Journal of the Printing Arts* 63 (Fall/Winter 2008–09): 53–71.

—  "A Land of Youth: Nationhood and the Image of the Child in the National Film Board of Canada's Still Photography Division."

Indigenous Peoples." *Partnership: The Canadian Journal of Library and Information Practice and Research* 3, no. 1 (2008):1–19.

Smith, E. Valerie. "The Black Corps of Engineers and the Construction of the Alaska (Alcan) Highway." *Negro History Bulletin* 51–57, nos. 1–12 (1993): 22–37.

Smith, Shawn Michelle. *American Archives: Gender, Race and Class in Visual Culture*. Princeton: Princeton University Press 1999.

Solomon-Godeau, Abigail. "Who Is Speaking Thus? Some Questions on Documentary Photography." In *Photography at the Dock: Essays on Photographic History, Institutions, and Practices*, 169–83. Minneapolis: University of Minnesota Press 1991.

Stacy, Sarah. "The Economic Nationalism of *Weekend Magazine*." In *The Cultural Work of Photography in Canada*, edited by Carol Payne and Andrea Kunard, 136–52. Montreal and Kingston: McGill-Queen's University Press 2011.

Stange, Maren. *Symbols of Ideal Life: Social Documentary Photography in America, 1890–1950*. Cambridge: Cambridge University Press 1989.

Steichen, Edward. *The Family of Man*. New York: Museum of Modern Art 1955.

Stephen, Jennifer A. *Pick One Intelligent Girl: Employability, Domesticity, and the Gendering of Canada's Welfare State, 1939–47*. Toronto: University of Toronto Press 2007.

Stimson, Blake. *The Pivot of the World: Photography and Its Nation*. Cambridge, MA: MIT Press 2006.

Stott, William. *Documentary Expression and Thirties America*. Chicago: University of Chicago Press 1986.

Straw, Will. "Montreal Confidential: Notes on an Imagined City." *CinéAction* 28 (Spring 1992): 58–64.

Strong-Boag, Veronica. "Canada's Wage-Earning Wives and the Construction of the Middle Class, 1945–60." *Journal of Canadian Studies* 29, no. 3 (1994): 5–25.

Stryker, Roy E. "The FSA Collection of Photographs." In *Photography in Print: Writings from 1816 to the Present*, edited by Vicki Goldberg, 349–54. Albuquerque: University of New Mexico Press 1990.

Sturken, Marita. *Tangled Memories: The Vietnam War, the AIDS Epidemic and the Politics of Remembering*. Berkeley: University of California Press 1997.

"Sudbury's Polio Clinic: A Whole Community of Volunteers Pitches in to Operate." *Weekend Picture Magazine* 3, no. 40A (10 October 1953): 2–5.

Sugiman, Pamela. *Labour's Dilemma: The Gender Politics of Workers in Canada, 1937–79*. Toronto: University of Toronto Press 1994.

Sutnik, Maia-Mari. *Michel Lambeth: Photographer*. Toronto: Art Gallery of Ontario 1998.

Sutton, Damian. "Immanent Images: Photography after Mobility." In *Afterimages of Gilles Deleuze's Film Philosophy*, edited by D.N. Rodowick, 307–25. Minneapolis: University of Minnesota Press 2010.

Tagg, John. *The Burden of Representation: Essays on Photographies and Histories*. Amherst, MA: University of Massachusetts Press 1988.

— *The Disciplinary Frame: Photographic Truths and the Capture of Meaning*. Minneapolis: University of Minnesota Press 2009.

Taussig, Michael. *Mimesis and Alterity: A Particular History of the Senses*. London and New York: Routledge 1993.

Tester, Frank, and Peter Kulchyski. *Tammarniit (Mistakes): Inuit Relocation in the Eastern Arctic, 1939–63*. Vancouver: UBC Press 1994.

Tester, Frank, and Paule McNicoll, "A Voice of Presence: Inuit Contributions toward the Public Provision of Health Care in Canada, 1900–30." *Histoire Sociale / Social History* 41, no. 82 (2008).

Torosian, Michael. *Michel Lambeth: Photographer*. Ottawa: National Archives of Canada 1986.

Trachtenberg, Alan. "From Image to Story: Reading the File." In *Documenting America, 1935–43*, edited by Carl Fleischhauer and Beverly W. Brannan, 43–73. Berkeley: University of California Press 1988.

— *Reading American Photographs: Images as History, Mathew Brady to Walker Evans*. New York: Hill and Wang 1989.

Tsinhnahjinnie, Hulleah J. "When Is a Photograph Worth a Thousand Words?" In *Photography's Other Histories*, edited by Christopher Pinney and Nicolas Peterson, 40–51. Durham and London: Duke University Press 2002.

Vastokas, Joan M., ed. *Perspectives of Canadian Landscape: Native Traditions*. Toronto: Robarts Centre for Canadian Studies, York University 1990.

*Views from the North*. Cybercartographic atlas (designed by the Carleton University Geomatics and Cartographic Research Centre in collaboration with Carol Payne). www.viewsfromthe-north.ca.

Vizenor, Gerald. "Fugitive Poses." In *Excavating Voices: Listening to Photographs of Native Americans*, edited by Michael Katakis, 7–16. Philadelphia: University of Pennsylvania Museum of Archaeology and Anthropology 1998.

Walsh, Andrea. "Visualizing Histories: Experiences of Space and Place in Photographs by Greg Staats and Jeffrey Thomas." *Visual Studies* 17, no. 1 (2002): 37–51.

Wareham, Evelyn. "From Explorers to Evangelists: Archivists, Recordkeeping, and Remembering in the Pacific Islands." *Archival Science* 2, nos. 1–2 (2002): 187–207.

Waugh, Thomas, Michael Brendan Baker, and Ezra Winton, eds. *Challenge for Change: Activist Documentary at the National Film Board of Canada*. Montreal and Kingston: McGill-Queen's University Press 2010.

Whitelaw, Anne, Brian Foss, and Sandra Paikowsky, eds. *The Visual Arts in Canada: The Twentieth Century*. Toronto: Oxford University Press 2010.

Wickens-Feldman, Renate. "The National Film Board of Canada's Still Photography Division: The Griersonian Legacy." *History of Photography* 20, no. 3 (Autumn 1996): 271–7.

Williams, Raymond. "Culture Is Ordinary." In *The Routledge Critical and Cultural Theory Reader*, edited by Neil Badmington and Julia Thomas, 82–94. New York: Routledge 2008.

"Winter on the Farm." *Weekend Picture Magazine* 4, no. 1 (9 January 1954): 4–7.

"The Wondrous Fair." *The Canadian Magazine* 3, no. 24 (17 June 1967): unpaginated. http://expo67.ncf.ca/expo67_food_p1.html (accessed 9 January 2009).

Woodall, Joanna, ed. *Portraiture: Facing the Subject*. Manchester and New York: Manchester University Press 1997.

Wright, Chris. "Material and Memory: Photography in the Western Solomon Islands." *Journal of Material Culture* 9, no. 1 (2004): 73–85.

Young, Robert J.C. *Colonial Desire: Hybridity in Theory, Culture and Race*. London and New York: Routledge 1995.

Zaslow, Morris. *The Northward Expansion of Canada, 1914–67*. Toronto: McClelland & Stewart 1988.

# INDEX